How to select & use
MEDIUM-FORMAT CAMERAS

Theodore DiSante

Executive Editor: Carl Shipman
Editor: David A. Silverman
Art Director: Don Burton
Book Design & Assembly: George Haigh
Typography: Joanne Nociti, Michelle Claridge
Photography: Theodore DiSante, unless otherwise credited

Notice: Cooperation of the camera manufacturers mentioned in this book is gratefully acknowledged. However, this is an independent publication. The information contained in this book is true and complete to the best of our knowledge. All recommendations are made without any guarantees on the part of the author or HPBooks. The author and publisher disclaim all liability incurred in connection with the use of this information. Specifications, model names and operating procedures may be changed by the manufacturers at any time and may no longer agree with the content of this book.

Published by H.P. Books, P.O. Box 5367, Tucson, AZ 85703 602/888-2150
ISBN: O-89586-O46-5 Library of Congress Catalog No. 81-80941
©1981 Fisher Publishing, Inc. Printed in U.S.A

1
Medium-Format Cameras

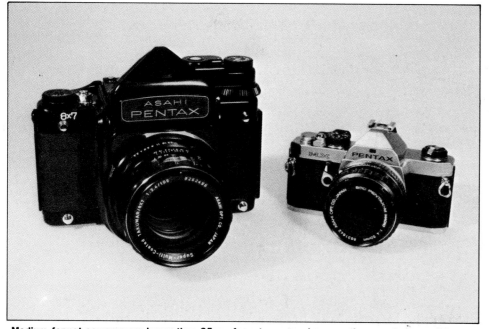

Medium-format cameras are larger than 35mm-format cameras because they create larger images. Even so, they offer some of the fast handling and ease of operation of 35mm-format cameras. The medium-format camera at left is the largest Pentax SLR, the 6x7. Next to it is a Pentax 35mm SLR, the MX.

In this book, medium-format cameras are defined as those producing images on film that are larger than the 35mm film frame and smaller than 2-1/4x3-1/4 inch sheet film. As you will see, many different formats and cameras fit into this category. The cameras' common characteristics are that they have some of the handling ease of a 35mm camera yet offer the benefits of a larger image.

These characteristics make a medium-format camera the choice of many professional photographers. More and more serious amateurs are also finding that a medium-format camera suits their photographic needs.

Because medium-format images are larger than a 35mm frame, medium-format equipment is usually larger and heavier than comparable 35mm equipment, although there are exceptions. This can make it more difficult to hand-hold at times, making a tripod necessary. Another reason for a size difference is that most medium-format equipment is built to withstand the rugged and steady use a working professional demands of his equipment. This also tends to make it more expensive than 35mm equipment, but again, there are exceptions.

However, professional-quality camera equipment is always a sound investment *because* it is made to last a long time. An inexpensive camera that does not last can be more expensive in the long run than a higher-priced quality camera that lasts for years.

Whether you are a professional or a serious amateur, there is a medium-format camera that is best for you. They are made in a variety of sizes and shapes, and each is part of a system of interchangeable accessories that lets you use medium-format cameras for almost any photographic purpose, from portraiture to industrial photography to photomacrography.

The first five chapters of this book describe common aspects of medium-format systems. The camera-brand chapters later in the book describe the equipment in each system and how to use it.

THE MEDIUM-FORMAT IMAGE

The basic advantage of the medium-format image is that the larger the image, the more detail you can record in a film frame. This means that with the same type of film, you can enlarge a medium-format image much more than a 35mm image before the increase in apparent graininess begins to obscure detail.

You'll find this helpful if you make large prints or shoot for publication. In addition, the medium-format negative is much easier to retouch than a 35mm negative—an important consideration in portrait photography.

Standard image sizes produced by medium-format cameras are shown in

ROLL-FILM FORMATS

35mm

4.5x4.5 cm
(1-5/8x1-5/8 inch)

4.5x6 cm
(1-5/8x2-1/4 inch)

6x6 cm
(2-1/4x2-1/4 inch)

6x7 cm
(2-1/4x2-3/4 inch)

6x6 cm on 70mm film
(2-1/4x2-1/4 inch)

Medium-format images created by the cameras discussed in this book have various sizes. All are larger than the 35mm frame. As shown here, each format has nominal dimensions.

These photos of the same subject are shown in both square and rectangular formats. Which do you prefer? Why? Does the format influence your decision? I think a preference for the square or rectangular image is basically a personal, esthetic choice. Usually, a subject can be photographed well *both* ways.

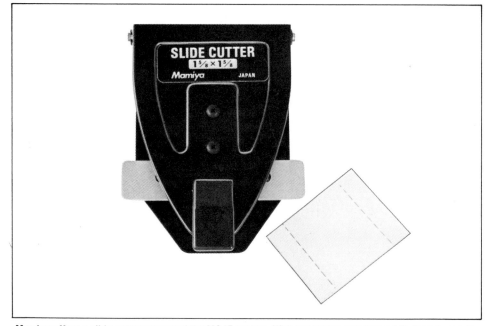

Mamiya offers a slide cutter as part of the M645 system. With the cutter, you trim a 4.5x6 cm image to the 4.5x4.5 cm, or *superslide*, format. Also shown is a mask that fits in the viewfinder to show the image area that becomes the superslide.

the accompanying illustration. The camera's *basic format* is determined by a rectangular or square gate in the camera or film back, directly in front of the film plane. Each format has two dimensional names, one in metric and the other in US customary units. These names indicate the nominal frame size, not the exact frame size. In this book I'll use just the metric name when referring to a certain format.

Square or Rectangular Image?—The relative merits of the square or rectangular image depend on your esthetic preference, not on the intrinsic merit of a square or rectangular picture. Some photographers like the rectangular image because it gives flexibility in composing the image. Others claim that the square image is superior *because* you don't have to worry about vertical or horizontal image orientation. You must decide what you prefer.

Remember, you can always crop the square format to make it rectangular or the rectangular format to a square, if necessary. I have done both to the photos in this book.

The other major consideration in selecting a format is the *area* of the image. The largest format, 6x7 cm, is rectangular, and the next smaller size, 6x6 cm, is square. Obviously, the larger the image, the fewer you can get on a roll of 120 or 220 film—but each frame can record more detail.

This is sometimes reason enough for photographers to choose one format over the other. Some individuals would rather reload film more often than settle for a smaller image, while others are content with getting a slightly smaller image, reloading less, and paying less per image. See Chapter 4 for a table showing the number of images you can get with different image formats and film sizes.

If you can't decide which format is best for you, consider buying a medium-format camera that accepts interchangeable backs. Then you can use either the camera's basic format or that of an accessory back.

4.5x4.5 cm—This square format is usually called the *superslide* because the image is most often used in a special 2-inch-square slide mount that fits into a regular 35mm slide projector. Because the superslide has almost twice the area of the 35mm image, it gives better image quality than a 35mm slide when it is projected.

Unlike the other three formats, the 4.5x4.5 cm format is not basic to any medium-format camera. The only way to get it in camera is with an accessory film back designed to give superslides. Currently, only Hasselblad offers a film back for this format. Other camera manufacturers suggest trimming a 4.5x6 cm image to fit the superslide mount.

4.5x6 cm—There are two good reasons why this format is very popular among medium-format photographers. First, the format's aspect ratio, width divided by height, is nearly the same as 8x10 and 11x14 printing paper. This means you can enlarge the image onto papers this size without cropping or wasting paper space. Like the 35mm image, the 2.7X larger 4.5x6 cm format is rectangular so you can make both horizontal- and vertical-format photos.

The second reason is that you can get 15 or 16 images on a single roll of 120 film. Accessory backs from Rollei and Hasselblad for this format give 16 images. You reload less often than with larger formats, and the cost per image is proportionately less.

6x6 cm—Because it has been in use for so long, this is the format most people think of first when considering medium format. In fact, film-edge frame numbering on 120 and 220 rolls corresponds only to this format. Frames on 120 rolls are numbered from 1 to 12, and on 220 rolls numbered from 1 to 24.

This format is also called the *2-1/4-inch-square* format. A picture this size is large enough to give excellent image quality even when cropped rectangularly. Like the superslide, it too can be used in special slide mounts and projected. However, you must use a special large projector, such as one made by Rollei, Leitz, or Kindermann, that is designed for the large slide mount. I recommend you use glass-mounted slides so heat from the projector lamp won't buckle the mounted slide.

6x7 cm—This format is also called the *ideal format*—for two reasons. Like the 4.5x6 cm image, its aspect ratio is practically the same as that of 8x10 and 11x14 printing paper. In addition, it is the largest medium-format image you can get on roll film. One roll of 120 film will produce ten 6x7 cm images. Image quality approaches that of 4x5 inch sheet film.

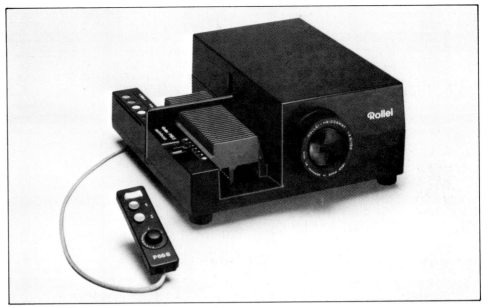

The P66-S Autofocus slide projector made by Rollei holds a tray that accepts thirty 6x6 cm glass-mounted slides. Features include automatic slide changing in intervals from 4 to 30 seconds, accessory lenses, a continuously variable projector lamp, and remote control with the switch shown or with an accessory infrared transmitter.

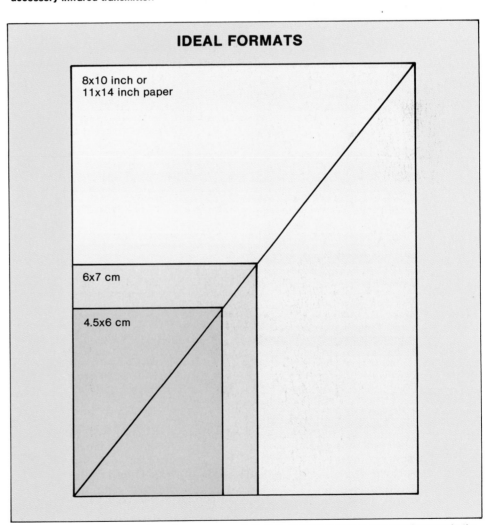

IDEAL FORMATS

8x10 inch or 11x14 inch paper

6x7 cm

4.5x6 cm

According to some medium-format camera manufacturers, an ideal format is one that has nearly the same aspect ratio as that of standard 8x10 inch or 11x14 inch printing paper. This means full-frame enlargements of a 6x7 cm or 4.5x6 cm image fill the paper with less waste than other formats. This may or may not be important to you because many photographers use the white, unexposed part of the paper as a framing element for the enlargement.

CHARACTERISTICS OF THE MEDIUM-FORMAT TLR

The abbreviation *TLR* means *twin-lens reflex*. This refers to the optical system of the camera. In a TLR camera, two lenses of identical focal length are mounted one above the other with centers 40mm to 50mm apart. The top lens is for viewing and the bottom lens is for taking the picture. In this book they are called the *viewing lens* and the *taking lens*.

One of the first modern TLRs was introduced in the late 1920's, and was called the *Rolleiflex*. Since then, many changes and improvements have been made to the TLR by several manufacturers, but the basic design and characteristics have remained unchanged.

Generally, a TLR is less expensive than a medium-format SLR because it is less complicated and requires fewer moving parts. However, this does not mean image quality is necessarily less than you can get with a medium-format SLR. TLRs have important advantages and they deserve consideration when you are planning to buy a medium-format camera. Both new and used TLRs are available from many camera stores.

Even though they are relatively light, the main disadvantage of TLR cameras is with camera handling. Because of their shape and the location of exposure controls, you cannot operate one as quickly as a medium-format SLR camera. In addition, they do not have as many features nor the versatility of the SLRs described in this book. This makes TLRs most suitable for subjects that can be photographed leisurely.

How the Image is Formed—As shown in the accompanying drawing, the image formed by the viewing lens is reflected by a mirror and intercepted by the focusing screen. With the standard waist-level, or *folding hood*, viewfinder of the TLR, you see the intercepted image right side up but laterally reversed. This puts the left side of the subject on the right side of the focusing screen and vice-versa.

When you turn the focusing knob, both lenses move together. The distance from the viewing lens to the mirror to the focusing screen is the same distance as from the taking lens to the film plane. Therefore, a focused image on the focusing screen will also be in focus on the film plane.

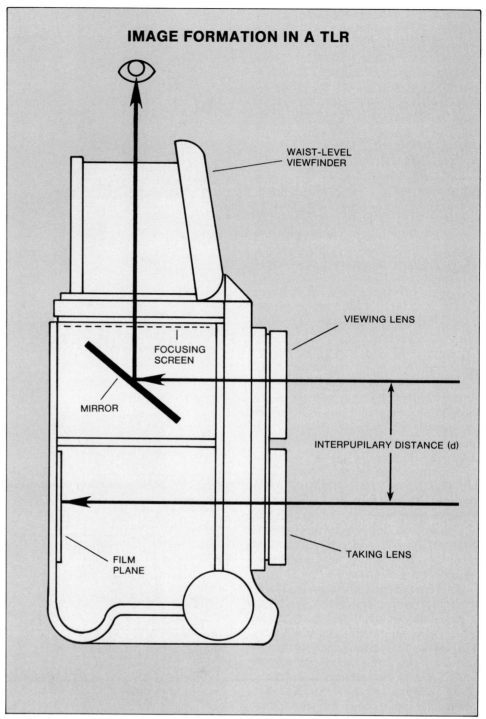

IMAGE FORMATION IN A TLR

WAIST-LEVEL VIEWFINDER

VIEWING LENS

FOCUSING SCREEN

MIRROR

INTERPUPILARY DISTANCE (d)

FILM PLANE

TAKING LENS

The scene imaged by the viewing lens of a TLR is reflected from a fixed mirror to the focusing screen. This creates an upright, laterally reversed image. The scene imaged by the taking lens exposes the film.

Unlike the taking lens, the typical viewing lens does not have an adjustable aperture for visually checking depth of field. Depth of field must be checked using a scale on the camera or with depth-of-field tables—not very convenient alternatives. The viewing lens of some TLRs has a larger aperture than the maximum aperture of the taking lens, giving a bright image on the focusing screen.

Making the Exposure—The only shutter in a TLR camera is a leaf shutter built into the taking lens. When you trip the leaf shutter, the viewing image is not blacked out because the mirror does not move. The leaf shutter opens and closes, and the image formed by the taking lens exposes film at the film plane. This characteristic of the TLR is very convenient because you are able to see what the subject is

doing at the moment of exposure, not just before and just after, which happens with an SLR. If the subject blinked or moved, you can shoot again, instead of discovering it later in the processed photo.

Because the only internal camera motion during exposure is in the leaf shutter, which operates very quietly and with little vibration, TLR cameras can be hand-held at long shutter speeds easier than most SLR cameras. Some photographers can hand-hold a TLR at 1/10 second shutter speed and get sharp photos. Of course, the other advantage of the leaf shutter is electronic flash sync at all shutter speeds. This is described in more detail in Chapter 3.

Parallax Error—The image you view through a TLR is not exactly the same image you make on the film. This is because the centers of the two lenses are separated vertically by a distance, *d*, giving them slightly different fields of view. This effect is called *parallax*.

If you imagine superimposing the processed image with the one you see on the focusing screen, you would perceive an offset between two identical parts of the images. The resultant shift between the two images is called the *parallax error*, and is calculated by **M x d**. In this formula, *M* is image magnification as described in Chapter 2. What happens is that the camera excludes part of the image you want and includes part of the image you don't want.

The farther away the subject is from the camera, the smaller the parallax error. If subject distance is many times greater than the distance between the two lenses, the lenses view essentially the same field. For example, if subject distance is 3.0m, lens focal length is 80mm, and d is 50mm, the parallax error is less than 1mm. This is an error of only 1.8% with a 6x6 cm image.

As subject distance approaches focal length, which happens in close-up photography, parallax error is significant. Some camera manufacturers solve this problem with an automatic parallax correction device that shows you the actual taking image on the focusing screen. When using a TLR without parallax correction for close-up photography, you'll have to remember to move the camera so the taking lens is in the position the viewing lens was in when you composed the image.

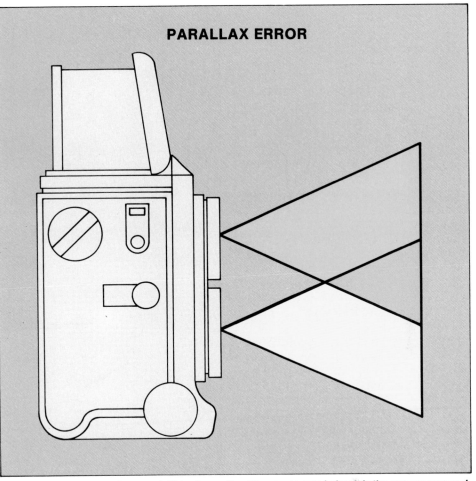

PARALLAX ERROR

The red area represents image cutoff due to parallax. The orange area below it is the area you see *and* photograph. The yellow area is the image gained. This image shift, or *parallax error*, increases as magnification increases.

The picture looked like this in the waist-level viewfinder of a Mamiya C330f. Lateral reversal suggests that the musician is leaving ƎИO YAW.

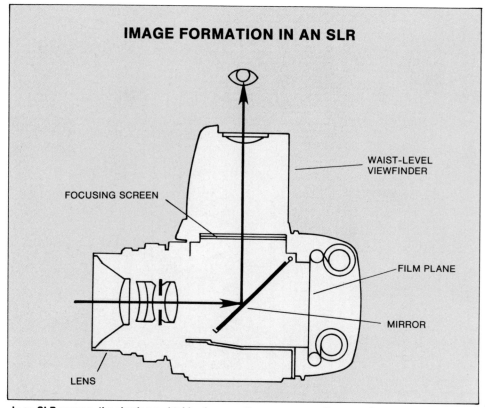

IMAGE FORMATION IN AN SLR

FOCUSING SCREEN

WAIST-LEVEL VIEWFINDER

FILM PLANE

MIRROR

LENS

In an SLR camera, the viewing and taking lens are the same, so parallax error does not occur. Before film is exposed, the mirror swings up out of the way. After exposure or film advance, depending on the camera model, the mirror drops down again so you can view the scene through the lens.

CHARACTERISTICS OF THE MEDIUM-FORMAT SLR

One of the first medium-format *single-lens reflex* (SLR) cameras was made in 1936 and was called the *Reflex Korelle.* After World War II it was known as the *Agiflex.* Other medium-format SLRs of the mid-1930's were made by National Graflex, Zeiss Ikon, and Exakta. However, it wasn't until the Hasselblad 1600F was introduced in 1948 that the medium-format SLR seriously undermined the popularity of the TLR. Now, only a few TLR systems are still being made, while the number of SLR systems is increasing.

How the Image is Formed—The accompanying illustration shows the light path from the subject to the camera's focusing screen. With this kind of camera, you view, focus, and take the picture through one lens. The image on the focusing screen is right side up and laterally reversed, but most SLRs offer an accessory pentaprism viewfinder that shows the image with correct orientation. There is no parallax error.

Exposing Film—Medium-format SLRs are available with and without focal-plane shutters. Those with focal-plane shutters operate like 35mm SLR cameras. Those without focal-plane shutters use interchangeable lenses with built-in leaf shutters. See Chapters 2 and 3 for a discussion of shutter operation in these two kinds of cameras.

In both cases, the mirror swings out of the way so light can expose film in the film plane. This blacks out the viewfinder image until the mirror drops back in place after exposure or film winding.

Hand-Holding the Camera—Except for the Pentax 6x7 camera, the general shape of medium-format SLR camera bodies described in this book is unlike a 35mm SLR camera. Generally, the medium-format SLR is heavier and boxier, with the length being larger than the width or height. This makes hand-holding medium-format cameras different than that of 35mm cameras.

Typically, you support the camera's weight with your left hand, which frees your right hand to operate exposure controls and the shutter button, and steady the camera's side during exposure. The length and weight of the camera and lens often makes it difficult to hold the camera still enough even at some relatively fast shutter speeds, such as 1/125 second.

General guidelines for the limit of hand-holding cannot be given because the cameras and lenses described in this book are of various sizes and weights. And, photographers vary in their steadiness and experience. Usually, the rule of 35mm photography—the fastest shutter speed that you should hand hold is the reciprocal of the lens focal length—*does not* apply. You should use faster shutter speeds than this rule implies. Only some testing and experience will help you find the limit of your hand-holding ability.

To make camera holding easier—or more like 35mm SLRs—camera manufacturers make handgrips for their cameras. These typically mount to the tripod mounting screw on the camera base and have a handle that is on one side of the camera. The most convenient ones have a shutter button on the grip's handle. Basically, they let you hold and operate the camera as you would a 35mm SLR. I recommend you use one of these grips whenever you do not use a tripod. The grips are useful for both eye-level and waist-level viewing.

THE MEDIUM-FORMAT SYSTEM

The design philosophy behind a system camera is that no one camera and lens is best for all photographic situations. Often, specially designed camera equipment is necessary to make a certain kind of photo. This is why camera manufacturers make interchangeable lenses in a variety of focal lengths, viewfinders, focusing screens, film backs, grips and other accessories compatible with a camera body. System accessories provide photographic versatility.

Each of the SLR cameras in this book is part of a system. Some TLR cameras, such as the Yashica Mat-124G and Mamiya cameras, also are part of systems with interchangeable accessories, but these systems are less extensive than the SLR models.

VIEWFINDERS

The image created on film by a camera lens is upside down and laterally reversed. In both TLR and SLR medium-format cameras, a mir-

These are some ways to view through a standard waist-level viewfinder. The method in the photo above is also convenient for low-angle shooting. Even if the camera is on the ground, you can easily view the scene. With the viewing method shown below, steady the camera with a neck strap.

With the magnifier over the focusing screen, you view the image by bringing the camera to your eye. This is useful for scenes requiring critical focusing. With some cameras, you can also view the scene on your left or right side, as shown below.

ror reflects the upside-down, reversed image onto a focusing screen. This reflection turns the image right side up on the focusing screen, but does not correct lateral reversal.

The orientation of the image you view depends on the camera's viewfinder, or *finder*. The viewfinder also affects the way you hold the camera and, to a certain extent, what kind of subjects you can shoot. The standard viewfinder of medium-format cameras in this book is either a folding hood or a pentaprism viewfinder.

The Folding Hood—This viewfinder, also called a *waist-level* viewfinder, is the simplest, lightest and least expensive interchangeable viewfinder. When folded down, it protects the focusing screen from dirt and scratches. When you unfold it, folding sides snap into place around the screen to exclude stray light from the focusing screen. The folding hood has no optical elements other than a small magnifier lens you can move in position over the focusing screen for critical focusing.

When you use the folding hood, you can hold the camera many different ways. Without the magnifier in place, you can hold the camera at waist level against your body and look down at the focusing screen. Holding it against your body helps to damp vibrations and camera shake, but it also makes it difficult to see the image well.

In addition, ambient light can reduce the contrast of the viewing

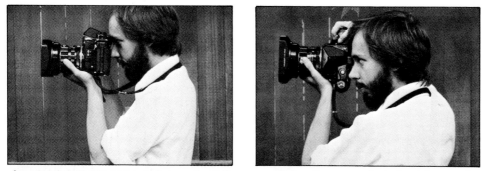

A pentaprism viewfinder is used at eye level. You can easily turn the camera for horizontal- or vertical-format photos.

image. For this reason, many photographers use the built-in magnifier to make focusing easier.

After you flip the magnifier into place, you must bring the camera to your eye and look down into the camera at a 90° angle to the subject. After focusing, you can flip the magnifier out of the way and hold the camera at waist level, on the ground, sideways, or even over your head to see the whole scene.

What you see is the image intercepted by the focusing screen. It is right-side-up and laterally reversed. With this image orientation, you can become confused which way to tilt or turn the camera while composing. For example, if the subject moves to your left, the viewfinder image moves to your right. As you become more experienced with this kind of viewer, lateral reversal is less of a problem. However, using the viewfinder to follow moving subjects is impractical.

Generally, this viewfinder is fine for most tripod setups, if the subject is relatively still, or if you shoot from a low angle. In addition, you can see all of the focusing screen, which in some cases shows 100% of the final image.

The Pentaprism—Due to multiple reflections in the pentaprism, this viewfinder presents an image that is both laterally correct and right-side-up. You usually use the camera at eye level. In addition, the viewfinder image is magnified to make focusing even easier. Because this is the way most 35mm SLR cameras work, many photographers already used to it tend to prefer it.

Eye-level viewing is essential for photography requiring a camera you can handle quickly or use for high-angle shooting. The main disadvantages of these viewfinders are that they are relatively heavy and expensive when compared to the folding hood. Sometimes, the camera

manufacturer designs the pentaprism to view less than 100% of the focusing screen to save weight and space.

Other Viewfinders—Both basic folding hood and pentaprism designs are incorporated into other interchangeable viewfinders. Some manufacturers make solid, non-folding waist-level viewfinders and have the magnifier permanently in place. The magnifier is usually adjustable so you can adjust it to fit your eyesight if necessary. This design makes focusing easy because stray light is always excluded.

Pentaprism viewfinders are available with and without built-in light meters and with a choice of eyepieces. As you will see in the discussion of each camera brand, some systems offer more than one kind of pentaprism viewfinder. Pentaprism viewfinders are available for TLR cameras too.

Sportsfinders are also made for medium-format cameras. In some cases, they are built into the folding hood viewfinder. When you use a sportsfinder, the camera becomes a point-and-shoot camera. You view the *subject* through a mask in the finder that indicates the approximate field of view for that lens. Typically, you use a small lens aperture and a prefocused lens to give good depth of field for the subject. Following action is very easy because you are not limited to seeing just the subject. Your peripheral vision helps you to follow and frame the subject just right.

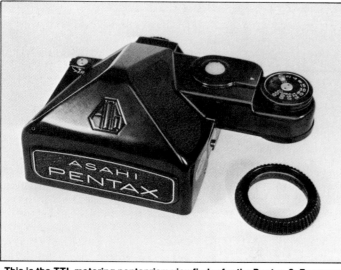

This is the TTL metering pentaprism viewfinder for the Pentax 6x7 camera, also shown in the top photos. Except for the Yashica Mat-124G and Rollei SLX, which have a meter built into the camera body, all medium-format cameras described in this book accept an accessory metering finder.

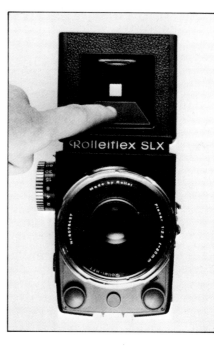

Pushing the front panel of the Rollei SLX waist-level viewfinder raises the magnifier eyepiece. Pushing the panel down more folds it over the focusing screen. You then view the scene through the hole in the rear of the finder. When you use a sportsfinder, parallax error increases.

A *biprism*, also called a *split-image*, is a focusing aid using with two wedges of glass or plastic. The wedges taper in opposite directions, causing an out-of-focus image to appear split, as shown below. This aid works well with scenes having straight lines and edges.

VIEWFINDER DISPLAY WITH BIPRISM

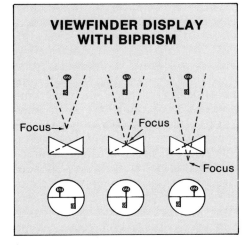

FOCUSING SCREENS

It helps to choose the right focusing screen for a particular application. All but one of the camera systems in this book have interchangeable focusing screens in different designs. Practically all use a Fresnel lens for a bright, evenly illuminated image on the screen. The screens are different combinations of matte fields and engraved focusing aids. These are shown and described in each camera-brand chapter, later in this book.

Generally, an all-matte field is good for close-up work, small lens apertures, and when judging depth of field is important. Microprism focusing aids are helpful for general-purpose photography of subjects with fine details. When you use one, the image will seem to snap into focus.

A biprism aid makes focusing on straight lines easy; however, it is not best for close-up photography or when you view through apertures smaller than maximum. In these cases, one side of the biprism can black out.

Screens using grid lines or crosshairs are useful when the camera must be aligned with the subject's straight lines, such as in architectural photography. You can also use them to align images when making in-camera multiple exposures.

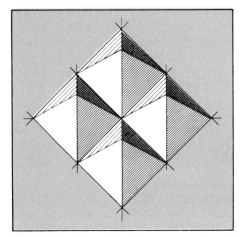

A *microprism* focusing aid is an array of small pyramids. Intersections on the pyramids work like biprisms, so when the image is even slightly out of focus, it appears fuzzy. Microprism focusing aids are sometimes a ring surrounding a biprism in the center of the focusing screen.

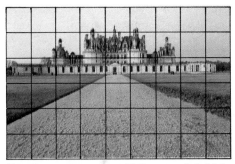

Focusing screens with grid lines are helpful in architectural photography, which is one of the many ways to use medium-format cameras.

The Magnifying Hood viewfinder for the Mamiya RB67 Pro-S camera has a built-in diopter adjustment. The adjusting ring is just below the rubber eyecup. All viewfinders in this book with a built-in diopter adjustment work similarly.

ADJUSTING EYEPIECE MAGNIFICATION

Many of the interchangeable viewfinders for medium-format cameras let you adjust the viewfinder's eyepiece magnification to fit your eyesight. This helps you focus the lens and get the sharpest possible image on the focusing screen.

The eyepiece magnifier that comes with the viewfinder is usually set for people with normal vision. If you wear glasses to correct an eyesight problem, you'll have normal vision when you use the viewfinder with your glasses on. However, some people find this inconvenient because the glasses hit the eyepiece or rubber eyecup. In addition, you cannot always see all of the viewfinder image while wearing glasses.

To avoid these problems, change the interchangeable *diopter correction lens* that comes with the viewfinder. These single-element lenses are available in a variety of diopter strengths, typically from about +3 to -3.

The easiest way to find the right magnifier is to do it at your camera store. Focus the lens at infinity, take off your glasses, then view a faraway object through the finder. If the subject is not in focus, try different magnifiers in the eyepiece until the subject is sharp on the screen. Use that magnifier when not viewing through eyeglasses.

Some of the interchangeable viewfinders described in this book have a built-in *diopter adjustment* in the eyepiece. To adjust it, follow the basic procedure just described, except that you adjust the eyepiece until the image is sharp. When you find the proper setting, lock it.

LENSES, LENS ATTACHMENTS AND CLOSE-UP EQUIPMENT

Both SLR and TLR camera systems include lenses and lens attachments for a variety of purposes. See Chapter 2 for a discussion of lenses and lens accessories for medium-format cameras. In addition, each camera-brand chapter details the lenses and accessories made by each manufacturer for that system.

INTERCHANGEABLE FILM BACKS

A very handy accessory for medium-format cameras is the inter-changeable film back. Only SLR cameras use them, but not all of them do. The most versatile interchangeable film back is one with a *dark slide*. When in place, this removable opaque card prevents light from reaching the film. You can remove the film back from the camera body in the middle of a roll without fogging exposed and unexposed film.

This feature lets you attach a Polaroid back or another film back with a different format or type of film and use it for subsequent exposures. For example, a zone-system photographer could have three film backs loaded with the same kind of b&w film, with each roll designated for a different development time based on the kind of scene being shot. If the photographer wants to shoot a scene requiring a normally-developed negative, he would use the back loaded with film intended for that kind of development. The other film backs would contain film intended for less and more development respectively.

Some photographers need to shoot the same subject in b&w and color, but can afford only one camera. They can use two film backs loaded with different films and shoot in *both* b&w and color.

Interchangeable backs also let you shoot a variety of image formats, depending on what you need. For example, with a 70mm film back you can bulk load film for the maximum number of exposures in one load. See Chapter 4 for a discussion of different kinds of film, formats, and exposures per load.

The interchangeable film backs of some systems don't have dark slides, so you can't change backs in the middle of a roll without fogging film. In this case, the only advantage the backs offer is that you can get a different image format and number of exposures per roll with each back.

Polaroid Backs—Camera manufacturers and independent companies use parts made by Polaroid and fit them to mounting brackets that couple to the camera.

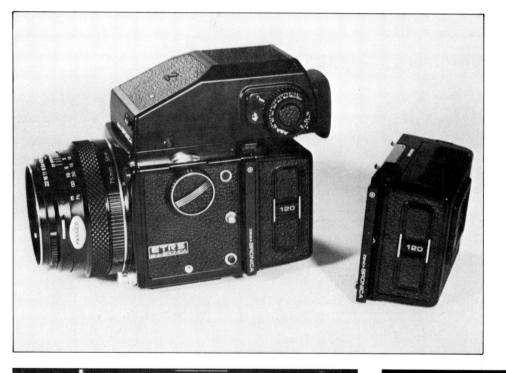

The Bronica ETR-S camera accepts interchangeable backs that have dark slides.

Interchangeable film backs let you be both versatile and economical. I made these two portraits with the Bronica ETR-S and two 120 film backs. Because the subject was photographed with Kodak Ektachrome 400 and Tri-X, exposure settings were the same for each photo.

Most of the camera systems described in this book have a tripod adapter like this Hasselblad model. The adapter attaches to a standard tripod screw. A plate on the bottom of the camera slides in the adapter, where it can be quickly clamped securely. This makes tripod mounting of the camera fast and easy.

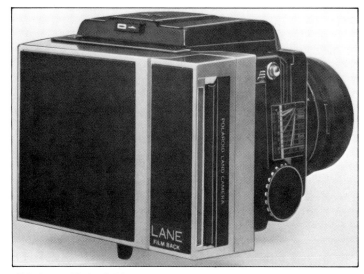

This is the Model 3-70 back designed by the Lane Corporation for the Mamiya RB67 Pro-S camera. This back accepts Polaroid SX-70 film and automatically transports the print out of the back after exposure. You do not have to time or peel apart the print. It develops itself automatically.

Some of the backs made by independent companies offer convenient features that the manufacturer's back does not have. For example, the Polaroid backs made by Hasselblad have a piece of glass in front of the film plane to shift the plane of sharp focus to coincide with the film plane. This is necessary because the film plane in their Polaroid back is in a different place than the film plane of their roll-film backs. The problems with the glass are that it can become dirty and degrade image quality, or crack and break.

The Polaroid back made by NPC for Hasselblad cameras does not use glass. According to NPC, the glass is not necessary due to design differences that put the film plane in the same plane as that of a roll-film back. In addition, the back accepts *both* 100/600- and 80-series Polaroid film.

Two manufacturers also make a motorized Polaroid back that accepts Polaroid SX-70 film. After exposure the film is automatically transported from the back. It develops automatically—no peeling or timing is necessary. Currently, this SX-70 back is made only for the Mamiya RB67 Pro-S camera.

Another manufacturer makes a Polaroid back with a built-in timer. This is very convenient because the development of all peel-apart Polaroid films must be carefully timed for best image quality. This back is made for the Mamiya RB67 Pro-S camera.

OTHER MANUFACTURERS' POLAROID BACKS

COMPANY	CAMERA	BACK	POLAROID FILM
NPC Photo Division 1238 Chestnut St. Newton Upper Falls, MA 02164 (617-969-3487)	Hasselblad 500C, 500C/M, SWC/M, 2000FC	MF-1	100/600- and 80-series
	Mamiya RB67 Pro-S	MF-3	100/600- and 80-series
	Bronica ETR-S	MF-5	100/600- and 80-series
	Mamiya RB67 Pro-S	MF-6	SX-70
Lane Corporation 1019 Highway 301 S. Tampa, FL 33619 (813-626-4242)	Mamiya RB67 Pro-S	Model 3-80	80-series
		Model III	100/600-series
		Model IIID	100/600-series
		Model 3-70	SX-70
Bogen Photo Corp. 100 S. Van Brunt St. Englewood, NJ 07631 (201-568-7771)	Hasselblad 500C, 500C/M, SWC/M, 2000FC	Arca-Swiss	100/600-series
Weinberger AG Förrlibuckstrasse 110 CH-8005 Zurich, Switzerland	Pentax 6x7	Weinberger Polaroid Back	100/600-series
Klinger Precision Instr. 3402-I W. MacArthur Santa Ana, CA 92704 (714-641-5878)	Hasselblad 500C, 500C/M, SWC/M, 2000FC	HM-II	100/600- and 80-series

2
Lenses

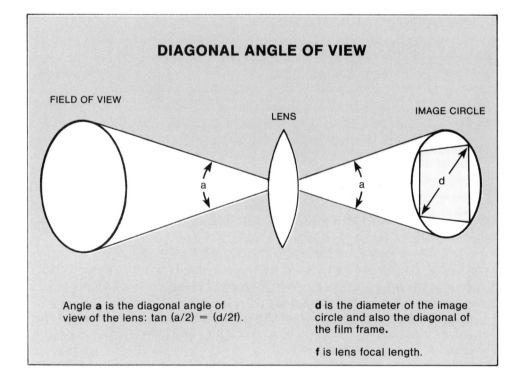

DIAGONAL ANGLE OF VIEW

FIELD OF VIEW

LENS

IMAGE CIRCLE

Angle **a** is the diagonal angle of view of the lens: tan (a/2) = (d/2f).

d is the diameter of the image circle and also the diagonal of the film frame.

f is lens focal length.

Each of the SLR cameras discussed in the book is part of a system and each accepts interchangeable lenses. Depending on the camera brand and model, you can use lenses with automatic or non-automatic diaphragm, with or without built-in leaf shutters in focal lengths ranging from 30mm to 1000mm. Some systems include fish-eyes and zooms. In addition to interchangeable lenses are lens attachments such as extension tubes, telephoto converters, reversing adapters, bellows, close-up lenses, filters and lens hoods.

Each manufacturer offers a different assortment of lenses and accessories. Those currently available are described in the camera-brand chapter. General information about medium-format lenses is included here.

FOCAL-LENGTH CLASSIFICATION

The image formed by a circular lens is a circle. The image becomes rectangular or square because of a gate in front of the film plane that blocks some of the image. This makes the diagonal of the rectangular or square image equal to the diameter of the image circle formed by the lens. See the accompanying diagram.

Lenses are usually classified in one of three categories, depending on the diagonal angle of view recorded on film. This angle can be mathematically derived when you know the lens focal length and the diagonal of the film frame. The three categories and their respective diagonal angle of views are:

WIDE-ANGLE	60° or more
STANDARD	40° to 59°
TELEPHOTO	39° or less

They are sometimes subdivided even further, but it is not necessary for this discussion.

Because medium-format cameras are available in a variety of formats—with some models even having a variety of formats—you cannot categorize the focal length of medium-format lenses as wide-angle, standard, or telephoto unless you also designate image format.

For example, suppose you photograph a scene with two cameras from the same position. The cameras are the Pentax 6x7 with a 150mm lens and a Hasselblad with a 150mm lens and the A16S back, which gives superslides. The resultant photos will look different. Perspective will be the same. Even though the lenses have the same focal length, the Pentax image will show much more of the scene. As shown in the accompanying table, the diagonal angle of view for the Pentax format is 1.5 times that of the Hasselblad because the diagonal of the 6x7 cm image is much greater than that of the superslide.

Also in the table is the diagonal angle of view relative to focal lengths of lenses used with 35mm cameras. This shows how the different formats compare with regard to lens selection, and it will help you select the medium-format lenses you need most for the type of photography you do.

TELECONVERTERS

Some medium-format cameras offer teleconverters, or *telephoto extenders*, as part of their system. These lens accessories fit between the lens and camera body to effectively lengthen the focal length of the lens used. They are composed of diverging lens elements that increase the lens-to-film distance, thereby increasing focal length.

Currently available teleconverters for medium-format cameras are 2X types—they double the focal length of the lens. These accessories can be very handy to have when the price or weight of a longer-focal-length lens is prohibitive. In addition, teleconverters made for medium-format cameras preserve the automatic features of the camera lens.

The sacrifice you make by using a teleconverter is loss of light at the film plane. With a 2X converter, you lose two steps of light. The effective aperture is twice the *f*-number of the lens setting. For example, if the lens is set

LENS FOCAL LENGTH	DIAGONAL ANGLE OF VIEW				
	35 mm	4.5x4.5 cm	4.5x6 cm	6x6 cm	6x7 cm
40mm	57°	71°	82°	89°	96°
50mm	47°	59°	70°	77°	83°
75mm	32°	41°	50°	56°	61°
80mm	30°	39°	47°	53°	58°
90mm	27°	35°	42°	47°	52°
100mm	24°	32°	38°	43°	48°
150mm	16°	21°	26°	30°	33°
200mm	12°	16°	20°	22°	25°
300mm	8°	11°	13°	15°	17°
400mm	6°	8°	10°	11°	13°
600mm	4°	5°	7°	8°	8°
800mm	3°	4°	5°	6°	6°
1000mm	2°	3°	4°	5°	5°

DIAGONAL ANGLE OF VIEW FOR VARIOUS FORMATS

Note: Medium-format lenses with focal lengths of about 30mm have built-in barrel distortion with a diagonal angle of view about 180°. These exhibit the fish-eye effect.

for *f*-4, the effective aperture is *f*-8.

However, depth of field *is not* increased when you use a teleconverter. Doubling the *f*-number is only a way of expressing the light loss at the film plane. In fact, depth of field decreases when you use a teleconverter because the image is being magnified by the accessory.

In my opinion, the good points of a teleconverter outweigh the bad. Not all of the camera manufacturers agree because not all of the brands described in this book have teleconverters in their systems.

An independent photographic manufacturer, Vivitar, makes 2X teleconverters for several medium-format cameras. Currently, these are the Hasselblad, Mamiya SLR, and Pentax 6x7 cameras. Vivitar teleconverters couple with the automatic diaphragm of the camera lens and have multicoated optics.

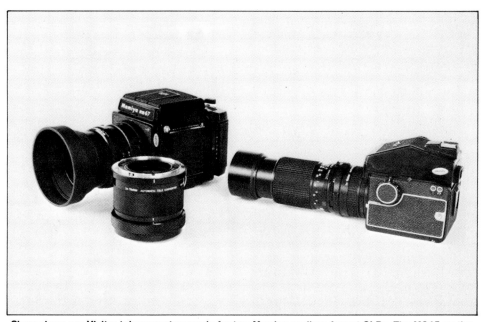

Shown here are Vivitar teleconverters made for two Mamiya medium-format SLRs. The M645 on the right is mounted to the teleconverter designed for that model. The RB67 Pro-S is shown next to the teleconverter made for it. Mamiya does not offer a teleconverter for either system.

CLOSE-UP PRINCIPLES & EQUIPMENT

Each camera system described in this book offers a variety of lens accessories for close-up shooting, or *photomacrography*. They range from simple close-up lenses to automatic bellows. The equipment for each camera brand is described in its own chapter.

The common considerations of photomacrography—calculating magnification, adding extension, the resultant exposure correction factor, depth of field, and effective aperture for both normal- and reverse-mounted lenses—are summarized here. Mathematical derivations and optical principles are not discussed in detail, but some formulas and mathematics are included.

This section serves as a handy reminder and collection of the necessary formulas, charts and tables you'll need for close-up, macro, or high-magnification photography. If you want to, you can skip it for now and come back to it later when you need to do close-up photography.

CALCULATING MAGNIFICATION

Magnification is the ratio of image size to subject size. This is also the ratio of image distance to subject distance, as shown in the accompanying illustration. Image and subject distances are actually measured from optical points called *lens nodes*, not the center of a lens element. You don't always know where the nodes are, but this is not always necessary to use these formulas effectively. Examples of this will be shown later.

CLOSE-UP LENSES

The simplest lens accessory for close-up shooting is the close-up lens. It mounts or screws into the front of the lens like a filter, but unlike a filter the glass element has optical power and changes the magnification range of the camera lens. One of the major benefits of close-up lenses is that no exposure correction is necessary due to the magnification they give.

Labeling Close-Up Lenses—Most are classified in *diopters*, which is the reciprocal of the focal length expressed in meters:

Diopters = 1 / Focal Length (meters)

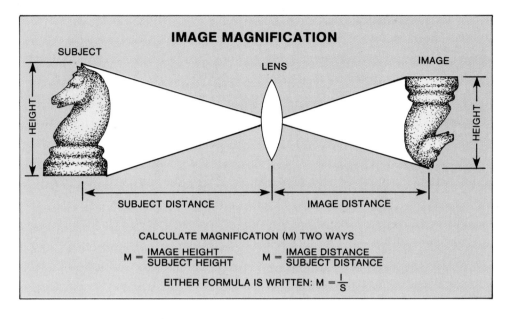

IMAGE MAGNIFICATION

SUBJECT — LENS — IMAGE

HEIGHT / SUBJECT DISTANCE / IMAGE DISTANCE / HEIGHT

CALCULATE MAGNIFICATION (M) TWO WAYS

$$M = \frac{\text{IMAGE HEIGHT}}{\text{SUBJECT HEIGHT}} \qquad M = \frac{\text{IMAGE DISTANCE}}{\text{SUBJECT DISTANCE}}$$

EITHER FORMULA IS WRITTEN: $M = \frac{I}{S}$

However, to calculate the magnification you can get with a certain combination of close-up and camera lenses, you need to know the focal length of the close-up lens in millimeters:

Focal Length (mm) = 1000 / Diopters

For example, a 3-diopter close-up lens has a focal length of 333mm (13.1 inches). If you are using more than one close-up lens, add the diopters and calculate one focal length for the combination.

Calculating Magnification—Minimum magnification occurs when the camera lens focus control is set to infinity:

$$M_{min} = \frac{\text{Focal Length of Camera Lens (mm)}}{\text{Focal Length of Close-Up Lens (mm)}}$$

In this case subject distance is equal to the focal length of the close-up lens or lenses, even though the camera lens is set at infinity.

As you focus on closer subjects, magnification increases. Maximum magnification occurs when the lens focus control is set to its closest focusing distance. Calculating maximum magnification is not as simple as the previous formula. These calculations are done for you in camera-brand chapters describing systems with screw-in close-up lenses.

Image Quality with Close-Up Lenses—Using a close-up lens tends to degrade image quality. Typically, the image is slightly out of focus in the corners. This effect is loss of *flatness of field*. It happens because close-up lenses are usually made of single elements, which can't be optically corrected for aberrations. Double-element lenses can be corrected somewhat, but they are more expensive. A balance between these cases is created by lens manufacturers who design a close-up lens or lenses for a particular camera lens. This way they can minimize the flatness of field problem that is characteristic of close-up lenses.

Sometimes, depending on magnification and *f*-stop, you won't notice any loss of image quality. For best results with close-up lenses, do not use more than one at a time—but if you must, put the one with the higher diopter rating closest to the lens. Closing the aperture helps restore image quality by increasing depth of field. However, actual depth of field is still less than the calculated value. Higher magnifications tend to reduce sharpness in the image.

All optical designs involve compromises. In this case a balance is achieved between convenience and slightly reduced image sharpness.

FOCAL LENGTH OF CLOSE-UP LENSES		
LENS POWER IN DIOPTER	**Focal Length**	
	mm	**inches**
1	1000	40
2	500	20
3	333	13
1 + 3	250	10
2 + 3	200	8
1 + 2 + 3	167	7
10	100	4

MAGNIFICATION FROM EXTENSION

A useful formula involving image distance and magnification shows their relationship to lens focal length:

I = F x (1 + M)
 I is image distance
 F is lens focal length
 M is magnification

When you photograph subjects that are far away or very large relative to the image, magnification is very small, or nearly zero. When this happens, image distance approaches the value of the lens focal length. This makes complete sense because, by definition, focal length is image distance when the lens is focused at infinity:

I = F x (1 + 0)
 = F

Focal length is *minimum* image distance.

As you focus on closer objects, you turn the focusing ring so the lens travels away from the film plane, making both I and M larger. Eventually the lens reaches the physical limit of its travel. The distance, or *extension*, the lens travels by being focused closer is called the *focus travel.* If you add more distance between the lens and camera body, image distance increases.

According to the formula, magnification also increases. This formula can be simplified to:

X = M x F
 X is added extension
 M is magnification
 F is lens focal length

Increasing image distance is the principle behind getting more image magnification with extension tubes and bellows.

A Bellows Example—With the formulas given here, close-up shooting is simplified. For example, suppose you want to photographically reduce a 100mm square document to fit a nominal 6x6 cm format, which is about 56x56 mm. First, calculate image magnification. Be sure to use the same units for distances:

M = I / S = 56mm / 100mm = 0.56

Second, calculate the extension needed. If you are using the standard 80mm lens for this format, the value of X is:

X = M x F = 0.56 x 80mm = 45mm.

Third, calculate image distance (I). This is the sum of the extension you add and the extension given by the lens. If the lens focus control is set to infinity, its extension is equal to the focal length. If the lens focus control is not focused at infinity, you don't know its extension due to focus travel.

I = X + F = 45mm + 80mm = 125mm

Fourth, find subject distance (S) with one more calculation. Using the magnification formula again:

S = I / M = 125mm / 0.56 = 223mm

For this example, attach an 80mm lens set at infinity to a bellows. Extend the bellows so the distance from the lens mounting flange of the camera to the lens mounting flange of the front standard is 45mm (X). Next, put the lens 223mm away from the subject. Measuring this lens-to-subject distance is not easy unless you know where the proper lens node is, but you can assume the node is at the aperture ring and measure from there. Then focus on the subject by moving the *whole* bellows system slightly forward or backward until the viewfinder image is sharp.

These formulas assume that the lens focus control is set to infinity.

You can increase magnification by turning the focusing ring to move the elements away from the film plane. This also decreases lens-to-subject distance. To find focus you must reposition the entire camera and bellows assembly.

I suggest you use the lens set to infinity for most bellows work and adjust magnification with bellows extension. This way, magnification is easy to calculate because it depends only on the extension of the bellows, which is usually easy to read because of a scale on or near the rail. Adding extension with the lens focus control introduces an unknown distance (T) and makes the calculations less exact.

Extension Tubes—These tubes fit between the lens and camera body to give a fixed amount of extension. Typically, two or three extension tubes of different lengths are available for each system. This lets you stack the tubes in various combinations to get various amounts of extension.

Minimum magnification occurs when the lens is set to infinity. To get

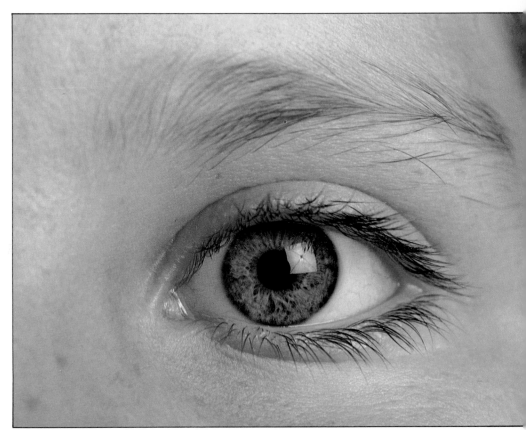

I photographed this eye at life-size on film, using extension equal to the lens focal length. I used a Mamiya M645 camera, 80mm macro lens with 40mm of helicoid extension, and a 40mm extension tube. One Elinchrom 11 Mono Pro flash was used in a Larson SoffBox, which you see reflected in the iris.

 To determine exposure, I used a flash meter at the subject plane. The meter recommended an aperture of *f*-32. Because exposure compensation for life-size magnification is two steps, I set the lens aperture to *f*-16—two steps more exposure than the meter recommended.

One side of the reverse adapter connects to the filter mount on the front of the lens. The other side has a mounting flange that attaches to the lens mount on the camera. In this photo, an RS-58 adapter ring is being screwed onto the front of the 70mm leaf-shutter lens of the Mamiya M645 system.

more magnification, turn the focusing ring in the direction of closer focusing. This guarantees that you will be moving the camera forward and backward while trying to focus, but such is the nature of extension tubes.

Some manufacturers make tubes with adjustable extension, allowing you to change magnification with the tube alone. This doesn't make finding focus any easier, but it does give the lens a bigger magnification range.

To choose the appropriate extension tube, or tubes, first determine the approximate magnification you'll be using. Second, use the extension formula to determine the right focal-length lens necessary with the extension tube, or tubes, you have.

For example, if you need a magnification of 0.3 and all you have is a 28mm extension tube, the approximate lens focal length needed is:

$$F = X / M = 28mm / 0.3 = 93mm$$

No manufacturer makes a 93mm lens, but you can come close to a 0.3 magnification with a 90mm or 100mm lens. With the 100mm lens, you could use the added focus travel of the lens to get a 0.3 magnification. With the 90mm lens, minimum magnification is slightly greater than 0.3.

Maximum magnification with the lens and tube is calculated with the focus travel of the lens (T), the lens focal length (F), and the extension of the tube (X):

$$M_{max} = (T + F + X) / F$$

These calculations are done for you in the chapter for each camera-brand system that has extension tubes.

Adapter Ring—When working with a magnification greater than or equal to 1.0, use an adapter ring to reverse the standard lens on the extension tubes or bellows. The ring connects to the front of the lens and has a mounting flange on the other side so it mounts to the camera, thus reversing the lens. Only lenses designed for cameras with focal-plane shutters can be reversed.

Lens manufacturers recommend reversing general-purpose lenses because most are designed to give best image quality when subject distance is greater than image distance.

When magnification is life-size, these distances are the same, and for magnifications greater than 1.0, image distance is greater than subject distance. When the lens is reversed, the distance between the subject and the back of the lens is less than or equal to the distance between the front of the lens and the film plane, as the lens designer intended.

For the magnification formulas to work with a reversed lens, you need to know the extension due to reversing the lens. Use this value with the formulas instead of the focal length of the lens. Adapter rings may also have some extension of their own. Add it to the extension of the bellows or extension tubes.

The amount of extension of a reversed lens depends on lens design. Most standard and wide-angle lenses have a reversed extension longer than the lens focal length, but this does not happen with some telephoto lenses. They have negative extension; therefore, they decrease magnification if they are reversed.

If the reversed lens is of conventional design—that is the rear elements do not move independently of the front elements when the focusing ring is turned—turning the focusing ring of a reversed lens does not change magnification.

Another Way to Find Setup Distances—All of these setup formulas and calculations for magnification with extension are summarized in the accompanying chart. Use it this way:

1) Determine the magnification you need.
2) Draw a vertical line from the horizontal magnification axis and intersect the four curves.
3) Draw horizontal lines from each of the four intersection points to the vertical axis. Read the distance for each point and record it as shown at the bottom of the chart.
4) Multiply each distance by the focal length of the lens you'll use. Use the lens set to infinity.
5) Use these setup distances for the bellows or extension tube system. Best focus may require adjustment of the camera position.

EXPOSURE CORRECTION FACTORS

As image distance increases, the brightness of the light at the film plane decreases, meaning that an exposure compensation based on magnification is necessary to avoid underexposure. When no added extension is between a regular lens and camera, the light loss due to magnification is usually negligible, but when you use a macro lens or any added extension, the light loss can be significant and must be accounted for to get good exposure. This is another good reason you should be able to calculate image magnification before shooting.

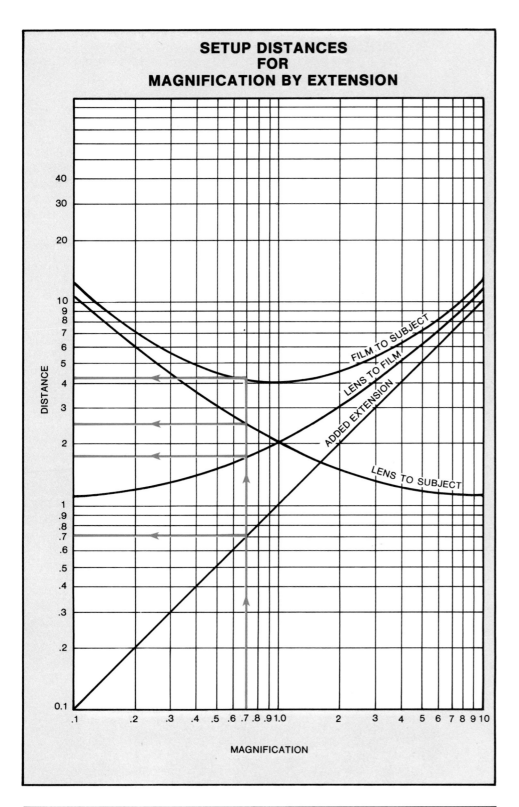

SETUP DISTANCES
FOR
MAGNIFICATION BY EXTENSION

DISTANCE

FILM TO SUBJECT

LENS TO FILM

ADDED EXTENSION

LENS TO SUBJECT

MAGNIFICATION

EXAMPLE		
Distances Taken From Graph:	**Multiply By Lens Focal Length**	**Actual Setup Distances**
Film to Subject — 4.2	x 80mm	336mm
Lens to Subject — 2.4	x 80mm	192mm
Lens to Film — 1.7	x 80mm	136mm
Added Extension — 0.7	x 80mm	56mm

The formula you use to calculate the exposure correction factor (ECF) depends on the lens and the way it is mounted. Lenses can be classified one of three ways and can be mounted either normally or reversed. This gives three different cases to consider.

You can avoid this aggravation if you use a camera with a built-in, through-the-lens meter. It automatically compensates for any light loss as long as the light level at the film plane is within the meter's sensitivity range. If it isn't, meter the scene with an accessory meter and calculate the exposure correction factor with the appropriate formula. Then make the correction with shutter speed, aperture, or both.

Calculating Pupilary Magnification—This factor, P, is the ratio of the diameters of the two pupils of the lens viewed from the front and back. Sometimes the pupilary magnification is stated in the literature that comes with the lens. If it isn't, you can get a close approximation by measuring it yourself.

Measure exit and entrance pupils by holding a millimeter scale in front of the pupil. For this 35mm lens for the M645 system, I measured a rear diameter of 17.5mm and a front diameter of 9mm. Pupilary magnification, P, is approximately 17.5mm/9mm = 1.9.

The match head shown in this close-up photo was magnified 3X on film using a Pentax 6x7 camera, Auto Bellows, and the 105mm lens mounted reversed. The bellows scale indicates magnification for the 105mm lens mounted either normally or reversed.

I measured flash exposure with a flash meter held next to the match and used the recommended setting of *f*-64 as effective aperture in the exposure correction formula for a normal lens. This gave a lens setting of *f*-16. With this aperture and image magnification, depth of field calculated to about 0.4mm, which was acceptable for the subject.

Set the lens to an intermediate aperture and put a light behind it. Depress the coupling pin on an automatic lens to stop down the lens to the selected aperture. Put a scale across the front of the lens and measure the diameter of the aperture opening. Repeat the procedure for the back of the lens, then calculate P:

$$P = \frac{\text{Diameter of rear (exit) pupil}}{\text{Diameter of front (entrance) pupil}}$$

P for wide-angle lenses, also called *retrofocus lenses*, is greater than 1.0. It is less than 1.0 for telephoto lenses, and approximately 1.0 for standard lenses. *Normal* lenses are defined as those lenses with a P value of approximately 1.0. Even though standard lenses—those having a diagonal angle of view between 40° and 59°—are usually normal lenses, not all normal lenses are standard lenses.

Using a Normal Lens—This is the simplest case because the correction depends only on magnification (M):

$$ECF = (1 + M)^2$$

You can use the exposure correction factor two different ways. Multiply it by shutter speed to get a new, longer speed, or convert it to exposure steps using this formula:

$$\text{Exposure Steps} = 3.3 \times \log(ECF)$$

For example, if magnification is 4.5, and you used a hand-held meter to get an exposure setting of *f*-11 at 1/30 second:

$$ECF = (1 + 4.5)^2 = 30$$
$$\text{Exposure Steps} = 3.3 \times \log(30)$$
$$= 4.9 \text{ steps}$$

You can make the correction by either multiplying 1/30 by ECF to get a one-second shutter speed, by opening the aperture about five steps, or with a combination of aperture and shutter speed correction, such as *f*-5.6 at 1/4 second. At slow shutter speeds, compensation due to long-exposure reciprocity failure may be necessary. See Chapter 4 for more information on reciprocity failure.

Using a Telephoto or Wide-Angle Lens—When using either of these lenses, include the factor P in the ECF formula:

$$ECF_p = (M/P + 1)^2$$

As you can see, if P is 1.0, this formula reverts to the simple case already given for a normal lens.

Using a Reversed Lens—Most lenses are designed to give optimal image quality—that is, minimal optical aberrations—within a certain magnification range.

For general-purpose lenses, the range is surpassed when magnification is life-size or greater. These kinds of lenses should be used reversed to get best image reproduction when magnification is greater than or equal to 1.0. In this case, the front of the lens faces the film plane and the back of the lens is toward the subject. Some of the cameras in this book have reverse mounting adapters that let you do this.

Again, the formula takes into account the pupilary magnification, which is constant for these formulas *regardless* of how the lens is mounted. When you use a lens reversed, the formula is:

$$ECF_r = ((MP + 1)/P)^2$$

With a normal lens, P is approximately 1.0, and the formula reverts to the simplest case already mentioned.

EFFECTIVE APERTURE AND FLASH PHOTOGRAPHY

Because the light level at the film plane decreases when magnification increases, the actual aperture acts as if it were smaller. This gives the *effective aperture* (EA), according to this formula:

$$EA = f\text{-actual} \times (M + 1)$$
$$f\text{-actual is aperture set on lens}$$
$$M \text{ is magnification}$$

To use this idea for flash photography, the formula must be manipulated

a bit so you can determine the aperture setting on the lens after determining the effective aperture. When finding exposure this way, don't use the ECF formulas too. They do the same thing and you'd be correcting twice, overexposing the film.

Using a Normal Lens—For example, suppose you have a flash with a guide number of 16 meters and you want to position it 1.0 meter from the subject, which is being magnified 3X. Using the regular guide number formula:

$$f\text{-stop} = GN / \text{distance}$$
$$= 16m / 1.0m$$
$$= f\text{-}16$$

However, this setting is the effective aperture not the actual f-stop (f-actual). The guide number calculation does not take lens extension and the subsequent light loss into account. To find the actual lens setting to use with this flash setup, use this formula:

$$f\text{-actual} = EA / (M + 1)$$
$$= f\text{-}16 / (3.0 + 1)$$
$$= f\text{-}4$$

Therefore, you set the lens at f-4, but set the calculator on the flash, whether the flash is automatic or not, at f-16. This is the simplest case for a normal lens mounted normally or reversed. When you use a wide-angle or telephoto lens, pupilary magnification must be included.

Using a Wide-Angle or Telephoto Lens—Pupilary magnification becomes part of the equations in much the same way as with ECF formulas. When using a wide-angle or telephoto lens mounted normally, use these two formulas:

$$EA_p = f\text{-actual} \times (M / P + 1)$$
$$f\text{-actual} = EA_p / (M / P + 1)$$

Using a Reversed Lens—When using a wide-angle or telephoto lens mounted in reverse, the formulas become:

$$EA_r = (f\text{-stop} / P) \times (M \times P + 1)$$
$$f\text{-actual} = (EA_r \times P) / (M \times P + 1)$$

STEP VS. STOP

You'll notice in this book that the term *step* is used instead of *stop* or f-stop when exposure is discussed. This is standard ANSI usage because exposure depends on *both* shutter speed and lens aperture, not just lens aperture as *f-stop* and *stop* imply. If this bothers you, read *stop* or *f-stop* instead of *step*.

SUMMARY OF EQUATIONS FOR MAGNIFICATION BY EXTENSION, PUPILARY MAGNIFICATION AND REVERSED LENSES

	With Normal Lens (P = approx. 1)	With Telephoto or Retrofocus Lens	With Reversed Telephoto or Retrofocus Lens
Exposure Correction Factor	$ECF = (1+M)^2$	$ECF_p = (M/P+1)^2$	$ECF_r = ((MP+1)/P)^2$
Equivalent Aperture	$EA = f\text{-actual} \times (M+1)$	$EA_p = f\text{-actual} \times (M/P+1)$	$EA_r = (f\text{-actual}/P) \times (MP+1)$
Lens Setting To Get Desired EA	$f\text{-actual} = \dfrac{EA}{(M+1)}$	$f\text{-actual} = \dfrac{EA_p}{(M/P+1)}$	$f\text{-actual} = \dfrac{(EA_r \times P)}{(MP+1)}$
Macro Depth of Field	$DOF_n = \dfrac{2fC(M+1)}{M^2}$	$DOF_p = \dfrac{2fC(M+P)}{P(M)^2}$	$DOF_r = \dfrac{2fC(MP+1)}{P(M)^2}$

DEPTH OF FIELD

If you have ever done close-up shooting, you know that one of its major problems is the shrinking depth of field that accompanies increasing magnification. Even at the smallest aperture, depth of field is sometimes very narrow, making only two-dimensional subjects appropriate subjects at times. Because of this, being able to calculate the approximate depth of field before making the setup helps you get the best image.

The depth-of-field formulas here include a previously undefined variable, C. This is the diameter of the *circle of confusion*, which is defined as the smallest circle on an image that still looks like a point to the human eye. Essentially, this is the degree of unfocus that we can tolerate in an image and still consider it sharp.

People use different values of C, depending on the final use of the image. For general-purpose photography, we can assume that C = 0.03mm, or 0.001 inch. If you wish, you can reduce it even more, but this also reduces the calculated depth of field by the same percentage, yet has no effect on the actual image.

These formulas, like the other lens formulas given, are based on geometric principles of lens design. Therefore, they show that as aperture becomes smaller, depth of field keeps increasing. In the real world of lenses, however, this doesn't happen.

The formula becomes impractical when diffraction effects due to small aperture negate any increase in depth of field and make focusing more of a problem. Use these formulas for magnifications from 0.1 to 3.0. Again, the formula you use depends on the lens and the way it is mounted.

Using a Normal Lens—This is the simplest case because pupilary magnification is approximately 1.0. Depth of field (DOF) for a normal lens mounted normally or reversed is:

$$DOF_n = \frac{((2) \times f\text{-actual} \times C \times (M+1))}{M^2}$$

f-actual is aperture set on lens
M is magnification
C is diameter of the circle of confusion

Using a Wide-Angle or Telephoto Lens Mounted Normally—The depth of field in this case is affected by P:

$$DOF_p = \frac{(2) \times f\text{-actual} \times (C) \times (M+P)}{P \times M^2}$$

Using a Reversed Wide-Angle or Telephoto Lens—Remember that P is constant and the formula changes when the lens is reversed:

$$DOF_p = \frac{(2) \times f\text{-actual} \times (C) \times (M \times P + 1)}{P \times M^2}$$

RECOMMENDED ENLARGING LENSES FOR MEDIUM-FORMAT IMAGES

Image Format	Enlarging Lens Focal Length
4.5x4.5 cm	75mm
4.5x6 cm	75mm
6x6 cm	90mm
6x7 cm	100mm

Generally, for good corner-to-corner light coverage of the slide or negative, you should use an enlarging lens with a focal length no greater than the diagonal of the film frame.

3
Shutters

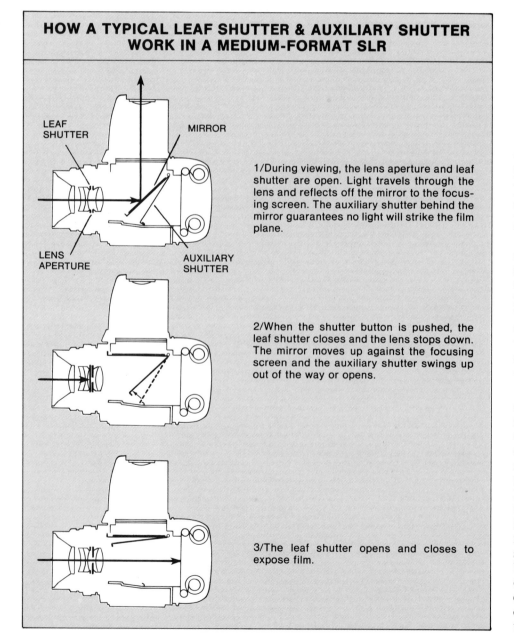

HOW A TYPICAL LEAF SHUTTER & AUXILIARY SHUTTER WORK IN A MEDIUM-FORMAT SLR

LEAF SHUTTER

MIRROR

LENS APERTURE

AUXILIARY SHUTTER

1/During viewing, the lens aperture and leaf shutter are open. Light travels through the lens and reflects off the mirror to the focusing screen. The auxiliary shutter behind the mirror guarantees no light will strike the film plane.

2/When the shutter button is pushed, the leaf shutter closes and the lens stops down. The mirror moves up against the focusing screen and the auxiliary shutter swings up out of the way or opens.

3/The leaf shutter opens and closes to expose film.

Medium-format cameras are available with or without focal-plane shutters. Those without a focal-plane shutter use lenses with built-in *leaf*, or *lens*, shutters. Some of these cameras also have an *auxiliary shutter*, or *light baffle*, between the mirror and focal plane. This "second shutter" prevents light that gets past the mirror from striking the film plane while the lens shutter is open during reflex viewing. Medium-format cameras with focal-plane shutters will also accept special leaf-shutter lenses. Specifics are discussed in each camera-brand chapter.

These shutter differences give you something else to consider in choosing a medium-format system. Depending on the kind of shooting you do most, you may have a preference for a certain shutter design. This chapter discusses both kinds, including advantages and disadvantages, so you can decide which is best for you.

THE LEAF SHUTTER

A leaf shutter resembles an aperture stop. Both are made of five or six metal blades, also called *leaves*, that open and close together like the pupil of an eye. For maximum effectiveness, the leaf shutter is placed next to the lens aperture stop.

How It Works—When the shutter is tripped, the blades open fully by moving outward in unison. A timing mechanism holds them open for the selected exposure time. Then the blades close simultaneously. The opening and closing time is relatively constant for all shutter speeds; what changes is the length of time the shutter is fully open.

The other mechanical operations that occur with leaf shutter operation depend on the camera and lens design. The simplest case is a TLR, which has a lens for viewing and a lens for shooting. The only mechanical motion is opening and closing the lens shutter.

Medium-format SLR cameras are more complex. For example, the leaf shutter must close *before* the mirror swings up and the auxiliary shutter opens or swings up right before exposure. When the lens operates automatically, the lens aperture typically stops down to the preselected *f*-stop before the mirror swings up. Then the leaf shutter opens and closes.

Obviously, the more things that are going on after you push the shutter button, the more complex the lens is, requiring mechanical or electrical connections between camera and lens. This complexity generally makes leaf-shutter lenses more expensive than shutterless lenses.

Even so, the leaf-shutter lens has one particular advantage—flash sync at *all* shutter speeds. The top shutter speed is not as fast as some focal-plane shutters, but this is rarely a problem. The leaf-shutter lenses mentioned in this book have a shutter-speed range from 1/500 to 30 seconds.

Leaf-Shutter Efficiency—In an *ideal* leaf shutter, blades would open instantly, remain open for the selected exposure time, and close instantly. This is diagrammed in Figure 3-1. Exposure, the product of illuminance and time, is represented by the area under the curve—in this example a rectangle.

However, mechanical leaf shutters do not work that way. The shutter takes a few milliseconds to open and to close. For the same exposure time as the ideal-shutter example, the graph for a real shutter is the trapezoid of Figure 3-2.

Even though total exposure time remains the same, there is a difference in exposure—the area under the curve. The area is less than the area under the curve of the ideal shutter because the sides of the drawing are not vertical—the shutter cannot open and close instantly. This means that the film is underexposed.

The *effective exposure time* is the exposure time an ideal shutter would use to give the same total exposure as the real shutter. Effective exposure time is derived from the rectangle of Figure

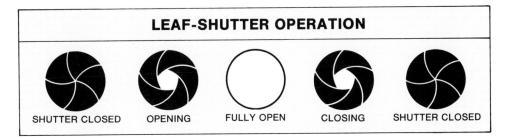

LEAF-SHUTTER OPERATION

SHUTTER CLOSED OPENING FULLY OPEN CLOSING SHUTTER CLOSED

3-3. Notice that the effective exposure time is shorter than real exposure time.

The ratio of effective exposure time to total exposure time is called *leaf-shutter efficiency*, and it varies with respect to shutter speed and aperture. Of course, there is also mechanical variability in the shutter, but this depends on shutter design and manufacturing quality control. It too can affect exposure, but in a less predictable way.

Improving Leaf-Shutter Efficiency— One way to increase leaf-shutter efficiency is to select a shutter speed that gives a long total exposure time, thus minimizing the effect opening and closing time have on total time. This is illustrated in Figure 3-4, in which two different shutter speeds are drawn with their total exposure time and effective exposure time curves. The longer the shutter remains fully open, the greater the efficiency.

You can also increase leaf-shutter efficiency through aperture selection. The aperture effect on leaf-shutter efficiency is similar to that of long exposure time.

For large apertures, the shutter must open fully, or nearly so, to let light through all of the large hole in the aperture stop. However, when you use a small aperture, the shutter does not have to open all the way, even though it does anyway. The shutter is *effectively* wide open as soon as it is the same size as the aperture. This essentially lengthens the fully-open exposure time and reduces the proportion of opening and closing time to total time. As shown in Figure 3-5, the smaller the aperture, the higher the efficiency.

Exposure Compensation Due to Leaf-Shutter Efficiency—Because of leaf-shutter efficiency—or, depending on your point of view, leaf-shutter inefficiency—shutter manufacturers make a compromise in shutter design. In most cases, the shutter speed engraved on the lens or camera is the

effective exposure time when used at full aperture. The rationale is that fast shutter speeds are often used with large apertures for good exposure.

Efficiency improves at any shutter speed when the aperture decreases to *f*-8 or smaller, but the improvement is only significant at fast shutter speeds,

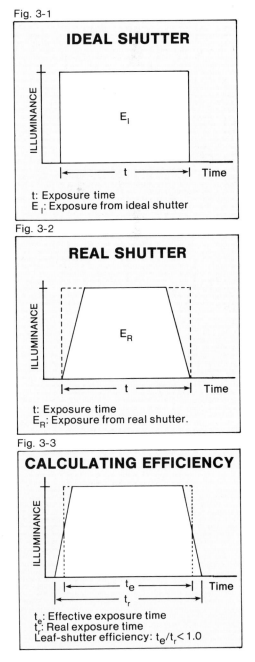

Fig. 3-1

IDEAL SHUTTER

ILLUMINANCE

E_I

t Time

t: Exposure time
E_I: Exposure from ideal shutter

Fig. 3-2

REAL SHUTTER

ILLUMINANCE

E_R

t Time

t: Exposure time
E_R: Exposure from real shutter.

Fig. 3-3

CALCULATING EFFICIENCY

ILLUMINANCE

t_e Time
t_r

t_e: Effective exposure time
t_r: Real exposure time
Leaf-shutter efficiency: $t_e/t_r < 1.0$

Fig. 3-4

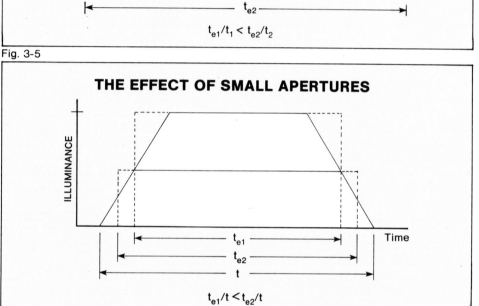

THE EFFECT OF SLOW SHUTTER SPEED

ILLUMINANCE

Time

t_{e1}

t_1

t_2

t_{e2}

$t_{e1}/t_1 < t_{e2}/t_2$

Fig. 3-5

THE EFFECT OF SMALL APERTURES

ILLUMINANCE

Time

t_{e1}

t_{e2}

t

$t_{e1}/t < t_{e2}/t$

For this photo of a platform diver on a very bright day, I used Ektachrome 400 in a Rollei SLX with a telephoto leaf-shutter lens. When metering from an 18% gray card, the camera meter recommended an exposure of f-16 at 1/500 second. Because this combination would have overexposed the film by one step, as shown in the accompanying table, I made the exposure at f-22 at 1/500 second.

such as 1/125, 1/250, and 1/500 second. If you use a small aperture with a fast shutter speed, such as when shooting high-speed film in daylight, the shutter can be more efficient than you "expect" it to be and give more exposure than the film requires.

Color and b&w negative films tolerate overexposure fairly well and can be printed if overexposed. However, color transparency films will not give good image quality if overexposed.

The image will be too light and colors will be washed out. For best exposure of any film, you should make an exposure correction based on aperture and shutter speed.

Typical corrections recommended by Eastman Kodak as shown below. You should conduct your own tests to see how your lens shutter works at different combinations of small aperture and fast shutter speed. When in doubt, bracket for best results.

Flash-Sync Operation—Many leaf-shutter lenses have both M- and X-sync terminals for M-type flashbulbs and electronic flash, respectively. All have X-sync.

When set to X-sync, the leaf shutter triggers the electronic flash at the instant it becomes fully open. Electronic flash is of very short duration. The flash is over before the shutter can close at *any* shutter speed. This means electronic flash synchronizes with *all* lens shutter speeds.

Flashbulbs have a longer rise time, so a triggering delay is built into the M-terminal and shutter button mechanism. When you push the shutter button, the bulb is given approximately 17 milliseconds—about 1/60 second—for its chemical, light-producing reaction to put out maximum light. F-type bulbs have a rise time of about 8 milliseconds.

As you can see in the accompanying diagram, the bulb's light output peaks soon after. Then it starts diminishing. Obviously, the amount of exposure due to the bulb's light will depend on shutter speed. When using M- or F-type bulbs, refer to the bulb's data sheet for recommended guide numbers at different shutter speeds. Also see the flash-sync tables in each camera-brand chapter for recommended sync speeds.

Using High-Speed Flash Sync—With the high-speed electronic flash sync of leaf shutters you have a lot of freedom to mix ambient and flash lighting to

TYPICAL EXPOSURE CORRECTIONS FOR LEAF-SHUTTER EFFICIENCY IN LEAF-SHUTTER LENSES				
Marked Shutter Speed	**APERTURE SETTINGS**			
	f-1.4 to *f*-5.6	*f*-8	*f*-11	*f*-16 and smaller
1/125	NONE	NONE	NONE	−1/3 step
1/250	NONE	NONE	−1/3 step	−2/3 step
1/500	NONE	−1/3 step	−2/3 step	−1 step

create a variety of effects. The most useful way to use the high-speed flash sync of a leaf shutter is for flash-fill lighting.

For example, if you are photographing a person outdoors in midday sun, you may not like the effect of dark facial shadows created by the lighting angle. You can lighten the shadows by filling them with more light from electronic flash.

First compose the scene and determine subject distance. Second, use the flash unit's guide number (GN) to calculate the *f*-stop for that subject distance. Third, meter the scene and determine the necessary shutter speed that corresponds to the *f*-number you calculated. Remember, this can be any shutter speed.

Don't expose film yet—an aperture adjustment is necessary. Here's why: The *f*-stop you calculated is based on the flash GN, which is for indoor scenes in rooms with reflecting surfaces. When used outside, flash calculated with a GN will underexpose the film by about a step, although this effect varies. In most flash-fill situations, there are subject areas receiving exposure from *both* flash and ambient light. The *f*-stop is already set for good ambient-light exposure. Therefore, close the aperture about a half step to compensate for the extra flash light on the subject.

This technique lightens shadows on the face, but doesn't remove them. Usually, this gives best results. If you want lighter shadows, increase flash exposure by moving closer or by opening the aperture. If you do the latter, you may want to adjust the lens shutter speed to keep the ambient ex-

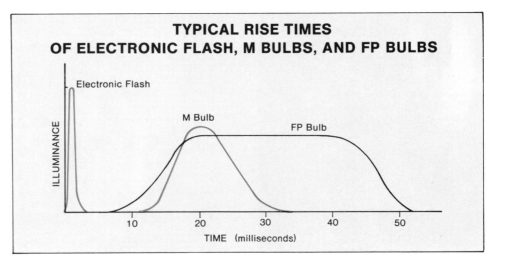

TYPICAL RISE TIMES OF ELECTRONIC FLASH, M BULBS, AND FP BULBS

posure constant. Bracket for best results.

For special effects, you can selectively under- or overexpose the part of the scene lit by ambient light only. Subject motion can be recorded as a blur, frozen, or be both blurred and frozen. You can even mix light sources for different background and foreground effects, such as tungsten-lit background and a flash-lit foreground photographed with either daylight or tungsten color film. Filter the flash, the lens, or both.

Calculating exposure for mixed-light setups can sometimes be tricky because the effect is not always predictable. For example, sometimes both long- and short-exposure reciprocity failure can occur if you use a flash at night. Depending on the scene, the flash unit's guide number (GN) may not be applicable because of few reflecting surfaces.

Remember that the shutter speed and aperture set on the lens determine

the ambient-light exposure. The aperture and the flash-to-subject distance determine the electronic flash exposure, but this is complicated further if the flash subject is also partially lit by ambient light. In this case, the flash exposure should be reduced, and you can do it by filtering it, moving it farther from the subject, or entering a faster film speed into its calculator dial if you use an automatic flash.

The leaf shutter gives you extra control with flash lighting that you may find helpful and fun. However, if you never use this feature, then you really don't need leaf-shutter lenses, and maybe a medium-format camera with a focal-plane shutter would be best for you.

THE FOCAL-PLANE SHUTTER

Currently, only the Hasselblad 2000FC, the Pentax 6x7, and the Mamiya M645 medium-format cameras have focal-plane shutters. The shutter is inside the camera

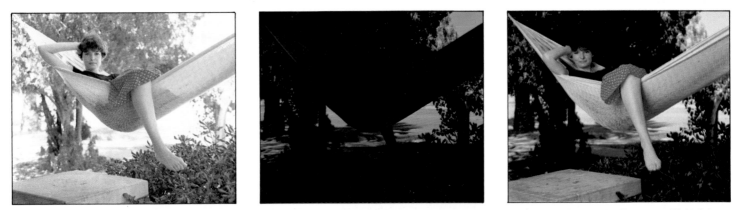

In this scene, the brightness difference between foreground and background light was about five steps. For the photo at left, metering foreground light determined exposure. Because this is skylight and reflected light, the photo has a blue cast and the background is overexposed.

For the center photo, I exposed for the background light. This silhouetted the subject. Shutter speed was 1/400 second. For the photo at right, I adjusted lens aperture for a half step more exposure than the center photo to lighten the background; shutter speed was unchanged. I used an Elinchrom 11 Mono Pro flash bounced into a Reflectasol umbrella at the correct distance for the aperture set on the lens. This gave balanced lighting.

Even though I made this photo in bright daylight with flash, the combination of the 1/500-second shutter speed of a leaf-shutter lens, a small lens aperture, and slow-speed color film underexposed the background. This helps isolate the flash-frozen hummingbird.

behind the mirror and a few millimeters in front of the film plane.

How It Works—The shutter uses two opaque curtains made of either cloth or metal. When you cock the shutter, the first curtain covers the film plane, and the second curtain is wound up on a roller.

When you push the shutter button, the first curtain is released. It travels across the film plane to the other side. The curtain begins exposing film as soon as the curtain starts moving across the frame. After a specific time, the second curtain starts moving in the same direction as the first, with its leading edge blocking exposure to the film. When the second curtain reaches the other side, exposure is complete. The first curtain is wound up on a

roller and the second curtain is in front of the film frame. Cocking the shutter again moves the curtains together, back to the other side. Now, the second curtain is rolled up and the first curtain covers the film plane.

The focal-plane shutter scans the film with a slit formed by the edges of the two curtains, so one edge of the film frame receives exposure before the other edge. The exposure time is equal to the interval between the time the trailing edge of the first curtain begins exposing the film and the time the leading edge of the second curtain begins blocking light. The shorter the exposure time, the smaller the slit. Although the curtains do accelerate slightly, thus changing the size of the slit as it travels, the effect on exposure is inconsequential.

Because a focal-plane shutter is in the camera body, the camera lens is less complicated than a leaf-shutter lens. This typically makes it less expensive than a leaf-shutter lens of the same focal length. And, without the built-in leaf shutter, the lens can be designed with a larger maximum aperture and a smaller minimum focusing distance.

Focal-plane shutters are faster than leaf shutters. For example, the Pentax 6x7 has a top speed of 1/1000 second, and the Hasselblad 2000FC has a top speed of 1/2000 second.

Flash-Sync Operation—Some cameras with focal-plane shutters have two terminals for flash connections. X is for electronic flash and **FP** is for FP-type flash bulbs. The FP circuit closes after you push the shutter button and before the shutter starts moving. FP bulbs have a rise time like

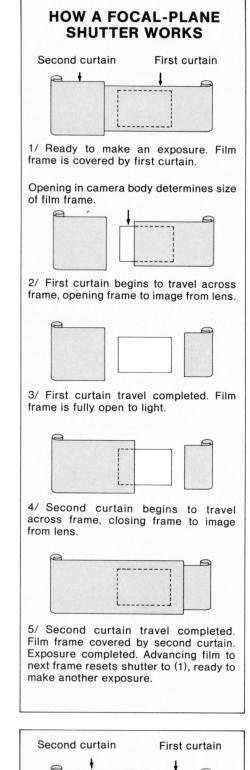

HOW A FOCAL-PLANE SHUTTER WORKS

Second curtain First curtain

1/ Ready to make an exposure. Film frame is covered by first curtain.

Opening in camera body determines size of film frame.

2/ First curtain begins to travel across frame, opening frame to image from lens.

3/ First curtain travel completed. Film frame is fully open to light.

4/ Second curtain begins to travel across frame, closing frame to image from lens.

5/ Second curtain travel completed. Film frame covered by second curtain. Exposure completed. Advancing film to next frame resets shutter to (1), ready to make another exposure.

Second curtain First curtain

If exposure time is short, second curtain "chases" first curtain across frame and exposure is through a narrow traveling slit between the two curtains.

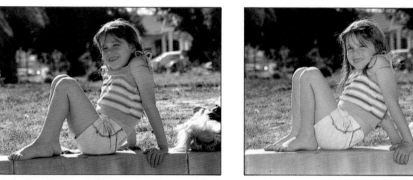

Using an on-camera flash with high-speed flash sync at 1/250 second filled the shadows with light, yet preserved the subject highlights and background light. As described in the text, with a leaf-shutter lens you choose composition and subject distance *first*. Then set aperture based on the flash GN. Meter the scene and use the shutter speed corresponding to the selected aperture. Open the aperture for a half step more exposure.

You can do similar things with a focal-plane shutter. But because the range of usable shutter speeds is more limited, so are allowable subject distances.

that of M-type bulbs, 17 milliseconds. This gives the bulb's light-producing chemical reaction time to produce light before the first shutter curtain starts moving.

The shutter operates while the bulb is producing light, which it does for about 25 milliseconds with an almost uniform output. This means you can use it with shutter speeds faster than about 1/60 second because it is effectively a continuous light source for the fast shutter speeds. However, as shutter speed changes, so does the guide number. This information is in the bulb's data sheet.

For electronic flash, the first curtain triggers the flash when its trailing edge reaches the end of its travel. If the second curtain is moving when the flash goes off, it blocks some of the light. Therefore, the *fastest* shutter speed you can use with electronic flash occurs when the first curtain fully opens the frame just before the second curtain *begins* closing it. During the brief time that the whole frame is uncovered, the flash exposes all of the frame at once. This is called the X-sync speed. Slower speeds also sync with flash.

X-sync shutter speed for electronic flash depends on the design of the shutter. For example, the cloth shutter curtains of the Pentax 6x7 camera travel 69mm horizontally, giving X-sync at 1/30 second. The Hasselblad 2000FC has metal shutter curtains that travel about 57mm horizontally. Its X-sync speed is 1/90 second, 1.5 steps faster than the Pentax. The Mamiya M645 cameras have flash sync at 1/60 second.

Even though the focal-plane shutter does not offer high-speed flash sync as a leaf shutter, you can still use it for some mixed-light scenes. Flash-sync speeds with electronic flash are at the slow end of the shutter-speed range, so use any combination of low ambient light, slow film speed, or neutral density (ND) filters allowing flash sync with slower speeds. For high-speed synchronization, use FP bulbs and a bulb holder.

Exposure calculations can be tricky, but always remember that with electronic flash the first priority is to use an X-sync shutter speed or slower. The aperture that balances with the shutter speed for the ambient light exposure then determines the flash-to-subject distance.

Shutter Efficiency—Focal-plane shutters do not exhibit shutter inefficiency with respect to exposure time and aperture as a leaf shutter does. Theoretically, there is some inefficiency in a focal-plane shutter due to its design, but for all practical purposes it won't affect exposure.

A far more important effect is variability in shutter speeds. The shutter should give the marked speed

You can use a focal-plane shutter creatively in mixed-light scenes. Here a 1/2-second exposure allows moving highlights to streak and blur, lending a sense of motion to an otherwise static scene. The slow shutter speed synchronized with flash exposure from an Elinchrom 11 Mono Pro flash bounced from a Reflectasol umbrella.

repeatably and not be erratic or consistently too slow. You can test this by shooting a roll on one scene. Use different shutter speed and aperture combinations that should give the same exposure. Use shutter speeds within the bounds of the reciprocity law for the film you are using. For general-purpose films this is between 1/1000 and 1/10 second.

If the processed images are reasonably similar, the shutter is working OK, but if one or more frames are under- or overexposed, there may be problems with the shutter. Have it checked by a camera repairman.

Other Focal-Plane Shutter Effects—If the subject is moving relative to the direction of shutter travel, then the image is distorted. This happens because the subject is in a different place at the end of exposure compared to its position at the beginning of exposure. This doesn't happen with leaf shutters because they expose the whole frame at once.

The amount of image distortion created by the focal-plane shutter depends on the direction and rate of subject motion and the shutter speed and direction of curtain travel. Don't worry about this unless you shoot very fast-moving objects with fast shutter speeds because usually the distortion is unnoticeable.

4

Film

There is an array of available films you can use with medium-format cameras for many different photographic situations. Whether you photograph under water, on land, from the air, or on the moon, you can find a film that is most suitable.

The films are made by several manufacturers in b&w, color negative and color transparency types in ASA speeds ranging from 32 to 1250. Different lengths are also available, from standard 120 rolls to 1200-foot rolls of 70mm film. In addition to these roll films are convenient Polaroid pack films in both color and b&w. Some medium-format cameras will even hold sheet films cut to fit special film holders. Sheet films are not discussed in this book.

Many of the films mentioned in this chapter have the same characteristics as the 35mm roll films of the same name. However, not all 35mm roll films have medium-format counterparts, and not all medium-format films have 35mm counterparts. For specific descriptions of the films mentioned here, see HPBooks' *How to Select & Use Photographic Materials and Processes* by David Brooks.

MEDIUM-FORMAT FILMS

The number of images you can get on a roll of medium-format film depends on the length of the roll and the size of the image made by the camera and back. The accompanying table shows the number of photos you can get with various image formats and films.

Unlike 35mm roll films, medium-format films make only one pass through the camera. After all the frames are exposed, you continue winding up the roll in the same direction. This helps reduce any possibility of damaging the film by rewinding. It also speeds up reloading the camera, a procedure that has more steps and is relatively slower than with 35mm film and camera.

Film loading is made faster when the camera uses a film insert. These can be loaded with film ahead of time and inserted into the camera back much like a 110 cartridge. After the film is exposed, remove the insert and load another preloaded insert.

120 Roll Film—As shown on the next page, the greatest variety of film emulsions is made in 120 rolls. This roll film has no perforations to guide it through the camera like a 35mm roll. Instead, it has an opaque paper backing for the length of the film, in addition to 16 and 12 inches (40cm and 30cm) of paper leader and trailer at the beginning and end, respectively. This makes daylight loading in subdued light possible because a few winds of the paper around the film help block light. It also protects the back of the film from being scratched or gouged during film travel.

When loading 120 film, you must first break and remove a paper band surrounding the roll. Put the take-up spool into the empty chamber before loading the unexposed roll of film. The full spool goes into the film chamber normally occupied by the empty spool. Because medium-format films are never rewound, the take-up spool is always from the most recently exposed roll of film.

The specifics of loading film into the camera or a film insert are detailed in each camera-brand chapter. Generally, you pull the paper backing across the insert and put its tapered tongue into the empty spool. Then you start winding the roll onto it by turning the take-up spool or winding key.

Stop winding when a large arrow printed on the back of the paper aligns with a start mark, notch, or arrow on the camera back or film insert. This puts the beginning of the film, which is taped to the paper backing, 7.5 inches (19cm) away from the start mark. The camera's exposure counter is calibrated for this distance, so when you close the camera back and advance the film more, the frame counter shows 1 when the first frame is in the film plane.

Also printed on the paper backing are different numbering systems for different image formats. With older TLR and SLR cameras, the numbers are visible through a window in the back of the camera. This was the way exposures were counted. None of the cameras in this book use this kind of window; each camera or back has its own counter.

When all of the film is exposed, advance the film until the whole roll is on the take-up spool. Depending on the camera, the counter stops counting or you feel no tension in the wind

FRAMES PER MEDIUM-FORMAT ROLL

FILM	DIMENSIONS	AREA	FRAMES PER ROLL			
			4.5x4.5	4.5x6	6x6	6x7
120	2.4x32.3 in. (6.1x82.1 cm)	77 sq. in. (501 sq. cm)	16	15, 16*	12	10
220	2.4x64.6 in. (6.1x164 cm)	155 sq. in. (1001 sq. cm)	NA	30, 32+	24	20
70mm (15' roll)	2.8x133 in. (70x337 cm)	366 sq. in. (2359 sq. cm)	NA	90	70	55

NA: Back not available
* With the Hasselblad A16S back
*+ With the Rollei 4.5x6 cm back

MEDIUM-FORMAT ROLL FILMS

B&W NEGATIVE FILMS

Speed	120	220	70mm
slow	Kodak Panatomic-X, ASA 32 Ilford Pan F, ASA 50 Agfa Agfapan 25	None	None
medium	Kodak Plus-X Pan Professional, ASA 125 Kodak Verichrome Pan, ASA 125 Ilford FP4, ASA 125 Agfa Agfapan, ASA 100	Kodak Plus-X Pan Professional, ASA 125	Kodak Ektapan 4162, ASA 100, 75-foot rolls Kodak Plus-X Pan 5062, ASA 125, 100-foot rolls Kodak Plus-X Portrait 5068, ASA 125, 100-foot rolls Kodak Plus-X Pan Professional, ASA 125, 100-foot rolls
fast	Kodak Tri-X Pan Professional, ASA 320 Kodak Tri-X Pan, ASA 400 Ilford HP5, ASA 400 Agfa Agfapan 400, ASA 400	Kodak Tri-X Pan Professional, ASA 320	Kodak Tri-X Pan, ASA 400, 15- and 100-foot rolls Kodak Royal Pan 4141, ASA 400, 100-foot rolls
very fast	Kodak Royal-X Pan, EI 1250	None	None

COLOR NEGATIVE FILMS

Speed	120	220	70mm
medium	Kodak Kodacolor II, ASA 100 Kodak Vericolor II Professional, Type S, ASA 100 Kodak Vericolor II Professional, Type L, ASA 64 to 80 Fuji Fujicolor F-II, ASA 100	Kodak Vericolor II Professional, Type S, ASA 100	Kodak Vericolor II Professional, Type S, ASA 100, 15- and 100-foot rolls Kodak Aerocolor Negative Film 2445, EAFS 100, 100-, 300-, 600-, and 1200-foot rolls
fast	Kodak Kodacolor 400, ASA 400 Fuji Fujicolor. F-II 400, ASA 400	None	None

COLOR TRANSPARENCY FILMS

Speed	120	220	70mm
slow	Kodak Ektachrome 50 Professional, ASA 50 Kodak Ektachrome 64 Professional, ASA 64 Agfa Agfachrome CT18, ASA 50 Fuji Fujichrome 100, ASA 100	None	Kodak Ektachrome 64 Professional, ASA 64, 15- and 100-foot rolls Kodak Aerochrome MS Film 2448, EAFS 32, 100-, 300-, 600-, and 1200-foot rolls Kodak Aerochrome Infrared 2443 Film, EAFS 40, 100-, 300-, 600-, and 1200-foot rolls
medium	Kodak Ektachrome 160 Professional Tungsten, ASA 160 Kodak Ektachrome 200 Professional Daylight, ASA 200 Agfa Agfachrome 400, ASA 400	None	Kodak Ektachrome 200 Professional, ASA 200, 15- and 100-foot rolls
fast	Kodak Ektachrome 400, ASA 400	None	None

lever when the film is all wound. Then open the camera back and remove the film. You'll see another paper band on the end of the backing. Lick the band and wrap it around the roll to prevent it from unwinding and fogging the roll. The paper band says **EXPOSED** so you won't confuse an exposed roll with an unexposed roll and try to reload it.

When the roll of exposed film is sealed with this paper band, about five winds of opaque paper cover the film. The circular ends of the spool also block light, but edge fog on the processed film can still occur if you are not careful about unloading and storing film in subdued light. Light can leak into the area between the inside of the spool ends and the paper backing. To avoid this, always handle exposed rolls in subdued light and transfer them to an opaque container until you can process them.

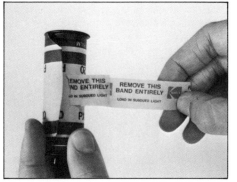

Before loading 120 or 220 roll film, completely remove the paper band surrounding the roll. Load the roll in subdued light.

After the roll is exposed and wound up, lick the end-paper band and wrap it around the roll to seal it shut. Avoid edge fog by keeping the film in subdued light until processing.

220 Roll Film—Besides the number of available emulsions, the only major difference between 220 and 120 roll film is that 220 film is twice as long. In some cameras the 220 roll must fit into the same chamber as a 120 roll, so the 220 roll does not have a con-

tinuous paper backing. Instead, it has paper leader and trailer taped to the ends to serve the same purposes as the beginning and end paper of a 120 roll.

As shown in the above table, only one color and two b&w films are available in 220. These are popular films

HANDLING 120 & 220 FILMS IN THE DARKROOM

Handling and processing 120 and 220 roll films is as easy as with 35mm film. Only a few procedures and pieces of equipment differ. In fact, if you already work with 35mm film, the only extra piece of equipment you need is a spiral reel designed for a 120 roll.

1/After removing the paper band that says *EXPOSED*, place your middle finger and thumb on the centers of the spool. Pull the paper and let the spool spin in your fingers. This end of the film is not taped to the paper so it naturally rolls up under it.

2/When the film is wound up completely, it remains attached to the paper backing with tape. Unpeel the tape from the paper backing, but leave the tape attached to the wound-up film.

3/Fold the tape over to the base side of the film and attach this tape-reinforced section of the film to the inside clip of the spiral reel.

4/Unwind the roll a bit and start winding the spiral reel to take up the film. Slightly squeeze the edges of the film so it slips into the channels of the reel. This procedure is the same as with 35mm film. A 120 spiral reel is practically the same size as two stacked 35mm spiral reels.

often used for both amateur and professional purposes. Even so, it is unfortunate there are not more emulsions from which to choose because 220 rolls are very convenient.

With them you can get twice as many exposures per load, and if you use a medium-format camera that is not quick loading or if you do not have more than one camera back or film insert, the less time you spend changing rolls, the more time you have to shoot.

70mm Film—For the maximum number of exposures with one film load, many photographers use double-perforated 70mm film. Except for its larger size, it looks like 35mm film. However, loading is different because exposed film is wound up onto another cassette. The film is available in cassettes or bulk rolls from the manufacturer through your camera dealer. See page 29 for a list of emulsions in 70mm.

Film backs holding 70mm film are available for the Mamiya RB67 Pro-S, the Bronica ETR-S, and Hasselblad cameras. These film backs hold daylight-loading cassettes that take a maximum of 15 feet (4.6m) of film. See the table on page 28.

As with 35mm bulk film, bulk-loaded 70mm film is both economical and convenient if you need to make many exposures. Astronauts, divers, aerial photographers, and some commercial photographers use 70mm film when shooting time is too valuable to waste by changing rolls. Processing labs that handle motion-picture film can process bulk-loaded 70mm film.

PROFESSIONAL OR AMATEUR FILM?

A factor in choosing Kodak color film is whether to use film intended for the professional or amateur photographer. When the word *Professional* is part of the name in Kodak color films, it means that the film is made to have optimal color balance when it is shipped, and it will not change as long as it is refrigerated prior to use. However, you can store the film for a short time unrefrigerated, such as two weeks at room temperature or two days at 120°F (49°C), and not see any difference in the processed film.

Film-speed tests are done on each emulsion batch of professional film before it leaves the factory. The recommended speed is then printed on the data sheet enclosed with the film. This speed can vary one-third step in either direction from its nominal ASA speed. The speed on the data sheet is accurate to within one-sixth step.

Films intended for the amateur photographer are made to reach their optimal color balance *after* they are shipped, so they eventually meet the standards of film users, as determined through customer-preference tests. This is true for other brands of film too. Variance from the nominal film speed is not printed on the data sheet, so you should test the film yourself if you want an accurate speed rating. If you buy a bulk supply of amateur film of one emulsion batch, you can preserve a certain color balance and speed by refrigerating the film when it meets your standards.

The differences between the films do not mean that professional film is better than amateur film. Rather, they let you choose a film that is compatible with the way you buy and use it. Photographers who make bulk purchases of professional film test part of an emulsion batch and do not want the characteristics to change from roll to roll. Many people buy small amounts of film at one time, and sometimes the film stays in the camera for weeks or even months. Amateur films accommodate this kind of user.

For best results, whether you buy professional or amateur film, keep unexposed and exposed film cool and do not subject it to high humidity. Have any exposed color film processed as soon as practical after exposure, or refrigerate it until it can be processed.

RECIPROCITY FAILURE

The reciprocity law states that if the exposure a film receives from frame to frame is unchanged, the photographic effect remains the same. For instance, a frame exposed at f-8 for 1/250 second should show the same effect as another frame exposed at f-16 for 1/60 second.

This law holds well for most normal photographic situations requiring shutter speeds from 1/2 to 1/1000 second, but at times longer *or* shorter, the law fails and the film shows signs of underexposure when processed normally. In addition, b&w film changes contrast, and color film can undergo a color shift because the emulsion layers respond differently to reciprocity failure. These problems can be corrected, though, by increasing exposure, adjusting development, and using filters.

Some reciprocity-correction guidelines are tabulated here. Recommended exposure compensations for color film include the effect of the filter. If possible, make the correction with the aperture instead of shutter speed. For shutter speeds in between those listed here, estimate correction. Blanks represent unpublished data. This information is supplied by the manufacturers and is based on their tests. All of the manufacturers suggest this information as a guide only, so bracket for best results. All data subject to change by the manufacturer.

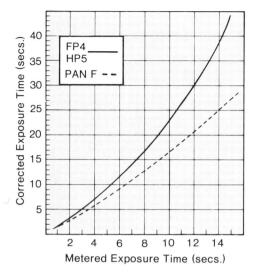

To make long-exposure reciprocity correction with Ilford b&w films, find the metered exposure time on the horizontal axis and follow it through the curve to find the corrected exposure time on the vertical axis. Example: If metered exposure time is 6 seconds, use 9 seconds with Pan F or 12 seconds with FP4 or HP5.

For extremely short exposure times, such as 1/10,000 second, increase exposure time one-half step by opening the lens aperture.

TYPICAL EXPOSURE INCREASE FOR RECIPROCITY FAILURE OF KODAK B&W FILMS

Film Type	If Indicated Exposure Time Is (Seconds)	USE ONE OF THESE CORRECTIONS (NOT BOTH) Open Aperture	Exposure Time	And Change Developing Time:
Panatomic-X	1/100,000	1 step	Use Aperture Change	20% more
Plus-X	1/10,000	1/2 step	Use Aperture Change	15% more
Tri-X	1/1000	None	None	10% more
	1/100	None	None	None
	1/10	None	None	None
	1	1 step	2 seconds	10% less
	10	2 steps	50 seconds	20% less
	100	3 steps	1200 seconds	30% less

EXPOSURE AND FILTRATION RECOMMENDATIONS FOR RECIPROCITY FAILURE IN SOME COLOR FILMS

FILM TYPE	INDICATED EXPOSURE TIME (sec.) 1/10,000	1	10	100
Color Negative Film				
Fujicolor F-II		+2/3 step no filter	+1-2/3 steps no filter	+2-2/3 steps no filter
Fujicolor F-II 400		+1 step no filter	+2 steps no filter	+3 steps no filter
Kodacolor II	none	+1/2 step CC15C	+1-1/2 steps CC30C	+1-1/2 steps CC30C
Kodak Vericolor II, Type S	none	NR	NR	NR
Kodak Vericolor II, Type L	NR	see data sheet	see data sheet	see data sheet
Kodacolor 400	none	+1/2 step no filter	+1-1/2 step CC10M	+2 steps CC10M
Color Reversal Film				
Agfachrome CT18		+1/2 step CC10B	+1 step CC10B	+3 steps CC15B
Agfachrome CT21		+1/2 step CC05B	+1 step CC10B	+3 steps CC15B
Fujichrome 100		none	+2/3 step no filter	+1-2/3 steps CC10C
Ektachrome 50 Professional	none	none no filter	+1/2 step CC10B	NR
Ektachrome 64 Professional	+1/2 step no filter	+1 step CC15B	+1-1/2 steps CC20B	NR
Ektachrome 160 Professional	+1/2 step no filter	+1/2 step CC10R	+1 step CC15R	NR
Ektachrome 200 Professional	+1/2 step no filter	+1/2 step CC10R	NR	NR
Ektachrome 400	none	+1/2 step no filter	+1-1/2 steps CC10C	+2-1/2 steps CC10C

NR: Not Recommended

POLAROID FILMS FOR MEDIUM-FORMAT BACKS

	FILM TYPE	ASA*	CHARACTERISTICS
COLOR	107C	3000	Medium-contrast print that does not need coating.
	667	3000	Professional version of 107C with minimal sensitometric variability. Does not need coating.
	107, 87	3000	Medium-contrast print that needs coating.
	084	3000	Professional version of 107 with minimal sensitometric variability.
	665		Yields b&w print and negative. Print needs coating and negative must be cleared in a 12% sodium sulfite solution.
B & W	108, 88	80	Polacolor 2 color print film that is balanced for 5500K light.
	668	80	Polacolor 2 color print film that is designed for use with electronic flash to give good skin tone reproduction.
	SX-70	150	Non-peel-apart instant color print film balanced for 5500K light. Develops automatically—no timing necessary.

* These speeds are based on 5000K light.

Polaroid Films—Instant pictures are not just for the impatient snapshooter. For most professional and scientific photographers, film is one of the cheapest photographic tools used. It is much less expensive than equipment, the time devoted to setting up, arranging the subject, and waiting for the results of processing.

Polaroid films are invaluable for judging lighting, checking setups, or getting an instant record of a subject. When the photographer is satisfied with the result of the Polaroid image, he can then expose conventional film. With Polaroid backs and film and the fine lenses of these medium-format systems, you can get b&w and color prints that can sometimes rival their conventional counterparts.

Medium-format Polaroid backs available from the camera manufacturers use 100/600-series or 80-series peel-apart Polaroid film. Most Polaroid backs use 100/600-series film. Three Hasselblad cameras and the Mamiya RB67 Pro-S models use an 80-series back. The Polaroid back for the Bronica ETR-S and SQ accepts *both* kinds of film. Two independent manufacturers make a back for Polaroid SX-70 film.

The 100/600-series Polaroid films are b&w and color print films in packs of eight individual exposures. A 100/600-series print is shown on the next page.

Two 80-series Polaroid films are currently available. They are packaged similarly and have the same emulsions as two films in the 100/600 series, as shown in the table. An 80-series print is shown on the next page.

The camera manufacturers use parts made by Polaroid in conjunction with mounting adapters they make to fit their cameras. Therefore, you load each manufacturer's back the same way. Follow the exposing and processing directions packaged with the film.

USING POLAROID FILMS

Polaroid films can help you get the best results from a shooting session because you can fine-tune lighting, exposure, and setup based on the results of an instant image. To take advantage of the instant results, you

1/Unlatch the large silver clip on the Polaroid back.

2/Unwrap the foil package containing the film pack. Handle the pack by the edges to avoid damaging the film—it's pressure-sensitive. Insert the pack into the back with the black-paper front facing the film plane.

3/Close the back and secure it with the silver clip. Then pull the black paper from the back.

4/After exposing the film, pull the white tab sticking out of the back. The tab has a number on it corresponding to the print number. This draws a yellow tab through the rollers.

5/Pull the yellow tab straight and smoothly until the film is out of the back. Then begin timing development.

6/At the end of development, separate the print from the negative. Here, the print is on the right and the negative sheet on the left. Developer chemicals are very caustic, so be careful not to contact them with your skin or clothes.

also have to take into account the differences between the Polaroid film and the roll film.

Film Speed—The first difference is film speed. None of the ASA speeds reported for Polaroid films are the same as commonly available medium-format films. Some kind of exposure compensation is necessary to equate the results of a Polaroid test with expected results of the roll film. There are a few ways to solve this problem.

For example, you can calculate exposure based on the roll film first and use neutral-density filters to "slow down" the Polaroid film so the same camera settings can be used. Or, camera settings based on the Polaroid film could be calculated, refined to get the best picture, then correlated to the roll film to get an appropriate camera setting.

Either way, you should calculate the difference in film speed in exposure steps so you can easily change shutter speed, aperture, neutral density, or a combination of the three. This exposure difference (ED) is the change you make to the camera to equate the Polaroid and roll film. The formula is:

$$ED = (\log(ASA_p / ASA)) / 0.3$$
ASA_p is the speed of Polaroid film
ASA is the speed of roll film

For example, if you test a setup with an ASA 3000 Polaroid film, and then shoot with an ASA 400 film:

EXPOSURE DIFFERENCE IN STEPS BETWEEN POLAROID AND CONVENTIONAL FILMS			
	POLAROID FILM SPEED		
Conventional Film Speed	**3000**	**80**	**75**
32	6.5	1.3	1.2
50	6.0	.70	0.32
64	5.6	0.32	0.20
100	4.9	0.32	0.40
125	4.6	0.65	0.75
160	4.2	1.0	1.1
200	3.9	1.3	1.4
320	3.2	2.0	2.1
400	2.9	2.3	2.4

The shaded area represents the portion of the table in which the Polaroid films are *slower* than the conventional films. To calculate neutral density, use this formula: ND= ED x .30.

$$ED = (\log(3000 / 400)) / 0.3$$
$$= 2.9 \text{ steps}$$

This also means you can use 2.9 steps of neutral density (ND) over the lens, as described in Chapter 5.

$$2.9 \text{ steps} \times (0.30 \text{ ND/step}) = 0.87 \text{ ND}$$

Use a 0.90 or 8X ND filter over the camera lens when shooting the Polaroid film at the camera settings determined by metering for an ASA 400 film. Or, you could adjust the camera for about three steps *more* exposure after finding the best settings with Polaroid film.

When using Polaroid film slower than the conventional film, use the formula this way:

$$ED = (\log(ASA / ASA_p)) / 0.3$$

These calculations are done for you in the accompanying table.

Reciprocity Failure—With some setups, you may also have to consider the reciprocity characteristics of both films. Unfortunately, they will never be the same. In this case you should bracket anyway. Experience, a test roll, and careful recordkeeping are usually the best ways to determine the proper exposure.

Color Temperature—Another consideration is the color temperature of the light source. Even though b&w Polaroid films are panchromatic, they are one-third step slower in 3200K light and one-third step faster in 10,000K light than speeds given for 5000K light.

Fig. 1/This photo was made with Polaroid Type 88 color print film exposed in the Mamiya M80 Polaroid back for the RB67 Pro-S system.

Fig. 2/This photo was made with ASA 3000 Polaroid Type 667 b&w print film. I used a Mamiya 16X neutral-density filter over the lens of the RB67 Pro-S camera to give the film an effective film speed of about EI 200. This closely matched the speed of the b&w film I was using in a roll-film back.

5
Metering

A camera with a coupled, through-the-lens meter is convenient and fast-handling simply because you can keep your eye on the exposure display and the scene at the same time, instead of switching your attention from one to the other. As with most 35mm SLRs, medium-format cameras also have through-the-lens meters, usually mounted in an accessory pentaprism viewfinder. Each camera-brand

chapter describes the meter, or meters, made for that system.

Unlike most 35mm SLRs, however, most of the cameras described in this book do not offer a meter as standard equipment. Therefore, there may be times when you will use an accessory hand-held meter to determine exposure settings. This chapter discusses various hand-held light meters, how they work, and how to use them.

HAND-HELD REFLECTED-LIGHT METERS
Hand-held reflected-light meters work like a built-in, through-the-lens camera meter with a full-frame averaging pattern. When you meter the scene, light reflected from the scene falls onto a flat disk that integrates the low and high values with those in between to give one average light value, or *luminance*.

This value is electronically transferred to a scale reading by a photocell. Then you enter the scale reading into a calculator dial, which displays different combinations of shutter speed and aperture for a certain film-speed setting. After choosing an appropriate *f*-stop and shutter speed for that scene, set the camera and shoot.

The Average Scene—The procedure just described works well *most* of the time. This is because many outdoor and indoor scenes have a luminance range of about seven steps between detailed shadows and textured highlights and equal amounts of light and dark areas. This is called the *average scene*, and its luminance range approximately matches the exposure range of most general-purpose b&w and color films exposed and processed normally.

When you meter an average scene, the average light reading corresponds to a scene luminance between detailed shadows and textured highlights. The recommended exposure setting places this *midtone* in the middle of the film's exposure range so it reproduces as a midtone.

Areas darker and lighter than the midtone, the shadows and highlights, are reproduced as such because they received less and more exposure than the midtone.

The Nonaverage Scene—Some scenes, called *nonaverage*, can cause a meter calibrated for an average scene

An average scene, such as this one, has approximately equal amounts of bright and dark areas. Most light meters are calibrated to give good exposure recommendations for average scenes.

1/When exposed according to the recommendation of an averaging hand-held meter, a predominantly white scene reproduces as mostly 18% gray.

2/This is the same scene as the one at left. Exposure was increased by one step, making it lighter, but still unacceptably underexposed.

3/If exposure is increased to two steps more than the first photo, the scene has essentially the same tones as the original scene.

4/An exposure of three steps more than the first yielded this print. Due to overexposure, the tones of the jacket are merging with the background.

The b&w prints in this series received the same enlarging and development times. The differences you see are due only to the differences in negative exposure.

to give an erroneous interpretation of scene luminance. Nonaverage scenes can be composed of predominantly light or dark tones or have a luminance range either longer or shorter than seven steps between detailed shadows and textured highlights.

In these cases the average luminance falling on the metering cell is not necessarily equal to the midtone of the scene. The midtone won't reproduce properly because you'll either under- or overexpose the film.

Most negative films accommodate some overexposure due to their long exposure range, but for best image quality you should give the film the minimum exposure to reproduce shadow detail. Transparency films become lighter as they are overexposed. Image quality of both negative and transparency films is far from optimum when underexposed.

For example, suppose you are photographing a light-skinned man dressed in white in front of a white wall. The meter cell integrates the reflected light falling on it and recommends a setting that will reproduce the white man, clothes, and wall as a midtone. This happens because the meter is calibrated for scenes with equal amounts of dark and light elements reflecting light. In this predominantly white scene, the meter interprets the light level as a midtone and gives an exposure recommendation that underexposes the scene. In a predominantly dark scene it does the opposite and overexposure results.

When confronted with a nonaverage scene, *you* must interpret the meter reading to avoid bad exposure settings. If the scene has more light than dark areas, give the film more exposure than the meter recommends. This exposure compensation is usually between one and three steps. If the scene is mostly dark, then one to two steps of underexposure relative to the meter's recommendation is best.

Substitute Metering—Another way to deal with the nonaverage scene is to find a midtone in the scene and meter from it. But because this can be difficult to do, the best way is to have your own midtone, put it in the light and meter from it.

An 18% gray card made by Eastman Kodak and sold in camera stores is one such midtone. A clean one always reflects 18% of the light incident to it—like the midtone of any average scene. Be sure to put the gray card in the same light falling on the subject of interest and angle the card to avoid glare or shadowing.

A subject reflecting 9% of the light has a *reflectivity* of 9% and creates one step less exposure than the midtone. A subject reflecting 36% of the light creates one step more exposure than the midtone. Therefore, you don't always have to meter from a gray card or midtone if you know the reflectivity of the subject. In fact, the reverse side of the gray card is white and reflects 90% of incident light. This corresponds to about 2.5 steps more exposure than the gray card reading. You meter from it, for example when light is dim, and increase exposure 2.5 steps.

You can also measure from a light skin tone, which reflects about 36% of incident light, and give one more step of exposure than the meter recommends. This reproduces the skin tone properly. To recalibrate your meter for the 36% reflector, use a film speed one step slower than the normal speed. All other things being equal, this will reproduce the skin tone correctly when you meter from it, and you don't have to carry around a gray card because a 36% skin tone is on the palms of your hands.

Some photographers base exposure on detailed shadows, so they recali-

I metered this scene by taking a close-up reading of light reflected from skin in full light. Because Caucasian skin reflects about 36% of incident light, I set the camera for one step *more* exposure than the meter recommended.

You can get good exposure when metering a non-average scene by using a reflected-light meter and a Kodak 18% gray card, as shown here. Notice how the card is slightly angled to avoid glare. The meter pictured is a Gossen Luna-Pro, which has an angle of view of about 30°.

For example, suppose you want to photograph a backlit scene and you prefer to exclude the background from the photo by using a long-focal-length lens. If you meter from camera position with a large-area type of meter, then the relatively bright background light striking the meter cell causes it to recommend underexposure, which makes the background too dark and the foreground much too dark.

Unless you know the angle of view of your meter and can estimate the area it is metering each time you use it, metering from a gray card or skin tone as described is a more foolproof way. You could move close to the subject and try to meter just that subject, but this is not always practical.

One advantage of large-area meters is that they are relatively inexpensive compared to the optional meters for the cameras described in this book. In addition, their sensitivity ranges are usually greater than a built-in camera meter. With good judgment and experience, you can get good exposures with one of these meters, but for overall convenience, I recommend a meter built into the camera or finder.

Spot Meters—The problems of large-area meters would be lessened somewhat if you could accurately view which areas of the scene are measured by the meter. Some meter manufacturers partially solve the problem by offering inexpensive add-on viewers that narrow the meter's angle of view and show it through an optical system.

Spot meters use this idea in a more refined way. They have lenses and an eyepiece you look through to see the scene on ground glass. You see the scene within an angle of view of about 30°, but the metering angle of view is much smaller—usually about 1° or 2°, as represented by a small circle in the center of the ground-glass image. The light falling on this small area is averaged and a scale readout is used to get a range of exposure settings.

The major advantage of the spot meter is that you can meter a small part of the scene that has a consistent tone and base exposure on only that tone. And you don't have to move from the camera position to do it.

Another advantage is that you can easily measure the subject's luminance range by measuring the light in a detailed shadow and textured highlight and find the difference in steps between them.

brate their meters by entering a film speed about two steps faster than the normal speed. Bracketing can help you get the best exposure when you are a bit unsure of the meter reading.

Large-Area Reflected-Light Meters—Another major factor in the way you meter is the type of reflected-light meter you use. The reading of a hand-held reflected-light meter can differ from a camera meter mainly because the hand-held meter's angle of view rarely matches the angle of view of the lens. This means that you may not always be metering exactly what you are imaging.

The *large-area* type of reflected-light meter has an angle of view of about 30°. To make a reading, you point the integrating disc along a line parallel to the *optical axis*, or center line, of the lens. This guarantees some overlap of the metered scene and the imaged scene. However, sometimes you may still have an exposure problem.

This is helpful when shooting either b&w negatives or color slides. In b&w photography, knowing the subject's luminance range is important in any tone-control system, such as the zone system. You base film speed and development time on both the luminance range and the way you interpret the scene.

If you know the exposure range of the color slide film you are shooting, you are better able to place the exposure if the luminance range is either shorter or longer than the film's exposure range.

For example, if the slide film has an exposure range of seven steps, and the subject's luminance range is nine steps, you must sacrifice two steps of scene detail to dense shadows, bright highlights, or both. Of course, the way you expose the film determines the result, and in this case I suggest bracketing one step in both directions to record all three possibilities. Later you can decide which image is worth keeping.

Because of their optical systems, spot meters are more expensive than large-area meters. Prices approach those of the optional metering viewfinders for medium-format cameras.

Metering with a spot meter eliminates some of the problems inherent in a large-area meter, whether built into the camera or not, but it is one more piece of equipment to carry.

INCIDENT-LIGHT METERS

The major limitation of any reflected-light meter is that its reading depends on the way elements in the scene reflect light and cast shadows. These elements create the average and nonaverage scenes.

An *incident-light* meter measures the light independent of anything in the scene and can be used more conveniently than a reflected-light meter because you don't have to interpret the meter reading due to the way the scene reflects light.

The incident-light meter looks like a large-area reflected-light meter except for a white plastic dome covering the photocell. When you put the dome of the meter in the same light illuminating the subject of interest and point it at the camera, it integrates incident light in such a way that the cell reads 18% of the light incident to the dome.

The meter gives a scale reading, which you transfer to a calculator dial that gives exposure settings. Some

The brightness of the sky in this non-average scene makes a large-area reflected-light meter recommend settings that give underexposure. With a spot meter you can base exposure on just a metered midtone, such as the screen door of the dome or a lit part of the tall green cactus.

The Pentax Digital Spotmeter reads a 1° circle in the field of view, shown by a small circle in the center of the frame. To find exposure settings, transfer the digital readout to a calculator dial on the lens.

meters give direct readings based on an aperture or *f*-stop you've chosen. An incident-light meter gives essentially the same results as using a reflected-light meter and a gray card. The extra convenience is that you don't have to carry the gray card around with you.

Types of Incident-Light Meters— These meters come in two basic designs. One is a large-area reflected-light meter that has a dome over the cell. They are for continuous light

sources, such as the sun or tungsten lamps.

Most manufacturers of large-area reflected-light meters and incident-light meters give you the option of using the meter in either a reflected or incident mode. The plastic dome slides in and out of place or unscrews from the meter so you can insert an integrating disc over the photocell.

Usually, other attachments are also available, depending on the meter's brand and sensitivity range. These attachments are for using the meter in different reflected modes, such as in enlarging or photomicroscopy.

The other kind of incident-light meter is usually called a *flash meter*. It works on the same metering principle as meters designed for continuous sources. The differences are in the type of photocell, the triggering mechanism, and the electronics. Some have outlets into which you plug the flash's sync cord so you can trigger the flash with the meter. This helps you use it to measure individual sources so you can create a certain effect.

Using an Incident-Light Meter— These meters are good to use if you photograph nonaverage scenes often or if the scene reflectance is constantly changing. Another feature of the incident-light meter is that you can measure the light coming from individual sources in a mixed-light setup.

This way you can easily determine the *light ratio* of a subject by pointing the meter at individual sources from the subject position. This is the ratio of the direct light on the subject and the light illuminating the shadowed side of the subject. The difference in exposure steps between readings is a measure of the light ratio.

The easiest way to make an *incorrect* reading with an incident-light meter is to forget about the inverse square law of light. The law states that for light sources that produce expanding beams, the illumination of a subject decreases by the square of the distance between source and subject.

Therefore, if you are lighting a subject with artificial light, you must meter from subject position. If you meter closer to the light, more light is falling on the meter's dome than if you were at subject position.

In this case, the recommended settings give underexposure. You don't have to worry about this with sunlit scenes because the sun is essentially at infinity and has parallel rays.

Depending on the brand of flash meter, you can measure flash only or mixed-light setups consisting of continuous and flash sources. These also contain a shutter mechanism that corresponds to typical shutter speeds you'll see on leaf-shutter lenses. The readout for these meters is usually in *f*-stops.

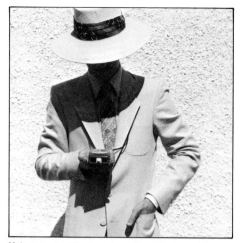

Using an incident meter at subject position in nonaverage scenes provides good exposure recommendations. The Gossen Luna-Pro is shown being used as an incident meter with its white plastic dome over the photocell.

Difference in Exposure Steps	Light Ratio
0	1:1
1/3	1:1.3
1/2	1:1.4
2/3	1:1.6
1	1:2
1-1/3	1:2.5
1-1/2	1:2.8
1-2/3	1:3.2
2	1:4
2-1/3	1:5
2-1/2	1:5.7
2-2/3	1:6.3
3	1:8
n	$1:2^n$

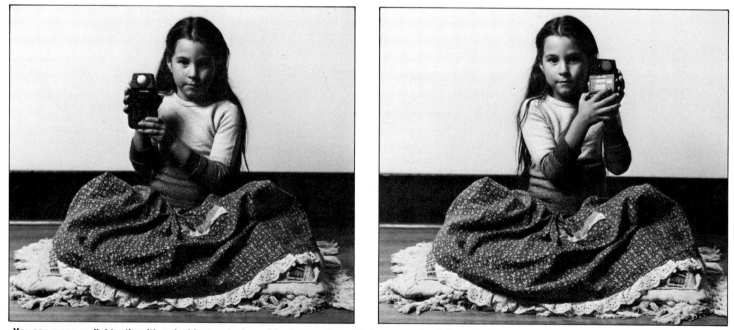

You can measure light ratio with an incident meter by making two readings. First measure the light on the lit side of the subject, as shown in the photo at left. Then measure the light on the shadowed side. The difference in exposure steps between the readings is a measure of light ratio, as shown in the table.

For general-purpose portraiture a light ratio between 1:2 and 1:4 is usually used. High-key lighting uses a lower ratio and low-key lighting a higher ratio. For this portrait the light ratio was 1:2, as measured by the subject with a Minolta flash meter.

HAND-HELD METERING AND EXPOSURE COMPENSATION

A camera with a built-in through-the-lens (TTL) meter automatically takes into account the effect of filters, and any light loss due to magnification and transmission factors of the lens elements.

However, if you use an accessory meter and filters or lens attachments with the camera, you must compensate for the absorption of the lens attachments. This is relevant for both reflected- and incident-light meters.

FILTER COMPENSATION

In this book a filter is defined as an accessory that fits on the lens and absorbs light. Unlike some lens attachments that do some kind of optical trick like creating multiple images or star patterns on specular highlights, the filter effect is not always noticeable. Filters can be used to adjust tonal contrast in b&w photography, correct color balance in color photography or minimize the effects of atmospheric haze. In these cases, good filter technique is less obvious than the improved impact of the image, which is exactly how technique should serve the photographer.

Because the filter absorbs light, the film should be given more exposure than if no filter were used. Of course, if you want the image to be darkened, then no compensation is necessary, but this is the exception and not the rule.

You can figure the necessary exposure compensation due to filters in different ways. The one that is right for you is the one you are most comfortable with and adept at doing. All give essentially the same result.

Filter-Factor Method—On some screw-in filters you'll notice a factor inscribed on the metal ring. This is the *filter factor*. Usually, it is expressed as a multiplier, such as 2X, 4X, or 8X. The number refers to the extra amount of exposure necessary to compensate for light absorption.

Because it is a multiplier, you can use it with *either* shutter speed or film speed. For example, if you use a filter with a factor of 4X, multiply the shutter speed recommended by a hand-held meter by 4 to get the new shutter speed. Or, divide the film speed entered into the meter by 4 when using that filter. Do one or the other, *not both*.

For example, suppose the hand-held meter recommends 1/1000 second shutter speed at f-8 for ASA 400 film. When using a 4X filter, you can use either a 1/250 second speed at f-8 or get the same result by metering the scene again based on a film speed of ASA 100.

The flaw with the second method is that you have to change the meter's film-speed setting every time you change filters. If you forget to reset the meter when not using the filter, you'll waste film with bad exposures.

Exposure-Step Method—As shown below, you can equate filter factors with exposure steps—every factor of 2 corresponds to one exposure step. With this method you can adjust f-stop, shutter speed or both, the necessary number of exposure steps.

For example, if you use a 4X filter, you need to give the film two more steps of exposure than the hand-held meter recommends. Using the same exposure reading as the previous example, you could change the f-8 at 1/1000 second setting to f-8 at 1/250 second, f-4 at 1/1000 second or f-5.6 at 1/500 second. In all three cases exposure is the same.

Neutral-Density Method—Sometimes you may want to reduce the light entering the lens to reduce depth of field or use slow shutter speeds. Neutral-Density (ND) filters are commonly used for this technique because they don't change the color balance of light entering the lens.

ND filters are available in gel form from Eastman Kodak in discrete values for accurate light control. Filter manufacturers make glass ND filters for 1, 2, and 3 steps of absorption. The table below shows their equivalence to exposure steps and filter factors.

I think it is easiest to remember that 0.10 neutral density units equal 1/3 exposure step. For example, a 0.60 ND filter absorbs two steps of light and has a filter factor of 4X. When using more than one ND filter, add neutral density units together to find the new density.

Filtering the Meter—If you put the filter over the window of the hand-held meter, it automatically compensates for the filter absorption. This way you can use the meter reading to determine camera settings without ever knowing the filter factor. After metering, put the filter back on the lens and use those settings. Although removing and reattaching the filter each time you want to meter can be tedious, it may be the best method when using color compensating (CC) or polarizing filters.

EQUIVALENT FILTER FACTORS, EXPOSURE STEPS, AND NEUTRAL DENSITY		
Filter Factor (FF)	**Exposure Step (ES)**	**ND Filter (ND)**
1.25	1/3	.10
1.4	1/2	.15
1.6	2/3	.20
2.0	1	.30
2.5	1-1/3	.40
2.8	1-1/2	.45
3.1	1-2/3	.50
4.0	2	.60
5.7	2-1/2	.75
6.25	2-2/3	.80
8.0	3	.90
10	3-1/3	1.00
11.3	3-1/2	1.05
100	6-2/3	2.00
1000	10	3.00
10,000	13-1/3	4.00
Formulas $FF = 10^{(ND)}$ $FF = 2^{(ES)}$	$ES = 3.3 \log (FF)$ $ES = 3.3 \times ND$	$ND = \log (FF)$ $ND = 3.3 \times (ES)$
Notes When using more than one filter, multiply filter factors to get the total filter factor.	Exposure steps add numerically.	When using more than one ND filter, add density units to get total density.

FEATURES OF CAMERA METERS

Meters for medium-format cameras are either in the camera or are part of an interchangeable finder. Terms used to describe these meters are:

METERING PATTERN

Three patterns are in common use.

Full-frame averaging meters give equal emphasis to light from all parts of the scene. Light in the corners of the scene will affect the meter the same way light in the center does. Because the meter integrates, or averages, all of the light in the scene to give an average brightness, it may not recommend best exposure.

Center-weighted meters use a metering pattern with maximum sensitivity in the central portion. The rationale is that most photographers put the main subject of interest in or near the center of the composition.

Bright sky can fool a full-frame averaging meter into thinking the scene is brighter than it is. A center-weighted meter can reduce this problem because the sky is usually at the top of the composition, where there is less meter sensitivity. These meters can still be fooled, but for most scenes they are more dependable than full-frame averaging types.

Spot meters are available for some cameras. These read a very small part of the total image, as indicated by a small disc visible in the viewfinder. With this meter you can base exposure on a middle tone or skin tone only and not have to worry about other elements in the scene. In addition, you can measure the scene's luminance range with the metering spot.

METERING CELLS

Three types of metering cells are used. They use battery power from the camera or viewfinder.

Cadmium Sulfide (CdS) cells work fast in normal light, but slow down in dim light. You can see this happening as you meter a low-light scene. Usually, the needle will stop moving after 30 seconds. Then the reading is accurate. CdS cells have a memory. If used to meter a low-light scene just after metering a bright scene, the second reading can be too high. Avoid this problem by letting the meter cell recover for about a minute after a bright-light reading.

Silicon and **Gallium** cells respond quickly to even low-light scenes, yet have no memory of previous readings.

EXPOSURE VALUE (EV) NUMBERS

Meter manufacturers often specify meter sensitivity range with EV numbers, a film speed, and an aperture setting.

As shown in the accompanying table, EV numbers represent pairs of exposure-control settings. A usable EV range is from −2 to +18. As you can see from the table, the settings for EV −2 imply low light and the settings for EV +18 imply very bright light. However, neither of these settings tell you *how much* light is on the scene.

Therefore, the brightness range meters can accurately measure is given by stating an EV range with a film speed and an aperture setting. The film speed is usually ASA 100 and the aperture is generally the maximum aperture of the fastest standard lens.

EV numbers are also used for exposure-control settings on Hasselblad lenses. As shown in the table, each number represents pairs of settings, all of which give the same exposure for the same scene. When you set a Hasselblad lens for a certain EV, you can conveniently choose different f-stop and shutter-speed combinations that give the same exposure.

STOPPED-DOWN METERING

With an automatic lens coupled to the camera meter, you view and meter a scene through the maximum aperture of the lens. This is called *full-aperture* metering. Just before exposure, the diaphragm in the lens stops down to the preselected f-stop.

If lens is not coupled to the meter, you must actually change aperture size to determine exposure. To do this with some lenses you use the **Manual**, or **M**, setting of the lens. As aperture size decreases, the image you view becomes darker and shows more depth of field.

This is called *stopped-down metering* because the lens is stopped down during metering.

EV NUMBERS & EQUIVALENT EXPOSURE SETTINGS

EV	4 min.	2 min.	1 min.	30 sec.	15	8	4	2	1	1/2	1/4	1/8	1/15	1/30	1/60	1/125	1/250	1/500	1/1000
−2	f-8	f-5.6	f-4	f-2.8	f-2	f-1.4	f-1												
−1	11	8	5.6	4	2.8	2	1.4	f-1											
0	16	11	8	5.6	4	2.8	2	1.4	f-1										
1	22	16	11	8	5.6	4	2.8	2	1.4	f-1									
2	32	22	16	11	8	5.6	4	2.8	2	1.4	f-1								
3	45	32	22	16	11	8	5.6	4	2.8	2	1.4	f-1							
4	64	45	32	22	16	11	8	5.6	4	2.8	2	1.4	f-1						
5		64	45	32	22	16	11	8	5.6	4	2.8	2	1.4	f-1					
6			64	45	32	22	16	11	8	5.6	4	2.8	2	1.4	f-1				
7				64	45	32	22	16	11	8	5.6	4	2.8	2	1.4	f-1			
8					64	45	32	22	16	11	8	5.6	4	2.8	2	1.4	f-1		
9						64	45	32	22	16	11	8	5.6	4	2.8	2	1.4	f-1	
10							64	45	32	22	16	11	8	5.6	4	2.8	2	1.4	f-1
11								64	45	32	22	16	11	8	5.6	4	2.8	2	1.4
12									64	45	32	22	16	11	8	5.6	4	2.8	2
13										64	45	32	22	16	11	8	5.6	4	2.8
14											64	45	32	22	16	11	8	5.6	4
15												64	45	32	22	16	11	8	5.6
16													64	45	32	22	16	11	8
17														64	45	32	22	16	11
18															64	45	32	22	16

SHUTTER SPEED (column group header above 4 min. through 1/1000)

MAGNIFICATION COMPENSATION

Image magnification has an effect on exposure, as described in Chapter 2. As magnification increases, the light level at the film plane decreases, and more exposure is necessary to compensate for the light loss. The various formulas you can use to calculate this exposure compensation factor are in Chapter 2. The one you use depends on the image magnification, the type of lens, and whether the lens is mounted normally or reversed.

When using an accessory meter, meter the subject and make an exposure correction based on the results of formula calculations. The exposure compensation factor can be used just like a filter factor or converted into equivalent exposure steps.

Yashica Mat-124G

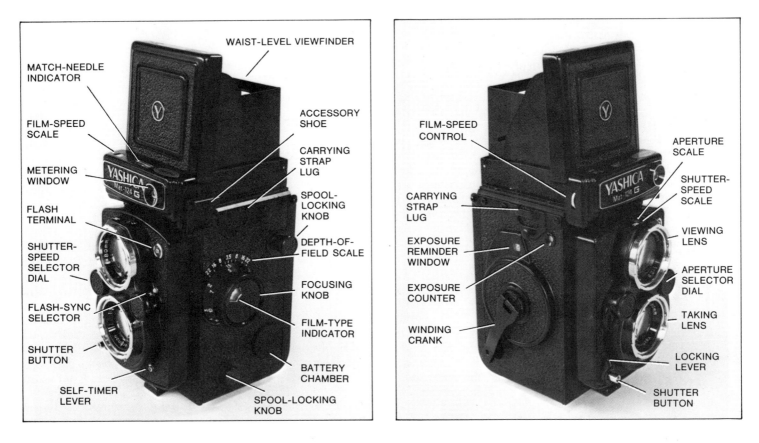

MATCH-NEEDLE INDICATOR · **FILM-SPEED SCALE** · **METERING WINDOW** · **FLASH TERMINAL** · **SHUTTER-SPEED SELECTOR DIAL** · **FLASH-SYNC SELECTOR** · **SHUTTER BUTTON** · **SELF-TIMER LEVER** · **WAIST-LEVEL VIEWFINDER** · **ACCESSORY SHOE** · **CARRYING STRAP LUG** · **SPOOL-LOCKING KNOB** · **DEPTH-OF-FIELD SCALE** · **FOCUSING KNOB** · **FILM-TYPE INDICATOR** · **BATTERY CHAMBER** · **SPOOL-LOCKING KNOB**

FILM-SPEED CONTROL · **CARRYING STRAP LUG** · **EXPOSURE REMINDER WINDOW** · **EXPOSURE COUNTER** · **WINDING CRANK** · **APERTURE SCALE** · **SHUTTER-SPEED SCALE** · **VIEWING LENS** · **APERTURE SELECTOR DIAL** · **TAKING LENS** · **LOCKING LEVER** · **SHUTTER BUTTON**

The Yashica Mat-124G is a simple, non-automatic camera that has the distinction of being the least expensive medium-format camera described in this book. In addition, it has other interesting and useful features that make it worthy of consideration if you need a medium-format camera only occasionally.

It is very light and accepts either 120 or 220 film to give 12 or 24 6x6 cm images with actual dimensions of 56x56 mm. A built-in CdS meter with its metering cell on the camera body eliminates the need for an interchangeable metering viewfinder.

Although the pair of 80mm lenses is not removable as are Mamiya TLR lenses, relatively inexpensive auxiliary add-on lenses give the camera both telephoto and wide-angle capability. Two sets of close-up lenses are also available.

Even though the Yashica Mat-124G does not have as many accessories and features as other cameras in this book, it is still a quality camera. Good photos are made by good photographers, not by the most expensive and versatile cameras. In skilled hands the Yashica Mat-124G offers medium-format capabilities that rival those of other cameras.

YASHICA MAT-124G CAMERA SPECIFICATIONS

Type: 6x6 cm twin-lens reflex.
Shutter: Copal SV leaf shutter with speeds from 1/500 second to 1 second, plus B. X-sync at all shutter speeds.
Standard Lenses: Yashinon 80mm f-3.5 taking lens and Yashinon 80mm f-2.8 viewing lens.
Film: 12 or 24 exposures with 120 or 220 film.
Power Source: 1.3V mercury battery (Eveready EPX-13 or equivalent).
Meter: Built-in CdS exposure meter with meter cell on the camera body. Meter operates manually within a measurement range from EV 4.5 to EV 17 at ASA 100 with the f-3.5 lens.
Other Features: Interchangeable auxiliary lenses for wide-angle, telephoto, and close-up shooting. Double-exposure prevention device.
Dimensions: Width 102mm (4"), height 141mm (5.8"), depth 102mm (4").
Weight: 1kg (2.2 lbs.).

LENSES FOR THE YASHICA MAT-124G

The fixed pair of standard 80mm lenses of the Yashica Mat-124G is a Yashinon f-2.8 viewing lens and a Yashinon f-3.5 taking lens. The latter is equipped with a Copal-SV leaf shutter offering standard shutter speeds from 1/500 to 1 second, and B. The interpupilary distance (d) of the lenses is 42mm (1.7 inches).

The fixed lenses accept a pair of 30mm, bayonet-mount auxiliary lenses. Two sets are available to either increase or decrease the focal length of the camera lenses.

Attaching Auxiliary Lenses—The auxiliary viewing lens of each set is the smaller of the two. Attach it to the camera's viewing lens by inserting the three lugs of the auxiliary lens mount into the flanges of the camera's viewing lens mount. Then turn the auxiliary lens about 60° clockwise until it

Yashica auxiliary lenses mount on the front of the fixed 80mm lenses of the Mat-124G.

AUXILIARY LENSES FOR THE YASHICA MAT-124G		
NAME	**FUNCTION**	**NOTE**
Wide-Angle	Reduces focal length of lens to 58mm. Field of view increases 75%.	Values on distance scale of the focusing knob are halved.
Telephoto	Increases focal length of lens to 113mm. Field of view decreases 50%.	Values on distance scale of the focusing knob are doubled.
Close-Up	Close-up shooting at subject distances nearer than 3.3 feet (1m).	See table on close-up lenses.

clicks and stops. Attach the larger auxiliary lens of the set to the camera's taking lens the same way.

Because both camera lenses have an auxiliary lens, you view the scene as it will be recorded. However, the viewfinder image is slightly darker than if no auxiliary lens were attached. The auxiliary viewing lenses reduce the amount of light passing through the lens combination.

Yashica solved this problem for the auxiliary taking lenses by using a front element about twice the diameter of the camera's taking lens. The larger area of the front element accepts more light and compensates for the light loss.

Using the Wide-Angle Lenses—Attaching the wide-angle auxiliary lenses to the fixed camera lenses increases the field of view about 75%. As mentioned, the viewfinder image is darker than it was before you attached the lenses. In addition, the actual subject-to-camera distance is *half* of the value indicated by the distance scale on the camera's focusing knob.

For best image quality, Yashica recommends that you use an aperture between f-5.6 and f-11 with the auxiliary lenses. Larger apertures do not give good flatness of field and smaller apertures vignette the image.

Neither of the auxiliary wide-angle lenses accepts screw-in filters. The best way to use a filter over the auxiliary taking lens is to attach a filter holder that will slip on the 57mm-diameter lens barrel of the lens. Then you can use gel, glass, or plastic filters that fit the filter holder. Yashica does not offer such a holder, but many filter manufacturers do.

Because the meter cell is on the body of the camera and not behind the lens, you should take the filter factor into account in exposure calculations. See Chapter 5 for information on metering and filters.

If you want to view the scene through the filter, temporarily switch the position of the auxiliary taking and viewing lenses. Or, remove the filter from the auxiliary taking lens and hold it over the auxiliary viewing lens. In either case, you *should not* meter at

This 58mm wide-angle view was made with the wide-angle auxiliary lens. Image vignetting is due to a lens aperture of f-16.

The fixed 80mm lens gives this perspective.

The telephoto auxiliary lens increases focal length to about 113mm. Lens aperture of f-16 vignetted the image.

CLOSE-UP LENSES FOR THE YASHICA MAT-124G

Lens	Diopter	Distance Setting	Magnification
No. 1	1.88	∞	0.15
		3.3 feet (1m)	0.25
No. 2	2.75	∞	0.22
		3.3 feet (1m)	0.33
No. 2 + No. 1	4.63	∞	0.37
		3.3 feet (1m)	0.42

This photo was made with the camera lenses fully extended. They remained fully extended for the following photos made with close-up lenses. This yielded maximum magnification.

this time. Either the filter or the auxiliary taking lens will block the meter cell, which will create an erroneous exposure recommendation.

Using the Telephoto Lenses—As with the auxiliary wide-angle lenses, the auxiliary telephoto lenses change the field of view. In this case it decreases about 50%. Because the focal length changes, a focus adjustment is necessary. The actual camera-to-subject distance is *twice* the indicated distance on the focusing knob.

The telephoto lenses also work best at apertures between *f*-5.6 and *f*-11 as recommended for the wide-angle lenses. Recommendations for using filters are the same too.

Close-Up Lenses—For close-up shooting of subjects nearer than 3.3 feet (1m) with the 80mm lenses, use a set of close-up lenses. Two sets are available, labeled **No. 1** and **No. 2**. The magnification ranges possible with the lenses used alone or stacked are shown in the accompanying table.

The viewing close-up lens of each set is physically longer. Mount it as you would an auxiliary lens, making sure that the red dot on the outside of the lens barrel is pointing straight up. This is important if you want to reduce parallax error due to increasing image magnification, as described in Chapter 1. In fact, at the closest subject distance possible with just the camera's 80mm lenses, parallax error is more than 3mm, or about 6%.

Yashica reduced parallax error by inserting a circular prism in front of the viewing close-up lens. The prism optically raises the subject seen by the camera's taking lenses, so you can view almost exactly what you are shooting. Each prism completely eliminates parallax error for only *one* film plane-to-subject distance. For the No. 1 lens this distance is 24 inches

(61cm) and for the No. 2 lens it is 15 inches (39cm).

Because of the prisms, you cannot use the viewing close-up lenses stacked. If you want the extra image magnification that stacked close-up lenses offer, use the No. 2 lens between the No. 1 lens and the camera lens.

Attach them to the camera's viewing lens first. Compose and focus the image with the camera on a tripod, then put the close-up lenses on the camera's taking lens. If you want to compensate for parallax error, *raise* the camera the interpupilary distance of the camera lenses, 42mm (1.7 inches). For best image quality, use the smallest aperture possible when shooting with close-up lenses.

THE BATTERY

A 1.3V mercury battery, Eveready EPX-13 or equivalent, powers the camera meter. The battery chamber is on the camera's left side below the focusing knob. To insert a battery, unscrew the black plastic cap that covers the chamber. Insert the battery with its positive pole facing out. Screw the cover back on the chamber.

Mount the viewing close-up lens so the red mounting dot points straight up.

With the No. 1 close-up lens.

With the No. 2 close-up lens.

With the No. 2 and No. 1 close-up lenses stacked.

The chamber, cover and battery are clearly marked with positive and negative signs. If you put the battery in backward, the meter will not work. All other camera functions are mechanical so you can still use the camera if the battery is missing or dead.

FILTERS AND LENS ATTACHMENTS

Yashica also offers other lens accessories for the camera's 80mm lenses or the close-up lenses. A rigid lens hood for the taking lens helps prevent stray light from striking the lens and reducing image contrast. It has a 30mm bayonet mount and attaches to the camera's taking lens like the auxiliary lenses do.

Filters for both b&w and color photography are available. They are listed in the accompanying table. Only

30mm bayonet-mount filters are offered by Yashica.

LOADING FILM

Open the camera back by turning the large round locking knob on the camera bottom to O. The back cover springs open. When the cover opens, the exposure counter is reset to a red S.

Free the empty spool in the bottom of the camera by pulling and turning the spool-locking knob on the camera's side until it locks open. Remove the empty spool and put it into the top take-up chamber. The spool-locking knob for the top chamber works the same way. Close the locking knobs.

Unwrap the paper band of the unexposed roll of film and insert the film into the bottom chamber. Then draw

the paper leader out with its black side facing the film plane and insert the tapered end into the take-up spool. Unfold the camera's winding crank from the right side and advance the leader by turning the crank clockwise.

If you are using 120 film, you have to wind the crank only about 1.5 turns before the arrow printed on the leader aligns with a green arrow on the bottom left side of the camera body. This alignment mark is almost hidden by the paper leader, so be sure to familiarize yourself with its exact location before loading the roll of film. If you are using 220 film, about two turns of the winding crank aligns the leader's arrow with a red arrow on the lower left side of the camera.

After aligning the arrows, adjust the pressure plate for the film you are using. A window in the pressure plate shows either a red **24EX.** for 220 film or a green **12EX.** for 120 film. To change the position of the pressure plate, grip the back of the cover so your thumbs are below the window. Press on the spring-loaded plate and slide it up or down to show the proper symbol in the window. Make sure the pressure plate springs back completely when you let go of it.

Setting the pressure plate adjusts for the thickness of the film and leader to hold the film flat in the film plane. In addition, it automatically sets the exposure counter for 12 or 24 exposures. The exposure-reminder window above the winding crank is also set by the pressure plate. It shows either a green **12EX.** or a red **24EX.**, depending on how you set the plate.

Close the back of the camera and turn the round locking knob on the camera bottom in the direction of the white arrow pointing to C until it stops. This also draws in the back cover latch to securely lock the camera back shut.

Turn the winding crank clockwise until it stops. This takes about 3.5 revolutions of the crank. At this point the exposure counter shows a black 1 in its window, signaling that the first frame is in the film plane. To cock the lens shutter, wind the crank back counterclockwise about 175° until it stops.

Doing It Wrong—If you load a 220 roll and set the pressure plate for 12 exposures, the film will not be held as flat as it could be. When you use larger apertures, this creates unsharp

YASHICA 30mm BAYONET-MOUNT FILTERS				
FILM	FILTER NAME	COLOR	APPROX. FILTER FACTOR	USE
Any	UV	clear	1X	Reduce UV exposure of film.
	ND2	gray	2X	Reduce amount of light entering lens by one step.
B&W	Y2	yellow	2X	Increase tonal contrast between clouds and sky.
	O2	orange	4X	Absorbs more blue than Y2. Penetrates haze better.
	R1	red	8X	Absorbs blue and green for more sky contrast and for darkening foliage.
	G1	green	2X	Masculine portraiture and lightening foliage.
Color	1A	light pink	1X	Reduce UV and excess blue of open shade.
	80B	blue	2X	Balance 3400K light for daylight color film
	81B	yellow	1.3X	Balance 3500K light for 3200K color film.
	82A	blue	1.25X	Balance 3000K light for 3200K color film.
	85	amber	1.6X	Balance 5500K light for 3400K color film.

To open the camera back, turn the locking knob counterclockwise.

Stop advancing film when the arrow on the paper leader aligns with the proper start mark. The 24-exposure start mark is shown here.

Adjust the pressure plate for 12 or 24 exposures before closing the camera back.

images. In addition, the exposure counter is set for only 12 exposures. After the 12th exposure, the winding crank will turn freely to wind up the roll. Winding it up will waste 12 frames of film.

However, if you discover your mistake after a few exposures, you can still expose the last 12 frames. After the 12th exposure, continue winding the crank as before—about 210° clockwise and then back counterclockwise until it stops. This advances the film and cocks the shutter, readying the next unexposed frame.

You must be careful not to overwind the film on the clockwise stroke because the crank does not stop automatically as it did for the first 12 exposures. Also, you must count the next 12 frames yourself because the exposure counter does not continue advancing. After shooting the 24th frame, wind the crank until the tension slackens. Then remove the film.

Loading 120 film and setting the pressure plate for 24 exposures puts too much pressure on the film in the film plane. The extra drag creates unnecessary strain on the winding mechanism and could lead to its premature wear.

Because the exposure counter is set for 24 exposures, you can be fooled into exposing the paper backing after the 12th exposure. The counter will advance even after you have wound up the roll completely—after the 16th "exposure."

VIEWING AND HANDLING

Open the waist-level viewfinder by lifting the sides of the viewfinder panel. When the viewfinder springs open, it automatically turns on the camera meter, which is described later. The all-matte focusing screen shows an upright, laterally reversed image on a bright field. You can see the whole image the film records.

In the center of the screen is a 12mm circle. Use this area to judge whether the focusing screen image is sharp or blurred. The camera does not have interchangeable viewfinders or focusing screens; however, you can use the viewfinder three ways.

Waist-Level Viewing—For waist-level viewing, hold the camera against your body by supporting it with your right hand. This frees your left hand to focus using the camera's focusing knob. Look down on the focusing screen to compose and focus the image. After focusing, steady the camera with your left hand and use your right index finger to push the camera's shutter button.

After exposure, switch the camera to your left hand so your right hand can turn the winding crank. As long as subject distance doesn't change, you can keep the camera in your left hand and push the shutter button with your left index finger. This detailed explanation makes handling the camera for waist-level viewing seem more difficult than it really is. Actually, switching hands becomes automatic very quickly.

Eyepiece Viewing—My major difficulty with waist-level viewing is trying to make the focusing screen

image sharp when it is two feet away from my eyes. In my opinion, the best way to focus is with the viewfinder's magnifying eyepiece in position over the focusing screen. To use this built-in, 3X magnifier, push the front of the unfolded viewfinder. The magnifier springs out over the focusing screen.

To focus, bring the camera to your eye while supporting its bottom with your right hand. Use your left hand to focus; push the shutter button with your right index finger. To retract the magnifier, gently push on its frame until it folds back flat against the front panel of the viewfinder.

Sportsfinder Viewing—The third way to use the viewfinder lets you view the subject directly instead of through a camera lens. Of course, you see the subject upright and laterally correct. This is the best method for following and photographing moving subjects.

After focusing on the subject using either of the two ways already described, push on the front panel of the unfolded viewfinder until its center folds down over the focusing screen. This *does not* turn off the meter. Bring the square hole at the back of the viewfinder to your eye and hold the camera against your cheekbone. You see essentially the same field of view as the 80mm viewing and taking lenses.

What you see is easier to follow and much brighter than the focusing screen image, but if the moving subject moves away from the area of good focus determined by your initial focus and aperture settings, you may get unsharp photos. For this reason, photographers often use this viewing

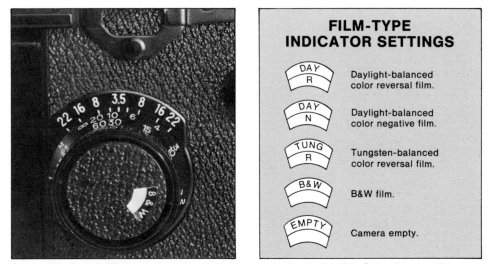

FILM-TYPE INDICATOR SETTINGS

DAY R	Daylight-balanced color reversal film.
DAY N	Daylight-balanced color negative film.
TUNG R	Tungsten-balanced color reversal film.
B&W	B&W film.
EMPTY	Camera empty.

Set the Film-Type Indicator on the camera's focusing knob after loading film. Shown here are the settings you can use.

The built-in sportsfinder of the Yashica Mat-124G shows practically the same field of view as the 80mm lenses. Don't use it with the auxiliary wide-angle or telephoto lenses.

method when shooting fast film, which allows small apertures for extensive depth of field and fast shutter speeds to freeze motion.

However, as mentioned in Chapter 3, the combination of fast shutter speeds, small apertures and a leaf shutter can lead to overexposure due to leaf-shutter efficiency. See the table in Chapter 3 for guidelines on exposure adjustment due to leaf-shutter efficiency.

To move the folded center panel away from the focusing screen, push the small silver button on the back of the viewfinder. Then close the viewfinder by retracting the magnifier and pulling down on the sides of the viewfinder's front panel. This will turn off the camera meter.

Use the sportsfinder when photographing action.

METERING

The Yashica Mat-124G has a built-in, manually operated CdS meter that is not part of the camera's viewfinder system. The meter's CdS cell is on the camera's nameplate above the viewing lens. A small plastic lens covers the cell and gives it an acceptance angle of about 52°, which is the same angle of view as the standard 80mm lenses. This makes the meter a full-frame averaging type when used with the 80mm lenses.

Setting Film Speed—Use the small silver control on the right side of the nameplate to center the film's ASA speed opposite a red mark in the window of the ASA scale on top of the nameplate. You can select film speeds from ASA 25 to ASA 400. They are marked in 1/3-step increments, but because the dial has no detents, you can get settings accurate to 1/6 step.

Setting Exposure—Turn the meter on by opening the viewfinder. When you hold the camera in one of the three described viewing methods, your thumbs will rest on two black dials between the two camera lenses. The left dial controls the aperture from f-3.5 to f-22. The right dial controls the shutter speeds, from 1/500 to 1 second, and B. You can see the selected aperture in white numbers and the shutter speeds in red numbers in the exposure-setting window on top of the viewing lens.

To the left of the Film-Speed Scale is a match-needle indicator. It has a thin red line and a thicker green line with a circular end. Shutter speed is coupled to the red line and aperture is coupled to the green line. The lines move as you adjust aperture and shutter speed. When the red line is centered in the circular end of the green line, exposure is correct.

Because the shutter-speed dial has weak detents and because you shouldn't use speeds between the standard marked ones, Yashica recommends that you set shutter speed first when metering. Center the desired speed opposite the small black line in the exposure-indicator window. Then adjust the aperture dial until the red and green lines in the match-needle indicator are aligned. The aperture dial has no detents so it is easy to make fine aperture adjustments. Read the selected aperture opposite the small black line in the exposure-setting window.

Set film speed using the silver control on the camera's right side. The camera's match-needle exposure display is to the left of the Film-Speed scale.

While your left thumb controls aperture size and your right thumb sets shutter speed, by looking down you can see the exposure display and the aperture and shutter-speed dials on top of the camera.

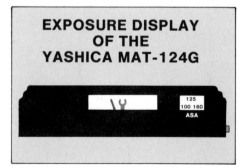

EXPOSURE DISPLAY OF THE YASHICA MAT-124G

The red line is coupled to shutter speed and the green line to aperture. When the two are aligned, exposure is correct.

Metering Problems—This kind of averaging meter works fine for average scenes. If you are using the 80mm lenses, you can judge if the scene the meter sees is average or not by viewing the same scene through the viewfinder. Then you can make any adjustment to the recommended exposure based on your judgment.

However, if you use either the wide-angle or telephoto auxiliary lenses, you do not meter the same scene you view. If the average luminance of the scene you meter differs from the average luminance of the scene you view, the recommended exposure settings can give bad exposure. If you suspect that this will happen, meter from an 18% gray card or bracket.

Determining Depth of Field—Because the camera's viewing lens does not have adjustable aperture, you cannot view depth of field of apertures smaller than *f*-2.8 on the focusing screen. The best way to judge depth of field is with the depth-of-field scale on the focusing knob.

SHOOTING FILM

A small black locking lever is connected to the shutter button, which is on the front of the camera on the right of the taking lens, as viewed from the

YASHICA MAT-124G METER SPECIFICATIONS

Type: Full-frame averaging type using a CdS metering cell on the camera body. Meter operates manually and is coupled to the aperture and shutter-speed dials of the camera. Exposure display is a match-needle indicator on the camera. Meter has the same angle of view as the fixed 80mm lenses.
Measurement Range: EV 4.5 to EV 17 with ASA 100 film and *f*-3.5 lens.
Film Speed Scale: ASA 25 to ASA 400.
Working Range: Shutter speeds from 1/500 to 1 second.
Power Source: 1.3V camera battery.

rear. When the red line on the lever is aligned with the red **L** on the camera body, the shutter button is locked. To unlock it, turn it clockwise until the red line points straight up.

When the first frame of film is in position in the film plane and you have composed and metered, hold the camera steady and slowly push the shutter button. During exposure you'll hear a quiet click and feel little vibration because the only mechanical action going on is the leaf shutter opening and closing.

There is no moving mirror between the taking lens and film plane to make noise and vibration and black out the viewfinder. This lets you handhold

shutter speeds down to about 1/15 second without sacrificing image sharpness due to camera shake.

Advancing Film—After exposure, turn the winding crank about 210° clockwise until it stops. This moves the next frame into position and advances the exposure counter. Cock the shutter by turning the crank back clockwise to its start position. It will automatically stop at the end of this stroke. The winding crank then locks and can't be moved again until after exposure.

Continue these steps until you expose all the film. If you are shooting 120 film, the exposure counter stops between **12** and **13**. If you are shoot-

Although it is a simple, non-automatic camera, the Yashica Mat-124G is capable of giving sharp, contrasty pictures. The 6x6 cm negative can be enlarged greatly before apparent graininess becomes a problem.

Winding film and cocking the lens shutter requires two strokes of the winding crank. Complete both strokes before pushing the shutter button.

The Yashica Mat-124G is very useful when used with a flash for informal portraiture.

ing 220 film, it stops at **24**. In either case, the winding crank is automatically freed to turn clockwise. Wind up the roll of film with about three complete revolutions of the crank. You can feel the winding tension slacken when the roll is fully wound. Open the camera, remove the exposed roll and seal it shut with its adhesive label.

Advancing Film Incorrectly—Do not turn the winding crank to advance film until the leaf shutter closes and ends exposure. Winding the crank before the shutter closes by itself makes the shutter blades close, ending exposure. This will also shake the camera during the cranking.

Although you can advance film with a series of ratcheted turns of the winding crank, I don't recommend it. Each turn will have to be made in both directions and there is no definite way of knowing when the film is advanced and the shutter cocked. Advancing the crank clockwise until it stops and then back counterclockwise until it stops is a quick operation that takes minimal fuss.

After each exposure, be sure to advance the winding crank until it stops. If you don't advance the film completely, you may be able to cock the shutter on the backstroke of the crank. The result on film is a partial double exposure on the previous frame because it was not fully advanced.

Long Exposures—For shutter speeds longer than one second, use the **B** setting of the shutter-speed dial. The shutter will stay open for as long as you depress the shutter button. Or, you can use a locking cable release screwed into the front of the button to conveniently hold it open for a long time.

Self-Timer—Before using the camera's self-timer, make sure the flash-sync selector lever behind the aperture selector dial is set to a red **X**. You can damage the self-timer if you

MAKING MULTIPLE EXPOSURES

The standard Yashica Mat-124G camera does not have multiple-exposure capability. If you want to make multiple exposures with it, I suggest you have it modified. Your local camera-repair service may be able to do this. One company that does this is Mileo Photo Supply, Inc., 2105 Ponce de Leon Blvd., Coral Gables FL 33134, (305) 446-0855.

They drill a small hole into the side of the camera and attach a small chain to the shutter-cocking mechanism. When you pull the chain, the shutter cocks. This way, you don't have to advance the film to cock the shutter. You cock the shutter after each exposure.

move its lever while the flash-sync selector is set to **M**.

The self-timer lever is marked with a red dot. It is under the camera's taking lens. For the maximum nine-second time delay, push it toward the shutter button until it stops. For the minimum one-second delay, push the lever slightly until it makes one quiet click. You can advance film and cock the shutter either before or after this step. When you push the shutter button, you'll hear the whirring sound of the timer and then the click of the shutter.

SHOOTING WITHOUT FILM

I suggest that you familiarize yourself with the camera by using it without film first. When no film is in the camera, all of the camera functions described will work. To make the exposure counter work, put the empty film spool into the top chamber. It advances every time you wind the crank and cock the shutter. After the 12th or 24th exposure, the crank advances the counter a bit more then is freed for continuous winding. Open the camera back to reset the counter to **S**.

USING FLASH

Because the Yashica Mat-124G has a leaf shutter, you can get electronic flash sync at all shutter speeds. The PC terminal for the flash connection is to the left of the camera's viewing lens, as viewed from the rear. When using electronic flash, set the flash-sync selector lever to the red **X**. F-type bulbs will synchronize at shutter speeds of 1/30 second or slower at this **X** setting. You can get flash sync at all shutter speeds with M-type flash bulbs by setting the flash-sync selector to the yellow **M**.

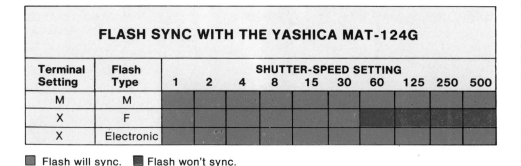

FLASH SYNC WITH THE YASHICA MAT-124G

Terminal Setting	Flash Type	SHUTTER-SPEED SETTING									
		1	2	4	8	15	30	60	125	250	500
M	M										
X	F										
X	Electronic										

■ Flash will sync.　■ Flash won't sync.

Rolleiflex SLX

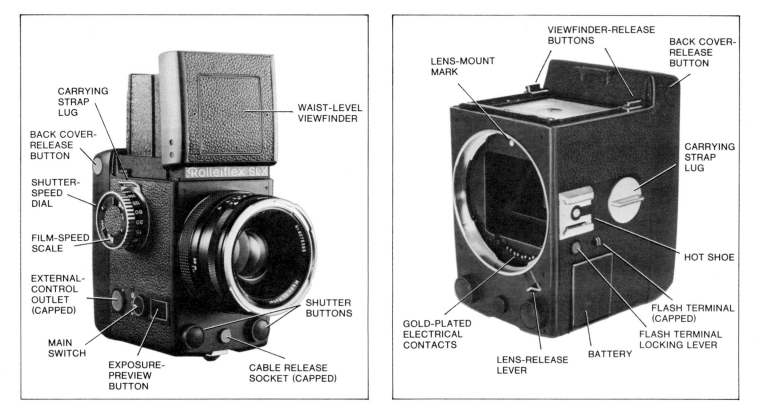

The Rolleiflex SLX camera is the first completely electronic medium-format camera. Microelectronic circuitry controls a shutter-preferred automatic-exposure system, a built-in center-weighted exposure meter, a built-in film winder, and a leaf shutter in the lens. The camera also has a non-metered manual mode.

The aperture and shutter mechanisms are operated by two linear motors that receive electronic signals from the camera's exposure computer. A 9.6V nicad battery with full charge can supply power for about 1000 exposures.

The camera's basic format is 6x6 cm for 12 or 24 exposures on 120 or 220 film respectively. Actual image size is 56x56 mm. The camera comes equipped with an f-2.8 80mm lens and a folding waist-level viewfinder. The nicad battery, a recharger, and an electronic cable release are also standard equipment. They are part of an

expanding system of interchangeable accessories including lenses, filters, viewfinders, focusing screens, film backs, extension tubes, and bellows.

The SLX is compact and easy to handle. It is made in West Germany by Rollei, and its design is based on the experience Rollei has with two other medium-format cameras—the Rolleiflex TLR and the all-mechanical SL 66 SLR. Filters and lens hoods of the SL 66 system fit the SLX.

ROLLEIFLEX SLX CAMERA SPECIFICATIONS

Type: 6x6 cm single-lens reflex with waist-level viewing.
Shutter: Electronically controlled leaf shutter in each lens with camera-controlled shutter speeds from 1/500 to 30 seconds, plus B. X-sync at all shutter speeds.
Standard Lens and Viewfinder: 80mm f-2.8 Zeiss Planar lens; waist-level viewfinder with 1.25X magnifier and sportsfinder.
Film: 12 or 24 exposures with 120 or 220 film.
Power Source: Rechargeable 9.6V nicad battery. Battery and recharger are standard equipment.
Meter: Built-in center-weighted meter and exposure computer for shutter-preferred, automatic exposure. Manual metering possible. ASA settings from 25 to 6400. Measurement range from EV 3 to EV 18 at ASA 100 with f-2.8 lens. LED exposure display.
Other Features: Interchangeable lenses, filters, viewfinders, film backs, focusing screens, grips, and film inserts. Automatic film winder for single- or continuous-exposure operation, exposure-preview button, electric cable release and mirror lockup, outlet for remote-control accessories.
Dimensions: Width 101mm (4"), height 136mm (5.4"), depth 151mm (5.9").
Weight: 1.9kg (4.1 lbs.).

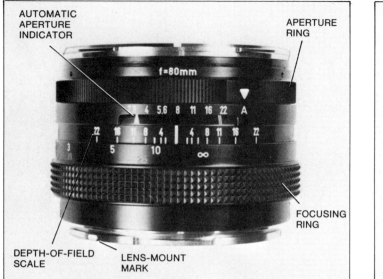

This is the standard _f_-2.8 80mm Planar lens. All lenses made for the SLX have the same basic features.

ROLLEI SLX LENSES

Lens	Minimum Aperture	Diag. Angle of View	Minimum Focus Distance ft.	Minimum Focus Distance m	Weight oz.	Weight g	Filter Series
40mm _f_-4 Distagon	_f_-32	88°	1.6	0.5	51	1450	VIII
50mm _f_-4 Distagon	_f_-32	75°	1.6	0.5	30	840	VI
55mm _f_-4 PC Super Angulon	_f_-32	85°	1.9	0.5	56	1650	104mm bayonet
80mm _f_-2.8 Planar	_f_-22	52°	3.0	0.9	21	590	VI
120mm _f_-5.6 S-Planar	_f_-45	36°	3.1	1.0	29	830	VI
150mm _f_-4 Sonnar	_f_-32	29°	4.6	1.4	31	890	VI
250mm _f_-4 Sonnar	_f_-45	18°	8.2	2.5	42	1200	VI
350mm _f_-5.6 Tele-Tessar	_f_-45	13°	16.4	5.0	58	1650	VI
140—280mm _f_-5.6 Variogon Zoom	_f_-32	30°— 16°	8.2/ 3.5*	2.5/ 1.0*	61	1750	90mm on lens, IX on hood

* In macro mode

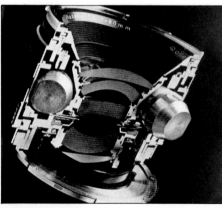

Two linear motors in each SLX lens receive electronic signals from the camera's exposure computer to operate the aperture and shutter mechanisms.

LENSES OF THE SLX SYSTEM

Most lenses for the SLX are made by Rollei and the Carl Zeiss Co., which has been world renowned for high-quality optics for over 100 years. Most glass elements are multicoated with Rollei HFT, _High Fidelity Transfer_, coating. Two lenses are made by the Jos. Schneider company to Rollei specifications. These lenses use Schneider multicoating.

Mechanically, SLX lenses have the same features. Two linear motors are built into each lens to operate the automatic aperture and built-in leaf shutter. Gold-plated electrical contacts for these motors are on the lens

mounting ring and connect electrically with contacts on the camera body. The aperture ring of each lens is used to select apertures manually or put the camera into its automatic-exposure mode.

The accompanying lens table summarizes the main features of SLX lenses. Special lenses are discussed here.

40mm _f_-4 Distagon—This wide-angle lens has a diagonal angle of view of almost 90° and gives a rectilinear image with minimal wide-angle distortion. It has a very wide front element and weighs over three pounds (1300g).

55mm _f_-4.5 Super Angulon PCS—This wide-angle perspective-control lens is made by Jos. Schneider & Co. to Rollei specifications. It has a gear-driven shift _and_ tilt. The horizontal shift is 12mm to the right or left and the vertical shift is 12mm up and 10mm down. The lens tilts up to 10° vertically. If you use the camera for vertical-format shooting with the 4.5x6 cm back, the tilt becomes a swing.

With the shift feature, you can control converging verticals, which are inherent in architectural photography. With the tilt or swing control, you can set the zone of sharp focus in a plane not parallel with the film plane. Of course, you can use the shift and tilt for creative distortion too.

Like other SLX lenses, the PCS lens is multicoated and has built-in linear motors for automatic-exposure leaf-shutter operation. Floating lens ele-

ments help maintain good image quality throughout the focusing range of the lens.

120mm *f*-5.6 S-Planar—The name *Planar* is given to lenses that maximize flatness of field, and the *S* designation means *special-purpose*. This lens is optically corrected to give best image quality at near subject distances, making the 120mm lens the best choice when you use the auto bellows or extension tubes for copy and close-up work.

140mm-280mm *f*-5.6 Variogon—This is a zoom lens made by Schneider for the SLX system. Despite its name, the lens is *not* a varifocal zoom—the image stays in focus throughout the zoom range.

The lens focuses down to 8 feet (2.3m) at all focal lengths. It also has a macro-mode control that lets you focus as close as 3.5 feet (1m) when the lens is set to a 140mm focal length.

MOUNTING THE LENS

All SLX lenses have a bayonet mount with four heavy-duty lugs. These attach to a large mounting ring on the camera body. Mounting the lens is quick and easy because no shutter or body cocking is necessary before mounting.

Line up the red mark on the outside of the lens mount with the red dot on the camera mount. Turn the lens clockwise about 45° until you hear a click, indicating the lens is securely attached. Attaching also aligns the five pairs of gold-plated electrical contacts on the lens with a corresponding set inside the camera. They transmit electrical signals from the camera to the lens and vice-versa. The lens can be set to any aperture when mounting.

Removing a Lens—To remove a lens, use the small black Lens-Release lever located below the lens, on the camera body. Slide the button toward the lens while turning the lens counterclockwise about 45°.

FILTERS AND LENS ATTACHMENTS

Most SLX lenses have a Rollei Series VI bayonet filter mount, which is similar to the lens bayonet mount, except for size. There are two of these four-lug rings on the lens—one for inner-mounting attachments, such as filters, and an outer ring for lens caps and the adjustable lens hood.

The 40mm Distagon lens has a Rollei Series VIII mount using only

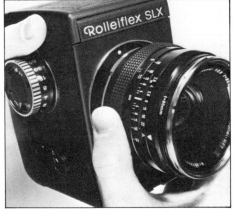

To bayonet-mount a lens, align the lens-mounting marks and turn the lens 45° clockwise.

Remove a lens by sliding the lens-release lever toward the lens and turning the lens counterclockwise 45°.

ROLLEI SERIES VI FILTERS

Filter	Approx. Filter Factor	Use
Medium Yellow*	2X	Increase sky/cloud contrast in b&w photography.
Orange	3X	Absorbs more blue than yellow filter for better haze penetration in b&w photography.
Light Red	4X	For dramatic sky/cloud contrast and darkening green foliage in b&w photography.
Green	3X	For masculine portraiture and lightening foliage in b&w photography.
R1.5	1.25X	Pale yellow filter to absorb excess blue of shadows in color photography.
Infrared	———	Visually opaque filter with transmission of wavelengths longer than 695nm. For b&w infrared photography.
Rolleipol Polarizer	2X	Polarizing filter to reduce reflections and glare in b&w and color photography.

*also available in Series VIII for the 40mm Distagon lens.

ROLLEI SERIES VI LENS ATTACHMENTS

Attachment	Use
Softar I	Creates a soft-focus effect that is independent of aperture
Softar II	Creates a stronger soft-focus effect than the Softar I.
Gelatin Filter Holder	Holds 75mm (3-inch) square gel filters.
Professional Lens Hood	Adjustable bellows lens hood.

WHAT ZEISS LENS NAMES MEAN

Lenses designed by the Carl Zeiss Co. have a trade name indicating something about the optical design of the lens. Here's what they mean:

Distagon: This wide-angle lens design is *retrofocus*, which means the rear lens node is actually behind the rear element of the lens. These lenses are designed to give best corner-to-corner sharpness for far subjects. When using them for near subjects, stop down the lens.

Planar: These lenses are designed to produce an image in a flat field. This promotes good corner sharpness in the image. They give best image quality when focused on far subjects.

S-Planar: These special-purpose (S) Planar lenses are designed to give flat-field images when focused on near subjects. This makes them ideal for close-up work.

Sonnar: Compact, moderate-focal-length telephoto lenses with most of their elements in the front section of the lens are called *Sonnar* lenses.

Tele-Tessar—These lenses have a positive lens element in the front of the lens and a negative lens element in the rear. A large air space separates the two. They are *telephoto* lenses, with the rear lens node actually in front of the lens. This is the opposite of the Distagon lenses.

three mounting lugs. The 350mm Tele-Tessar lens accepts 68mm screw-in filters and attachments.

The accompanying table shows filters and lens attachments available from Rollei in Series VI and VIII. A less-expensive alternative to glass filters is the Gelatin Filter Holder, available in Series VI only. It holds 75mm (3-inch) square gels.

The low-battery signal is a red LED above the focusing screen. When it first glows, enough battery power remains for about 40 more exposures.

THE BATTERY

A 9.6V nicad battery and recharger come with the SLX camera. Because there are no manual controls to mechanically wind film or cock the shutter, keeping the battery charged is very important. When the battery is completely discharged, the camera cannot be operated.

Low Battery Charge—However, approximately 40 exposures before this happens, the camera signals you to recharge the battery. A red LED located just above the focusing screen glows when you push the shutter button or the Exposure-Preview Button. This happens whether you are using the camera on automatic or manual.

The LED will also glow during subsequent exposures as the battery approaches discharge, but not for every one.

If you are using the camera on automatic, pressing the shutter button will sometimes close the aperture completely, blacking out the viewfinder image and giving no exposure. Open the aperture by pressing the Exposure-Preview Button. No exposure will occur and the film will not advance. Try to make the exposure again.

Recharging—To remove the battery from the camera, pull on a small recessed latch on the bottom-left of

the camera. The latch is attached to the battery, which slides out easily.

Inspect the fuse at the end of the battery that has the electrical contacts. If the fuse is blown, replace it with the spare M 0.8A/250V fuse stored in the side of the battery under a yellow slide. You should also check the fuse whenever the camera stops operating. A blown fuse may indicate serious

Remove the battery by pulling its recessed clip.

The operating fuse is mounted on the front of the battery. A spare fuse is stored in the side.

electrical problems that should be fixed.

Insert the battery into the recharger by matching the battery contacts with the contacts in the recharger. Before plugging in the AC cord, set the sliding switch on the bottom of the charger to the AC line voltage for your area.

When you plug in the AC cord, you'll see a red and green light on the recharger. The red light means that the battery is charging rapidly. In 10 to 15 minutes the light turns off, indicating that there is enough power in the battery for 100 more exposures. This is very handy if you are in the middle of a shooting session and the battery discharges completely.

The green light then remains on, indicating normal charging, which can last from one to three hours, depending on the degree of battery discharge. Normally, the battery is fully charged in one hour. If it was totally discharged at temperatures colder than room temperature, give it a three-hour recharge after the red light goes off. Don't exceed a three-hour recharge because this may damage the recharger's automatic control.

Remove the charged battery from the recharger and insert it into the camera by sliding it in with the latch facing down. When the battery is fully charged, it has enough power for 1000 exposures, or more than 80 rolls of 120 film.

If you use the camera in cold weather, the battery has reduced power and gives fewer exposures, as shown in the accompanying table. In very cold weather, keep the battery in a warm pocket and put it in the camera when you want to make an exposure.

Both lights of the recharger glow for the first 10 to 15 minutes. Then the red light goes off, signaling the end of quick charging.

MAXIMUM EXPOSURES USING THE SLX BATTERY	
Temperature Range	**Maximum Exposures**
32°F to 122°F (0°C to 50°C)	1000
14°F to 31°F (−10°C to −1°C)	500
13°F to −4°F (−11°C to −20°C)	50

INTERCHANGEABLE VIEWFINDERS

Three viewfinders are available for the SLX. With any of them you see 90% of the 6x6 cm frame area—approximately 95% horizontally and 95% vertically. To remove the standard waist-level viewfinder from the camera, first open it by pulling on the sides. Press down on two black locking

To remove a viewfinder, push down on the viewfinder-release buttons and slide the viewfinder toward the lens.

buttons on the sides of the viewfinder while sliding it back along the metal track.

To install a viewfinder, slide it on the track until you hear the latch click. Test the installation because you can click the latch and still have the front of the viewfinder misaligned on the track.

Folding Hood—This standard viewfinder is versatile and easy to use. It is shown in use on page 9. It unfolds and shows a laterally reversed image on the focusing screen. In this configuration it is a waist-level viewfinder. To use its built-in 1.25X magnifier, push the front of the unfolded hood. The magnifier swings into place and makes focusing easier by excluding stray light. An accessory 3.3X magnifier is also available for critical focusing.

To use the hood as a sportsfinder, push the front panel of the unfolded hood until it folds down over the focusing screen. You can then look through a square hole in the rear panel of the hood to view the subject directly—not through the lens.

If you rest your cheekbone on the camera back and your eyebrow on the top of the viewfinder, camera handling and viewing are both simple and accurate. An accessory mask marked for the field of view of the 150mm and 250mm lenses fits into the sportsfinder window.

Slightly push inward on the folding sides of the viewfinder and the front flips up to its normal unfolded position. To close the viewfinder, push the magnifier, then push on its folding sides.

45° Prism Finder—With this viewfinder you see a laterally correct image that is 2.5 times larger than the focusing screen image. You can rotate the viewfinder 360°—it has click stops every 90°. The eyepiece is at a 45° angle to the film plane, hence the viewfinder's name.

90° Prism Finder—This is like the 45° Prism Viewfinder except the eyepiece is at a 90° angle to the film plane.

INTERCHANGEABLE FOCUSING SCREENS

The standard focusing screen that comes with the camera has a grid, a microprism circle around a split-image spot, and a matte field. Five other focusing screens are available for specialized uses from portrait work to photomacrography. All are plastic and provide a bright viewfinder image from corner to corner. They are shown in the accompanying illustration.

To change a screen, first remove the viewfinder. Lift the frame holding the screen by pulling up on the protruding chromed rivets on both sides of the frame. Hold the frame up and slide out the screen. Put another screen into the frame. Do it carefully so you don't scratch it. Fold the frame back down until it clicks in place. Replace the viewfinder.

Remove a focusing screen by holding the frame up and sliding the plastic screen out. Be careful not to scratch it.

LOADING FILM

Compared to most medium-format cameras, the SLX loads very quickly. This is due to the camera's automatic film winder and plastic film inserts. You can load the inserts with either 120 or 220 film ahead of time and place them into the camera much like a 110 film cartridge. Accessory inserts

Open the camera back by pushing both back cover-release buttons at the same time.

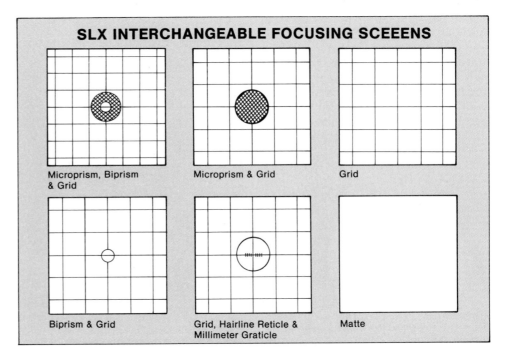

SLX INTERCHANGEABLE FOCUSING SCREENS

Microprism, Biprism & Grid

Microprism & Grid

Grid

Biprism & Grid

Grid, Hairline Reticle & Millimeter Graticle

Matte

come with a case that protects the film from direct light.

Loading the Insert—To remove the insert from the camera back, open the camera by pressing *both* release buttons on the side of the back near the top. Pressing just one button will not open the camera. The back is hinged at the bottom and swings down. Remove the insert from the camera.

The unexposed roll of film goes into the insert's empty chamber with the paper leader's black side facing out. Push the red metal tab to retract a retaining pin, and insert the roll. Pull the leader across the opening and insert the tongue into the slot in the take-up spool. Rotate the gear on the outside of the take-up spool toward the unexposed roll to advance the leader.

Because the insert is symmetrical, you put the unexposed roll into the empty chamber.

Stop winding when the large arrow printed on the other side of the paper backing aligns with the white triangles on the side of the insert. Only two layers of paper backing cover the unexposed film, so try not to load the insert in direct light.

The film follows its natural curl as it travels through the camera, which helps to maintain good film flatness in the film plane. You can put the folded endflap from the film box into the back of the insert. A window in the camera back shows the end flap.

Turn the large outside gear of the take-up chamber until the arrow on the leader aligns with the triangular mark on the insert.

Put the insert into the camera with the unexposed roll on top.

Loading the Camera—On the inside of the camera film chamber you'll see two symbols that correspond to a full and empty spool. Align the loaded insert with the symbols in the camera so the unexposed roll fits over the full-spool symbol. You can do this either by putting the insert in the camera back or by placing it against the symbols and closing the back.

Turn the Film-Selector Dial on the camera back so the white triangle points to the film type you are using, either 120 or 220. This sets the exposure counter and auto winder to the maximum number of exposures on the roll.

Set film speed using the dial set inside the shutter-speed dial. The film-speed dial is marked for ASA speeds from 25 to 6400 and DIN speeds from 15 to 39.

Set film speed by turning the center part of the shutter-speed knob. Read ASA and DIN film speed dials through the two windows.

Turn the camera on by setting the main switch to S or C. Advance the film to frame 1 by pushing one of the shutter buttons.

ADVANCING FILM

The camera controls film winding, and there is no way to manually override it. The built-in winder is extremely useful and simple to operate. To avoid wasting film, however, you must set the film insert and exposure counter properly.

Before Exposure—To get the first frame in position behind the lens, turn the camera on. Rotate the knurled plastic Main Switch on the lower right side of the camera from O (off) to S (single). Push either of the two shutter buttons on the front of the camera below the lens.

You'll hear mirror and shutter operation, then a whirring sound. This is the camera "exposing" the paper leader and advancing film until the first frame is behind the lens. While this happens, the exposure counter turns from 0 past a white line and stops at 1. If the exposure counter does not travel to 1 after you press the button the first time, push it again.

When set to C (continuous), the camera keeps exposing and winding film as long as your finger pushes the button. I don't recommend advancing film with the main switch set to C because if you hold the shutter button in too long, you'll go past 1 and expose film inadvertently.

If the exposure counter does not turn to 1 after you push the shutter button the second time, film is not moving. It may not be winding onto the take-up spool in a straight line and may be jamming the mechanism. If you suspect this, open the camera

back in a darkroom or changing bag and rewind the film with the gear on the insert. Then with room lights on, realign the start mark on the film to the mark on the insert, and reload the insert. Try to advance the film again.

If you put the film insert into the camera upside down, the camera's winder will rewind the roll when you press the shutter button. Then you'll have to remove the insert and rethread the unexposed film. Reload the insert with the full spool and the film-spool symbol aligned.

After Exposing the Roll—After you expose the last frame of the roll, the camera's winder automatically winds it completely onto the take-up spool. The exposure counter will show a red color in place of the numbers. Open the camera, remove the insert and push the metal tab to free the exposed roll of film. Seal the film so it won't unwind. Put the next preloaded insert into the camera, close the back, and push the shutter button to position the first frame. This takes only a few seconds.

Even if you don't have extra inserts, the loading procedure is fast. The insert is symmetrical, so you don't have to remove and reinsert the empty film spool every time you load an insert. Load the unexposed roll into the empty chamber; thread the film onto the take-up spool; align the start marks; and load the insert.

Reloading Inserts—You can't change inserts in the middle of a roll without losing film. There is no dark slide in the insert or film back to prevent fogging. Even if you unload the partially exposed roll in a darkroom or changing bag, the exposure counter goes back to 0.

This is OK if you load the camera with an unexposed roll, but when you reload the insert containing the partially exposed roll, the exposure counter does not remember the number of frames that were exposed. It starts at 0, and when you push the shutter button, the auto winder advances the roll about 6.5 inches (16cm), wasting about three 6x6 cm frames of unexposed film.

SETTING THE FILM-SELECTOR DIAL INCORRECTLY

If you load 120 film but have the film-selector dial on **220**, the camera is set to expose and wind 24 6x6 cm frames. You get only 12 exposures, of course, but the counter will work up to frame 18 while the camera still seems to operate and make winding noises.

You may be fooled into thinking you are exposing film when you actually aren't. You'll be "exposing" the paper leader. If you notice your mistake before the 12th exposure, changing the dial from **220** to **120** corrects the problem. The roll will be wound up automatically after the 12th exposure.

If your mistake is setting **120** for 220 film, the camera advances the roll 12 inches (30cm) after the 12th exposure because it is set to wind up a 120 roll. If you notice your mistake before the 12th exposure, reset the dial to **220** to get 24 exposures. If you notice your mistake after the camera has wound up 12 inches (30cm) of unexposed film, you can reset the dial to **220** to finish the remaining 20 inches (51cm) of film. You get seven more 6x6 cm exposures and waste only five frames on the unexposed portion.

VIEWING AND HANDLING

The way you hold the SLX depends on personal preference, but I think the best way is to cradle the camera in your left hand. This puts your left index finger next to the shutter button

Support the camera with your left hand and use your right hand to operate the camera controls. Either index finger can push the shutter button.

on the right side. Your right hand can then "float" from the focusing ring to the shutter-speed dial or exposure-preview button. When you hold the camera in your right hand, you can focus only with your left hand and cannot easily control the shutter button and exposure-preview button, as described later.

To view and focus, lift up on the sides of the folding hood and focus the image using the large knurled ring on the lens—the one closest to the camera. Turn the shutter-speed dial on the camera's right side to choose a shutter speed from 1/500 to 30 seconds by aligning the speed with a white index on the side of the camera.

EXPOSING FILM

When the exposure counter reads 1, and the main switch is set to **S** or **C**, you are ready to expose film. You can even operate the camera without a film insert. All camera functions will work except for the exposure counter. Practice using the camera without film to become familiar with its many unique features.

Push either the right or left shutter button, and the camera will make the exposure at the selected shutter speed. Depending on the exposure mode, the camera will automatically select the *f*-stop or use the one you choose manually.

As soon as the exposure is made and the mirror drops back in place, the winder advances film to the next frame. If the main switch is set to **S**, push the shutter button for another exposure. If the switch is set to **C**, the camera continues exposing and winding film at a maximum rate of three frames every two seconds until you remove your finger from the button.

AUTOMATIC EXPOSURE

To put the camera into its shutter-preferred, automatic-exposure mode using the built-in exposure meter,

ROLLEIFLEX SLX FILM WINDER SPECIFICATIONS

Type: Automatic film winder built into SLX camera.
Shooting Rate: Continuous operation up to 1.4 frames per second at the fastest shutter speed. Single exposures possible.
Shutter Speeds: Can be used with all lens speeds.
Operation: Activated by shutter buttons of camera, electronic cable release, or ME 1 Control Unit. Film wound from start mark to first frame. After exposure, film is advanced. Manual winding not possible. After roll is exposed, film is wound up automatically.
Power Source: Rechargeable 9.6V nicad camera battery.
Capacity: Approximately 80 rolls of 120 film per battery charge.
Other Features: Battery-check button with LED signal.

turn the aperture ring until the white triangle on the ring locks opposite the white **A** at the end of the *f*-stop scale on the lens. The automatic-exposure operating range is from EV 3 to EV 18 at ASA 100 with an *f*-2.8 lens. Three silicon photo cells on the auxiliary shutter behind the semi-transparent reflex mirror provide center-weighted metering.

Exposure Computation—When you push the shutter button, the exposure sequence of events happens in a fraction of a second. The camera sends an electronic signal to one of the linear motors in the lens to stop down the aperture completely. Then the meter cells read only the extraneous light coming through the viewfinder. The camera's computer stores that light reading and then starts opening the lens aperture while reading light coming through both lens and viewfinder.

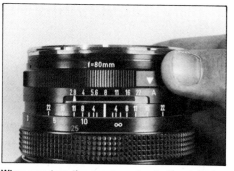

When you turn the aperture ring to the right for shutter-preferred automatic-exposure operation, a red panel adjacent to the aperture scale retracts, showing the white aperture indicator. Here it points to *f*-2.8.

The computer continuously subtracts the stored reading of extraneous light from the combined reading to determine the amount of light coming through the lens. It opens the aperture until the light from the lens is enough to give correct exposure with the shutter speed and film speed you've set on the camera.

As soon as the computer sets the correct aperture, it signals the other linear motor in the lens to close the leaf shutter. After it closes, the mirror and auxiliary shutter swing up. The linear motor then operates the leaf shutter for the selected exposure time; the mirror swings down; and the aperture and shutter open again for viewing and focusing. The auto film winder advances the film.

You can see some of this happening by watching the aperture-indicator window on the lens. When you push the shutter button, a white triangle travels along the aperture scale from maximum aperture to the minimum aperture and then back to stop at the aperture at which the exposure will be made. This cycle is repeated every time you push the shutter button.

The exposure-measuring system compensates for the extraneous light coming through the viewfinder as long as this light is not extremely bright. If you use the folding-hood viewfinder without the magnifier in place, make sure no direct light strikes the focusing screen. For long exposures on automatic, close the hood before pushing the shutter button. The prism viewfinders shield most of the extraneous light.

Exposure Display—The camera has exposure displays in two places. One is composed of two red LEDs that are visible through the viewfinder. The other is in the shutter-speed index.

When the camera can't find an appropriate aperture for the selected shutter speed, two small red LEDs to the right of the focusing screen glow three different ways, depending on which exposure error will occur.

If the camera settings will result in underexposure, even with the largest aperture of the lens, the bottom LED glows. If the camera settings will result in overexposure because the meter can't select an aperture small enough, the top LED glows. When both lights glow during exposure, this indicates that the light is too dim and the metering range is exceeded.

Observing the shutter-speed index will also indicate this last exposure error. When you choose a shutter speed that is too slow for the metering range and selected film speed, the shutter-speed index changes from white to red. It lets you mechanically

SLX METER SPECIFICATIONS

Type: Built-in, center-weighted averaging, through-the-lens meter using silicon photocells on the camera's auxiliary shutter. Coupled with exposure computer. Compensates for the light through viewfinder. Operates in a shutter-preferred automatic mode with LED over- and underexposure display, or on manual.
Measurement Range: EV 3 to EV 18 at ASA 100 with an *f*-2.8 lens.
Film-Speed Scale: ASA 25 to 6400.
Working Range: Shutter speeds from 1/500 to 30 seconds.
Power Source: Rechargeable 9.6V nicad camera battery.

SLX EXPOSURE DISPLAY

DISPLAY	CAUSE	CURE
	Settings give overexposure.	Turn shutter-speed knob toward light.
	Settings give underexposure.	Turn shutter-speed knob toward light.
	Metering range exceeded.	Select different shutter speed.

determine the dim-light limit of the metering range without turning the camera on.

Exposure-Preview Button—This rectangular button is next to the camera's main switch. Pushing the exposure-preview button before exposure makes the LED display glow if the battery needs charging or if the camera settings will give bad exposure. It also stops down the lens to the automatically selected aperture.

You can use the preview button to set exposure in advance. The LEDs indicate which direction to turn the shutter-speed dial for good exposure. Push the button and hold it in. If the top LED glows, turn the shutter-speed dial toward the front of the camera until the light goes out. In this case you are selecting a faster shutter speed to prevent overexposure. When the bottom LED glows, turn the dial toward the back of the camera to select a longer shutter speed. If both LEDs glow, turn the shutter-speed dial toward the front of the camera.

When you find the range of good exposure, use the exposure-preview button to see depth of field, if desired. The aperture remains stopped down until you release the button. This lets you use it for substitute metering. Meter from a reference tone, such as an 18% gray card, by pushing the button. After the camera selects an aperture, hold your finger on the button to keep the aperture stopped down. Focus and compose the image, then push the shutter button while holding in the exposure-preview button.

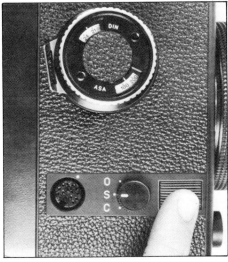

The Exposure-Preview button is next to the camera's main switch. With the button, you preview depth of field at the automatically selected aperture and use it for substitute metering.

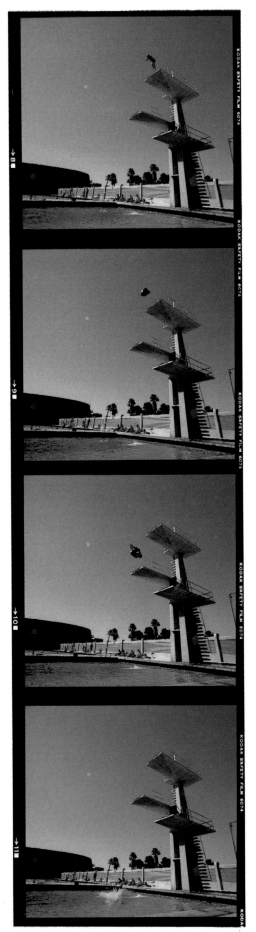

When used at the fastest shutter speed of 1/500 second, the continuous mode of the automatic film winder shoots one frame every 0.7 seconds, or 1.4 frames per second.

MANUAL OPERATION

To use the camera under manual control, without its meter, push the small red button on the bottom of the lens aperture ring and turn the ring until the white triangle indicates the desired aperture. As soon as the triangle moves away from the white **A**, a red panel covers the aperture indicator, eliminating any possible confusion about which mode the camera is using.

In the manual mode, the LED exposure display does not operate. Determine exposure settings with an accessory hand-held meter or use the camera's meter with the camera on automatic to select an aperture. Then switch the lens to manual to set whatever aperture you want. This may be necessary when you have to interpret the meter reading of a non-average scene. In this mode, the aperture ring has detents every one-third step. This agrees with the aperture readout of many accessory exposure meters, making it convenient for fine-exposure bracketing.

On manual, the exposure-preview button stops down the lens to the preselected aperture. If you hold in the button while turning the aperture ring from small to large apertures, aperture size will increase and the viewfinder gets brighter. But if you try to turn the aperture ring toward smaller apertures, the lens opening remains at the largest aperture you selected. To correct this, press the exposure-preview button again and the aperture stops down.

When you select aperture manually, a red panel appears below the aperture scale. The large white triangle on the aperture ring indicates the selected aperture.

OTHER CAMERA CONTROLS

The SLX camera and lenses have only a few controls, all of which are easy to use in spite of their multiple functions. Camera controls are near each other and on the same side for fast handling. This lets you give more attention to the subject than the camera. Some special camera operations follow.

Long Exposures—Shutter speeds shorter than one second are marked in white on the shutter-speed dial. Shutter speeds from 1 to 30 seconds are green. Unfortunately, this hinders reading the numbers in low-light situations requiring slower shutter speeds.

The shutter-speed index may turn red when you use these long speeds because the control has been set beyond the metering range of the camera. Even so, these speeds may be necessary for a special effect or to correct for reciprocity failure of the film you're shooting.

When you select B, the shutter-speed index always turns red. If the camera is on automatic, both exposure LEDs glow and the aperture opens completely when you push the exposure-preview or shutter button. For most situations, using the B setting in the manual mode is best.

With the B setting, the shutter is open as long as the shutter button is pushed. If you have a locking cable release, use it by attaching it to the cable-release socket. The socket is between the two shutter buttons and is normally covered by a small plastic dust cap.

Another simple method is to open the shutter with a cable release or by pushing the shutter button, and then turning the main switch to O. This turns off the camera but leaves the shutter open. The low-battery-power light glows when your finger is on the shutter button and the camera is off, but you can ignore it.

When the camera is turned off, you can take your finger off the button. When exposure is completed, turn the main switch to S and push the shutter button again to close the shutter. This technique makes the B setting act as a T, or time-exposure, setting.

Remote Release—The standard Remote Release has a 13-inch (33cm) cord and comes with the camera. You can get accessory remote releases with cords 16 feet (5m) or 33 feet (10m) long. Before plugging a cord into the camera, remove the round plastic cap on the External Control Outlet. Plug the release into the outlet.

An orange sliding switch on the handle of the remote release locks up the mirror and auxiliary shutter before exposure. Use it only for manual camera operation because the camera's metering cells don't work properly when they are locked up against the viewing screen. This will cause the aperture to stop down to its smallest opening. The release locks up both the mirror and the auxiliary shutter. They are automatically released after each exposure.

To expose film, you can push one of the shutter buttons, use a cable release, or press the green button on the handle of the remote release. This button is handy for tripod or high-magnification setups requiring minimal camera shake. If the camera's main switch is set to C and you hold the button in, you get continuous exposures and winding.

The camera's mirror is damped to minimize vibrations after it swings up, thus reducing the possibility of camera shake. When you use the camera with the mirror locked up before exposure, you'll notice that most of the vibration due to camera operation occurs *after* exposure, when the mirror and auxiliary shutter swing down.

Multiple-Exposure Release—This accessory is similar to the standard remote release that comes with the camera except it has a sliding switch that lets you make multiple exposures. If you don't use this switch, you can operate the release like the standard release.

For multiple-exposure operation, slide the multiple-exposure switch from SINGLE to MULTI. When you push the green button on the handle, the first exposure is made, but the mirror does not drop down and film does not advance. Push the green button again for another exposure. Repeat this as many times as you want. The mirror stays up throughout the sequence, so you can't refocus, recompose, or use the camera's meter to determine exposure automatically.

To end exposure and advance film, slide the multiple-exposure switch back to SINGLE.

Using Flash—SLX cameras synchronize with electronic flash at all shutter speeds. The camera has X-sync only. See the table on page 62.

The flash X-sync terminal is above the battery. A small cap covers the terminal, which accepts standard PC sync cords. A sliding switch to the right of the X-sync terminal is used to lock the Rollei sync cord in place. Above the terminal is a hot shoe for small electronic flashes. Rollei does not recommend connecting flashes to both outlets for simultaneous flash operation.

INTERCHANGEABLE CAMERA BACKS

The standard back of the SLX is detachable so you can use accessory backs. To change backs, first open the camera by pushing both release buttons at the top rear. Open the back and swing it all the way down. At the bottom of the back near the hinge, you see a small white arrow pointing to a button. Push the button in the direction of the arrow and continue opening the back until it detaches from the camera.

To install another back, push the button in the same direction as before and line up the camera and back along the hinge halves. Push them together. When you hear a click, release the button and close the back.

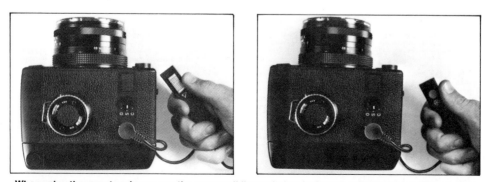

When using the remote release, use the orange sliding switch to lock up the mirror and auxiliary shutter in the camera. Then push the green button on the other side of the handle to operate the lens shutter. Use the remote release only with manual camera operation.

To remove a back, open it and take out the insert. Then slide the button next to the white arrow in the direction of the arrow. The hinge separates, freeing the back.

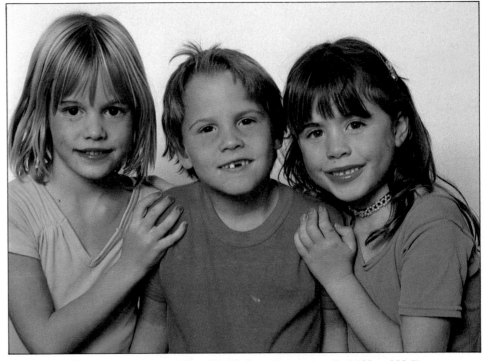

With the 4.5x6 cm back you can get 16 or 32 4.5x6 cm images per roll of 120 or 220 film.

4.5x6 cm Back—This looks and operates like the standard 6x6 cm back. It gives 16 or 32 4.5x6 cm images on 120 or 220 film respectively.

A viewfinder mask comes with it. The mask goes over the focusing screen and shows the image format being photographed.

Polaroid Back—To install, match the hinge halves and close the back. This back does not have a release button near the hinge like the other two backs. Push the two tabs on the top of the back to remove it.

Load 100/600-series Polaroid film as described in Chapter 4. One pack yields eight prints in the 6x6 cm format. Unfortunately, using Polaroid film to test exposure is not as convenient as with Polaroid backs for other medium-format cameras. Because there is no dark slide for the Polaroid back, you have to remove it in a darkroom or changing bag to avoid fogging the next sheet of film.

After making the Polaroid test and installing a regular film back, you must shoot the whole roll of film unless you don't mind the exposure counter returning to 0 when you open the back in the middle of the roll.

Because there is no dark slide in the regular film back, you must open it in a darkroom or changing bag to remove the partially exposed roll without fogging it. This design limits the potential usefulness of the instant image to check lighting and exposure before shooting roll film.

ME 1 ELECTRONIC CONTROL UNIT

The ME 1 is an accessory electronic control unit that expands the versatility of the SLX and converts it into a remotely operated, multiple-exposure camera. When connected to the ME 1, the camera has three exposure modes. You can make single or continuous exposures, 2 to 10 exposures on one frame at preselected intervals

ME 1 ELECTRONIC CONTROL UNIT SPECIFICATIONS

Type: Accessory remote control unit that operates the SLX camera in three exposure modes: remote-controlled single exposures, automatically triggered multiple exposures, and manually triggered multiple exposures. The ME 1 connects to the camera with a cord that plugs into the camera External Control Outlet.

Features: Resettable frame counter that counts up to 999 frames; control buttons with LED indicators for exposure-metering checks, mirror lockup, and shutter operation; built-in intervalometer and multiple-exposure dials; carrying strap; accessory connecting cable 33 feet (10m) long.

Remote-Control Single Exposures: In this mode, pushing the start button makes a single exposure when the exposure dial is set to 1. Exposure metering can be previewed and the mirror can be locked up before exposure. After exposure, film is automatically advanced and ME 1 counter advances.

Automatically Triggered Multiple Exposures: Exposure Dial selects number of exposures from 2 to 10 on one frame. Interval Dial selects time interval from 0.1 to 1.5 seconds between exposures. Press **start** to start exposure sequence. Use the camera manually to determine exposure. After exposure, film is advanced automatically and the ME 1 counter advances.

Manually Triggered Multiple Exposures: Exposure Dial and Interval Dial set to **man.** Press the start button for each exposure of the multiple-exposure sequence. Use camera manually to determine exposure. To end exposure of the film, turn the Exposure Dial to **mot.**, which automatically advances film and ME 1 counter.

Power Source: Rechargeable 9.6V nicad camera battery.

Dimensions: Width 181mm (7.1"), height 38mm (1.5"), depth 105mm (4.1").

Weight: 355g (12.5 oz.).

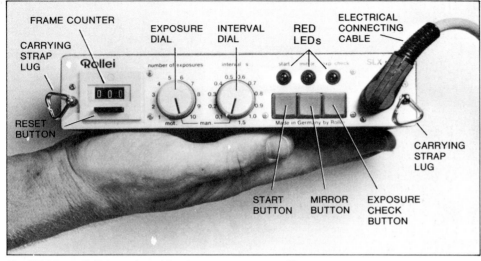

The ME 1 is small, light, and provides three ways to expose film.

from 0.10 to 1.5 seconds, or any number of exposures at any manually determined exposure interval. It can do all this by remote control up to 33 feet (10m) away when you use the accessory connecting cable. The standard cable is 5 feet (1.7m) long.

The ME 1 is very small and light, partly because it uses power from the camera. So for best results, recharge the camera battery for about an hour to make sure it is fully charged before using the ME 1. You can keep the ME 1 attached to the camera indefinitely because it does not use electrical power when not operating.

Remote-Control Single Exposures— When you use the ME 1 as a remote-control unit only, it does the same things as a Remote-Release Switch. Connect the ME 1 to the camera by plugging one end of the cable into the ME 1 and the other end into the camera's External-Control Outlet; both ends of the cable are the same.

Push the Reset Button beneath the Exposure Counter on the ME 1 to zero the reading. Set the Exposure Dial to 1 or mot. (motor). The Interval Dial can be set anywhere because it has no effect until you select two or more exposures.

Three red buttons, each with an LED indicator, are on the right side of the ME 1. The buttons are labeled start, mirror, and exp. check (exposure check). The start button acts as the camera's remote shutter button.

When the camera is set for automatic-exposure operation, pushing the exposure check button before the start button will indicate whether the camera can select a suitable aperture for the chosen shutter speed. If it can, the LED above the exposure check button flashes on and off when you press the button. If under- or overexposure would result, the light glows continuously while the button is depressed. You should then change shutter speed to find a good exposure setting. The camera's exposure display will also indicate under- or overexposure when the exposure check LED glows.

Pushing the mirror button locks up the mirror and auxiliary shutter. Before locking them up this way, set the aperture manually. Otherwise, the camera's automatic metering system will stop down the diaphragm to minimum aperture when you trip the shutter.

To expose film with the ME 1 in this mode, push the start button. The LED above it glows at the moment exposure ends. Then the winder advances the film. If the camera is on automatic exposure, the exposure check LED glows before the start LED. A flash indicates good exposure, and a continuous glow indicates a bad exposure. When you set aperture manually, only the start LED glows.

The camera's main switch can be set to S or C. When set at S, it gives one exposure and advances the film once when you push the start button. When set to C, it gives continuous camera operation as long as you depress the start button. The exposure counter on the ME 1 advances every time the film winder operates, but unlike the camera's frame counter, film does not have to be in the camera for the numbers to advance.

Automatically Triggered Multiple Exposures—For multiple exposure operation, the camera *must* be set for manual operation. The mirror and auxiliary shutter are locked up during the exposure sequence; therefore, the automatic-exposure system can't work properly. This eliminates any need to use the exposure check button.

In its automatic mode, the ME 1 uses a built-in intervalometer. Set the Exposure Dial to the number of exposures you want on one frame—from 2 to 10. If you set the dial between numbers, you'll get 10 exposures on one frame. Next, set the Interval Dial to the time you want *between individual exposures.* Its range is 0.1 to 1.5 seconds in 0.1 second increments.

For example, if you choose 5 on the Exposure Dial and 0,5—which is European notation for 0.5—on the Interval Dial, the film will be exposed five times with a half-second delay between exposures. Then the winder will advance the film automatically.

Calculate exposure and set aperture and shutter speed on the camera. Put the camera's main switch to S. If you use it on C, you may inadvertently expose too much film.

To start the multiple exposure, push the start button of the ME 1. Its LED glows every time the shutter operates. Pushing the camera's shutter button also starts the multiple-exposure sequence if that is more convenient. You can hear the shutter operate every time.

Generally, an automatically triggered multiple exposure has a delay interval too fast for most electronic flash units to recycle fully. If the flash has not recharged, the camera will operate anyway and that exposure will be made without flash. This problem can be solved by using a powerful automatic flash at close range or an electronic flash designed to give repeating flashes and an exposure interval no shorter than the flash recycle time.

Instead of flash, Rollei recommends that you use a black background with very bright continuous light sources to make multiple exposures automatically with the ME 1.

While multiple exposures are being made by the ME 1, you should not readjust the interval dial or press the mirror button. If you set the camera shutter-speed dial to B, the first exposure on the frame lasts for about as

This photo was made using the ME 1 to automatically trigger eight exposures with an exposure interval of 0.2 seconds. Photo by Youngblut.

MAGNIFICATIONS WITH SLX LENSES AND EXTENSION TUBES

LENS	EXTENSION (mm)	MAGNIFICATION RANGE
50mm	9	0.18—0.30
	17	0.34—0.46
	34	0.68—0.80
	68	0.85—0.93
	128*	2.56—2.68
80mm	9	0.11—0.21
	17	0.21—0.31
	34	0.43—0.53
	68	0.85—0.95
	128*	1.60—1.68
120mm	9	0.08—0.17
	17	0.15—0.23
	34	0.28—0.38
	68	0.57—0.66
	128*	1.07—1.16
150mm	9	0.06—0.18
	17	0.11—0.23
	34	0.23—0.35
	68	0.45—0.57
	128*	0.85—0.97

* All four tubes stacked.

long as the selected time between exposures. Then the shutter closes and opens again. It will stay open until you turn the Exposure Dial to **mot.** (motor). This closes the shutter, releases the mirror and auxiliary shutter, and advances film.

Manually Triggered Multiple Exposures—When you turn the Exposure and Interval dials to **man.** (manual), you can control both the number of exposures on one frame and the time interval between them. As in the automatically-triggered mode, the aperture and shutter speed should be set manually.

Push the start button each time you want to make an exposure. The camera shutter button will make only the first exposure if you press it— remaining exposures must be made with the start button of the ME 1. The start LED blinks continuously between exposures. When you make an exposure, this light stays on for the exposure duration. After the last exposure, turn the Exposure Dial to **mot.** to release the mirror and auxiliary shutter, and advance the film.

With this method, using flash for each exposure is easy because you can make an exposure as soon as you notice that the flash has recycled. You can even change shutter speed between exposures if you like.

PUPILARY MAGNIFICATION OF SOME SLX LENSES

Lens	P
40mm	2.25
50mm	1.80
80mm	1.20
120mm	1.06
150mm	0.75
250mm	0.57

APPROXIMATE FOCUS TRAVEL OF SLX LENSES

LENS FOCAL LENGTH	APPROXIMATE FOCUS TRAVEL
40mm	4mm
50mm	6mm
80mm	8mm
120mm	11mm
150mm	18mm
250mm	28mm
350mm	26mm

The **B** setting of the shutter-speed dial should not be used. The first exposure lasts as long as the start button is depressed. Pushing the button again opens the shutter, which closes only when you turn the Exposure Dial to **mot.** to advance film.

AUTOMATIC EXTENSION TUBES

Four automatic extension tubes are available for close-up shooting with SLX lenses. Mount them to the camera and lens in the same way as described for mounting the lens to the camera. As mentioned previously, the 120mm S-Planar lens gives best image quality in the close-up range. None of the lenses can be reversed to improve image quality for magnifications greater than 1.0.

The four tubes provide 9mm, 17mm, 34mm, and 68mm of extension. They can be used singly or combined and still allow automatic metering because each tube has a set of gold-plated electrical contacts to transfer the electronic signals between camera and lens.

To find the magnification range possible with various combinations of extension tubes and lenses, use the magnification formulas in Chapter 2 or the data in the accompanying tables.

AUTOMATIC BELLOWS

This lightweight, aluminum bellows has variable extension from 67mm to 204mm. With the 80mm lens, this gives a magnification range of 0.8 to 2.7. Like the extension tubes, the Auto Bellows has a set of gold-plated

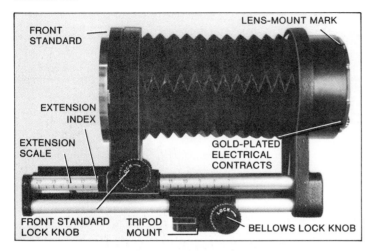

FRONT STANDARD

LENS-MOUNT MARK

EXTENSION INDEX

EXTENSION SCALE

FRONT STANDARD LOCK KNOB

TRIPOD MOUNT

GOLD-PLATED ELECTRICAL CONTACTS

BELLOWS LOCK KNOB

The rear standard of the auto bellows does not move. Even with the tripod mount all the way toward the camera, the assembly is unbalanced. Using a heavy-duty tripod may solve any problems this causes.

MAGNIFICATION RANGE WITH SLX LENSES AND AUTO BELLOWS

LENS*	MAGNIFICATION RANGE+	EXPOSURE COMPENSATION (STEPS)
50mm	1.34—4.08	1-2/3—3-1/2
80mm	0.84—2.55	1-1/2—3-1/3
120mm	0.56—1.70	1-1/3—2-2/3
150mm	0.45—1.36	1-1/3—3
250mm	0.27—0.82	1—2-1/2

* Lens set to infinity.
+ Bellows extension range: 67mm to 204mm.

FLASH SYNC WITH SLX LENSES

FLASH TYPE	SHUTTER-SPEED SETTING									
	1	2	4	8	15	30	60	125	250	500
F										
Electronic										
M										

■ Flash will sync. ■ Flash won't sync.

Two accessory grips are designed for the SLX. Both are useful for eye-level viewing. Shown is the Pistol Grip.

Because of the predominantly green background of this close-up scene, I let the meter of the SLX determine exposure automatically. It has a through-the-lens meter, so it automatically compensated for the extra exposure necessary due to magnification.

contacts in the lens and camera mount for automatic-exposure operation.

Mounting the Camera—Attach the camera to the rear of the bellows as if you were mounting a lens. Line up the red marks in the camera mount and rear standard of the bellows and turn the bellows 45° clockwise until it clicks in place. The lens mounts on the bellows front standard in the same way. Any lens can be used, but the 120mm S-Planar is recommended for best image quality. Lenses cannot be used reversed. Both camera and bellows fit either a standard American or European tripod screw.

Determining Extension—The tripod mount of the bellows moves along the bottom set of rails. Unlock the small knob on the left side of the tripod mount and turn the drive knob, on the right side, counterclockwise to move the bellows unit away from the subject. Because the camera is heavier than the lens and bellows, the unit is always unbalanced. Using a heavy-duty tripod with the bellows partially solves this problem.

The front standard has similar locking and drive knobs. As you turn the drive knob counterclockwise, the standard moves forward very smoothly. The front edge of the standard's base travels along a scale on the top left rail so you can read bellows extension. The scale shows centimeters (cm) of extension with divisions every 0.5cm. Use the magnification formulas in Chapter 2 to calculate magnification due to extension, or see the accompanying tables.

A problem with the bellows is that the rails always extend forward, below the lens, unless you use full extension. This can create difficulty in some setups if the rails extend past the front of the lens. You may not be able to get the lens as close to the subject as you wish. Using a long-focal-length lens may solve the problem.

Pentax 6x7

Except for its larger size and weight, the Pentax 6x7 camera looks and handles like a 35mm SLR. It offers many of the benefits of a 35mm SLR, including fast, easy handling, through-the-lens metering, an electronically operated focal-plane shutter, pentaprism viewing, and bayonet-mount lenses for quick interchangeability, plus the advantages of a larger image. For these reasons, this is the camera many 35mm SLR users choose to shoot medium-format photos.

Even though the camera system is known as the *6x7*, indicating an approximate image size of 6x7 cm, the actual image size is 55x69 mm. The aspect ratio is nearly the same as that of an 8x10 or 11x14 print. This is what Pentax means when it says the 6x7 format is the "ideal format."

The camera is extremely rugged and well balanced for a variety of applications in or out of a studio. Besides a full range of lenses from 35mm fisheye to 1000mm telephoto, the system includes a selection of interchangeable viewfinders, focusing screens, filters and extension tubes. For copy and close-up work, an auto bellows, macro lens, and a heavy-duty copy stand are available. A special underwater housing increases the versatility of the camera.

A basic setup includes the camera, an *f*-2.4 105mm lens with automatic aperture and a metering pentaprism viewfinder. A non-metering pentaprism viewfinder is also available. The current model accepts either 120 or 220 roll film and yields 10 or 20 exposures respectively.

The pre-1976 model gives 21 exposures with 220 film. This earlier model has a slightly different film loading procedure and does not have a mirror-lockup control. These differences are explained later. Unless otherwise mentioned, this description of the 6x7 camera applies to both pre- and post-1976 models.

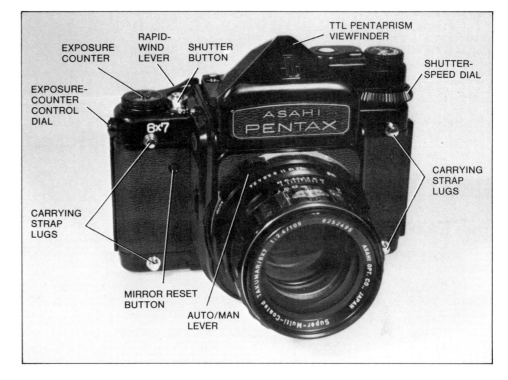

LENSES OF THE 6x7 SYSTEM

Lenses for the 6x7 camera are made by Pentax specifically for this system. Pentax lenses are multicoated with seven layers of lens coating—called *Super-Multi-Coating* or *SMC*—on most glass elements. Light loss due to internal reflections at glass and air interfaces is limited to 0.2%. Flare and ghost images are reduced; contrast and resolution of the image are noticeably better than with uncoated lenses.

Some of the lenses are called *SMC Takumar 6x7 Lenses.* As new lenses are made, they will be called *SMC Pentax 6x7 Lenses.* The major difference between 6x7 lenses and those designed for a 35mm SLR is size. The accompanying table summarizes features of 6x7 lenses. Special lenses are discussed here.

6x7 CAMERA SPECIFICATIONS

Type: 6x7 cm single-lens reflex with eye-level viewing and instant-return mirror.
Shutter: Electronically operated focal plane shutter with speeds from 1/1000 to 1 second, plus B. X- and FP-sync, with X-sync at 1/30 second.
Standard Lens and Viewfinder: 105mm SMC Takumar 6x7 *f*-2.4 lens and metering pentaprism viewfinder.
Film: 10 or 20 exposures on 120 or 220 film.
Power Source: 6V silver-oxide battery (Eveready No. 544 or equivalent).
Other Features: Interchangeable lenses, filters, viewfinders, and focusing screens. Mirror lockup and battery check.
Dimensions: Width 184mm (7.2"), height 149mm (5.9"), depth 156mm (6.1").
Weight: 2.4kg (5.3 lbs.).

PENTAX 6x7 LENSES

Lens	Minimum Aperture	Diagonal Angle of View	Minimum Focus Distance		Weight		Filter Size (mm)	Camera Mount
			ft.	m	oz.	g		
35mm f-4.5 Fish-Eye	f-22	180°	1.5	0.45	33	920	Built-in	Inner
45mm f-4	f-22	88°	1.2	0.37	17.1	485	82	Inner
55mm f-4	f-22	78°	1.3	0.40	22	615	77	Inner
55mm f-3.5	f-22	78°	1.5	0.45	33	920	100	Inner
90mm f-2.8	f-22	53°	2.0	0.65	17.1	485	67	Inner
75mm f-4	f-22	61°	2.3	0.70	21	600	82	Inner
75mm f-4.5 Shift	f-32	61°	2.3	0.70	34	950	82	Inner
90mm f-2.8	f-22	53°	2.0	0.65	17.1	485	67	Inner
90mm f-2.8 Leaf-Shutter	f-22	53°	2.8	0.85	22	610	67	Inner
105mm f-2.4	f-22	45°	3.3	1.0	22	628	67	Inner
135mm f-4 Macro	f-32	36°	2.7	0.85	23	645	67	Inner
150mm f-2.8	f-22	33°	4.9	1.5	27	768	67	Inner
200mm f-4	f-22	26°	8.2	2.5	32	900	67	Inner
300mm f-4	f-45	17°	16.4	5.0	50	1425	82	Inner
400mm f-4	f-45	12°	26.2	8.0	91	2570	77	Outer
500mm f-5.6	f-45	10°	26.2	8.0	113	3200	95	Inner
600mm f-4	f-45	8°	39.4	12.0	212	6000	77	Outer
800mm f-4	f-45	6°	65.6	20.0	624	17,700	77	Outer
1000mm f-8 Reflex	Built-in ND filters	5°	114.8	35.0	226	6400	Built-in	Outer

35mm f-4.5 Fish-Eye—This full-frame fish-eye makes a rectangular image with a 180° diagonal angle of view and typical fish-eye barrel distortion. Because of its fish-eye design, you can't use filters or a lens hood in front of the lens without vignetting the image. This problem is partially solved by built-in filters selected by a ring near the front of the lens. They are UV, Y2, O2, and R2 filters.

75mm f-4.5 Shift—This moderately wide-angle lens is recommended for architectural photography because you can shift the lens up to 20mm in any direction parallel to the film plane. This enables you to correct converging lines in architectural photography, make double-image panoramas, and produce creative image distortion. The lens is non-automatic with a preset aperture diaphragm.

90mm f-2.8 Leaf-Shutter—This lens is the only one in the 6x7 system with a built-in leaf shutter, which provides X-sync from 1/30 to 1/500 second. In addition, it is the only lens designed to make multiple exposures. It has its own cocking lever, X-sync terminal, cable-release socket, and shutter.

When the Copal-C leaf shutter is not cocked, the lens operates like the other 90mm 6x7 lens. Its angle of view and maximum aperture are almost the same as the standard 105mm lens, so you can use it instead of the 105mm lens and have the advantages of a built-in leaf shutter. Using it is described later, page 71.

135mm f-4 Macro—The maximum magnification of this moderate telephoto lens is about 0.3 without added extension. The focal length is long enough to provide a working distance of 20 inches (50cm) between lens and subject at maximum magnification, making lighting easier. It is optically corrected to give equally good image sharpness at both near and far focus.

As you turn the knurled focusing ring, a scale on the lens shows *Reduction Ratio* (RR). This scale indirectly gives image magnification because magnification (M) is the reciprocal of reduction ratio.

As magnification increases, the light level at the film plane decreases. A through-the-lens meter, such as the TTL Meter Pentaprism Finder, automatically compensates for this light loss. If you use a non-metering finder and accessory meter, you must calculate and use an exposure correction factor (ECF).

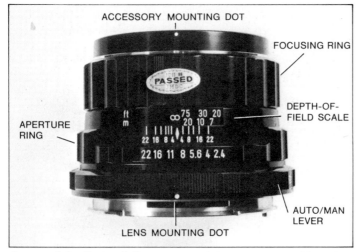

Lenses of the Pentax 6x7 system are similar to those for 35mm SLR cameras, except for size.

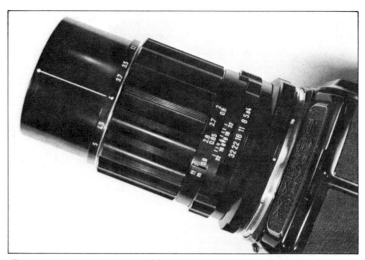

The scale at the front of the 135mm Macro lens shows Reduction Ratio. In this photo, the ratio is 4. Because magnification is the reciprocal of reduction ratio, magnification is 0.25.

Convert ECF into the necessary increase in exposure steps. This is done for you in the accompanying table and in Chapter 2. For this example, open the aperture 2/3 step.

1000mm *f*-8 Reflex—By folding the light path of this lens with built-in mirrors, Pentax designed a very short and light long-focal-length lens. In fact, the 1000mm lens is shorter and only a bit heavier than the 600mm telephoto.

With this optical design, a conventional variable lens aperture can't be used, and the aperture is fixed at *f*-8. A set of neutral density (ND) filters is built into a revolving ring at the rear of the lens so you can adjust the light passing through the lens. Labeled **X1**, **X2**, **X4**, and **X8**, they provide 0, 1, 2, and 3 steps of light reduction.

Behind the neutral density ring is a color filter selector with four filters: Y2, R2, Skylight and a blank position, which is clear optical glass. Filter factors are engraved on the filter ring.

T6-2X Rear Converter—This accessory is used with outer- and inner-mount telephoto lenses longer than 135mm, except the 500mm and 1000mm lenses. It doubles the focal length of the lens and effectively doubles the *f*-number.

MOUNTING LENSES

All Pentax 6x7 lenses bayonet mount; however, the camera has two mounts—one inside the other. The inside mount is for lenses from 35mm to 300mm and the 500mm telephoto. All other lenses attach to the outside mount.

To install a lens on the inner mount, align the orange dots located on the

To mount an inner-mount lens, align the orange dots and rotate the lens clockwise about 45°.

rear of the lens and the side of the camera mount. Rotate the lens clockwise until it clicks into place, then test it by trying to rotate it in the other direction.

When properly mounted, these lenses operate with full-aperture metering. A lever on the lens, just to the right of the orange alignment dot, lets you choose either automatic or manual aperture. Sliding the lever down and releasing it exposes the orange symbol **MAN**. You can then stop the lens down by manual rotation of the aperture ring to view depth of field or for stopped-down metering. Depressing the AUTO/MAN lever releases it from **MAN**. It slides up, exposing **AUTO** in white letters. This sets the lens for automatic aperture.

Remove the lens by pushing the lens-release lever on the left side of the camera while turning the lens counterclockwise.

Remove an inner-mount lens by sliding the lens-release lever back and turning the lens counterclockwise.

Mounting lenses onto the outer bayonet mount is just as easy. Loosen the outer ring on the rear of the lens and turn it so a white dot faces up, directly across from the focus indicator. Then place the lens onto the lugs of the outer mount on the camera body and turn the ring on the lens counterclockwise until it is snug. Before using the camera, test the connection—if the lens is improperly mounted it could fall off. These long-focal-length lenses do not have automatic-apertures, so the aperture size changes as you rotate the lens aperture ring. Remove the lens by turning the outer ring clockwise.

FILTERS

The accompanying table lists available Pentax filters for the 6x7 system. Except for the polarizing and the Morning & Evening (82A) filter, all are Super-Multi-Coated. Pentax filters

USING THE MAGNIFICATION SCALE OF THE 135mm MACRO LENS			
Reduction Ratio	Magnification	Exposure Compensation Factor	Approx. Increase In Exposure Steps
30	0.03	1.1	0
15	0.07	1.2	
10	0.10	1.3	
8	0.13	1.3	1/3
7	0.14	1.4	
6	0.17	1.4	
5	0.20	1.5	1/2
4.5	0.22	1.5	
4.0	0.25	1.7	
3.7	0.27	1.8	
3.5	0.29	1.8	2/3
3.2	0.31	1.9	1

The 135mm macro lens is ideal for head-and-shoulder portraiture.

Film	Filter Name	Color	Approx. Filter Factor	Use
67mm, 77mm, 82mm, 95mm & 100mm PENTAX 6x7 FILTERS				
B&W	UV	clear	1X	Reduce UV exposure of film.
	Y2	yellow	2X	Increase tonal contrast between clouds and sky.
	O2	orange	3X	Absorbs more blue than Y2; cuts haze more.
	R2	med. red	6X	Absorbs blue and green for more sky contrast; darkens foliage.
Color	Skylight	light pink	1X	Reduce UV and excess blue of open shade.
	Cloudy	amber	0.5X	More warming than Skylight. Use on a cloudy day.
	Morning/ Evening+	light blue	0.5X	Reduce warmth of light at morning or evening.
Any	Polarizer*	gray	3X	Reduce glare and reflections by polarizing light entering the lens.

* Available in 67mm only. + Not available in 95mm.

When the mirror is locked in a half-up position due to a dead battery, use a pointed object to press the mirror-reset button. This will raise the mirror all the way. Then push the shutter button again.

bayonet mount onto the lens, but the lenses are also threaded to accept screw-in filters as shown in the lens table. Pentax filters are available in 67mm, 77mm, 82mm, 95mm, and 100mm diameters.

Filters for lenses up to 300mm attach to the front of the lens. The 35mm fish-eye and 75mm shift have a gelatin-filter holder in the rear.

The 400mm through 1000mm lenses accept 77mm filters in the rear of the lens. To install either a bayonet or screw-in filter, remove the adapter ring from the rear of the lens by unscrewing it. Mount the filter in it, then screw the adapter back into the lens. Attach the lens to the camera as usual.

Pentax also makes three gelatin-filter frames that bayonet mount onto lenses designed for 67mm, 82mm, and 100mm filters. They hold standard 75mm (3-inch) square gels.

THE BATTERY

The Pentax 6x7 camera uses battery power for the electronically-operated shutter and the TTL Meter Pentaprism Finder. It uses a 6V silver-oxide Eveready No. 544, or equivalent. Under normal conditions the battery has enough power for more than 8000 exposures.

Inserting the Battery—On the bottom of the camera next to the tripod socket is a small cover with a round handle. Turn the handle counterclockwise and remove. Insert the battery into the cylindrical opening in the cover. Align the positive terminal of the battery with the + in the chamber, replace the assembly, and turn the handle clockwise.

Battery Check—On the left side of the camera back, behind the shutter-speed dial, is a small white button labeled BATT. CHECK. If the red light on the top of the camera glows

when you push the button, the battery is good. If a fresh battery is installed backward, the light won't glow when the button is pushed.

Dead Battery—If the battery is dead, installed wrong, or not in the camera, the shutter won't operate. When you push the shutter button, the mirror swings up halfway and stops, blocking part of the field of view. When the lens is set to a large aperture, the viewfinder image darkens. You can check this by removing the lens to observe the mirror or by trying to rotate the rapid-wind lever. It locks because the shutter is still cocked, so you won't be able to turn the lever.

To correct this situation, install a fresh battery. Then use a small, blunt point, such as a pencil lead, to press the small button on the front left side of the camera body. The mirror swings up to cover the focusing screen. Press the shutter button again. The mirror swings down; the shutter opens and closes; and if film is in the camera, you will have wasted one frame.

Remote Battery Cord—In weather colder than 32°F (0°C), the battery will not operate at maximum power unless it is kept warm. To use the camera in cold weather, connect the battery and cover to one end of the Remote Battery Cord and put the battery in your pocket. A dummy battery and cover on the other end of the cord fit into the camera battery chamber.

INTERCHANGEABLE VIEWFINDERS

Interchangeable viewfinders make the 6x7 camera adaptable to most kinds of photography. They go on and off simply and quickly. To remove, depress the two Push-Button Side Locks on the sides and lift off the

The battery chamber is on the bottom of the camera.

Pushing the battery check button causes this indicator lamp (arrow) to glow red if the battery has sufficient charge.

Removing a viewfinder is a one-hand operation. Depress both push-button side locks and lift the finder off.

viewfinder. To install, place the viewfinder over the focusing screen and press down until both of its latches click into the camera. Test by lifting on the viewfinder.

Pentaprism Finder—With this viewfinder you see 90% of the image on the film. Because it is a pentaprism, image orientation is correct, so it is convenient for shooting moving subjects, vertical formats, and scenes requiring eye-level viewing.

Folding Focusing Hood—For waist-level viewing, the Folding Focusing Hood is ideal. It is extremely lightweight, and when not in use, it folds down neatly. Open it with a flick of your thumb. When open, the hood shields the focusing screen on four sides, making viewing and focusing easier, except when light comes from overhead.

A 1.6X magnifier swings in and out of position for critical focusing and as an aid in shielding even more ambient light. When you use the magnifier, the folding hood is no longer a waist-level viewfinder because you must move your eye to the magnifier lens. With either viewing method, you see 100% of a laterally-reversed image.

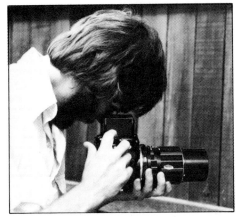

Here the folding focusing hood is being used with its magnifier.

Rigid Magnifying Hood—This viewfinder is a non-folding version of the folding hood with a 1.3X magnifier permanently in place. The eyepiece of the rigid hood has a built-in diopter adjustment that lets you correct the viewfinder to your eyesight.

When you put your eye to the rubber eyecup, ambient light is excluded, making the viewfinder appear very bright. It is good for most general-purpose photography in which eye-level viewing is not essential.

TTL Meter Pentaprism Finder—Even though the camera body does not incorporate a meter, you can still have through-the-lens (TTL) metering by using the TTL Meter Pentaprism Finder.

A full-frame averaging Gallium meter is built into this finder which, like the pentaprism finder, shows 90% of the laterally correct image. The meter has an EV range of 2.5 to 19 at ASA 100 with an f-2.4 lens. The meter's ASA dial has an ASA range from 12 to 3200.

After removing the lens and before attaching the TTL finder, put the Shutter-Speed Dial Adapter on the camera.

To install the viewfinder, remove the lens *first*. This is necessary so you can later couple the automatic-diaphragm lever to the meter. Next, place the Shutter-Speed Dial Adapter over the camera shutter-speed dial so you can turn it easily with the finder in place. Mount the viewfinder on the camera as previously described. Remount the lens.

On the underside of the viewfinder shutter-speed dial is a small spring-loaded connecting pin. Turn this dial slowly until you hear the pin click into place in a slot on the camera-body shutter-speed dial. This mechanical connection causes both dials to turn together. To change shutter speed,

Attach the TTL finder to the camera, then mount the lens.

turn the adapter to avoid putting unnecessary stress on the connecting pin.

Set film speed by lifting the outer ring of the viewfinder shutter-speed dial and turning it until the desired film speed number is centered in the window. Lower the ring to lock the setting.

As you look through the viewfinder, you see a correctly oriented image and a needle-centering exposure indicator directly below.

Turn the meter on with the small switch on the top right side of the pentaprism. The switch is spring-loaded and always goes back to **OFF** when you release it. After the meter is turned on, it operates for about 25 seconds then automatically turns itself off to prevent excess power drain on the camera battery. When this happens, the needle moves up to the + side of the indicator.

While the meter is on, the needle is visible within two exposure steps on either side of correct exposure. If the camera settings will produce more than two steps of over- or underexposure, the needle goes off scale until you correct the settings. Remember,

TTL METER PENTAPRISM EXPOSURE DISPLAY

Because the sky is about half of the field of view, the full-frame averaging metering pattern of the TTL pentaprism finder recommended good exposure for this scene.

Both the Right-Angle Finder and 2X Magnifier have a built-in diopter adjustment.

though, if this takes more than 25 seconds, the meter turns itself off. When metering, set either *f*-stop or shutter speed first and adjust the other to center the needle.

When an inner-mount lens is on the camera, the meter works at full aperture. You can't use stop-down metering with these lenses because the meter turns itself off if the AUTO/MAN lever is in the MAN position.

Stopped-down metering is required with outer-mount lenses and when a non-automatic lens accessory, such as a reverse adapter, is between an inner-mount lens and the camera. In this case, put the AUTO/MAN lever to MAN.

Also, the meter will not work if the battery is dead or installed wrong, or if the viewfinder is installed without first removing the lens from the camera body.

Viewfinder Accessories—Pentax makes four accessories to fit the pentaprism viewfinders only.

A Right-Angle Finder with an adjustable diopter eyepiece adapts a pentaprism viewfinder to uses such as copy or close-up work.

A hinged 2X Magnifier, which clips onto the pentaprism eyepiece, is useful for setups requiring critical focusing because it magnifies the central area of the focusing screen. To see the whole frame, raise the magnifier.

To correct pentaprism viewing for your eyesight when not using either of these accessories, Pentax offers correction lenses in seven diopter strengths from +2 to -5.

A rubber eyecup that excludes stray light from the TTL meter and makes viewing much more comfortable fits over the pentaprism or right-angle finder eyepiece.

USING THE CAMERA WITHOUT FILM

If the camera is not loaded with film, turning the rapid-wind lever won't cock the shutter. The lever moves 180° each time, but does not engage the shutter. There are two methods to operate the camera controls without film in the camera. I recommend you try this before shooting film to become familiar with all camera controls.

Camera Back Closed—This is the simplest way. Open the back of the camera by pulling down on the Back-Cover Release Lever. Put a fingertip on the button in the center of the exposure counter and rotate it counterclockwise until 0 moves past the orange triangular index. Keep the counter in this position with your finger and close the camera back.

This is the simple way to set the camera so you can operate it without film: While the back cover is open, turn the center of the exposure counter and rotate it counterclockwise past the first frame. Then close the back.

TTL METER PENTAPRISM FINDER SPECIFICATIONS

Type: Gallium, full-frame average metering either at full aperture or stopped-down aperture. Meter needle visible through the viewfinder window. Couples to both shutter-speed dial and diaphragm. Meter switch automatically turns off after 25 seconds.
Measurement Range: EV 2.5 to EV 19 with ASA 100 film and *f*-2.4 lens.
Film Speed Scale: ASA 12 to ASA 3200.
Working Range: Shutter speeds from 1 to 1/1000 second with ASA 100 film.
Power Source: 6V silver-oxide battery of the camera.
Dimensions: Width 123mm (4.84"), height 58mm (2.28"), depth 89mm (3.5").
Weight: 520g (18 oz.).

Now, the rapid-wind lever will cock the shutter and you'll feel much more resistance as it does. The shutter cocks with a full 180° turn of the lever, not with partial turns. With the camera in this mode, it can be operated as usual, but the exposure counter does not advance without film in the camera.

If you open the back of the cocked camera and push the shutter button, the shutter and mirror operate, but the only way to cock the shutter again is to turn the exposure counter past 0 and close the camera back.

Camera Back Open—Packed with each Pentax 6x7 camera is a small key that fits into a slot in the film chamber, tricking the camera into "thinking" the back is closed and film is loaded.

Open the camera back and look for the small chrome slot above the take-up spool, on the right side of the shutter curtain. Insert one end of the key into the slot, then push on the key to insert the other end. When properly inserted, it holds itself in place. Be very careful when inserting the key. Do not force it into the slot.

Then turn the film roller, which is on the left side of the take-up spool, to the right. Watch the exposure counter as you turn the roller. When the first mark past 0, which indicates frame 1, aligns with the triangular index, cock the shutter. **Do not turn the roller in either direction from this point. This can damage the shutter mechanism.**

The camera will operate with the back open, allowing you to watch the shutter work. The key must remain in the camera when the back is open. Once the shutter is cocked, though,

PENTAX 6x7 INTERCHANGEABLE FOCUSING SCREENS

Microprism (standard)

Biprism

Grid

Matte

Grid & Microprism

Pentax recommends that you have the focusing screen changed at any authorized Pentax service center rather than attempting it yourself.

you can remove the key and close the back. Then it operates exactly as with the previous method.

Using the camera with the key is not really worth the trouble and risk involved. This method is for the camera repairman who times and adjusts the shutter. To familiarize yourself with the camera, I recommend the first method. Remove the lens if you want to watch the mirror and shutter operate.

BEFORE LOADING FILM

You must perform two operations to adjust the camera for 120 or 220 film. Turn the Exposure-Counter Control Dial, which is next to the exposure counter, to 120 or 220 with a small coin or thumbnail. If you have a pre-1976 model, the dial settings are 10 for 120 film or 21 for 220 film. The current model makes 20 exposures instead of 21 on 220 film.

The Exposure-Counter Control Dial sets the shutter to the right number of frames that fit on the film in use. After 10, 20, or 21 frames have been exposed, the shutter disengages so you can use the rapid-wind lever to quickly advance the paper backing to roll up the film without having to cock

The more difficult way to operate the camera without film uses a special key. When properly inserted in the camera, it depresses a small plate that is ordinarily depressed by closing the back cover.

After the key is inserted, turn the film roller in the direction of the arrow until the exposure counter indicates frame 1.

This control sets the exposure counter for either 10 or 20 exposures. Setting it incorrectly can waste film.

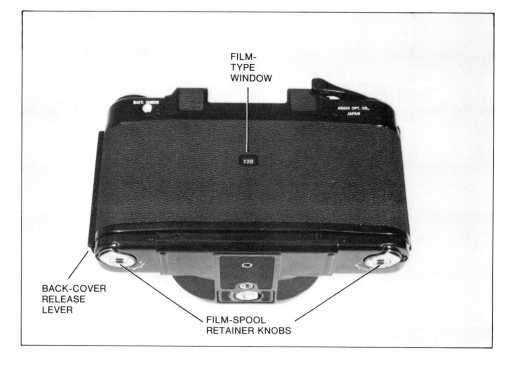

FILM-TYPE WINDOW

120

BACK-COVER RELEASE LEVER

FILM-SPOOL RETAINER KNOBS

and trigger the shutter each time. This is also an energy-saving convenience because the shutter uses battery power each time it operates.

Next, open the camera back by pulling down on the Back-Cover Release Lever. Depress the film pressure plate and slide it to the right or left until it locks into place. Engraved arrows and numbers indicate the proper directions for 120 and 220 film. A window in the camera back also displays the setting. Always make sure the window display agrees with the film in use.

Set the pressure plate by pressing and sliding it to the left for 120 film or to the right for 220 film. Here the plate is set for 120 film.

This adjustment is necessary to accommodate the different thicknesses of 120 and 220 film. The continuous paper backing of 120 film makes it thicker than 220 film, which has paper only on the ends of the roll. Therefore, the pressure plate is closer to the film-guide rails when it is set for 220 film.

Doing It Wrong—If you set the Exposure-Counter Control Dial for 120 film when 220 film is in the camera, the shutter disengages after 10 exposures, but the rapid-wind lever still advances film. If you notice this as soon as the rapid-wind lever becomes very easy to turn, set the film-selector dial for 220 film to restore shutter operation. Frame 11 will be wasted because you advanced the film once, but you can still expose the rest of the roll. Noticing your mistake later than this wastes even more frames.

If your mistake is setting the camera for 220 film when 120 film is loaded, recognizing the error and changing the setting from 220 to 120 before the 10th exposure gives 10 exposures on the roll. Then the shutter disengages.

After the counter passes the tenth exposure, you should not attempt to change the setting from 220 to 120 because this could damage the camera mechanism. You will get only 10 exposures on the roll, but you have to keep cocking the camera and tripping the shutter to wind up the roll.

If you don't recognize your error, the *shutter* operates to 20 or 21 exposures, depending on the model. The *exposure counter* operates as long as the film or paper backing advances, but it stops as soon as the paper is completely wound up, about frame 16. Turning the rapid-wind lever still cocks the shutter, so without checking the counter you may be fooled into thinking there is film in the camera.

If the pressure plate is set for 120 film and 220 film is in the camera, the film will not be as flat as it should be and, depending on aperture, the image may not be as sharp as possible. Conversely, if the plate is set for 220 film and 120 is loaded, the extra pressure on the film and paper may put undue stress on the winding mechanism.

Avoid these problems by checking both settings *before* you load film.

LOADING FILM

The 6x7 camera also differs from other medium-format cameras in the way film is loaded and taken up.

After setting the Exposure-Counter Control Dial and the pressure plate, load film. On the underside of the camera you'll notice two chrome handles that control the Film-Spool Retainer Knobs. Unfold the handles and turn them counterclockwise to the engraved white dot. Pull both handles outward and remove the empty spool in the left film chamber. Put it in the right side.

Unwrap the new film spool and insert it into the empty chamber with the black side of the paper leader facing the shutter curtain. At this point, push both retainer knobs into the bottom of the spools while turning and locking them into place. Fold the handles flush to the camera.

Pull the paper leader across the camera and insert its tapered tongue into a slot in the empty spool. Advance film using the rapid-wind lever until the vertical arrow printed on the paper aligns with the correct start mark adjacent to the upper film-guide rail. Post-1976 models have two start marks, one for each film type. The numbers 120 and 220 are clearly labeled with index marks, so there is little chance for confusion. On pre-1976 models, the start mark is the same for both 120 and 220 film.

When the arrow is opposite the correct start mark, close the camera back and continue turning the rapid-wind lever. It operates easily until the first frame moves into position behind the shutter curtain. You can see this happening as the exposure counter advances past 0 to the first mark. The shutter mechanism automatically engages when the first frame moves into position, making the rapid-wind lever harder to turn because it must also cock the shutter. If the start mark and arrow aren't aligned before the camera back is closed, the shutter

Post-1976 models, like the one shown here, have two start marks. Pre-1976 models have only one start mark.

FLASH SYNC WITH 6x7 CAMERA

Terminal	Flash Type	SHUTTER-SPEED SETTING											
		X	1	2	4	8	15	30	60	125	250	500	1000
FP	FP*												
X	Electronic												
X	M, MF, FP												

■ Flash won't sync.　■ Flash will sync.　* Large-class FP bulbs are recommended.

CAMERA OPERATIONS

Photographers familiar with a 35mm SLR readily adapt to the 6x7 camera because the cameras work the same way after film is loaded. Unlock the shutter button by turning its locking collar away from L. Focus on the subject, meter with the TTL pentaprism or hand-held meter, set aperture and shutter speed and press the shutter button. Particular features of using the 6x7 camera follow.

Shutter Speeds—The shutter-speed dial is a large knurled ring on the top left side of the camera. It has shutter speeds ranging from 1/1000 to 1 second, B and time-exposure settings. A position marked X automatically selects the X-sync speed of 1/30 second. Settings for various types of flashbulbs are summarized in the accompanying table.

As you turn the shutter-speed dial, you'll feel each setting click firmly into place. Do not try to set intermediate shutter speeds between click-stops on the dial.

The one exception to this rule is for time exposures. Set the shutter-speed dial anywhere *between* X and 1000. When you press the shutter button, the mirror swings up and the shutter opens. The shutter stays open until you turn the dial *either* to X or 1000. You can get the same time-exposure operation by using an in-between setting anywhere else on the shutter-speed dial, but it is less convenient than the X/1000 method. The camera does not have a self-timer.

Mirror Lockup—Post-1976 models have a Mirror Lock Lever on the right side of the outside wall of the mirror chamber. To use it, cock the shutter, then slide the lever up. The mirror

mechanism will engage before or after the first frame is in position, and you'll waste a frame or two of film.

Lock up the mirror before exposure by sliding this control up. Mirror lockup uses battery power continuously, so make an exposure soon after the mirror is up. Making an exposure is the only way to return the mirror to its normal position.

swings up to cover the focusing screen and stays there until you depress the shutter button to take the picture. After the shutter closes, it swings back down automatically.

When the mirror is locked up, it uses battery power constantly, so use the control only when necessary for situations demanding minimal camera shake due to mirror vibrations. In these cases, you should also use a standard cable release to trip the shutter. Attach the cable to the shutter button by screwing it into the top.

For stopped-down metering or to preview depth of field, set the AUTO/MAN lever to MAN.

One problem you may have with mirror lockup is using it accidentally. If the camera is cocked while you focus or adjust the aperture, a slip of the hand can slide the lever up, locking up the mirror and blocking the viewfinder before you can finish metering and composing. If this happens, try to make a good exposure with a point-and-shoot technique as soon as practical to avoid excess battery drain.

Multiple Exposures—The camera body does not have a provision for multiple exposures, but it can be done with the 90mm leaf-shutter lens.

USING THE 90mm LEAF-SHUTTER LENS

This lens has a built-in leaf shutter that increases the versatility of the 6x7 camera by providing both X-sync at speeds from 1/30 to 1/500 second and a simple multiple-exposure procedure. You can operate the lens in three modes using the U/S lever on the lens barrel.

Standard Lens Operation—If you don't cock the lens shutter, the lens works like any other 6x7 automatic lens. It mounts on the camera's inner mount with the only difference being the lack of an orange alignment dot on the lens—use the orange focus-indicator mark instead.

If you want to use the lens without its leaf shutter, but it is already cocked, release the shutter before mounting the lens. Move the U/S lever to U. Find the lens coupling pin on the back of the lens between bayonet lugs and move it along its slot. This simulates the camera operating the lens and trips the shutter. Then you can mount the lens on the camera.

Usual Leaf-Shutter Mode—The U of the U/S lever stands for *usual*, meaning this is the setting for flash-sync

FLASH SYNC WITH THE
90mm LEAF-SHUTTER LENS

Flash Type	SHUTTER-SPEED SETTING				
	30	60	125	250	500
Electronic					
FP*					
MF, M					

■ Flash will sync. ■ Flash won't sync.

*At 1/30, exposure is 1/3 less than calculated value.

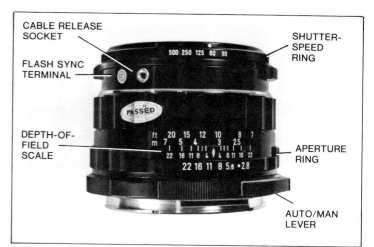

The 90mm Leaf-Shutter lens has two unique features: You can use it for multiple exposures, and it provides flash sync at all lens shutter speeds.

The U/S lever is on the bottom of the 90mm lens. When the U is visible and the lens shutter cocked, the lens is set for flash-sync operation at all lens shutter speeds.

operation at all shutter speeds, as described in Chapter 3.

The lens has an X-sync terminal, which synchronizes with electronic flash at all lens shutter speeds. To use other kinds of flash with the lens, refer to the guide number data for the particular bulb.

Once the lens is mounted, set the U/S lever to U and cock the lens shutter by turning the cocking ring. Plug the sync cord of the flash into the terminal on the lens.

If you meter with a hand-held meter, set the f-stop on the lens and adjust the camera shutter speed to 1/8 second. When metering with the TTL meter pentaprism, find the shutter speed for correct exposure by turning the camera shutter-speed dial. Transfer that speed to the lens and reset the camera speed to 1/8 second.

When the shutter button is pushed, camera and lens operate in this sequence:

The lens shutter closes and aperture stops down just before the mirror swings up.

When the mirror completely covers the focusing screen, the camera focal-plane shutter opens.

While the focal-plane shutter is completely open, the lens shutter opens, triggers the flash, and closes again.

The camera shutter closes and the mirror swings down.

To expose the next frame, cock *both* the camera and lens before pressing the shutter button.

Points to Remember—This is all quite simple, but there are a few very important steps to remember for flash sync. The camera shutter *must* operate at 1/8 second, or slower, so the lens shutter has time to open and close before the camera shutter begins closing. Shutter speeds faster than 1/8 second may give incomplete exposure, and slower shutter speeds will black out the viewfinder for an unnecessarily long time.

Always plug the flash cord into the terminal on the lens. Otherwise, the camera shutter triggers the flash and the film won't be properly exposed. In addition, you must cock the lens shutter before each flash exposure. If it isn't cocked, neither it nor the flash will operate, and the film will be exposed by the camera shutter only.

This photo was made with the usual (U) mode of the 90mm lens. The location of an Elinchrom 11 Mono Pro flash determined lens aperture. Then I metered outdoor light to find the corresponding shutter speed for this aperture. Settings of f-8 and 1/250 second gave balanced lighting.

USING PENTAX 6x7 CLOSE-UP LENSES

Close-Up Lens	Camera Lens	Approximate Magnification Range
S82	90mm	0.11—0.24
S82	105mm	0.13—0.27
T132	150mm	0.11—0.24
T132	200mm	0.15—0.26
T226	200mm	0.09—0.19

Use the Special (S) mode of the 90mm lens for multiple exposures. Trip the lens shutter by moving the U/S lever toward S. After the lever springs back, cock the lens again and make another exposure.

Never use the mirror-lockup lever of a post-1976 camera when the lens is set for flash-sync operation. When you move the mirror up, it will trip the lens shutter prematurely. After previewing depth of field, remember to put the AUTO/MAN switch back to AUTO.

Special Leaf-Shutter Mode—To make simple multiple exposures, use the S setting for the leaf-shutter lens. Set the U/S lever to S and cock the lens shutter. If you use a hand-held meter, set the lens shutter to the calculated exposure time. When using the TTL pentaprism, determine exposure time with the camera's shutter-speed dial and transfer the setting to the lens. Then set the camera's shutter-speed for a time exposure—between X and 1000—and cock the camera to position the next frame.

When you push the shutter button, the field of view blacks out. To trip the leaf shutter, slide the U/S switch on the lens to cover the S, or use a cable release screwed into the lens.

When the camera shutter button is pushed, camera and lens operate in this order:

The lens shutter closes, and the aperture stops down just before the mirror swings up.

The camera focal plane shutter opens and stays open.

The lens shutter opens and closes when it is tripped, exposing the film.

For multiple exposures, cock the lens shutter and trip it as many times as you wish while the camera shutter remains open. You can even change lens shutter speed and aperture for each exposure. However, because the camera mirror stays up throughout the entire operation, viewing and metering is not possible, and you must meter with a hand-held meter. When you finish the multiple exposure, turn the shutter speed dial to X or 1000. As long as the camera shutter stays open, it uses battery power, so use the S setting only when necessary.

Remember too, that any time you use a flash in the S mode, it must be connected to the sync terminal of the lens, not the camera. Another peculiarity of triggering the lens shutter is in the U/S lever. When you use the lever, make sure it always springs back to expose the orange S. If you slide it to expose the U and try to cock the lens shutter again, the shutter trips when you let go of the cocking ring.

Another application of the S setting is used with a post-1976 camera to minimize camera shake in a single exposure. After both lens and camera shutter are cocked, lock up the mirror. Then open the camera shutter and wait a few seconds before tripping the lens shutter with a cable release.

CLOSE-UP LENSES

For quick and simple close-up photography, Pentax makes three screw-in close-up lenses for both standard and telephoto 6x7 lenses. The S82 close-up lens is designed for the 90mm and 105mm lenses. The T132 and T226 close-up lenses fit the 150mm and 200mm lenses. For best image quality, Pentax recommends that you do not stack close-up lenses. See the accompanying table for the magnification range of the recommended lens combinations.

The special (S) mode of the 90mm lens was used to make this multiple exposure. When you use the lens this way, the viewfinder image remains blacked out during the exposures. This may require careful planning to align the images.

The mounting ring of each close-up lens is threaded to accept a 67mm screw-in filter. The lenses are also Super-Multi-Coated to give maximum image contrast. More information on using close-up lenses is in Chapter 2.

EXTENSION TUBES

Pentax offers two sets of fixed extension tubes and a tube with adjustable extension. One set has three tubes labeled No. 1, No. 2, and No. 3 with 14mm, 28mm, and 56mm of extension respectively. These fit inner-mount lenses only, and they couple with the automatic aperture of the lens.

The other set has only two tubes labeled A and B with 23mm and 46mm extension for outer-mount lenses.

The Helicoid Extension Tube has variable extension from 32.2mm to 52mm, giving a magnification range from 0.30 to 0.63 with the 105mm lens focusing scale set to infinity. It works only with inner-mount lenses, but does not preserve automatic-aperture operation.

Mounting Extension Tubes—With a tube from either set, mounting it on the camera is the same as if you were mounting a lens. Mounting the lens on the tube is the same as mounting the lens on the camera.

To remove an auto extension tube from the camera, first press the bayonet locking pin on the tube and turn the lens counterclockwise until the dots on the lens and tube match. Disassemble outer-mount lenses and tubes by rotating the retaining ring clockwise.

Using Extension Tubes—Extension tubes increase the distance between the rear lens node and the film, thereby increasing the magnification. They can be combined for a variety of image sizes with one lens. Formulas for magnification, extension and exposure correction factors are summarized in Chapter 2.

The leaf-shutter mode of the 90mm lens can be used with only one extension tube at a time. If two or more are attached, the lens may not synchronize properly with the camera because of mechanical slack and tolerances in

PUPILARY MAGNIFICATION OF SOME 6x7 LENSES

LENS	P
55mm f-3.5	1.67
75mm f-4.5	1.35
90mm f-2.8	1.21
105mm f-2.4	1.09
135mm f-4.0	0.84
200mm f-4.0	0.70

MAGNIFICATION RANGES WITH THE HELICOID EXTENSION TUBE AND 6x7 SMC LENSES MOUNTED NORMALLY

Lens*	Film-To-Subject Distance Range		Magnification Range	Exposure Compensation (steps)
	inches	cm		
75mm	15.0—13.1	38.0—33.3	0.43—0.69	1—1-1/3
90mm+	18.1—15.0	45.9—38.2	0.36—0.58	1—1-1/3
105mm	22.8—18.4	58.0—46.7	0.30—0.50	2/3—1
135mm	34.4—26.6	87.5—67.5	0.24—0.39	2/3—1
150mm	39.8—30.0	101.2—76.1	0.21—0.35	2/3—1
200mm	66.4—48.3	168.8—122.8	0.16—0.26	1/2—1

* Lens focused at infinity and mounted normally.
+ Leaf-shutter operation not possible.

MINIMUM MAGNIFICATION OF EXTENSION TUBES AND 6x7 SMC LENS COMBINATIONS

Lens*	Extension Tube(s)	Film-To-Subject Distance		Approximate Magnification	Exposure Compensation (Steps)
		in.	cm		
75mm	1	16.7	42.3	0.33	2/3
	2	14.0	35.6	0.52	1
	2+1	13.0	33.1	0.71	1-1/3
	3	12.8	32.4	0.89	1-1/2
	3+1	12.7	32.3	1.08	1-2/3
	3+2	12.9	32.7	1.27	2
	3+2+1	13.1	33.3	1.45	2
105mm	1	24.6	62.4	0.27	2/3
	2	20.0	50.7	0.40	1
	2+1	18.0	45.6	0.53	1-1/3
	3	17.0	43.1	0.67	1-1/3
	3+1	16.5	41.8	0.80	1-1/2
	3+2	16.3	41.4	0.93	1-2/3
	3+2+1	16.3	41.4	1.07	2
90mm	1	20.1	51.1	0.29	2/3
	2	16.3	41.4	0.44	1
	3	14.2	36.0	0.76	1-2/3
150mm	1	39.3	99.7	0.22	2/3
	2	31.7	80.5	0.31	1
	2+1	27.9	70.8	0.41	1-1/3
	3	25.7	65.3	0.50	1-1/3
	3+1	24.4	61.9	0.59	1-1/2
	3+2	23.6	59.8	0.69	1-2/3
	3+2+1	23.1	58.6	0.78	2

* Lens set to closest focus setting.

APPROXIMATE FOCUS TRAVEL OF 6x7 LENSES

LENS FOCAL LENGTH	FOCUS TRAVEL
55mm	11mm
75mm	11mm
90mm	12mm
105mm	14mm
135mm	41mm
150mm	20mm
200mm	20mm
300mm	21mm
400mm	24mm
600mm	36mm
800mm	32mm

EXTENSION TUBES AND 6x7 SMC LENS COMBINATIONS

Lens*	Extension Tube(s)	Film-To-Subject Distance in.	cm	Approximate Magnification	Exposure Compensation (steps)
400mm	A	176	447	0.11	1/2
	B	131	332	0.17	2/3
	B+A	109	276	0.23	1
600mm	A	317	805	0.10	2/3
	B	248	631	0.14	1
	B+A	211	535	0.17	1-1/3
800mm	A	507	1289	0.07	1/3
	B	385	978	0.10	1/2
	B+A	317	806	0.13	2/3

* Lens set to closest focus setting.

MAXIMUM MAGNIFICATIONS WITH EXTENSION TUBES AND REVERSED 6x7 SMC LENSES

Lens	Extension Tube(s)	Film-To-Subject Distance in.	cm	Approximate Magnification	Exposure Compensation (steps)
90mm	HET	14.3	36.3	1.4	2-1/3
	HET+1	14.6	37.1	1.5	2-1/2
	HET+2	14.9	37.9	1.7	2-2/3
	HET+3	15.7	40.0	2.0	3
	HET+1+3	16.1	41.0	2.2	3-1/3
	HET+2+3	16.6	42.1	2.3	3-1/3
	HET+1+2+3	17.0	43.2	2.5	3-1/2
105mm	HET	16.3	41.5	0.9	1-2/3
	HET+1	16.3	41.3	1.0	2
	HET+2	16.3	41.5	1.1	2
	HET+3	16.8	42.6	1.4	2-1/2
	HET+1+3	17.0	43.3	1.5	2-2/3
	HET+2+3	17.4	44.2	1.7	2-2/3
	HET+1+2+3	17.8	45.1	1.8	3
135mm	HET	25.2	64.1	0.4	1-1/3
	HET+1	23.5	59.6	0.5	1-2/3
	HET+2	22.5	57.0	0.6	1-2/3
	HET+3	21.5	54.6	0.9	2
	HET+1+3	21.4	54.3	1.0	2-1/3
	HET+2+3	21.4	54.3	1.1	2-1/3
	HET+1+2+3	21.5	54.6	1.2	2-1/2

HET: Helicoid Extension Tube used at maximum (52mm) extension.

MAGNIFICATION RANGE WITH THE HELICOID EXTENSION TUBE AND 35mm-FORMAT PENTAX LENSES REVERSE MOUNTED

Lens*	Film-To Subject Distance inches	cm	Magnification Range	Exposure Compensation (steps)
28mm f-3.5	8.1—8.9	20.7—22.6	4.22—4.92	4-1/2—5
35mm f-2	8.8—9.5	22.4—24.2	3.33—3.88	4—4-1/3
35mm f-3.5	8.0—8.7	20.4—22.2	3.27—3.84	4—4-1/2
50mm f-1.4	8.8—9.4	22.4—24.0	2.05—2.44	3—3-1/3
50mm Macro	9.4—10.0	23.8—25.4	2.12—2.50	3-1/3—3-2/3

* Pentax 35mm-format lens reverse mounted on the 6x7 49mm Reverse Adapter and 6x7 Helicoid Extension Tube.

the linkages. Nor can you use the leaf shutter when the 90mm lens is mounted on the Helicoid Extension Tube.

67mm REVERSE ADAPTER

When using auto extension tubes or the helicoid extension tube for magnifications of 1.0 or more, the lens should be reversed for best image quality. Pentax recommends using the 67mm Reverse Adapter to reverse mount the 90mm, 105mm, and 135mm lenses. Reverse mounting the 150mm and 200mm lenses will not give best image quality.

The back side of the adapter bayonet mounts onto the extension tube. The front of the adapter screws into the filter threads of the lens. Loosen the adjuster screw of the adapter to put the lens index pointing up. Tighten the screw.

The reverse adapter has about 9.5mm extension of its own, so when you calculate magnification, include it with the extension of the reversed lens. Turning the focusing ring of a reversed lens has no effect on lens elements. Therefore, the adapter is best suited for use with the helicoid extension tube, which is used to focus the image. If you use fixed-length tubes, the lens assembly gives just one image magnification.

49mm REVERSE ADAPTER

This is another adapter you can use to reverse mount Pentax lenses designed for 35mm cameras. Pentax recommends you use the 28mm f-3.5, 35mm f-2 or f-3.5, 50mm f-1.4, or 50mm f-4 macro lenses this way.

The 6x7 49mm reverse adapter attaches to the extension tube and lens as described for the 67mm reverse adapter. Turning the focusing ring of these reversed lenses has no effect on the lens elements. Therefore, the lens and adapter are best used with the Helicoid Extension Tube for a range of image magnificatons. See the accompanying table.

If you have Pentax 35mm-format lenses, you can use the 49mm Reverse Adapter to mount them onto the 6x7 camera for close-up photography.

This is the Auto Bellows viewed from the rear.

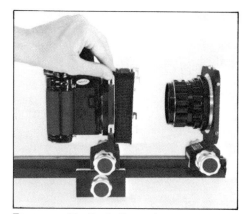

To reassemble the bellows after reversing the front standard with the lens attached, first loosen the bellows latches on the rear standard.

Second, bayonet-mount the bellows to the reversed front standard. Align the white mounting dots and turn the bellows counterclockwise.

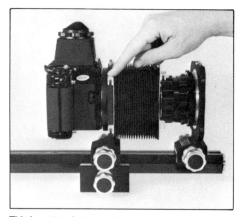

Third, extend the bellows and reattach the latches to the rear standard.

AUTO BELLOWS

For maximum magnification with the 6x7 system, use the Auto Bellows. It accepts any inner-mount 6x7 lens mounted normally, and lenses with a 67mm filter ring can also be mounted reversed, although Pentax recommends reversing only the 90mm, 105mm, and 135mm lenses. The bellows extends from 54mm to 352mm. With the 105mm lens mounted in reverse and set to infinity, maximum magnification is about 3.0.

You can get highest magnifications with short-focal-length lenses, but Pentax does not recommend using lenses shorter than 90mm. Focusing becomes difficult and the lens-to-subject distance decreases dramatically, making lighting much more difficult.

The 135mm macro lens is optically best-suited for close-up shooting with the bellows. In addition, you can use the 50mm *f*-4 macro lens designed for a 35mm Pentax SLR. It reverse-mounts onto the 6x7 49mm reverse adapter, which attaches to the bellows or an extension tube.

Mounting the Camera on the Bellows—Because you use the bellows on a tripod or copy stand anyway, attach it to the tripod or copy stand before mounting the camera and adjust the bellows balance with the adjustable tripod seat. Lock the bellows into position with its inner clamp knob. Next, move the black ring lever on the back standard of the bellows until it is straight up. Then insert the lugs of the camera's outer mount into the appropriate slots in the bellows mount. You'll hear it click when it is in all the way. Turn the ring lever counterclockwise as far as it goes—about 120°—to tighten the mount.

If you plan to use the TTL meter pentaprism, attach the viewfinder to the camera *before* mounting the camera on the bellows.

Mounting the Lens on the Bellows—For normal mounting, attach an inner-mount lens to the front standard of the bellows in exactly the same way as you would mount it on the camera.

Remove the lens by depressing the small silver lever near the mounting ring while turning the lens counterclockwise about 45°.

Reverse the lens by reversing the front bellows standard. First, remove the stop screw at the front of the bellows rail. Next, compress the bellows fully and lift both latches on the side of the front standard. As you move the standard away with the drive knob, the bellows stays retracted. Remove the standard from the rail, turn it around, and put it back on the rail, lens first. Replace the screw into the rail.

Remove the bellows from the camera by lifting the latches on the side of the rear board. Then attach the compressed bellows to the front of the reversed lens by lining up the white dot on the front of the bellows with the top of the lens. Turn the bellows counterclockwise if you are in front of

the camera. Reattach the bellows to the camera by sliding the latches in place.

If the lens is reversed, maximum magnification occurs when the lens is focused at infinity. Turning the focusing ring compresses the bellows and reduces magnification.

Using the Auto Bellows—Even though the bellows is quite large and rugged, it handles like one half its size. The standards move smoothly on a precision track as you turn the large knobs on the seat of each standard. Each knob has an inner clamp knob to lock the setting. Refer to Chapter 2 for

This black widow spider with its lunch was magnified twice life-size on film. I used the 105mm lens reversed and determined magnification with the bellows' magnification scale. Exposure compensation was about three steps.

Here the 105mm lens is mounted reversed and the bellows extended for a magnification of 1.0, as shown by the magnification scale.

formulas and charts to calculate setup distances and exposure correction factors for photomacrography.

The simplest way to use this bellows is with the stainless-steel scale that fits on top. The scale is marked in millimeters and magnification on both sides—one side for normal and the other for reversed mounting. The magnification scale works only with the 105mm lens and greatly simplifies calculating the exposure correction factor.

The scale hooks onto a small rod on the side of a magnetized plate on the rear standard. Another magnetized plate on the front standard secures it so you can read either magnification for the 105mm lens or extension for any lens. The index on the front standard is a slot in the cable-release socket on the side of the magnetized plate. Positioning the scale on the bellows is foolproof. If the lens is reversed, the scale won't go on straight with its normal side up, and vice-versa.

Focus on the subject with the lens aperture wide open and check depth of

field with the AUTO/MAN lever. When using the TTL meter pentaprism, use stopped-down metering if you can and forget about calculating exposure factors. If you use an ordinary cable release to trip the shutter, stop down the aperture manually before exposure.

An easier way is to use the Dual Cable Release that comes with the bellows for automatic-aperture operation. Attach the end of the cable release with the red ring to the top of the bellows' front standard and the other end to the shutter button on the camera. When you push the cable-

Using the Dual Cable Release lets you view through the maximum lens aperture. When you push the plunger, the lens stops down just before exposure.

RECOMMENDED MAGNIFICATION RANGES OF 6x7 SMC LENSES WITH THE AUTO BELLOWS

Lens*		Bellows Extension (mm)	Film-To-Subject Distance in.	cm	Mag. Range	Exposure Compensation (Steps)
90mm	N	54—100	15.1—13.9	38.4—35.4	0.6—1.1	1-1/3—2
	R	100—350	13.9—21.4	35.4—54.3	1.1—3.85	2—4-1/2
105mm	N	54—210	18.1—18.3	46.1—46.4	0.5—2.0	1-1/3—3-1/3
	R	110—350	16.7—21.9	42.4—55.5	0.7—3.0	1-2/3—4
135mm	N	54—135	26.0—21.3	66.2—54.0	0.4—1.0	1—2-1/3
	R	140—350	31.3—23.4	79.5—59.4	0.3—1.8	1—3-1/3
150mm	N	54—180	29.4—22.9	74.7—58.2	0.4—1.2	1—2-1/3
200mm	N	54—200	47.3—31.7	120.1—80.6	0.3—1.0	2/3—2

* Lens focused at infinity.
N: Lens mounted normally.
R: Lens mounted reversed.

release plunger, a pin comes out of the red-ringed end first, stopping down the aperture just before the other branch trips the shutter. If you attach the cable release in the opposite way and push the plunger, the camera shutter is tripped before the aperture is stopped down.

For long exposures, put the shutter-speed dial on **B** and lock the set screw on the side of the cable-release plunger when it is depressed. Time the exposure and release the set screw to close the shutter. You can also use the camera's time-exposure mode, but you may shake the camera too much when turning the shutter-speed dial to **X** or **1000** to end the exposure.

Using the 90mm Lens with Bellows

When the bellows is between the 90mm leaf-shutter lens and the camera, the shutters can't synchronize because there is no mechanical linkage between them.

However, you can still use the leaf shutter if the camera shutter is locked open. This is ideal for setups requiring flash sync at fast shutter speeds or multiple exposures.

Attach the red-ringed end of the cable release to the front board, but do not attach the other end of the cable release to anything. Set the camera's shutter-speed dial between **X** and **1000** for a time exposure. Once you select the lens shutter speed and aperture, after taking the exposure correction factor into account, depress the plunger of the cable release and lock it with the set screw. This closes the lens shutter. You can then open the camera shutter by pushing the shutter button. Operate the lens shutter as many times as you wish by cocking the lens shutter and triggering it manually. Or, minimize camera shake with a cable release screwed into the lens.

After exposure, close the camera shutter by turning the shutter-speed dial to **X** or **1000**, *then* release the set screw of the cable release. If you do it the other way around, the lens shutter opens while the camera shutter is also open, and you'll probably grossly overexpose the film.

Slide Copier

Another accessory for the auto bellows is the slide copier, which attaches to the bellows front rail with a screw. Because you will rarely, if ever, need to copy a 6x7 image or a 35mm slide at less than life-size, the bellows of the slide copier has latches that fit on the *reversed* front board.

The Quick Focusing Ring is handy for photographing fast-moving subjects. Two rings are available to fit on the focusing ring of most Pentax 6x7 lenses from 35mm to 200mm. With the Hand Grip, use your left hand to hold the camera and focus the lens.

The Slide Copier screws onto the front of the bellows rail. The Slide Copier's bellows latch to the reversed front standard of the bellows.

There is also a magnification scale on the rail of the slide copier that is calibrated for the 105mm lens.

6x7 MARINE HOUSING

With the Pentax 6x7 Marine Housing and other accessories, you can use the 6x7 camera underwater to depths of 50 meters. Three different ports are available to accommodate 6x7 lenses ranging from the 35mm fish-eye to the 200mm moderate-telephoto. There is also a special lens attachment that minimizes distortion with the 55mm *f*-3.5 lens.

The housing is built for easy handling on land or underwater. Large handles and knobs make camera adjustments swift and sure. In addition, the camera with 55mm lens weighs less underwater than the camera body does on land, so it isn't a chore to swim with the unit.

An eye-level mirror finder shows you 100% of the focusing screen with

This is the heavy-duty copy stand for the Pentax 6x7 system.

The 6x7 Marine Housing expands the versatility of the 6x7 camera system to include underwater photography.

1.8X magnification of the laterally reversed image. Other accessories include flash adapters for use with Nikonos, Rollei, Sunpack, or Toshiba flash units. Pentax does not make a flash unit for the housing.

Mamiya C330f & C220

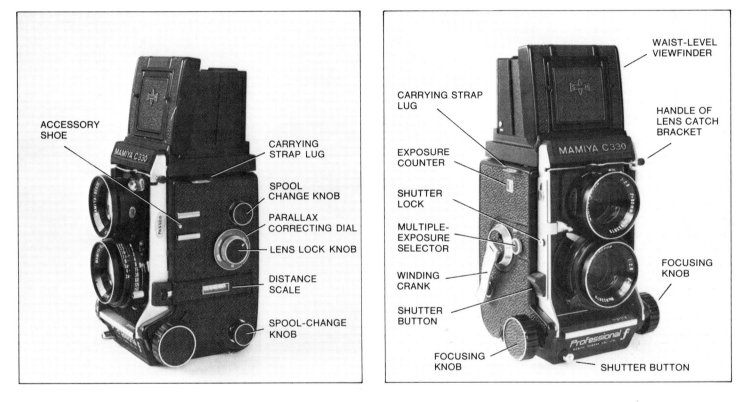

The first Mamiya TLR camera using interchangeable lenses, the Mamiyaflex C, was introduced in 1957. Since then it has undergone many changes and improvements. The camera was given more features to make handling easier, and additional interchangeable accessories were added to the system to give it more professional capability. The latest versions of Mamiya C cameras are the C330f Professional and the C220 Professional.

Of the two cameras, the C330f is more versatile. Both cameras accept interchangeable lenses and viewfinders, but the C330f can also use interchangeable focusing screens. In addition, the C330f has two shutter release buttons, and when you wind the film, the leaf shutter is automatically cocked. These features make handling the C330f faster than handling the C220. However, the C220 camera is lighter, slightly smaller, and less expensive than the C330f, shown above.

There are other differences between the cameras, discussed later in this chapter. Basically, the cameras work the same way. They accept either 120 or 220 film for 12 or 24 6x6 cm images, with an actual frame size of about 56x56 mm. The standard lens for the cameras is a Mamiya Sekor 80mm f-2.8 lens. Both cameras have a parallax-correction device, an exposure compensation scale, and multiple-exposure capability.

In addition to the accessories already mentioned, the system includes filters, lens hoods, grips, and tripod attachments. These many features make the Mamiya TLR system a relatively inexpensive alternative to SLR medium-format cameras.

MAMIYA C330f CAMERA SPECIFICATIONS

Type: 6x6 cm twin-lens reflex.
Shutter: Seikosha-S #0 with speeds from 1/500 to 1 second, plus B. M- and X-sync.
Standard Lenses: Mamiya-Sekor 80mm f-2.8 viewing and taking lens.
Film: 12 or 24 exposures with 120 or 220 roll film.
Other Features: Rack-and-pinion focusing with locking lever, one-way film-advance and shutter-cocking winding crank; multiple-exposure capability, automatic parallax and exposure-compensation indicator; interchangeable lenses, viewfinders and focusing screens.
Dimensions: Width 122mm (4.8"), height 168mm (6.6"), depth 114mm (4.5").
Weight: 1.7kg (3.8 lbs.).

LENSES OF THE MAMIYA TLR SYSTEM

Seven pairs of multicoated interchangeable lenses are made by Mamiya. The taking and viewing lenses for each focal length have the same maximum aperture. They are mounted on a lensboard that attaches to the front standard of the camera's rack-and-pinion bellows.

Each pair of lenses has the same basic features, including a Seikosha-S #0 leaf shutter; a shutter-speed range from 1/500 to 1 second, plus B; both M and X flash sync; and an interpupilary distance of 50mm (2.0 inches). Other features of each lens pair are summarized in the table below.

105mm DS ƒ-3.5 Lens—This is the *only* lens of the system that has a depth-of-field scale and variable aperture on the viewing lens. With the other lenses, you determine depth of field using depth-of-field tables.

The variable aperture of the 105mm DS lens lets you visually check the zone of sharp focus by turning an aperture ring on the lens and viewing the image on the focusing screen. The depth-of-field scale and variable aperture setting are on the top of the lens so they are easy to see and operate when you glance from the waist-level viewfinder to the lens.

Before using the depth-of-field scale on the lens, you must first find the subject distance from a scale on the side of the camera. Transfer the subject distance from the camera's scale to the red index on the distance scale of the lens. Read depth of field between the lines marked with the chosen aperture.

MAMIYA C220 CAMERA SPECIFICATIONS

Type: 6x6 cm twin-lens reflex.
Shutter: Seikosha-S #0 with speeds from 1/500 to 1 second, plus B. M- and X-sync.
Standard Lenses: Mamiya-Sekor 80mm ƒ-2.8 viewing and taking lens.
Film: 12 and 24 exposures with 120 and 220 roll film.
Other Features: Rack-and-pinion focusing with locking lever; ratcheted film-advance and shutter-cocking knob/winding crank; multiple-exposure capability; automatic parallax and exposure-compensation indicator; interchangeable lenses and viewfinders.
Dimensions: Width 118mm (4.6"), height 167mm (6.6"), depth 113mm (4.4").
Weight: 1.1kg (2.1 lbs.).

MAMIYA-SEKOR LENSES FOR THE C330f AND C220

Lens	Minimum Aperture	Diagonal Angle of View	Minimum Focus Distance ft.	m	Weight oz.	g	Filter Size (mm)
55mm ƒ-4.5	ƒ-22	71°	0.7	0.2	12	330	46
65mm ƒ-3.5	ƒ-32	63°	0.8	0.3	12	340	49
80mm ƒ-2.8	ƒ-32	51°	1.1	0.4	11	310	46
105mm DS ƒ-3.5	ƒ-32	41°	1.8	0.6	12	336	46
135mm ƒ-4.5	ƒ-45	33°	2.7	0.9	13	370	46
180mm ƒ-4.5	ƒ-45	25°	3.9	1.3	22	620	49
250mm ƒ-6.3	ƒ-64	18°	6.2	2.1	22	630	49

Control the depth-of-field scale of the 105mm DS lens with the outer ring. Set lens aperture with the small lever near the lens board.

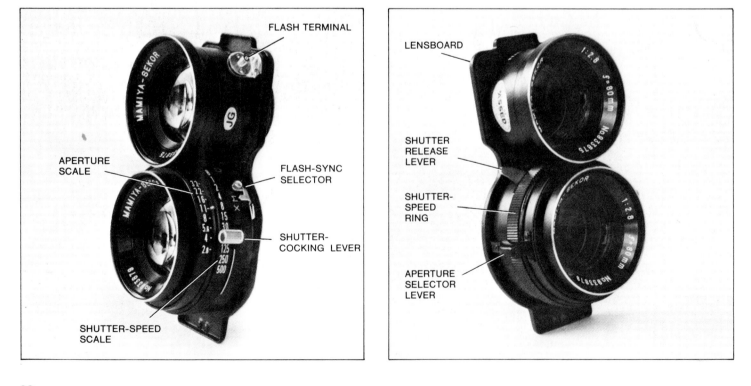

FLASH TERMINAL

APERTURE SCALE

FLASH-SYNC SELECTOR

SHUTTER-COCKING LEVER

SHUTTER-SPEED SCALE

LENSBOARD

SHUTTER RELEASE LEVER

SHUTTER-SPEED RING

APERTURE SELECTOR LEVER

When using one of the system's metering viewfinders, be sure to have the variable aperture of the viewing lens set to *f*-3.5 during metering. Otherwise you'll get bad exposure recommendations.

MOUNTING LENSES

The ability to use interchangeable lenses with the C330f and C220 is the best reason to own a Mamiya TLR. Changing lenses is not as fast as it is with an SLR camera, but it doesn't have to be. As stated in Chapter 1, TLR cameras are best for leisurely shooting.

Before Removing the Lens—Fully retract the camera lens on the rack-and-pinion bellows by turning one of the camera's two focusing knobs toward you. If the bellows is not fully retracted, you can't remove the lens.

The simplest way to change lenses is with both the lens and the C330f camera cocked. Do this by winding the camera's crank one full turn. Film advances and the camera's cocking lever moves the lens cocking lever, tensioning the shutter. The winding crank stops just past top center. Keep it in this position throughout the mounting procedure.

The handle of the C220's winding crank folds back into a knob. This makes it easy to operate with a series of partial turns, as you would manually wind a watch. However, winding does not cock the lens shutter, so you have to tension the lens with its cocking lever after every exposure. Move the lever down until it stops.

Turn the Lens Change Knob on the camera's left side so the white triangu-

lar index points to UNLOCK. On the C220 the same word shows in a window above the knob. This procedure puts a red line in the viewfinder, locks the shutter button, and moves an opaque cover over the rear of the taking lens. The cover blocks light to the film plane when the lens is removed. Don't push the cover while the lens is off the camera. If you do, it may retract, letting light fog the film.

Lens Removal—To remove the lens, hold the camera so the lens faces up. Grasp the head of the Lens Catch Bracket. Pull it toward you and up to

Unclamp the lens by pulling the Lens Catch Bracket toward you and up.

Swing the bracket out of the way and lift out the lens.

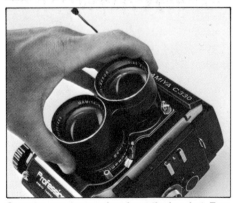
Seat the new lens and reclamp the bracket. Turn the Lens Change Knob to *LOCK*.

unlatch the lens catch. Swing it out of the way and lift the lens out of the camera.

Attaching the Lens—Before attaching a lens, cock its shutter with its shutter cocking lever. Attach the cocking lever side of the lens to the camera body first and seat the lens in the camera.

When attaching the 180mm lens, hold down its spring-loaded auxiliary cocking lever so it will couple with the cocking lever of the C330f body. This isn't necessary with the C220 body because it does not have a cocking lever.

Reclamp the lens catch bracket and turn the lens change knob to LOCK. This frees the shutter button, removes the red line in the viewfinder, and retracts the opaque cover behind the taking lens. Because you mount a cocked lens on a cocked camera, you are ready to make an exposure.

If you mounted an uncocked lens on an uncocked C330f camera, advance film and tension the shutter by winding the camera's crank until it stops.

If the camera is cocked but the mounted lens isn't, push its shutter cocking lever to tension the shutter. If you mount a cocked lens on an uncocked camera, you will make an inadvertent double exposure when you push the shutter button. Avoid this by winding the camera crank before pushing the shutter button.

Parallax Correcting Dial—Surrounding the lens change knob of the C330f is the Parallax Correcting Dial. Turn it so its red index mark is aligned with the number corresponding to the focal length of the newly attached lens.

Before removing the lens board, you must retract the camera lens and turn the Lens Change Knob to UNLOCK. **Shown is the C330f; the C220 has a similar knob.**

After changing lenses on the C330f, set the index (arrow) of the Parallax Correcting Dial to the focal length of the lens.

When using the 55mm or 65mm lens, set the index to 80. Then attach the Parallax Correction Plate to the viewfinder. This is described and illustrated later.

When using the 250mm lens, set the index to 180. No correction plate is necessary because the lens doesn't focus close enough to necessitate parallax correction.

Changing the Distance Scale—After changing the lens and setting the parallax correction dial, adjust the sliding distance scale of the C330f. It is a six-sided rod located below the lens change knob on the camera's left side. Turn the knurled knob at the front of the scale so the number to the right of the knob corresponds with the focal length of the newly attached lens.

Adjust the distance scale of the C330f after setting the parallax correction dial.

Older models of the C330f do not have a rod with a distance scale for the 105mm DS lens. They have a scale for an old 105mm lens, which is constructed differently than the 105mm DS lens. If you attach the 105mm DS lens to an older C330f, replace the six-sided distance scale with a new one, available from Mamiya. To remove the scale from the camera, first extend the bellows fully by turning one of the two focusing knobs. Pull the end cover of the scale toward the lens and remove it. Then remove the six-sided distance scale by pushing on the end of the scale with a pencil tip or wooden match stick.

Insert the new scale and attach the knurled knob. Replace the end cover.

LOADING FILM

Before loading film, set the Multiple-Exposure Selector to **SINGLE**. The selector knob is next to the winding crank. This locks the shutter button until film is wound and the first frame is in the film gate.

Set the multiple-exposure selector to SINGLE. Shown is the C330f; the C220 camera has a similar control.

Open the camera back by turning the knurled button on the camera back 90° clockwise until the red dot on the button faces up. Then slide the button to the right until the cover opens. The exposure counter resets to 0.

Opening the camera back is a two-step operation. Turn the button clockwise; then push it to the right.

Pull out the lower-left spool-change knob to free the empty spool. Place it in the upper chamber. Unwrap the roll of film and put it in the bottom chamber with the leader's black side facing forward. Draw the leader tongue across the camera and feed it into the empty spool. Turn the winding crank until the start mark printed on the paper leader matches the red dots on the film-guide rails. Use the same start mark for both 120 and 220 film.

Adjusting the Pressure Plate—Because the cameras accept either 120 or 220 film, you should adjust the pressure plate to match the type of film you are using. For 220 film, twist the pressure plate so its red dot is aligned with the **220** above the plate. When using 120 film, put the dot under the **120**. This adjustment puts the plate farther from the film plane to compensate for the continuous paper backing.

Do not adjust the plate incorrectly. If it is set for 120 film and 220 film is

After aligning the leader and start marks, adjust the pressure plate.

in the camera, the film won't be as flat as possible in the film plane. This can reduce image sharpness, although small apertures can compensate for this somewhat. Setting the plate for 220 film and loading 120 film can create unnecessary drag on the winding mechanism because the plate is too close to the film plane.

When you close the back cover after loading film, turn the knurled button counterclockwise until it stops. This prevents accidental opening of the back. When the back is closed, the winder and exposure counter of the C330f are automatically set for the proper number of exposures for either 120 or 220 film. Depending on how you set the pressure plate, a blue **120** or red **220** is visible in a window on the back cover of either camera.

With the C220, you must set the exposure counter manually with a sliding control above the exposure counter. A window below the switch shows a blue **120** or red **220**.

Advancing Film—Turn the winding crank clockwise until it stops—about three revolutions with the C330f and about six with the C220. The crank of the C330f will always stop just past top center. A 1 will show in the exposure counter next to the crank. The camera is ready for the first exposure.

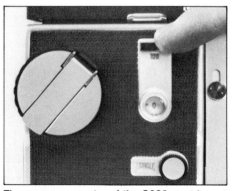

The exposure counter of the C220 must be set manually.

VIEWING AND HANDLING

Open the standard waist-level viewfinder by lifting up on the cover. It unfolds and springs up to expose the focusing screen, which shows 85% of the upright, laterally reversed image. For critical focusing, bring the viewfinder to your eye and raise the -1.5 diopter magnifier by pushing the front panel of the unfolded hood. Five other magnifiers are available to fit your eyesight better, if necessary. They range from -3 to +2 diopters, in 1 diopter increments. Retract the magnifier by pushing it down until it folds back.

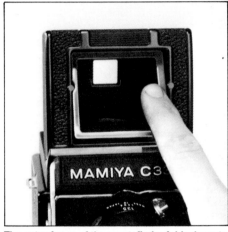

The outer frame of the sportsfinder folds down to show the approximate field of view of the 65mm lens.

The waist-level viewfinder can also be turned into a sportsfinder. Push the front panel of the unfolded hood to raise the magnifier. Then continue pushing the front panel until it folds down to cover the focusing screen. View the scene through the hole in the rear panel.

The front, inner hole of the sportsfinder corresponds to the field of view of the standard 80mm lens. When using the 65mm lens, also push in the outer folding frame to enlarge the viewing hole for the larger field of view.

When using a lens larger than 80mm, view the scene through a mask that fits over two studs on the front panel of the unfolded hood. These masks are available for the 105mm DS, 135mm, 180mm, and 250mm lenses. A sportsfinder adapter that fits the waist-level viewfinder of the C220 is available for the 65mm lens.

In addition to the standard waist-level viewfinder, there are five interchangeable viewfinders, described later.

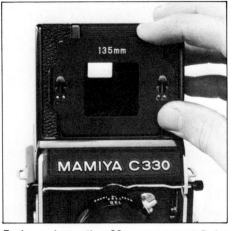

For lenses longer than 80mm, use a sportsfinder mask over the opening.

Finding Subject Distance—Focus the image by turning one of the two focusing knobs. If you use the C330f, you can lock the setting with the lever on the left-hand knob. Push it forward to lock it.

The distance scale of the C330f is just above this focusing knob. When using the 55mm, 65mm, and 80mm lenses, read subject distance in feet across from the index mark in the window on the camera body. The distances are indicated in red numbers.

When using the 105mm DS, 135mm, 180mm, and 250mm lenses, read subject distance in feet where the front of the camera body intersects the sliding distance scale. Do not move the lens board so close to the camera that the scale index has passed the infinity mark. If you do, the lens is less than one focal length away from the film plane. Nothing will be in focus.

The C220 has a different type of distance scale. It is similar to that of the

Mamiya RB67 Pro-S, also described in this book. Above the left-hand focusing knob is a plate that moves in and out with the bellows. Color-coded curves are printed on the plate, with corresponding focal lengths of the system's lenses. Determine subject distance by finding where the curve corresponding to the focal length of the lens in use intersects the vertical distance scale. It is marked in feet and meters. See the accompanying photo.

The distance scale of the C220 is a sliding plate attached to the bellows. At this bellows extension, the 105mm DS lens is focused at 4 feet (1.2m).

Determining Depth of Field—When not using the 105mm DS lens, you can't determine depth of field visually. You must use depth-of-field tables, which is more tedious. These tables are in the instruction books for both camera and lens.

Shown above left is the red distance indicator (arrow) used when a 55mm, 65mm, or 80mm lens is on the C330f. When using longer lenses, use the front panel of the camera as the distance index (arrow), shown at right. Notice that it is possible to focus "farther away" than infinity. Nothing is in focus at this setting.

By using the variable aperture of the 105mm DS viewing lens, I judged depth of field on the focusing screen before photographing this backlit tree.

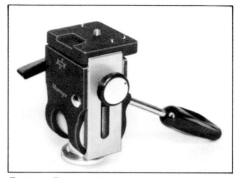

To use a Paramender, you attach the camera to the top tripod screw then attach the Paramender to a tripod. After composing the image, you use the Paramender's lever to *raise* the camera the interpupilary distance, 50mm (2.0 inches). The Model 3 Paramender shown here also has a built-in pan head.

EXPOSURE COMPENSATION DUE TO BELLOWS EXTENSION	
ECF	EXPOSURE STEPS
1.5	1/2
2	1
2.5	1-1/3
3	1-1/2
4	2

When you have determined subject distance and aperture, refer to the table to find the zone of sharp focus.

The 105mm DS lens has both a variable aperture and a depth-of-field scale on the viewing lens, eliminating the need for a depth-of-field table. The variable aperture operates manually and has no detents. It is *not* coupled to the aperture ring of the taking lens.

Automatic Parallax Correction—As

described in Chapter 1, when magnification increases, parallax error also increases. In addition, exposure compensation is necessary for best exposure. The automatic parallax correcting device built into the C330f helps minimize both of these problems. For it to work properly, the Parallax Correcting Dial must be set for the lens in use, as described earlier.

As you focus on nearby subjects, a pointer appears on the left side of the focusing screen. It indicates two things—the image cutoff due to parallax error and the necessary exposure compensation. If you use one of the system's two metering viewfinders with either camera, the meter automatically provides the exposure increase if the light at the film plane is within the meter's sensitivity range. For best exposure, you should meter *after* composing and focusing. Then you have to consider only the parallax error.

The image area above the pointer is excluded due to parallax error. When hand-holding, you can preview the approximate image area you are gaining at the bottom by moving the camera *down*, positioning the image line determined by the pointer at the top of the screen.

When the camera is mounted on a tripod, you can use one of two *Paramenders* to eliminate parallax error. The Paramender fits between the camera and tripod. After you compose and focus the image, operate the lever on the Paramender to raise the camera 50mm, the interpupilary distance. This puts the taking lens in the same position as the viewing lens was in when you composed the picture.

When the focusing screen is removed, you see the pointer of the automatic parallax corrector of the C330f. It moves as the bellows is extended, indicating the exposure compensation factor and what part of the image will be excluded due to parallax error.

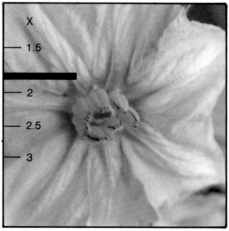

All interchangeable focusing screens for the C330f have this scale. The black bar represents the moving pointer, which in this case recommends an exposure compensation between 1.5X and 2X. The area above the pointer is excluded on film due to parallax error.

The pointer indicates the necessary exposure compensation factor on a scale on the left-hand side of the screen. The scale value is a multiplier you can use with the shutter speed to find a corrected longer speed. The accompanying table shows how the exposure correction factor corresponds to correction in steps. For example, if the pointer indicates a 2X compensation is necessary, you can adjust the shutter speed or aperture to give one step more exposure.

When using the 55mm or 65mm lens on the C330f, you must install a special parallax correction plate for best parallax correction. Remove the waist-level viewfinder and turn it upside down. Turn the plastic correction plate upside down and insert its chamfered end into the clips at the back of the finder's bottom. Retract the spring-loaded clip at the finder's front to secure the plate. Reattach the viewfinder.

When you view through a viewfinder that shows a laterally reversed image, you see two red scales on the plate. The left scale shows the exposure compensation determined by the pointer in the viewfinder. The right scale indicates parallax error. Determine image cutoff with the line corresponding to the exposure compensation factor indicated by the pointer. When you use a metering viewfinder, you can ignore the recommended exposure compensation if the light at the film plane is within the meter's sensitivity range.

Viewfinders that show a laterally correct image use a slightly different correction plate. It is described and il-

Film	Filter	Color	Approx. Filter Factor	Sizes (mm)	Use
B&W	Y2	yellow	2X	46, 49	Absorbs UV and some blue to increase tonal contrast between clouds and sky.
	YG	yellow-green	2X	46, 49	Absorbs blue and some red for masculine portraiture and lightening foliage.
	O2	orange	3X	46, 49	Absorbs more blue than Y2 and penetrates haze better for stronger tonal contrasts in landscapes.
	R1	red	8X	46	Absorbs more blue and green than O2 for more sky/cloud contrast. Darkens foliage.
Color	SL	pink	1X	46, 49	Absorbs UV and excess blue of open shade.
Any	UV	clear	1X	46, 49	Absorbs UV to prevent excess blue in color photo or hazy effect in b&w photo. Also protects lens.

MAMIYA FILTERS FOR MAMIYA TLR LENSES

lustrated with the CdS Porrofinder later in this chapter.

Non-Automatic Parallax Correction—The C220 uses a different method to correct parallax error and exposure. Refer to the sliding distance plate after focusing. Beneath the curved lines are horizontal bars corresponding to the various lenses of the system. Read the exposure compensation factor where the bar corresponding to the lens focal length intersects a black index mark below the sliding scale. See the accompanying table to change the factor into exposure steps.

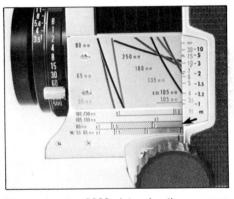

When using the C220, determine the exposure compensation factor by referring to the sliding distance plate. In this example the factor for the 80mm lens is 2X. This corresponds to image cutoff above the lower line on the focusing screen, shown below.

Install the 55mm/65mm parallax correction plate in a non-prism viewfinder when you use the 55mm or 65mm lenses.

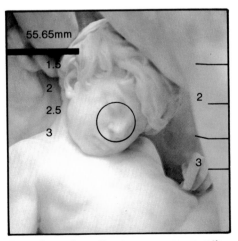

The pointer shows the exposure compensation factor at the left. Transfer that number to the scale on the right to determine image cutoff.

This is the focusing screen for the C220 camera. It is an all-matte, non-interchangeable screen.

The parallax correction scale on the focusing screen has two horizontal lines above the center of the screen. The area above the top line is cut off when an exposure compensation of 1.5X is recommended by the sliding distance plate. The line below it corresponds to image cutoff when a 2X compensation is necessary. When exposure compensation is 3X, the image area above the center of the screen is cut off. Estimate in-between values, or use a Paramender for exact parallax adjustment.

SHOOTING FILM

After focusing and composing, meter the scene. Use a hand-held exposure meter as described in Chapter 5 or one of the two interchangeable metering viewfinders, described later.

Set aperture with the aperture selector lever on the right side of the taking lens. The ring has detents in one-step increments. A red index mark on the left side of the lens indicates the selected *f*-stop. Turn the shutter-speed ring to set a shutter speed from 1/500 to 1 second, or B, opposite the index mark.

Making the Exposure—Unlock the shutter button of the C330f by moving the lock button on the camera's right side away from the engraved L. The shutter button of the C220 cannot be locked.

The other shutter button of the C330f is in the same position as the only shutter button of the C220—on the camera's right side. The most convenient way is to push it down with your right thumb. You can also expose film with a cable release screwed into the lower shutter button of the C330f or the top right side of the C220.

After Exposure—The shutter button locks after exposure. With the C330f, advance film and the exposure counter by winding the crank one revolution clockwise until it stops just past top center. This also frees the shutter button and cocks the lens shutter automatically. You can shoot again immediately after advancing film.

When using the C220, you only advance film and the exposure counter with the winding crank. After this, you must manually cock the shutter with your left thumb before each exposure. If film is not advanced and the shutter is cocked, or vice-versa, you can't depress the shutter button. This prevents inadvertent multiple exposures.

When the last frame on the roll is exposed with either camera, the shutter button automatically locks and the winding crank can be turned continuously. Wind up the roll with about four complete revolutions of the crank, or until you feel winding tension slacken. If necessary, you can also wind up a partially exposed roll by turning the crank while the shutter button is depressed.

Long Exposures—For exposures longer than one second, use the B setting of the shutter-speed dial. When you push the shutter button, the shutter stays open for as long as your finger remains on the button. For more convenient long-exposure operation, use a locking cable release to keep the shutter open.

Multiple-Exposure Operation—Normally, you can't depress the shutter button after exposure if film has not been advanced, even though the lens shutter is tensioned. This prevents accidental multiple exposures.

However, you *can* trip the shutter again by pushing down on the shutter lever on the taking lens. This will give a multiple exposure, but may create camera shake.

There is a better way to make a multiple exposure: Turn the camera's multiple-exposure selector to MULTI either before or after the first exposure. Now the shutter button is freed after exposure without your having to advance film. With either camera, you must cock the lens manually.

Using the multiple-exposure selector disengages only the double-exposure-prevention device. It does not

Unlock the shutter button of the C330f by sliding the locking button toward the lens.

Support the bottom of the camera with your left hand and steady the right side with your right hand. To make an exposure with the C330f, push one of two shutter buttons. One is on the front of the camera, on the lower right side as viewed from the back. Use your left index finger to push the button.

APPROXIMATE MAXIMUM MAGNIFICATIONS WITH MAMIYA TLR LENSES

Lens*	Closest Subject Distance in.	cm	Approx. Max. Mag.	Max. Parallax Error (mm cutoff)	Exposure Compensation (steps)
55mm	4.6	11.8	0.88	44.0	1-2/3
65mm	5.6	14.2	0.84	42.0	1-2/3
80mm	7.9	20.1	0.66	33.0	1-1/2
105mm DS	17.5	44.4	0.31	15.5	2/3
135mm	29.5	74.9	0.22	11.0	1/2
180mm	40.8	103.7	0.21	10.5	1/2
250mm	64.5	163.9	0.18	9.0	1/2

* Lens set to closest focusing distance.

FLASH SYNC WITH MAMIYA TLR LENSES

Terminal Setting	Flash Type	SHUTTER-SPEED SETTING									
		1	2	4	8	15	30	60	125	250	500
M	M										
X	F										
X	Electronic										

■ Flash will sync. ▨ Flash won't sync.

When you turn the multiple-exposure selector to MULTI, the shutter button is automatically freed after exposure. Cock the lens again manually and expose film. Do not turn the winding crank until you want to advance film. Shown is the C330f; the C220 has a similar selector.

disengage the film-wind mechanism. If you wind the camera crank with the selector at MULTI, you'll advance film and the exposure counter, thus ending the multiple exposure.

After you finish the multiple-exposure, set the selector to SINGLE. Advance film and the exposure counter by turning the winding crank.

Besides using the multiple-exposure feature for multiple-exposure photography, you can also use it to operate the camera without film. I recommend

you do this to familiarize yourself with camera operation before you shoot film. To make the exposure counter work, put an empty film spool in the camera's upper chamber.

Using Flash—The lenses of the system have both M- and X-flash sync. To set the lens for M- or X-sync, set the sync selector opposite the engraved **M** or **X** next to the lens shutter speed dial. Plug the PC cord of the flash into the flash terminal on the viewing lens. An accessory shoe on the camera's left side holds the flash.

The accompanying table shows the shutter speeds that synchronize with various kinds of flash units at both M and X settings. M-type bulbs sync at all speeds when the selector is set to M. Electronic flash units sync at all shutter speeds when the selector is set to X. F- and M-type bulbs do not sync when the selector is set to X.

INTERCHANGEABLE VIEWFINDERS

In addition to the standard waist-level viewfinder, there are four other viewfinders for the C330f and C220. To remove a viewfinder from the camera, loosen the locking screw behind the viewfinder. Pull back on the viewfinder and lift it off.

Attach the new viewfinder by matching the grooves on the front of

After loosening the viewfinder locking screw, lift the viewfinder from the camera. Attach the new finder on the camera's front pins and lower it. Tighten the locking screw.

the hood to the pins on the camera body. Lower the hood in place so the groove in the back of the viewfinder mates with the screw. Tighten the locking screw.

When using a metering viewfinder, you do not have to consider the exposure compensation factor indicated by the camera. The meter automatically compensates for it as long as the light at the film plane is within the metering range. For best exposure, always meter *after* composing and focusing.

When using a filter on the taking lens, you must consider the filter factor before setting exposure controls on the taking lens. See Chapter 5. You can avoid this step by putting the filter over the viewing lens when metering. Put the filter back on the taking lens for the exposure.

Magnifying Hood—This viewfinder shows the image laterally reversed on the focusing screen. It has two built-in magnifiers. With a knob on the side, you can select image magnification of 3.5X or 6X. To help get best focus, the

Using a fast shutter speed, such as 1/500 second, for flash-lit portraiture is a good way to minimize the exposure due to bright ambient light. You can do this only with leaf-shutter lenses.

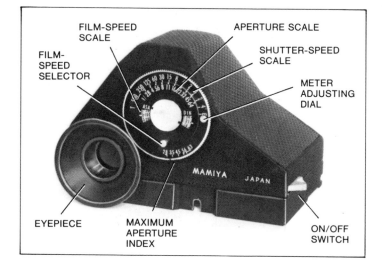

FILM-SPEED SCALE
FILM-SPEED SELECTOR
APERTURE SCALE
SHUTTER-SPEED SCALE
METER ADJUSTING DIAL
EYEPIECE
MAXIMUM APERTURE INDEX
ON/OFF SWITCH

MAMIYA JAPAN

MAMIYA CdS PORROFINDER SPECIFICATIONS

Type: Porroprism metering viewfinder with built-in spot meter using a CdS photo cell. Shows upright, laterally correct image. Meter operates manually by reading a 5.5mm diameter circle on the focusing screen. Adjust the meter's aperture and shutter-speed ring to determine exposure and transfer settings to camera lens. Viewfinder display shows match-needle indicator and location of metering cell. Built-in diopter correction in viewfinder's eyepiece.
Measurement Range: EV 3 to EV 18 at f-2.8 with ASA 100 film.
Film-Speed Scale: ASA 12 to 6400 and DIN 12 to 39.
Working Range: Shutter speeds from 1/500 to 1 second.
Power Source: One 1.5V silver battery (Eveready S-76 or equivalent).
Dimensions: Width 105mm (4.1"), height 66mm (2.6"), depth 85mm (3.3").
Weight: 300g (11 oz.).

viewfinder also has a built-in diopter adjustment.

Prism Finder—This eye-level viewfinder gives an upright, laterally correct image that is 2.5X larger than the focusing screen image. Because of the size of the glass prism, the finder is quite large and heavy. I recommend you use one of the handgrips when you use an eye-level viewfinder on a TLR. It will help you hold the camera steady.

CdS Porrofinder—This eye-level viewfinder uses a *porroprism* to give an upright and laterally correct image. Unlike a solid glass pentaprism, a porroprism uses mirrors in the viewfinder housing. This makes it lighter than a pentaprism.

The built-in CdS exposure meter in this finder uses a 1.5V silver-oxide battery, Eveready S-76 or equivalent. *Do not* use a 1.3V mercury battery with the viewfinder. If you do, the

meter will give bad exposure recommendations. Install the battery in the chamber on the bottom of the finder, with the positive terminal adjacent to the cover.

After attaching the finder to the camera, set the meter for the maximum aperture of the lens. Move the outer ring of the adjusting dial so its red index is opposite the maximum aperture of the lens. Remember to check this every time you change lenses. Set film speed with the inner scale of the adjusting dial. You can set film speeds from ASA 12 to 6400 or DIN 12 to 29. The meter sensitivity range is EV 3 to EV 18 at ASA 100 with an f-2.8 lens.

Turn on the meter with the switch on the right side. When the meter is on, an arm with a CdS cell on the end swings into view. The cell covers a 5.5mm diameter circle in the center of the focusing screen image. This is the metered area, which essentially makes the CdS Porrofinder a spot meter. Point the center of the screen at a consistent midtone and turn the meter's adjusting dial until the match-needle indicator of the viewfinder display is centered in the circle.

When using the 105mm DS lens, make sure the variable aperture of the viewing lens is fully open. Otherwise, you'll get an erroneous exposure recommendation.

The meter is not coupled to the exposure controls on the lens. You must take your eye away from the meter and choose an aperture and f-stop combination aligned on the dial. Transfer these settings to the lens and make the exposure.

To conserve battery power, turn the meter off when you are not using it.

When the finder is detached from the camera, the meter is automatically turned off. Move the camera if the midtone you want to meter is not in the center of the focusing screen image. The meter is designed for on-camera use only.

When using the 55mm or 65mm lens, you must use a parallax correction plate in the viewfinder for best parallax correction. Install it as described previously.

When you view the scene, you'll see three bent lines on the right side of the image. When the pointer, which is now on the right side of the laterally correct image, touches one of these lines, follow the line down. The area above the lower stage of the line is cut off. If the pointer is between two lines, estimate image cutoff. There is no exposure compensation scale because the meter will automatically compensate for any exposure increase if the light is in the meter's range.

CdS Finder—This viewfinder is shaped like the Magnifying Hood, giving an upright, laterally reversed image with an image magnification of 3.4. It has a manually operating CdS meter built in to read a 5.5mm diameter circle in the center of the focusing screen.

The meter has a sensitivity range of EV 3 to EV 18 at f-2.8 with ASA 100 film. It uses two 1.5V silver batteries, such as the Eveready S-76. They fit into a battery chamber on the meter's bottom. *Do not* insert 1.3V mercury batteries. Even though they look similar, they will make the meter work unreliably.

After attaching the viewfinder to the camera, focus the lens to infinity and adjust the eyepiece of the view-

CdS PORROFINDER EXPOSURE DISPLAY

When you turn on a CdS meter of this system, a black arm swings in view. The metering spot is the 5.5mm black circle at the end of the arm.

MAMIYA CdS FINDER SPECIFICATIONS

Type: Rigid hood viewfinder with built-in spot meter using a CdS photo cell. Meter operates manually by reading a 5.5mm diameter circle on the focusing screen. Adjust the meter's aperture and shutter-speed ring to determine exposure and transfer settings to camera lens. Viewfinder display shows match-needle indicator and location of metering cell. Built-in eyecup and diopter correction in viewfinder's eyepiece.
Measurement Range: EV 3 to EV 18 at *f*-2.8 with ASA 100 film.
Film-Speed Scale: ASA 12 to 6400 and DIN 12 to 39.
Working Range: Shutter speeds from 1/500 to 1 second.
Power Source: Two 1.5V silver batteries (Eveready S-76 or equivalent).
Dimensions: Width 95mm (3.7"), height 92mm (3.6"), depth 90mm (3.5").
Weight: 300g (11 oz.).

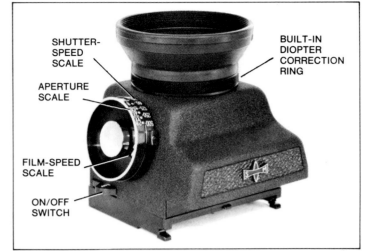

SHUTTER-SPEED SCALE
APERTURE SCALE
BUILT-IN DIOPTER CORRECTION RING
FILM-SPEED SCALE
ON/OFF SWITCH

55,65mm

When the pointer is aligned with the top of the line, follow the line down to the lower stage. The area above this stage is cut off due to parallax error.

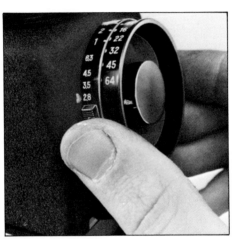

Set maximum lens aperture on the CdS Finder by pulling the shutter-speed ring out and aligning the index with the correct *f*-number.

CdS FINDER EXPOSURE DISPLAY

With a CdS meter of this system, exposure is correct when the match needle is centered in the circle of the exposure display.

finder by moving it up or down until you get the sharpest possible focusing screen image. Before setting film speed, set the meter for the maximum aperture of the lens. Pull the shutter-speed dial out slightly and turn it so the small orange *f*-number on the scale corresponding to the maximum aperture of the lens is aligned with a small index mark on the viewfinder. Be sure to reset this every time you use a lens with a different maximum aperture.

Set film speed by pulling the aperture dial out slightly and turning it so the film speed is aligned with an index mark. The scale is marked for ASA speeds from 12 to 6400 and DIN speeds from 12 to 39.

Turn the meter on. This positions the metering cell, which is connected to a plastic arm of the power switch, at the center of the focusing screen. It reads a very small part of the image, letting you use it like a spot meter. To

meter other parts of the scene, move the camera until the area of interest is in the center of the screen.

Adjust the aperture and shutter-speed scales of the meter until the match-needle in the top of the screen is centered in the circle. Then turn the meter off to prevent unnecessary drain on the battery. When using the 105mm DS lens, make sure the variable aperture of the viewing lens is fully open. Otherwise, you'll get an erroneous exposure recommendation.

The aperture and shutter-speed scales of the viewfinder recommend pairs of settings that you can use to get the same exposure for the metered scene. Set the lens shutter speed and aperture based on these recommendations. The meter is designed for on-camera use only.

When using the 55mm or 65mm lens, you must use a parallax correction plate in the viewfinder for best parallax correction. Install it and use it

as described previously for the waist-level viewfinder. You can ignore the exposure recommendations if the light is within the meter's range.

Diopter Correction Lenses—The eyepiece of the eye-level viewfinders accepts a diopter correction lens to better fit your eyesight if necessary. The lens fits into the eyepiece ring of the viewfinder. Nine are available, in diopter strengths ranging from -2 to +2.5 in 0.5 diopter increments.

To install, turn the eyepiece ring counterclockwise to remove it. Place a positive correction lens into the eyepiece so the flat side faces out. When installing a negative correction lens, have the concave surface face the outside. Screw the eyepiece ring back into the viewfinder.

INTERCHANGEABLE FOCUSING SCREENS

The focusing screen of the C220 is not removable. However, the C330f

After removing the viewfinder and extending the bellows, unlock the frame catch and lift off the focusing-screen frame.

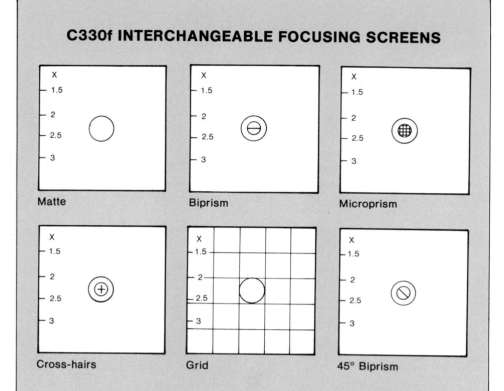

C330f INTERCHANGEABLE FOCUSING SCREENS

Matte

Biprism

Microprism

Cross-hairs

Grid

45° Biprism

accepts six interchangeable focusing screens. In addition to the parallax-correction lines and exposure compensation scale, all incorporate a Fresnel field lens for bright viewing from corner to corner. The standard focusing screen for both the C330f and the C220 is a matte screen with a clear center spot. See the accompanying illustration for other screens.

Before changing screens on the C330f, you must remove the viewfinder. Extend the rack-and-pinion bellows using the camera focusing knobs. This gives the focusing-screen frame catch enough room to swing out when you pull it. The frame catch is at the front of the focusing screen frame. After pulling out the catch, lift up on the frame and pull it back to remove it from the camera.

Install a focusing screen by inserting the rear of the frame into the guide pins on the camera body. Lower the front of the frame in position. Lock the frame catch while depressing the front of the frame. Then replace the viewfinder.

INTERCHANGEABLE GRIPS

To help make hand holding the cameras easier, Mamiya makes six different hand grips. They fasten to the tripod mounting screw on the camera base.

Grip Holder—Two models are available in this design. The simpler one has a handle on the left side of the camera with an accessory shoe on top of the handle. The other grip holder is more convenient because it has a shutter button on the grip that actuates the lower shutter button of the C330f camera. This makes it impractical for the C220. It can also be used with the Mamiya RB67 Pro-S camera.

Multi-Angle Grip—This is similar to the Grip Holder except it has a mova-

This grip holder can also be used with the Mamiya RB67 Pro-S camera, described in Chapter 11.

ble handle and accessory shoe that can be swiveled and secured in a variety of positions. It too works well with the Mamiya RB67 Pro-S but is not practical for the C220.

Pistol Grips—I recommend these grips for eye-level photography. Three models are available. All place the handle below the camera. The handle has a trigger that actuates the shutter button on the camera.

The pistol grip for the C220 has a cable release that connects to the cable-release socket of the camera. The two pistol grips for the C330f use a plate that actuates the camera's shutter button. The Model II pistol grip can also be used with flash-gun brackets and with the RB67 Pro-S.

The Model II pistol grip makes eye-level viewing with the C330f much easier.

The Multi-Angle Grip lets you swivel both the accessory shoe and the handle.

10
Mamiya M645 System

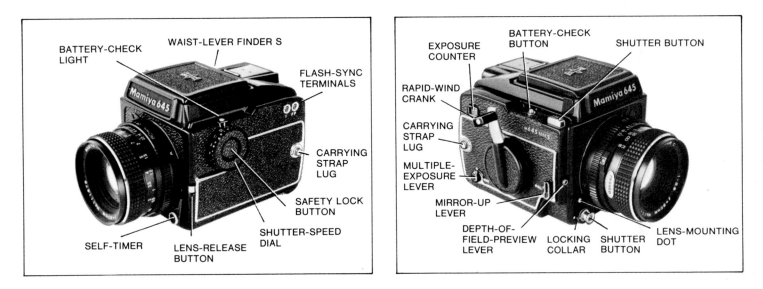

Mamiya was the first camera manufacturer in recent years to design a camera and system around the 4.5x6 cm format, known in Japan as the 6x4.5 cm format. This was the first-generation M645 SLR camera introduced in early 1975.

Its popularity stimulated expansion of the system so that today the M645 system includes three cameras and a wide range of interchangeable accessories. The cameras are the M645 1000S (shown above), the M645, and the M645J. They are nearly identical, differing only in the number of features available. These differences are mentioned as aspects of the system are described.

The M645 1000S is the most versatile of the three cameras. It has a top shutter speed of 1/1000 second, a locking shutter-speed dial, a depth-of-field preview lever, and a self-timer. The M645 is identical to the 1000S

except for these four features. The M645J is a lower priced version of the M645, with one shutter button instead of two, fewer shutter speeds, and no mirror-lockup. Unless otherwise mentioned, the camera descriptions in this chapter apply to all three models.

M645 cameras give 15 or 30 42x56 mm images on 120 or 220 film respectively. Each camera is compatible with standard interchangeable accessories, including lenses, film inserts, viewfinders, focusing screens, close-up equipment, and grips.

MAMIYA M645 1000S CAMERA SPECIFICATIONS

Type: 4.5x6 cm single-lens reflex with instant-return mirror.
Shutter: Electronically controlled focal-plane type with shutter speeds from 1/1000 to 8 seconds, plus B. X-sync at 1/60 second. FP-sync also available.
Standard Lens: Mamiya-Sekor C 80mm *f*-1.9 or *f*-2.8 lens.
Film: 15 or 30 exposures with 120 or 220 film loaded on special inserts.
Power Source: 6V silver-oxide battery (Eveready No. 544 or equivalent).
Other Features: Interchangeable lenses, viewfinders, and focusing screens. Multiple-exposure-lever, battery check, accessory power winder and grips, two shutter release buttons, self-timer, mirror-lockup lever, shutter-dial lock, depth-of-field preview lever.
Dimensions: Width 99mm (3.9"), height 80mm (3.1"), depth 110mm (4.3").
Weight: 1.4kg (3.1 lbs.).

LENSES OF THE M645 SYSTEM

The lenses are made by Mamiya-Sekor and labeled C for multicoated. All have automatic, full-aperture metering. Because the cameras have a focal-plane shutter, the lenses work like those for 35mm SLR cameras. The only major difference, of course, is size. The accompanying lens table shows main features of the lenses. Special lenses are discussed here.

24mm *f*-4 Fish-Eye—This lens uses ultra-low-dispersion glass for improved image quality. It gives typical fish-eye distortion and has a 180° diagonal angle of view. The image fills the frame. You can't use regular lens hoods or filters. Instead, a cutaway lens hood and a four-filter ring are built into the lens.

Select a filter by turning the knurled ring located on the rear of the lens hood. This rotates a disc inside the lens that has four filters in it. Each filter setting has a firm detent so you won't accidentally put a filter partway in front of the lens element. The name of the filter you select is visible in color through a window on the top of the lens hood: SL-1B, Y48(Y2), O56(O2), LB-A(81C).

70mm *f*-2.8 Leaf-Shutter—This is the only lens of the system that has a built-in leaf shutter. When you use the leaf shutter, you can get flash sync with all shutter speeds of the lens, from 1/30 to 1/500 second.

It has a diagonal angle of view slightly larger than the normal 80mm lens, so you can use it as a normal lens for both focal-plane and leaf-shutter operation. Using the lens both ways is described beginning on page 102.

80mm *f*-4 Macro—By itself, this close-up lens gives a maximum image magnification of 0.5. When it is used with the Auto Macro Spacer, which adds 40mm of extension, you can get magnifications from 0.5 to 1.0.

The lens uses floating elements to give good image sharpness and flatness of field throughout the magnification range. Using it for close-up shooting is described beginning on page 104.

145mm *f*-4 Soft-Focus—This lens has built-in controls for selecting varying degrees of spherical aberration to soften the image while still retaining focus. Its focal length is slightly longer than normal, making it an effective portrait lens. You can use it without any soft-focus effect.

You control the soft-focus effect with the lens aperture and the Softness Control Ring at the front of the lens. On the ring you'll see five colored dots of different sizes, a reminder of the degree of soft focus each setting gives. The large orange dot gives the most effect and the small blue dot the least.

To use the lens without the soft-focus effect, set the aperture to *f*-8 or a smaller opening. Turn the softness control ring so the blue dot is aligned with the center index mark, which is red. Focus the lens and read subject distance across from the blue distance-scale index mark.

For the maximum soft-focus effect, set the orange dot across from the red

MAMIYA M645 CAMERA SPECIFICATIONS

Type: 4.5x6 cm single-lens reflex with instant-return mirror.
Shutter: Electronically controlled focal-plane shutter with speeds from 1/500 to 8 seconds, plus B. X-sync at 1/60 second. FP-sync also available.
Standard Lens: Mamiya-Sekor C 80mm *f*-1.9 or *f*-2.8 lens.
Film: 15 or 30 exposures with 120 or 220 film loaded on special inserts.
Power Source: 6V silver-oxide battery (Eveready No. 544 or equivalent).
Other Features: Interchangeable lenses, viewfinders, and focusing screens. Multiple-exposure lever, battery check, accessory power winder and grips, two shutter buttons, mirror-lockup lever.
Dimensions: Width 99mm (3.9"), height 80mm (3.1"), depth 110mm (4.3").
Weight: 1.3kg (2.9 lbs.).

MAMIYA M645J CAMERA SPECIFICATIONS

Type: 4.5x6 cm single-lens reflex with instant-return mirror.
Shutter: Electronically controlled focal-plane shutter with speeds from 1/500 to 1 second, plus B. X-sync at 1/60 second. FP-sync also available.
Standard Lens: Mamiya-Sekor C 80mm *f*-1.9 or *f*-2.8 lens.
Film: 15 or 30 exposures with 120 or 220 film loaded on special inserts.
Power Source: 6V silver-oxide battery (Eveready No. 544 or equivalent).
Other Features: Interchangeable lenses, viewfinders, and focusing screens. Multiple-exposure lever, battery check, accessory power winder and grips, one shutter button.
Dimensions: Width 99mm (3.9"), height 80mm (3.1"), depth 110mm (4.3").
Weight: 1.3kg (2.9 lbs.).

MAMIYA SEKOR C LENSES FOR M645 CAMERAS

Lens	Minimum Aperture	Diag. Angle of View	Minimum Focus Distance ft.	Minimum Focus Distance m	Weight oz.	Weight g	Filter Size (mm)
24mm *f*-4 Fish-Eye	*f*-22	180°	1.0	0.30	28	785	Built-in
35mm *f*-3.5	*f*-22	90°	1.5	0.46	16	445	77
45mm *f*-2.8	*f*-22	76°	1.5	0.45	17	470	67
55mm *f*-2.8	*f*-22	65°	1.5	0.45	12	333	58
70mm *f*-2.8 Leaf-Shutter	*f*-22	53°	2.8	0.85	14	395	58
80mm *f*-1.9	*f*-22	47°	2.3	0.70	15	420	67
80mm *f*-2.8	*f*-22	47°	2.3	0.70	9	255	58
80mm *f*-4 Macro	*f*-22	47°	0.6	0.18	21	585	67
110mm *f*-2.8	*f*-22	35°	4.0	1.2	14	390	58
145mm *f*-4 Soft-Focus	*f*-32	27°	5.0	1.5	32	900	77
150mm *f*-3.5	*f*-32	26°	5.0	1.5	15	420	58
210mm *f*-4	*f*-32	19°	8.0	2.4	25	715	58
300mm *f*-5.6	*f*-32	13°	13.0	4.0	25	710	58
500mm *f*-5.6	*f*-45	8°	30.0	9.1	80	2280	105
105mm-210mm *f*-4.5 Zoom	*f*-32	37°-19°	8.0	2.4	43	1220	77

index mark and use an aperture of *f*-4. For minimum effect, use the blue-dot setting and an aperture of *f*-5.6. You can vary the degree of soft focus continuously between these extremes by using settings between the dots, by selecting any aperture between *f*-4 and *f*-8, or both.

To adjust the lens for soft-focus effects, set the Softness Control Ring and lens aperture for the effect you desire—maximum, minimum, or in between. To find best focus, with the lens A/M lever set to **A**, pull the focusing ring toward the camera and turn it to focus. This stops the lens down to about *f*-6.3, largely eliminating the soft-focus effect.

To preview the effect or to check depth of field, set the A/M lever to **M** to stop down the lens. Then adjust the lens aperture and the Softness Control Ring to change the degree of soft focus if necessary. After finding the best effect, reset the A/M lever to **A** for full-aperture metering.

Mamiya recommends the matte or grid-line focusing screens with this lens. The other focusing screens have a biprism or microprism, which tend to blur and make focusing difficult.

To find subject distance from the distance scale on the lens, read the distance opposite the distance-scale index mark that is the same color as the dot indicating the selected soft-

Find subject distance from the 145mm Soft-Focus lens by using the distance-scale index that is the same color as the dot across from the red index line. In this example, subject distance is 4m (12 feet). When focusing, pull on the focusing ring, as shown here, to stop down the lens and get a sharper image.

focus effect. For example, if you set the white dot across from the red index mark, read the focused subject distance opposite the white line.

When you change the setting of the softness control ring, you must refocus because the lens elements have moved. Because of the complex lens design, no depth-of-field scale is on the lens. Judge depth of field visually by setting the A/M lever to **M** and looking through the viewfinder.

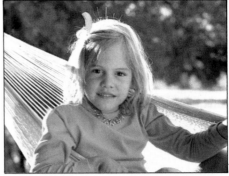

Soft-focus effects work well with backlit scenes. For this series a square Larson Reflectasol bounced 5:00 PM sunlight toward the subject. No soft-focus effect is evident in this photo because the lens aperture was between *f*-8 and *f*-11.

Minimum soft-focus in this photo was created by the blue-dot setting and an aperture between *f*-5.6 and *f*-8.

For an intermediate effect I used the red-dot setting and an aperture between *f*-4 and *f*-5.6.

The maximum soft-focus effect occurs at the orange-dot setting and an aperture of *f*-4. Because the effect varies with respect to subject, lighting conditions, and lens settings, I suggest you try a variety of lens settings until you are better able to predict a certain result on film.

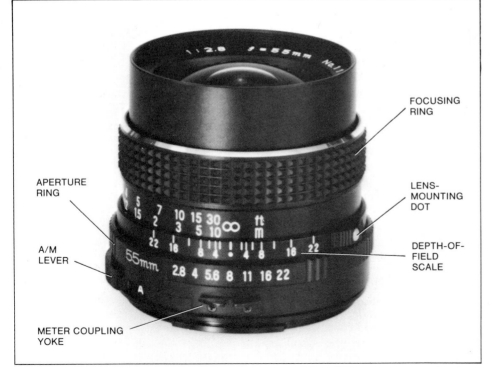

FOCUSING RING

LENS-MOUNTING DOT

DEPTH-OF-FIELD SCALE

APERTURE RING

A/M LEVER

METER COUPLING YOKE

Mamiya lenses for the M645 system are similar to those for 35mm SLR cameras, except for size.

After doing these steps, meter the scene. If you use a metering viewfinder, the A/M lever *must* be set to A for correct metering. If you use an accessory hand-held meter, the lever can be set to A or M.

MOUNTING LENSES

Lenses attach quickly and easily with a three-claw bayonet mount. The camera can be cocked or uncocked before you mount the lens. No meter coupling is necessary unless you use a metering viewfinder.

To mount a lens, align the red plastic dot of the lens with the red plastic dot of the camera body. Turn the lens 45° clockwise until it clicks in place.

To remove the lens, push the lens-release button on the front-left side of the camera—as viewed from the back—while turning the lens 45° counterclockwise until it stops.

To mount a lens, line up the two red mounting dots, seat the lens in the mounting flange, and turn the lens clockwise.

Remove a lens by pushing the lens-release button and turning the lens counterclockwise. With practice, you can do it with one hand.

FILTERS AND LENS ATTACHMENTS

Each lens, except for the 24mm fish-eye, accepts screw-in filters. The accompanying table shows filter size for the lenses. Mamiya makes filters of high-quality optical glass in 58mm, 77mm, and 105mm diameters.

Mamiya does not make 67mm filters for the 80mm Macro and the

MAMIYA FILTERS FOR THE M645 SYSTEM

Film	Filter Name	Color	Approx. Filter Factor	Sizes (mm)	Use
B&W	SY48 (Y2)	yellow	2X	58, 77, 105	Absorbs UV and some blue to increase tonal contrast between clouds and sky.
	YG	yellow-green	2X	58, 77, 105	Absorbs blue and some red for masculine portraiture and lightening foliage.
	SO56 (O2)	orange	3X	58, 77, 105	Absorbs more blue than SY48 and penetrates haze better for stronger tonal contrasts in landscapes.
Color	SL (skylight)	pink	1X	58, 77, 105	Absorbs UV and excess blue of open shade.
	81C	yellow	1.5X	77	Absorbs excess blue on cloudy days.
	82C	blue	1.5X	77	Absorbs excess red of morning or evening sunlight.
Any	PL (polarizer)	gray	2X-4X	77	Eliminates reflections and increases tonal contrasts and color saturation.
	ND16	gray	16X	77	Reduces light reaching the film by 4 steps without changing color balance.
	UV	clear	1X	58, 77, 105	Absorbs UV to prevent excess blue in color photo or hazy effect in b&w film. Also protects the lens.

80mm *f*-1.9 lenses. Any screw-in filter having this threaded diameter can be used with these lenses.

Bellows Lens Hood—This adjustable lens shade is a bellows that you can use for each lens from 55mm to 300mm. Attach the hood to the lens by securing it to a 58mm or 67mm adapter that screws into the lens.

A slot in the rear of the hood accepts 75mm (3-inch) square gel filters. The front of the hood holds a mask for use with the 150mm, 210mm, and 300mm lenses. It restricts the opening of the hood to the field of view of the lens.

An accessory slide-copy attachment fits on the front of the hood and accepts transparencies. It holds film-carrier masks behind a frosted piece of plastic so you can copy transparencies onto the 4.5x6 cm image. The left side of the track is marked for the extension of the bellows lens hood.

Focusing Handle—Attach this accessory over the lens focusing ring and tighten the set screw. The handle lets you focus quickly and accurately for action photography. It fits on all lenses from 55mm to 300mm, except for the 70mm leaf-shutter and 80mm *f*-1.9 lenses.

Lens Hoods—Soft-rubber lens hoods are supplied with lenses from 45mm to 110mm. Lenses longer than this, and the 80mm macro, come with built-in hoods. The lens hood for the 45mm wide-angle lens is the same hood for the 65mm wide-angle lens of the Mamiya RB67 Pro-S system.

THE BATTERY

The camera uses an Eveready No. 544 6V silver-oxide battery, or equivalent, to power the electronically-regulated focal-plane shutter and the metering viewfinders. The shutter circuit uses capacitors to time the shutter and activate mechanical operations. Most electronic shutters have an electromagnetic circuit to hold the shutter open during exposure. These shutters use much more electricity per exposure.

Because of its shutter design, the M645 shutter circuit drains very little battery power. One battery has enough energy for about 100,000 exposures. If you use the PD Prism S or AE Prism viewfinder for each exposure, the battery has enough power for about 5000 exposures.

The battery-check button is on the top-right side of the camera. If you push this red button and the battery is still good, a green LED above the shutter-speed dial glows. If the LED does not glow, the battery should be replaced.

The battery-check light can also be the shutter-speed index for the cameras' shutter-speed dial.

Dead Battery—If you push the shutter button when the battery is dead, the shutter will open, but not close. To close the shutter when this happens, push the battery-check button down firmly.

Changing the Battery—The battery chamber is in the bottom of the camera. The cover is clearly labeled with the type and brands of battery you should use. Open the cover and remove the dead battery.

Replace it with a fresh one. Observe battery polarity because a fresh battery installed backward won't work. Close the cover and press the battery-check button to test the battery.

LOADING FILM

M645 cameras do not accept interchangeable backs. They use preloadable 120 and 220 inserts. The exposure counter is built into the camera body.

To open the back of the camera and remove the insert, push inward on the back cover memo clip while moving the Back-Cover Latch in the direction of its inscribed white arrow. The back cover opens from the top and swings down. Remove the insert by squeezing both sides of its Release Latch—which is labeled either **120** or **220**—and pulling on the insert.

Open the back of the camera by pushing the memo clip and moving the lever to the right.

To remove the film insert, squeeze the sides of the release latch and pull the insert out.

When the insert is removed from the camera, the camera exposure counter returns to **S**. For this reason you should not change inserts in the middle of a roll. If you do, the exposure counter "thinks" you are loading a fresh roll, and you'll waste some frames when you then advance the counter to frame one.

Open the spool clips on the left side of the insert and put the empty take-up spool into the bottom chamber. Close the spool clip to secure the empty spool. Insert the unexposed roll into the top chamber and close the clip. Draw out the paper leader so its black side faces away from the

pressure plate. Insert the tapered leader into the empty spool. Rotate the end of the take-up spool to advance the leader until the start mark on the paper leader aligns with the red **START** mark on the side of the top spool clip.

Put the loaded insert into the camera by squeezing both sides of the release latch and inserting it with the unexposed roll on top. You can't put it in upside down. Then push the outer sides of the insert to lock it in place. If the insert does not go in all the way, turn the camera's winding crank slightly while pushing in the insert.

Close the back cover and turn the winding crank about six revolutions to advance the film and exposure counter to the first frame. The exposure counter will show 1 and the crank will stop automatically.

If you can keep turning the crank after six revolutions, the multiple-exposure mechanism is probably engaged and film is not advancing. The multiple-exposure lever is on the lower right side of the camera body. Make sure its white dot is aligned with a white dot on the camera and not the word **MULTI**.

To advance the paper leader, roll the take-up spool until the start marks are aligned.

Loading Film Incorrectly—Because the insert automatically sets the exposure counter for either 15 or 30 frames, you should not load 120 film in a 220 insert or vice-versa. Doing it causes problems.

If you load 220 film in a 120 insert, the shutter button locks after exposure 15. You must wind up the rest of the roll with the film-winding crank. In addition, the pressure plate is set for the thickness of film and paper leader, so it will not hold 220 film as flat as possible. If you load 120 film in a 220 insert, the paper backing could get caught in the focal-plane shutter and damage the camera.

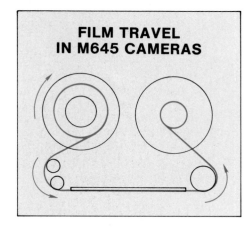

FILM TRAVEL IN M645 CAMERAS

CAMERA OPERATIONS

Before loading and exposing film with an M645 camera, I suggest that you familiarize yourself with camera operations by using it without film. To use the shutter button when no film is in the camera, move the multiple-exposure lever so its white dot is aligned with the word **MULTI**.

Now the winding crank will cock the camera with every revolution, and the shutter button trips the shutter. Only the exposure counter does not work. Before loading film, be sure to move the multiple-exposure lever back to its vertical position.

Exposure Controls—If you are not using a metering viewfinder, determine the exposure settings with an accessory hand-held meter, as described in Chapter 5. Set the *f*-stop on the lens. The aperture ring has detents every full step.

Set shutter speed on the camera shutter-speed dial. Align the desired speed with the white dot on the camera body. The shutter-speed dial of the M645 1000S has a safety lock button in its center. Depress the button to turn the dial and release it after setting the speed.

The other two M645 cameras do not have this safety device, but the detents of the dial are firm enough to prevent accidental movement. Do not set the shutter-speed dial of any camera between marked speeds.

Green numbers on the dial represent full seconds. All other numbers are fractional speeds. Orange fractional speeds are from 1/15 to 1/2 second. Faster speeds are in red.

The three cameras have different shutter-speed ranges. The M645 1000S has a range from 1/1000 to 8 seconds. The M645 also goes to 8 seconds, except its top speed is 1/500

second. The range of the M645J is the shortest, from 1/500 to 1 second. All have a **B** setting.

Another setting of the shutter-speed dial is a red circle with a dot in the center—⊙. This setting is used for time exposures and for coupling the PD Prism and AE viewfinders to the camera. Using it is described in more detail later.

Viewing and Handling—Focus the lens with the knurled ring on the lens barrel. With all lenses you can view depth of field by moving the A/M lever on the left side of the lens to **M**. This stops down the lens to the selected aperture. Use this method also for stopped-down metering. Moving the lever back to **A** makes the automatic aperture function again.

Only the M645 1000S has a depth-of-field preview lever. It is conveniently located on the front of the camera. To stop down the lens, push up on the lever when the A/M lever is set to **A**. The aperture stays stopped down as long as you push on the lever.

With any camera and lens combination you can stop down the lens aperture to visually check depth of field. Turn the A/M lever to M.

Only the M645 1000S has a spring-loaded depth-of-field lever on the camera.

Both the M645 1000S and the M645 cameras have two shutter buttons. One is on the front and the other is on the top right side of the camera, as viewed from the back. The M645J has one shutter button on the front of the camera.

When holding any of the cameras for horizontal-format photos, support the camera with your left hand so your left index finger is on the front shutter button. Your right hand is then free to operate camera controls and steady the side of the camera during exposure. If the handle of the crank is between your fingers, you can cock the camera with one smooth revolution.

For vertical-format photos, support the camera with your left hand and use your right index finger to push the top shutter button. Mamiya offers various grips that make both horizontal- and vertical-format photos much easier. These are described later.

When holding an M645 camera horizontally, your left index finger will naturally be in front of the bottom shutter button.

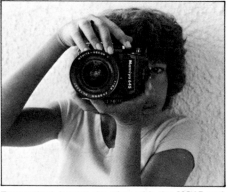

For vertical-format shooting with the M645 and M645 1000S cameras, use your right index finger to push the top shutter button. Notice how the handle of the winding crank is between the photographer's fingers.

Exposing Film—Before you can push the shutter button to expose film, the front shutter button must be unlocked. Turn the knurled collar of the front shutter button clockwise so its white dot aligns with the white dot on the body. Turning the collar so its red dot is aligned with the camera's white dot locks the button. This will also lock the top shutter button of the M645 and M645 1000S cameras.

When you push the shutter button to expose film, the camera operates like any 35mm SLR camera with an instant-return mirror. After exposure, the winding crank is free and the shutter button locks. Wind the crank one complete revolution until it stops. This advances the film and the exposure counter and also frees the shutter button for the next exposure.

When you have exposed the maximum number of frames for the film you are using, the shutter button automatically locks and the winding crank is freed. Wind up the roll with about three revolutions of the crank. The tension in the crank lessens noticeably when the roll is wound up.

Multiple-Exposure Operation— When the multiple-exposure lever is aligned with the word MULTI, the double-exposure-prevention mechanism is disengaged. This lets you cock the camera shutter by winding the crank without advancing either the film or the exposure counter.

You can set the lever to MULTI either before or after the first exposure of the multiple-exposure sequence. As long as the lever is down, you can cock the shutter and expose the frame any number of times. You can change lenses or camera position between exposures because the mirror comes down after each exposure.

After the last exposure of the multiple-exposure sequence, flip the lever back to the white dot. The next turn of the winding crank will advance film and the frame counter.

body in front of the winding crank. After focusing on the subject, lock the mirror up by moving the lever from its vertical position to its horizontal position. You can do this before or after cocking the shutter.

Only the M645 and M645 1000S cameras have a mirror-lockup lever. Push it down to lock up the mirror.

Expose film by pushing the shutter button or use a cable release screwed into the front shutter button. The mirror does not swing down after exposure or when you wind the crank to cock the shutter. It stays up until you move the mirror-lockup lever into its vertical position.

Long Exposures— The M645 1000S and the M645 cameras allow long camera-controlled shutter speeds up to 8 seconds. The longest camera-controlled shutter speed of the M645J is 1 second. If you need to make an exposure longer than these, you can use one of three time-exposure methods.

When you set the shutter-speed dial to B, the shutter will stay open as long as you depress the shutter button. Or,

you can use a locking cable release to hold the shutter open.

Another way is to remove the camera battery before exposure. Then you can set the shutter-speed dial to any setting. When you push the shutter button, the mirror swings up and the shutter opens. It will stay open until you press the battery-check button firmly. Obviously, this method does not drain the battery at all. Put the battery back in the camera for normal camera operation.

With the third method, you set the shutter-speed dial to ⊙. When you push the shutter button, the mirror swings up and the shutter stays open, draining the battery. The battery can lose all of its power after several hours, so don't use this method too often or for too long. Close the shutter by moving the shutter-speed dial to B or 1000. With the M645 or M645J, turn the shutter-speed dial to B or 500.

Self-Timer— An audible self-timer is built into the M645 1000S camera to give a time delay between 5 and 10 seconds before exposure. The timer is on the front of the camera.

Rotate the timing lever after advancing film and cocking the shutter. If you rotate the lever 90° clockwise, the time delay is 5 seconds. Rotating it a full 180° gives a delay of 10 seconds. You can get a time delay between these settings, but rotating the lever less than 90° will not cock the delay mechanism.

The timing lever springs back to its original position when you let go of it,

All M645 cameras have a multiple-exposure lever. Push it down to make multiple exposures.

Mirror-Up Exposures— The reflex mirror is heavily damped when it swings up, but you can further reduce the possibility of camera shake during exposure by locking the mirror up before exposure. The mirror-lockup lever is on the right side of the camera

A long and short exposure made this photo. The streaks of light are due to the long, camera-controlled shutter speed of 8 seconds. An on-camera flash illuminated the foreground. The M645 1000S camera with 24mm fish-eye lens was mounted to the car's rollbar.

Here the timing lever is set for a time delay of 10 seconds. The other center line represents 5 seconds.

exposing a small activating lever. Push the activating lever in the direction of its engraved arrow to start the time delay. During the time delay, the top shutter button will move downward. Do not advance film until the button springs back to its normal position.

You can stop the time delay before the exposure by moving the timing lever back to intercept the moving activating lever.

Start the time delay by pushing the small activating lever.

If the camera is not cocked before you start the timer, the activating lever will start to move when you push it, then it will stop. Reset the timing lever, cock the camera, and start the timer again by pushing the activating lever. If you cock the camera before resetting the lever, the timer begins operating again as soon as the film is advanced. It will trip the shutter when the delay is finished, possibly before you are ready for the exposure.

If you use the self-timer with the B setting of the shutter-speed dial, a shutter speed of about three seconds results.

INTERCHANGEABLE VIEWFINDERS

Mamiya does not supply a viewfinder as standard equipment on the M645 cameras. You can choose among the following viewfinders. Each camera can use any viewfinder. They are easy to attach and remove.

Before attaching a viewfinder, make sure the white dot of the Finder Release Button points straight up. If it is aligned with the white dot of the viewfinder, press the button and let go. It will automatically spring into the up position. When the dot points up, the button can't be depressed. It acts as a lock when you attach the viewfinder to the camera.

Lower the back of the viewfinder onto the camera body and slide it forward until it stops. Then lower the front of the viewfinder until it clicks and locks in place.

Remove a viewfinder by turning the release button 60° clockwise to align the white dots of the button and finder. Push the button in while lifting the viewfinder from the camera.

Turn the release button clockwise to align the dots, then push in the button.

With the button still depressed, lift up on the finder.

To use the Waist-Level Finder S as a sportsfinder for the 110mm, 150mm, or 210mm lenses, attach the plastic auxiliary mask to the wire frame.

Waist-Level Finder S—This lightweight viewfinder is actually two finders in one. To use it as a waist-level finder, pull on the opening flange of the top. The hood springs open, revealing the focusing screen, which shows 80% of the laterally reversed image.

To raise the built-in 1.3X magnifier, push its release button on the right side of the open hood. The magnifier uses a -1.5 diopter lens. Five other lenses of +1 to -3 diopters are also available to better fit your eyesight, if necessary.

To use the viewfinder as a sportsfinder, close the hood by pushing on its sides and folding it back down. Then raise the eyepiece located on the top of the folded hood. Unfold the eyepiece so the sight is vertical. The wire frame of the sportsfinder is folded over the top of the folded hood. Lift it up to use it.

The sportsfinder shows 80% of the field of view of the standard 80mm lens. To use the 110mm, 150mm, or 210mm lenses, attach the plastic auxiliary mask to the wire frame. It has markings that indicate 80% of the field of view of the three lenses. Visually place the center dot of the mask in the circular sight to view the scene most accurately.

Without the mask on the wire frame, you can easily open the folded hood to check focus. If you need to open the hood while the mask is attached to the frame, pull on the bottom of the frame to use the second set of clips, which tilt the mask away from the hood. This gives the hood the extra room it needs to open, but does not significantly change the field of view you sight. If necessary, you can fold the frame and mask in this configuration over the folded hood.

Waist-Level Finder—This viewfinder is the same as the Waist-Level Finder S except that it doesn't have a built-in sportsfinder.

Prism Finder—This viewfinder shows 94% of the image, upright and laterally correct. Viewfinder magnification is 0.74. Use it for eye-level viewing when you don't need to meter through the lens. It also has a hot shoe and interchangeable correction lenses in a range of +2 to -3 diopters. The following prism viewfinders also have these features.

PD Prism Finder S—This metering viewfinder uses silicon photo diodes and an LED exposure display for fast, accurate, center-weighted metering, even in low light. It has a sensitivity range of EV -1.15 to EV 19 with ASA 100 film and an ƒ-1.9 lens.

The meter uses electrical power from the camera battery through two gold-plated electrical contacts in the viewfinder and body. Before or after attaching the viewfinder to the camera, turn the camera shutter-speed dial until the red ⊙ is aligned with the shutter-speed index. This connects the shutter circuit of the camera to the viewfinder's meter and turns the meter on.

Turn the aperture ring of the lens until its meter coupling yoke engages the coupling pin of the viewfinder. Make sure the pin is centered in the yoke. If it isn't, use a pencil to push the pin into the center of the yoke.

Lift the ASA dial and turn it to set an ASA speed from 25 to 6400. The setting is visible in the window next to the dial. Set the A/M lever of the lens to A for full-aperture metering.

To view the LED exposure display, push a small white button on the side

To couple the lens aperture ring to the metering finders, mate the meter coupling yoke of the lens with the finder's coupling pin. This sets the meter for the maximum lens aperture.

of the viewfinder. The display will operate for 15 seconds after you push the switch. This is usually enough time to set the camera controls. Then it turns off to save battery power. However, the meter is still on and measuring light.

Turning the camera shutter-speed dial to any setting other than ⊙ turns off the meter. When the meter is off and you push the shutter button, exposure time is controlled by the set-

To turn the meter on and connect it to the camera's shutter-timing circuit, set the camera's shutter-speed dial to ⊙. With the M645 1000S, you set the shutter-speed dial by pushing its center locking button and turning the dial.

ting of the camera shutter-speed dial.

To meter, adjust the aperture ring on the lens and the shutter-speed dial on the viewfinder until the center LED of the exposure display glows green. The finder shutter-speed dial has detents every step from 1/1000 to 8 seconds. Because the dial can be turned continuously either way, there is a very firm detent when you turn the dial from 1/1000 to 8 seconds. Do not set the dial between the standard shutter speeds. Use the aperture ring for exposure adjustments smaller than one step.

The exposure display is seven rectangular LEDs—six red and one green. When the center green LED glows, exposure is correct. When one of the red LEDs glows, the exposure settings will give under- or overexposure. The three LEDs above the center represent one, two, and *three or more* steps of overexposure. The bottom LEDs represent one, two, and *three or more* steps of underexposure. This makes metering nonaverage

PD PRISM FINDER S EXPOSURE DISPLAY

When exposure is correct, the center LED glows green. One of the other six LEDs glows red if exposure is incorrect.

MAMIYA PD PRISM FINDER S SPECIFICATIONS

Type: Center-weighted averaging pentaprism viewfinder using silicon photocells. Shows 94% of the image magnified 0.74X. Meter works manually with an electronic shutter control circuit operated with a shutter-speed dial on the viewfinder. LED display shows correct exposure and one, two, or three steps of under- or overexposure. Built-in hot shoe and eyecup.
Measurement Range: EV -1.15 to EV 19 with ASA 100 film and ƒ-1.9 lens.
Film-Speed Scale: ASA 25 to 6400.
Working Range: Shutter speeds from 1/1000 to 8 seconds.
Power Source: Camera battery.
Dimensions: Width 75mm (2.9"), height 57mm (2.2"), depth 120mm (4.7").
Weight: 426g (15 oz.).

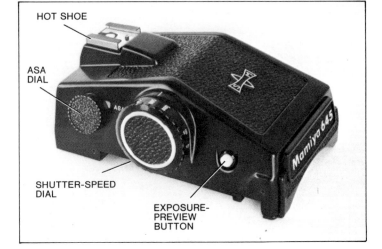

HOT SHOE

ASA DIAL

SHUTTER-SPEED DIAL

EXPOSURE-PREVIEW BUTTON

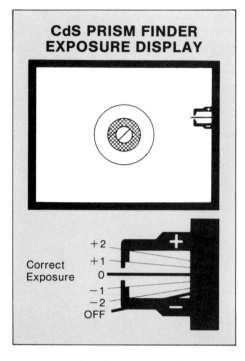

CdS PRISM FINDER EXPOSURE DISPLAY

Correct Exposure

+2
+1
0
−1
−2
OFF

scenes easier because you can set shutter speed and aperture for accurate under- or overexposure, relative to the recommended settings.

If you use the top or bottom LED to indicate three steps of compensation, first adjust the exposure settings to give a two-step compensation. Then adjust aperture or shutter speed one more step to make the third LED glow.

CdS Prism Finder—Because this center-weighted metering viewfinder uses a CdS cell, it has a slightly shorter sensitivity range than the PD Prism S viewfinder. Its range is from EV 2.85 to EV 17 with an f-1.9 lens and ASA 100 film.

The meter uses its own 1.5 silver-oxide battery, Eveready S-76 or equivalent. The battery chamber is next to the finder eyepiece and has a screw-in cover. Position the battery's positive terminal so it touches the back cover, or the meter won't work.

When you install a lens on the camera, make sure you engage the coupling pin and yoke of the finder and lens. This connection couples the meter to the entire aperture range of the lens. Set the A/M lever of the lens to A for full-aperture metering.

Set film speed by lifting the finder's ASA dial and turning it to set an ASA speed between 25 and 6400 opposite the index next to the window. Turn the meter on with the switch next to the ASA dial.

Adjust the lens aperture ring and the meter's shutter-speed dial to center the match-needle indicator, visible in the viewfinder. When it is centered, exposure is correct, but you can also use it to determine under- and overexposure settings of one or two steps, as shown in the accompanying illustration.

When the needle gives the appropriate indication, set the camera's shutter-speed dial to the same setting shown on the viewfinder's shutter-speed dial. This is very important because the dials are not coupled. The viewfinder dial is coupled only to the meter and does not set the camera's shutter speed. Do not use in-between settings with either shutter-speed dial.

Because you must adjust two shutter-speed dials when using this meter, I recommend that you use shutter priority. Set the shutter speed you want to use on the camera and viewfinder dial. Then use the lens aperture ring to center the needle.

For candid people photography, I prefer the convenience of a metering viewfinder because it lets me respond to a changing scene quickly.

When the light is at the low-light limit of the meter's sensitivity range, the viewfinder's shutter-speed dial locks. This prevents you from using a shutter speed that will give an unreliable meter reading.

AE Prism Finder—For aperture-preferred, automatic-exposure metering, use this viewfinder. It has a sensitivity range from EV 2.85 to EV 17 when used with ASA 100 film and an f-1.9 lens. The meter uses battery power supplied by the camera through two gold-plated electrical contacts in the viewfinder and camera body. Do not use this meter with leaf-shutter operation of the 70mm leaf-shutter lens, described later.

Before attaching the viewfinder to the camera, set the camera shutter-

HOT SHOE

SHUTTER-SPEED INDEX

ASA DIAL

SHUTTER-SPEED DIAL

POWER SWITCH

ON OFF

MAMIYA CdS PRISM FINDER SPECIFICATIONS

Type: Center-weighted averaging pentaprism viewfinder using CdS photocells. Shows 94% of the image magnified 0.74X. Meter operates manually with a shutter-speed dial on the viewfinder. After centering the match-needle indicator in the viewfinder, set the shutter speed on the camera. Match-needle indicator also shows one or two steps of over- or underexposure. Built-in hot shoe and eyecup.

Measurement Range: EV 2.85 to 17 with ASA 100 film and f-1.9 lens.

Film-Speed Scale: ASA 25 to 6400.

Working Range: Shutter speeds from 1/1000 to 1 second.

Power Source: One 1.5V silver-oxide battery (Eveready S-76 or equivalent).

Dimensions: Width 75mm (2.9"), height 57mm (2.2"), depth 120mm (4.7").

Weight: 426g (15 oz.).

AE PRISM EXPOSURE DISPLAY

speed dial to ⊙. Attach the meter to the camera as described and turn the aperture ring to couple the yoke of the ring to the pin of the viewfinder.

Lift the ASA dial and rotate the dial to set an ASA speed from 25 to 6400 in the window next to the dial. Turn the meter on by moving the power switch to ON. You'll hear it click. In addition, a red semicircular warning mark visible on the left side of the viewfinder image will disappear. If you push the shutter button before turning the meter on, the camera will expose the film for two seconds.

Set the A/M switch of the lens to A for full-aperture metering. As you rotate the aperture ring, the shutter speed will be selected steplessly by the meter. *Do not* change the setting of the camera shutter-speed dial. This will turn the meter off and the camera will give a two-second exposure.

The exposure display shows standard shutter speeds from 1/1000 to 2 seconds at the top of the viewfinder image. A moving black needle indicates the shutter speed selected by the

USING THE AE PRISM FINDER WITH THE M645 AND M645J CAMERAS

The AE Prism Finder is set for the M645 1000S, which has a maximum shutter speed of 1/1000 second. To use the viewfinder with the M645 or M645J, you should adjust the meter for the cameras' maximum speed of 1/500 second.

Insert the Adjustment Key supplied with the meter into the Adjustment Screw near the power switch. Turn the key clockwise about 60° until it stops. Now the meter will give a maximum shutter-speed reading of 1/500 second. In the case of overexposure, the needle enters the red mark between the **1000** and **500**.

meter. When the needle is between standard settings, an in-between speed is selected.

When the meter cannot select a shutter speed fast enough, the needle moves to the red warning mark to the left of the shutter speeds, indicating overexposure. To correct this, turn the aperture ring toward the needle to stop down the aperture. In the case of underexposure, the needle will be in the right-hand warning mark. Open the aperture by turning the ring toward the needle.

When metering nonaverage scenes, use a substitute metering technique. Meter from an 18% gray card or other subject with an average reflectance, such as green grass, and push the AE Lock Button in the center of the power switch. As long as the button is depressed, the shutter speed selected by the meter is locked in. Expose film while depressing the button.

The meter will not select shutter speeds longer than two seconds. For longer exposures, turn the camera shutter-speed dial to B. This will turn

MAMIYA AE PRISM FINDER SPECIFICATIONS

Type: Center-weighted averaging pentaprism viewfinder using CdS photocells. Shows 94% of the image magnified 0.74X. Meter operates automatically in an aperture-preferred mode. You select aperture and the meter automatically selects shutter speed in stageless steps. Viewfinder display shows shutter-speed scale and needle indicator. Memory lock button included. Built-in hot shoe and eyecup.
Measurement Range: EV 2.85 to 17 with ASA 100 film and ƒ1.9 lens.
Film-Speed Scale: ASA 25 to 6400.
Working Range: Shutter speeds from 1/1000 to 2 seconds. Can be adjusted to a working range from 1/500 to 2 seconds for M645 and M645J cameras.
Power Source: Camera battery.
Dimensions: Width 75mm (2.9"), height 57mm (2.2"), depth 120mm (4.7").
Weight: 426g (15 oz.).

HOT SHOE

ASA DIAL POWER SWITCH EXPOSURE-PREVIEW BUTTON

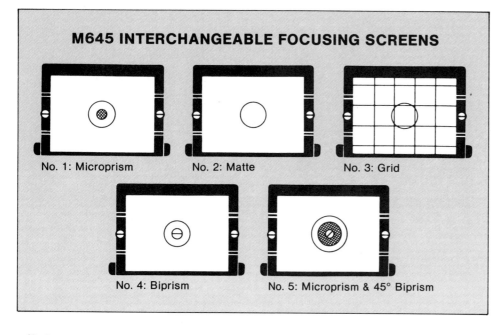

M645 INTERCHANGEABLE FOCUSING SCREENS

No. 1: Microprism No. 2: Matte No. 3: Grid

No. 4: Biprism No. 5: Microprism & 45° Biprism

off the meter, pin the needle to the right, and show the red semicircular warning mark in the viewfinder.

Prism Viewfinder Accessories—The prism viewfinders accept viewing aids that make certain setups easier to view. To correct the finder eyepiece to fit your eyesight, you can install a correction lens in the finder eyecup. Six lenses are available in strengths from −3 to +3 diopters.

Angle Finder Model 2 attaches to the eyepiece of the viewfinder to turn the viewing direction 90° from eye level, making it useful for low-angle shooting and copy work. It has a built-in diopter correction from −4 to +4. A 2X magnifier is also available for precise focusing of the center of the focusing screen. It has built-in diopter correction from −5 to +5.

INTERCHANGEABLE FOCUSING SCREENS

Five focusing screens are available for M645 cameras. Each uses a glass screen over a plastic Fresnel lens for clear, accurate focusing. The No. 1 screen comes with the M645 camera. The M645 1000S and M645J come

with the No. 5 focusing screen. See the accompanying diagram.

To remove a focusing screen from the camera, first remove the viewfinder. Then lift out the screen by pulling up on the two screws in the screen's frame. The frame with screen lifts out. Handle only the black metal frame to avoid scratching the plastic Fresnel field lens under the screen. Because the focusing screen is glass, it can be marked with a grease pencil and cleaned with a soft cloth soaked in solvent. This is often helpful in multiple-exposure photography.

Remove a focusing screen by lifting on the silver screws on the frame.

To replace, insert a screen and lower the frame into position. Then push lightly on both sides of the frame to set it in place. Install the viewfinder.

USING FLASH

The cameras have two flash-sync terminals on the left side of the camera body. They are labeled **X** and **FP**. When using electronic flash, plug the sync cord into the X-sync terminal. Use a shutter speed of 1/60 second or slower to synchronize the focal-plane shutter with the flash. Mamiya recommends that you use a flash-sync speed of 1/30 second or slower if the flash duration is longer than 1/1000 second.

For high-speed flash sync, use FP bulbs and plug the sync cord of the flash gun into the FP terminal. MF- and M-type bulbs use the X-sync terminal for flash sync, as shown in the accompanying table. Refer to the data sheets of the bulbs for guide numbers at different shutter speeds.

USING THE 70mm LEAF-SHUTTER LENS

For electronic flash sync at shutter speeds faster than 1/60 second, use this special 70mm lens. It has a built-in Seiko leaf shutter with a shutter-speed range from 1/30 to 1/500 second. You can also use the lens with the leaf shutter disengaged, allowing the camera's focal-plane shutter to expose the film. Attach and remove the lens from the camera as you would any other M645 lens.

Operation Without Leaf Shutter—After attaching the lens to the camera, set the A/M lever of the lens to A. Then grip the shutter cocking ring and turn it clockwise as far as it will go. This cocks the shutter and leaves it open for viewing. Turn the shutter-speed ring on the lens so the F setting on the ring is aligned with the shutter-speed alignment dot. This disengages the leaf-shutter mechanism from the camera.

FLASH SYNC WITH M645 CAMERAS

Terminal	Flash Type	Shutter-Speed Setting										
		8s-1s	2	4	8	15	30	60	125	250	500	1000
FP	FP											
X	Electronic											
X	MF											
X	M, FP											

■ Flash will sync. ■ Flash won't sync.

FLASH SYNC WITH 70mm LEAF-SHUTTER LENS

Flash Type	Shutter-Speed Setting				
	30	60	125	250	500
Electronic					
FP					

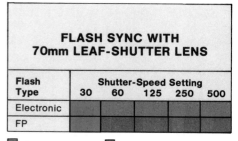

■ Flash will sync. ■ Flash won't sync.

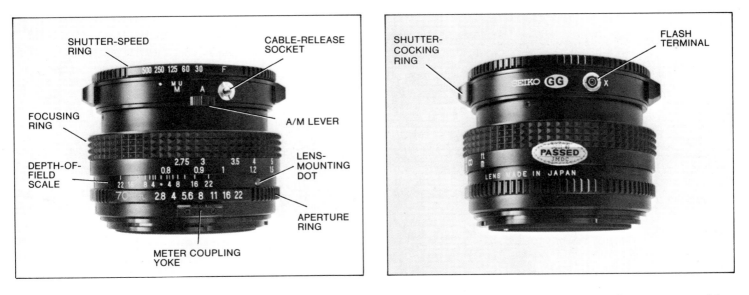

SHUTTER-SPEED RING — CABLE-RELEASE SOCKET

FOCUSING RING

DEPTH-OF-FIELD SCALE — A/M LEVER

LENS-MOUNTING DOT

METER COUPLING YOKE — APERTURE RING

SHUTTER-COCKING RING — FLASH TERMINAL

Now you can do full-aperture metering through the lens and operate the camera and lens as you would normally. You do not need to recock the lens shutter after exposure because the blades remain open and the mechanism disengaged. Turn the camera's winding crank to advance film for the next exposure.

Leaf-Shutter Operation—To use the leaf shutter, turn the shutter-speed ring of the lens to select a speed from 1/30 to 1/500 second. This automatically engages the shutter mechanism. Then adjust the shutter speed of the camera to 1/8 second or slower. This slow focal-plane speed is necessary because the leaf shutter operates when the focal plane shutter is completely open. If the camera shutter operates at 1/15 second or faster, you won't get good exposure.

When using flash, connect the sync cord of the flash to the PC terminal under the lens. If you attach the cord to the camera's terminal or use the hot shoe, the camera—not the lens—triggers the flash. This will also give bad exposure.

Select the lens aperture and press the shutter button. What happens is:

The leaf shutter closes and the aperture automatically stops down.

The focal-plane shutter starts opening after the mirror swings up.

When the camera shutter is fully open, the leaf shutter opens, trips the flash, and closes.

The focal-plane shutter closes and the mirror swings down.

After this exposure sequence, the viewfinder image is dark because the leaf shutter remains closed. Cock the leaf shutter to open it, then advance the film normally by cocking the camera. Push the camera shutter button to make the next exposure.

If you don't cock the lens shutter before exposure, pushing the camera's shutter button operates the focal-plane shutter but not the leaf shutter. Advancing the film after this will waste an unexposed frame. Avoid wasting the frame by engaging the multiple-exposure lever and recocking the lens and camera. Push the camera shutter button to expose film. Advance the film after disengaging the multiple-exposure mechanism.

Metering for Leaf-Shutter Operation—The leaf-shutter operation just described is the simplest case, in which you determine exposure with a hand-held accessory meter. If you use one of the metering viewfinders to determine exposure, such as in a flash-fill situation, more steps are involved because the leaf shutter is not meter coupled. In all cases, set the A/M lever on the lens to A.

When you meter with the PD Prism Finder S, the camera shutter-speed dial must be set to ⊙. Use the meter dial to determine the shutter-speed setting on the lens. After setting the lens, change the shutter-speed setting of the meter to 1/8 second or slower.

When metering with the CdS metering viewfinder, keep the camera shutter-speed dial set to 1/8 second or

By using the high-speed flash sync of the 70mm leaf-shutter lens I could freeze motion with flash and slightly underexpose ambient-light exposure. I metered the scene with the PD prism finder, as described in the text.

slower. Use the meter's dial to determine exposure time. After metering, set the shutter speed on the lens and adjust aperture.

Neither manual nor automatic-exposure operation is possible with the leaf-shutter and the AE Prism viewfinder because the leaf shutter isn't coupled with the meter.

Depth-of-Field Preview—When checking depth of field after setting the lens aperture, set the A/M lever on the lens to M. After previewing depth of field, set the A/M lever back to A. If you don't, the leaf shutter won't operate when you push the shutter button. However, the focal-plane shutter will. The frame will be unexposed.

Using the depth-of-field lever of the M645 1000S makes the leaf shutter operate, and you'll have to recock it before exposing film. If you want to use the depth-of-field lever of the M645 1000S, you must first move the shutter speed ring on the lens to F. Check depth of field, then reset the lens shutter speed to the selected speed.

Mirror-Up Leaf-Shutter Operation—You can also use the leaf-shutter lens with the camera's mirror locked up to minimize mirror shock. The easy way is to use the Mirror-Up lever of the M645 1000S and M645 to raise the mirror before pushing the camera shutter button. A more difficult way follows.

After focusing and metering, cock the lens shutter and set the lens shutter speed. Then move the A/M lever to M. Above the M you'll see the letters **MU**, standing for *Mirror Up*. Set the camera shutter speed to B; otherwise, the procedure won't work and you'll get bad exposure.

To operate the camera, you should use a special Dual Cable Release, available from Mamiya. It has two

For mirror-up operation with the lens shutter, slide the A/M lever to M.

cables leading from the plunger. The long silver-tipped end screws into the shutter button on the front of the camera. The short black-tipped end screws into the cable-release socket on the lens.

To expose film, push the plunger of the dual cable release in two steps. Push it down initially and stop when you feel resistance. You'll hear the mirror swing up, the leaf shutter close, and the focal-plane shutter open. Do not release the plunger at this point. If you do, the focal-plane shutter will close and the film will be unexposed. However, you can remedy this by engaging the multiple-exposure mechanism and cocking the camera again. Restart the procedure.

Use the Dual Cable Release to expose film when using the Mirror-Up control of the 70mm leaf-shutter lens.

After waiting a while for vibrations to cease, push the plunger all the way down. This operates the leaf shutter. Release the plunger to close the focal-plane shutter. Advance the film.

CLOSE-UP EQUIPMENT

A variety of close-up equipment is available for the M645 cameras. You can make close-up photos in different ways, depending on how you combine the accessories. See Chapter 2 for a discussion of close-up equipment and how to calculate the necessary exposure corrections. Of course, if you use a metering viewfinder, you do not have to calculate exposure compensation due to magnification as long as the light at the film plane is within the meter's sensitivity range.

80mm Macro Lens—When used alone, this automatic lens will give image magnifications up to 0.5. Attach it to the camera as you would other lenses, then set the distance scale to the infinity setting. Push the silver Magnification Selector Button and turn the Magnification Selector Ring until the red **N** on the ring aligns with

the red line on the filter mounting ring. The selector ring will lock in place.

This procedure sets the floating lens elements for best image sharpness within the magnification range of the lens. The distance scale must be set to infinity to lock the lens selector ring properly.

Use the lens as you would other automatic lenses. Image magnification is conveniently marked on a green scale in front of the lens distance scale.

For image magnifications between 0.5 and 1.0, use the Auto Macro Spacer with the lens. The spacer is an extension tube giving 40mm of extension. It preserves the automatic features of the 80mm macro lens.

Set the floating lens elements whenever using the 80mm macro lens. Here the silver button on the Magnification Selector Ring is being pressed and the ring is being turned to align the red line with the red **N**. This is for *normal* magnifications up to 0.5. Notice the lens distance scale is set to infinity.

Before attaching the spacer to the lens, remove the lens from the camera and set it to *f*-4.

To attach the spacer to the lens, hold the knurled ring at the back of the spacer and rotate the coupler ring of the spacer with your other hand until the red line on the Aperture Ring Coupler aligns with the red alignment mark on the spacer's mounting flange. Then hold this position secure with the hand gripping the rear knurled ring. Align the red dot of the spacer with the red lens-mounting dot. When you do this, the pin on the spacer will slip into the yoke on the lens. Rotate the lens clockwise while gripping the knurled ring of the spacer.

Of course, if you do not use one of the metering viewfinders, this coupling procedure is not necessary. In this

When you mount the Auto Macro Spacer to the 80mm macro lens properly, the spacer's coupling pin slips into the lens coupling yoke, as shown here. This is necessary for automatic lens operation. The auto extension tubes mount to lens in the same way.

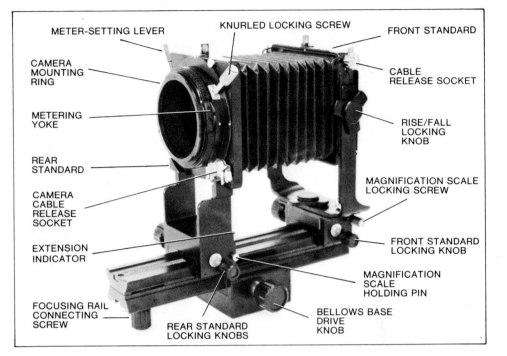

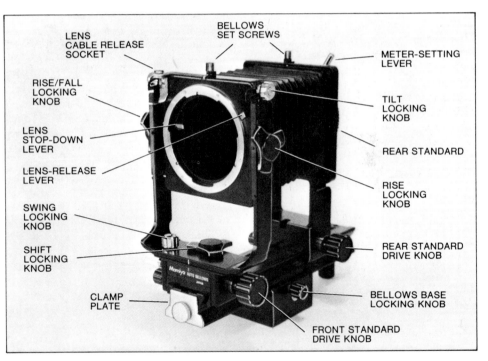

case, all you have to do is align the dots of the spacer and lens and then turn the lens until it is locked to the spacer.

In either case, attach the spacer and lens combination to the camera by aligning the red dot on the rear knurled ring of the spacer with the red mounting dot on the camera. Turn the assembly clockwise until it stops.

Before using the lens, set its distance scale to infinity. Press the magnification selector button of the lens and turn the magnificaton selector ring until the green line on the ring aligns with the green S below the ring. The ring will lock in place. As a memory aid, think of the S as standing for *Spacer*. Also use this setting when the macro lens is mounted on the bellows.

Remove the lens and tube assembly from the camera as you remove a lens from the camera. To remove the spacer from the lens, push the lens-release button of the spacer while turning the spacer's rear knurled ring counterclockwise.

Auto Extension Tube Set S—A set of three automatic extension tubes is available, giving 12mm, 24mm, and 36mm of extension. The tubes are labeled No. 1, No. 2, and No. 3-S, respectively. They are designed for use with the *f*-1.9 and *f*-2.8 80mm lenses only. Image vignetting can occur if you use them with other lenses. See the table on page 108.

If necessary, you can use the tubes stacked. When stacking tubes, use the No. 3-S ring next to the camera body to avoid vignetting. Mounting a lens to a tube and mounting the assembly to the camera is the same as described for the 80mm Macro lens and Auto Spacer. Removal is also the same.

Reversing Rings—Reversing rings are available for lenses with 58mm and 67mm screw-in threads. Use these rings with the 80mm lenses and extension tubes when image magnification is 1.0 or more, or when you reverse a lens on the Auto Bellows. Each ring gives 3.7mm of extension to the lens.

Screw the ring into the front of the lens and then attach the rear of the ring to the camera as you would mount a lens. When metering and exposing, set the A/M lever of the lens to M for stopped-down metering.

AUTO BELLOWS

The Auto Bellows is a most versatile tool for close-up shooting. It extends from 48mm to 179mm, giving a maximum magnification of 2.8 with the 80mm *f*-1.9 lens reversed. Its front standard swings, tilts, shifts, and rises for extra image control. The top rail of the bellows can be pivoted 90° so the camera and bellows assembly travels left and right for panorama shooting.

The camera can also be rotated for horizontal- or vertical-format photos while attached to the bellows. In addi-

tion, you can attach the Bellows Lens Hood to the front of the lens. With the Slide Copy Attachment on the front of the hood, you can duplicate transparencies simply and efficiently onto the 4.5x6 cm format.

Attaching the Camera—The camera mounting ring on the rear standard is secured with a knurled locking screw protruding from the ring. When you loosen the knob all the way, you can remove the ring from the standard. This lets you mount the camera to the ring whether or not it is attached to the bellows. However, I think the easiest way to mount the camera is when the ring is attached to the bellows.

To do this, loosen the knurled screw and turn the ring so the horizontal-alignment mark on the ring is aligned with the mark in the top center of the rear standard. This puts the knurled screw in the 2 o'clock position as you view the standard from the rear.

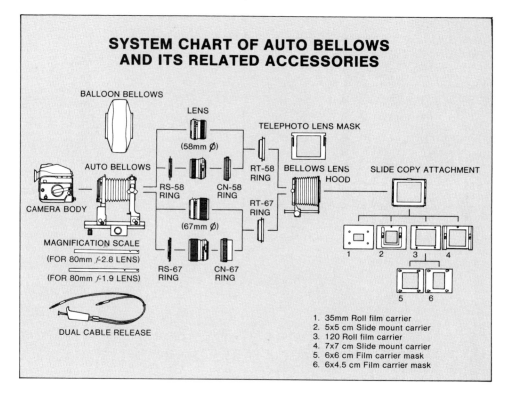

SYSTEM CHART OF AUTO BELLOWS AND ITS RELATED ACCESSORIES

1. 35mm Roll film carrier
2. 5x5 cm Slide mount carrier
3. 120 Roll film carrier
4. 7x7 cm Slide mount carrier
5. 6x6 cm Film carrier mask
6. 6x4.5 cm Film carrier mask

Before mounting the camera, use the knurled locking screw to put the horizontal alignment mark at the top center of the rear standard, top arrow. The other arrow points to the vertical alignment mark. Then move the meter setting lever across from the knurled locking screw.

Tighten the screw to secure the ring. The other silver lever is the meter-setting lever. Turn it so it is directly opposite the knurled locking screw. Align the red mounting dot on the camera body with the alignment mark across from the knurled locking screw in the mounting ring's flange. Turn the camera clockwise to secure it.

If you will be using a metering viewfinder with the camera and bellows, move the meter-setting lever up or down to engage the meter-coupling pin in the viewfinder in the yoke of the meter-setting ring.

Then turn the ring until the white dot on the meter-setting ring is aligned with the white dot on the camera-mounting ring. An extra set of dots is on the other side of the rings. When using lenses longer than 80mm on the bellows, align the green dot of the meter-setting ring with the white dot of the camera-mounting ring. If you do not use a metering viewfinder, this procedure is unnecessary.

Now the camera is set for horizontal-format images. To revolve the camera 90°, loosen the knurled locking screw and revolve the camera 90° counterclockwise. Match the vertical alignment mark on the ring with the top center mark on the rear standard and tighten the knurled locking screw.

Align the mounting dots of the rear standard and the camera. Turn the camera clockwise.

When using a metering viewfinder with the camera, align white dots with the meter-setting lever. The arrow points to the green dot that should be across from the white dot when lenses longer than 80mm are used on the bellows.

For vertical-format close-up photos, loosen the knurled locking screw and turn the camera 90° until the vertical alignment mark is on top (arrow). Tighten the screw.

Before detaching the camera from the standard, put the camera in its horizontal position and tighten the knurled locking ring. Depress the camera lens release button and turn the camera counterclockwise.

Attaching the Lens—Align the red plastic mounting dot on the lens with the mounting mark on the front standard. Turn the lens clockwise about 60° until it stops. To remove the lens, press the small lens-release lever on the front standard and turn the lens counterclockwise.

When using a regular lens for image magnifications greater than 1.0, you should first attach the lens to one of the reversing rings. Screw the ring into the filter threads of the lens. Then mount the ring as you would a lens.

Attach the lens to the front standard as you would attach it to the camera.

Attaching the Magnification Scale—Two aluminum magnification scales come with the bellows. The long one is designed for use with the *f*-1.9 80mm lens and the short one for the *f*-2.8 80mm lens.

To attach either, loosen the scale-attaching screw on the front standard's

APPROXIMATE FOCUS TRAVEL OF SOME M645 LENSES	
LENS	**FOCUS TRAVEL**
80mm	10mm
80mm Macro	40mm
55mm	6mm
70mm	6mm
110mm	11mm
150mm	17mm
210mm	20mm
300mm	24mm

PUPILARY MAGNIFICATION OF SOME M645 LENSES	
LENS	**P**
55mm, *f*-2.8	1.39
70mm, *f*-2.8	1.15
80mm, *f*-1.9	1.25
80mm, *f*-4 Macro	1.08
80mm, *f*-2.8	0.98
110mm, *f*-2.8	0.81
150mm, *f*-3.5	0.75
210mm, *f*-4	0.69

base. If the 80mm lens is mounted normally, attach the front notch of the scale to the screw. If the 80mm lens is mounted reversed, attach the rear notch to the screw. Rest the scale on the holding pin on the rear standard and tighten the screw.

When you use any other lens with the bellows, you can use either scale to read mm of extension, but not magnification. In this case attach the front notch to the scale-attaching screw. The accompanying close-up tables are based on this setting.

Using the Bellows—To extend the bellows, unlock the lock knobs on the right side of the front and rear standards. Use the larger knobs on the left side to move the standards. The bellows track will move forward or backward on an adjustable base that attaches to your tripod. This is convenient to adjust subject distance after setting image magnification.

The easiest way to determine magnification is with a standard 80mm lens set to infinity, mounted normally

or reversed. Read image magnification from the scale directly, using the indicator on the rear standard.

Reading extension is not as simple because extension is not marked with numbers. To solve this problem, remember that when image magnifica-

Using the magnification scale with 80mm lenses is fast and easy. Use the indicator on the rear standard (arrow) to determine extension, magnification, and the exposure compensation factor. In this example, the reverse-mounted 80mm *f*-2.8 lens is extended for a magnification of 2.

When using an 80mm or other lens mounted normally, attach the front notch of the magnification scale to the scale-attaching screw.

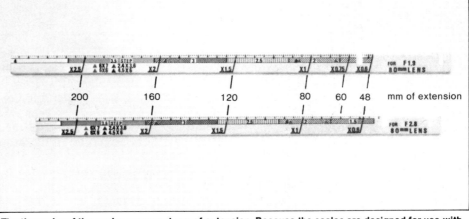

The tic marks of the scales represent mm of extension. Because the scales are designed for use with the standard 80mm lenses focused at infinity, you can multiply the engraved magnification factor by 80 to find mm of extension.

RECOMMENDED MAGNIFICATION RANGES OF MAMIYA M645 LENSES AND AUTO BELLOWS

Lens*		Extension (mm)	Lens-To-Subject Distance+ inches	cm	Mag. Range	Exposure Compensation (Steps)
55mm f-1.9	N	48—179	2.7— 0.8	6.9— 2.1	0.9—3.2	1-1/2—3
	R	48—179	1.3— 0.7	3.2— 1.7	2.0—4.4	3—4-1/2
70mm f-2.8 Leaf-Shutter	N	48—179	5.2— 2.1	13.1— 5.2	0.7—2.5	1-1/2—3-1/2
	R	48—179	3.1— 1.8	7.9— 4.6	1.3—3.1	2—4
80mm f-1.9	N	48—179	6.2— 2.4	15.8— 6.1	0.6—2.2	1-1/2—3-1/2
	R	90—221	3.8— 2.1	9.6— 5.4	1.1—2.8	2—3-1/2
80mm f-2.8	N	48—179	6.9— 3.1	17.6— 7.8	0.6—2.2	1-1/2—3-1/2
	R	72—203	5.2— 2.9	13.2— 7.4	0.9—2.5	2—3-1/2
80mm Macro	N	48—179	6.0— 2.1	15.2— 5.4	0.6—2.2	1-1/2—3-1/2
	R	48—179	5.1— 3.6	13.0— 9.1	1.2—2.8	2-1/2—4
110mm	N	48—179	13.1— 5.4	33.3—14.8	0.4—1.6	1—3
	R	124—179	7.5— 6.1	19.1—15.4	1.0—1.5	2-1/2—3
150mm	N	48—179	25.4—11.3	64.5— 0.3	0.3—1.2	1—3
210mm	N	48—179	44.8—18.5	113.8—46.9	0.2—0.9	1—2-1/2

* Lens focused at infinity.
+ Measured from lens flange to subject.
N: Lens mounted normally.
R: Lens mounted reversed.

USING EXTENSION TUBES AND SOME MAMIYA M645 LENSES

Lens	Extension Tube(s)	Lens-To-Subject Distance in.	cm	Magnification	Exposure Compensation (Steps)
80mm f-1.9	1	24.4—11.6	56.8—29.4	0.50—0.30	1/3—1/2
	2	11.7— 8.1	29.6—20.5	0.29—0.44	1/2—1
	3-S	8.1— 6.3	20.6—16.0	0.44—0.59	1
	1+3-S	6.3— 5.3	16.0—13.3	0.59—0.74	1—1-1/3
	2+3-S	5.3— 4.5	13.3—11.5	0.74—0.89	1-1/3—1-1/2
	1+2+3-S	4.6— 4.0	11.5—10.2	0.88—1.03	1-1/2—1-2/3
80mm f-2.8	1	23.1—12.1	58.7—31.0	0.15—0.30	1/3—2/3
	2	12.4— 8.8	31.5—22.2	0.29—0.45	2/3—1
	3-S	8.8— 6.9	22.4—17.7	0.44—0.60	1—1-1/3
	1+3-S	7.0— 5.8	17.8—15.0	0.59—0.74	1-1/3—1-2/3
	2+3-S	5.9— 5.2	15.1—13.2	0.73—0.89	1-2/3—2
	1+2+3-S	5.3— 4.8	13.3—12.0	0.88—1.04	2
70mm f-2.8 Leaf-Shutter	1	16.5—15.7	41.9—39.9	0.16—0.27	1/3—1/2
	2	13.9—11.8	35.5—30.0	0.33—0.44	1/2—1
	3-S	11.1—10.1	28.2—25.5	0.49—0.60	1—1-1/3
	1+3-S	9.8— 9.1	24.5—23.0	0.66—0.77	1-1/3—1-1/2
	2+3-S	8.8— 8.4	22.3—21.3	0.82—0.93	1-1/2—1-2/3
	1+2+3-S	8.3— 7.9	20.9—20.2	0.99—1.09	1-2/3—2

tion is 1.0, bellows extension is 80mm—if the lens is focused at infinity. Then you can count the tic marks in groups of five or ten to get the actual mm of extension. Or, you can refer to the accompanying photo to see how many mm of extension the scale's tic marks represent.

To *measure* actual extension for those lenses, measure the distance between the lens flange of the front standard and the extension indicator on the rear standard. Then you can use the formulas and charts in Chapter 2 to find image magnification.

You can also use the scales to determine the exposure compensation due to image magnification. The patterned scale below the extension scale indicates the compensation in steps. This part of the aluminum scale can be used only with the standard 80mm lenses mounted normally, not reversed. When they are mounted in reverse, or if you use other lenses, see the discussion in Chapter 2 about exposure compensation factors. In either case, you can usually avoid this step completely by using a metering viewfinder.

After determining the necessary extension and magnification, focus on the subject by moving the bellows forward and backward using the drive knob on the adjustable base. To view depth of field, set the A/M lever on the lens to M. For best image quality, Mamiya recommends that you use the smallest aperture possible. Focusing may be easiest if you use the No. 2 matte or No. 3 grid-line focusing screen in the camera. Prism viewfinder attachments also help.

Metering—The metering viewfinders work as described; however, you must use a stopped-down metering technique because the lens is not coupled to the viewfinder. The meter-setting lever on the bellows only sets the meter for the lens maximum aperture.

Set the A/M lever on the lens to M and adjust the aperture and shutter-speed dial on the camera or viewfinder to get correct exposure settings. In my opinion, the easiest way is to determine aperture first, based on the depth of field you desire. Then adjust the shutter-speed dial of the viewfinder or camera, depending on the viewfinder you use.

Exposing Film—A Dual Cable Release comes with the Auto Bellows. With it you can automatically stop down the lens and trip the camera shutter with one smooth push of the plunger. Screw the silver-tipped end of one cable into the cable release socket on the front standard. Screw the black-tipped end of the other cable into the socket on the rear standard. As a memory aid, remember that the black tip connects with the black camera. Set the A/M lever of the lens to A.

When the image is focused and the exposure controls are set, smoothly push the plunger of the Dual Cable Release. The silver-tipped cable works first and stops down the lens. At this point you feel some resistance in the plunger mechanism. Continue pushing the plunger to trip the shutter. Do not release the plunger until exposure is finished; otherwise, the lens diaphragm will open again, possibly before exposure is finished. For minimal camera shake, lock up the mirror before pushing the plunger.

When you use lenses reversed on the bellows, you cannot use the Dual Cable Release to stop down the lens

Using the Dual Cable Release gives automatic-aperture operation.

After removing the standard bellows, insert the bag bellows into each standard. Then tighten the set screw.

before exposure. In this case, set the A/M lever of the lens to M to stop down the lens before exposure. Use a regular cable release or one of the cables of the Dual Cable Release to operate the shutter.

Using the 70mm Leaf-Shutter Lens—You can use the 70mm Leaf-Shutter lens with the bellows, but exposing film with its leaf shutter is a more involved procedure than the one just described. Set the camera shutter-speed dial to B and *reverse* the Dual Cable Release. Screw the black-tipped end into the cable release socket *on the lens.* Screw the silver-tipped end into the cable release socket on the rear standard. Set the A/M lever of the lens to M, adjust aperture and cock the leaf shutter.

When you push the plunger down partway, the camera's focal-plane shutter opens after the mirror swings up. Wait a bit for vibrations to diminish if necessary. Pushing the plunger all the way down trips the leaf shutter of the lens. When you release the plunger, the camera shutter closes.

Using Bellows Movements—The front standard of the bellows has four movements. It has a fall and rise of 12mm up or down; a shift of 15mm to the left or right; swings up to 23°; and tilts up to 13°. The normal centered positions for each movement are marked with click stops.

When the bellows is extended a slight distance, its folded sides restrict some of these movements. In this case, you can remove the bellows and replace it with a special bag bellows. Remove the regular bellows by loosening the set screw on the top of each standard. Lift out the top of the bellows frame and pull up to release the frame. Do this at each end. Attach the bag bellows by reversing this procedure. The length of the bag bellows

limits extension of the standards to about 100mm (4 inches).

Adjust the swing by loosening the silver knob under the front standard and rotating the U-shaped standard support to the left or right. This lets you get better focus and depth of field when photographing a subject plane that is not parallel to the film plane. Move the standard according to the *Scheimpflug* principle illustrated on the next page.

To adjust the shift, loosen the star-shaped knob under the front standard. Then you can slide it back and forth to move the image left or right. You can also use the shift to adjust for the

To adjust swing, loosen the silver knob on the base of the standard. Adjust shift by loosening the star-shaped knob.

Tilt the lens by loosening the silver knob on the side of the standard. Then adjust rise by loosening the star-shaped knob.

image movement that occurs when you swing the standard.

Loosen the silver knob on the left side of the front standard to adjust tilt. It too obeys the *Scheimpflug* law.

To adjust the rise and fall of the front standard, loosen the star-shaped knobs on both sides of the standard. Move the standard up and down to move the image up and down. You can also use the rise and fall to adjust for the image movement that occurs when you tilt the standard.

When you use these bellows movements, be careful to avoid image vignetting. It will vary according to bellows extension and the movements used, so general recommendations can't be given. Using the smallest possible aperture will help minimize vignetting. For best results, check depth of field visually after using the movements.

Slide Duplicating—To conveniently copy transparencies in sizes from 6x7 cm to 35mm onto the 4.5x6 cm format, use the Bellows Lens Hood and Slide Duplicating Attachment with an 80mm standard lens and the Auto Bellows. The lens hood attaches to a normally mounted lens as described. For image magnifications greater than 1.0, attach the lens hood to the reversed lens with a special adapter ring. The Slide Duplicating Attachment is a frame with a piece of frosted plastic that holds film-carrier masks. The attachment fits into a slot in the front of the hood.

The track for the lens hood is marked at the correct subject distance for copying the whole image of each format onto the 4.5x6 cm frame. The aluminum magnification scales of the auto bellows are also marked at the correct image distance for these magnifications. If you want greater image magnifications, adjust the bellows for more extension. Of course, subject distance decreases.

GRIPS

Mamiya offers three grips that make hand-holding the camera easier. The Deluxe L-Grip Holder and the Pistol Grip relocate the shutter button to the handle of the grip. Pushing this button moves a plate that depresses the camera's shutter button.

Hold the handle of each grip in your left hand. This frees your right hand for winding the camera, focusing, and exposure controls. I recommend these grips for action photography.

USING BELLOWS MOVEMENTS

1/Because the face of this fossilized rock was not parallel to the film plane, part of the image is out of focus. Not even a small lens aperture could compensate for this.

2/Swinging the front standard of the bellows puts more of the image in focus. Note how it also shifted the image relative to the first photo.

3/By shifting the front standard, I could duplicate the composition of the first photo, yet still have all of the image in focus due to the swing. All of these adjustments were done while looking through the camera's viewfinder. Always check depth of field to determine the degree of vignetting.

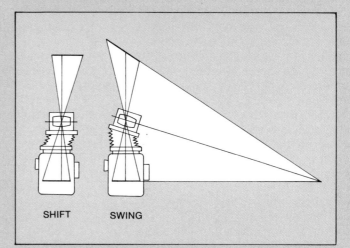

SHIFT SWING

4/The drawing at left shows how shifting the front standard adjusts the position of the image. At right is the *Scheimpflug* principle illustrated. When the lines determined by the slanted subject plane, the primary plane of the lens, and the film plane all meet at one point, the subject plane is in sharp focus.

1/To adjust the bellows for "panoramic" close-up shooting, first remove the track's clamp plate.

2/Then loosen he focusing rail connecting screw a few turns.

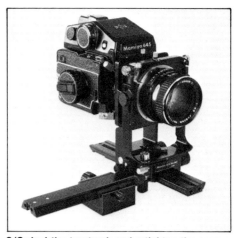

3/Swivel the top track and retighten the screw. The bellows can still be extended on the top track. Use the adjustable bellows base to move the bottom track to the left or right.

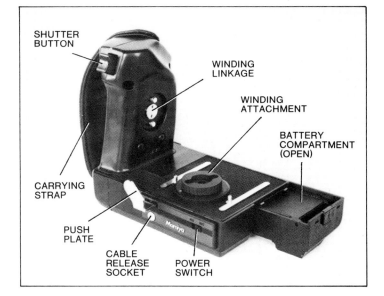

POWER DRIVE SPECIFICATIONS

Type: Automatic film winder and shutter cocking unit for all M645 cameras. Attaches to base and cocking mechanism.
Operation: Activated by shutter button on winder grip. Film wound from start mark to first frame. After each exposure, film is automatically advanced and shutter cocked. Single-frame operation only. After roll is exposed, film is wound up automatically. Stop winding by turning power switch off.
Film Advance Rate: Approximately 1 frame per second.
Shutter Speeds: Can be used with all camera speeds.
Power Source: Six AA batteries in winder base.
Capacity: Approximately 40 rolls of 120 film with manganese batteries; 100 rolls of 120 film with alkaline batteries; 80 rolls of 120 film with nicad batteries.
Other Features: Cable release socket, tripod socket, grip for easy handling.
Dimensions: Width 152mm (5.9"), height 120mm (4.8"), depth 86mm (3.3")
Weight: 650g (24 oz.) without batteries.

POWER DRIVE

The Power Drive for M645 cameras is a motorized film winder that makes shooting easier by eliminating manual camera winding. It automatically advances the film and cocks the shutter after each exposure, with a maximum frame rate of one frame per second.

The winder uses six AA batteries that fit into a battery compartment in the base. To load batteries, depress the battery lock on the side. Pull out the battery case, open it and load the six AA batteries.

Attaching the Power Drive—Before attaching the camera to the Power Drive, you must remove the camera's winding crank or knob. To remove the crank of the M645 1000S, first rotate it clockwise until it stops. Then press its release lever and wind the crank counterclockwise about 20° until it detaches from the body.

To remove a winding knob, advance it until it stops. Insert a small screwdriver or wooden matchstick into the slot on its release lever and press it in the direction away from the camera body. Rotate the knob counterclockwise to remove.

Insert the Winding Attachment into the faceplate of the camera's winding mechanism. Align the red dot of the attachment with the red dot on the faceplate and rotate the attachment about 20° clockwise. It does not lock in place. If the M645 camera you are using doesn't have the red dot on the faceplate, align the attachment's red dot to the 11 o'clock position on the faceplate. Then rotate it clockwise.

Put the camera on the winder so the two alignment pegs of the winder fit

Remove a winding knob by depressing its release lever. Then turn the knob counterclockwise and lift it off.

After attaching the Winding Attachment to the camera and then the winder to the camera, push the Coupler Knob on the winder's grip to mate the winding mechanisms.

into two holes on the camera bottom. Then tighten the mounting screw into the camera tripod socket. Turn and push the retracted Coupler Knob on the winder grip to mate the winding attachment on the camera body to the winding linkage of the winder.

Using the Power Drive—Load film normally and turn on the winder with its power switch on the front of the base. When you push the shutter button on the winder's grip, the film automatically advances to the first frame and stops.

When you press the winder shutter button to make an exposure, keep your finger on the button until the film is advanced to the next frame. If you remove your finger before exposure is finished, film will not advance. The same thing happens if you use the camera shutter button to make the exposure. In this case, pressing the winder shutter button again will advance the film to the next frame. The shutter won't operate a second time.

After film is advanced, remove your finger from the shutter button and press it again to make the next exposure. You won't get continuous exposure operation if you hold your finger on the button. When using a cable release, screw it into the cable release socket on the front of the winder to get automatic film winding after each frame is exposed.

After exposure 15 on 120 film or exposure 30 on 220 film, the winder automatically winds up the film. This takes about five seconds, then the winder continues turning. Turn off the winder with its power switch.

11

Mamiya RB67 Pro-S

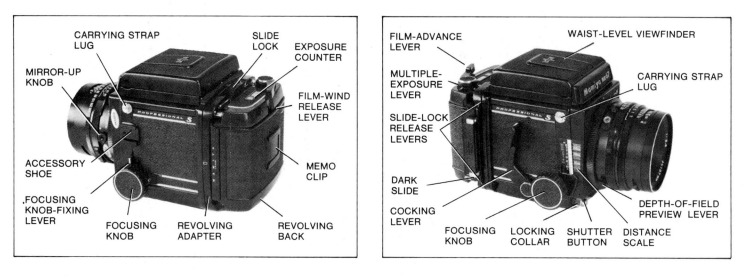

Another medium-format SLR made by Mamiya is the RB67 Pro-S. Some of the camera's most important features are abbreviated in its name. *RB* stands for revolving back, *67* denotes the 6x7 cm image format; and *Pro-S* implies its professional capabilities.

The *Pro-S* designation is for the latest version of the RB67 camera and system. The major differences between this model and earlier ones are additional safety interlocks and a built-in double-exposure-prevention mechanism, with override, on all Pro-S film backs. Many accessories com-

patible with earlier RB67 cameras are compatible with the RB67 Pro-S.

With the standard revolving back for 120 film, you can get 10 exposures per roll. Because the RB67 Pro-S is designed to be a professional camera, you can also use film backs designed for 220 and 70mm film that give more exposures per load. Two Polaroid backs are also available. Other parts of the Pro-S system include interchangeable leaf-shutter lenses, viewfinders, focusing screens, film backs, and grips.

The RB67 Pro-S is one of the largest and heaviest cameras described in this book. You can take it out of the studio and use it for field work. It is built for rugged use on or off the tripod in temperatures ranging from 120°F to -5°F (50°C to -20°C).

LENSES OF THE PRO-S SYSTEM

Each lens of the Pro-S system is made by Mamiya-Sekor and is labeled

MAMIYA RB67 PRO-S CAMERA SPECIFICATIONS

Type: 6x7 cm single-lens reflex with waist-level viewing and non-instant return mirror.
Shutter: #1 Seiko leaf shutter built into each lens, with shutter speeds from 1/400 to 1 second, and T. X-sync at all shutter speeds. M-sync also built in.
Standard Lens and Viewfinder: Mamiya-Sekor C 127mm *f*-3.8 lens and waist-level viewfinder with built-in magnifier.
Film: 10 or 20 exposures with 120 or 220 film backs. 55 exposures with 70mm film back. Interchangeable back capability for Polaroid film, Pro-S backs, Mamiya G-Lock backs, and Mamiya M-Lock backs.
Other Features: Interchangeable lenses, viewfinders, and focusing screens. Multiple-exposure lever, mirror-lockup device, rack-and-pinion bellows focusing, safety interlocks, and revolving back adapter.
Dimensions: Width 104mm (4.1"), height 144mm (5.7"), depth 228mm (8.5").
Weight: 2.0kg (4.4 lbs.).

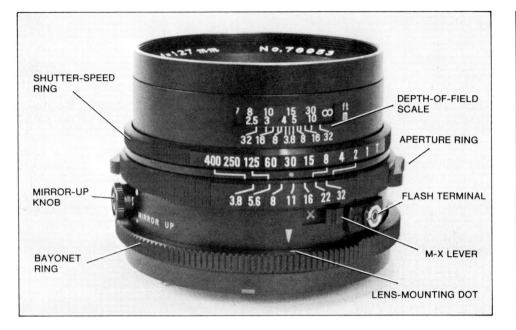

- SHUTTER-SPEED RING
- DEPTH-OF-FIELD SCALE
- APERTURE RING
- MIRROR-UP KNOB
- FLASH TERMINAL
- BAYONET RING
- M-X LEVER
- LENS-MOUNTING DOT

The 140mm macro lens has floating lens elements and color-coded scales for use with two different extension tubes. Using the lens for close-up shooting is described in detail beginning on page 128.

C for multicoated. The lenses have an automatic diaphragm and a Seiko #1 leaf shutter with shutter speeds from 1/400 to 1 second, including T. All have M- and X-sync and a depth-of-field-preview lever.

The standard lens of the system is the 90mm f-3.8 lens. The fastest lens is the 127mm f-1.9.

The unique feature of these lenses is that they do not have helicoid focus travel. Instead of turning a ring on the lens to move lens elements to focus the image, you turn a knob on either side of the camera body to extend or retract the lens on a built-in rack-and-pinion bellows, like a view camera. The accompanying lens table shows the main features of the lenses. Special lenses are discussed here.

37mm f-4.5 Fish-Eye—This special lens has a 180° angle of view that gives a rectangular image. Because the front element of the lens is extremely wide and curved, regular filters or lens hoods cannot be screwed into the front of the lens. The filter mount is

on the rear of the lens. It accepts 40.5mm screw-in filters. Four Mamiya filters in this size are included with the lens. They are labeled **UV, Y, R,** and **LB-A.**

The lens is designed to be used with a filter at all times. You cannot use more than one filter at a time.

140mm f-4.5 Macro—This lens uses floating lens elements that are adjusted manually for best image sharpness and flatness of field in a magnification range from 0.3 to 1.2. It is designed for use with the two Auto Extension Tubes also available from Mamiya. Using this equipment for close-up work is described in more detail later. You can also use this lens for general-purpose shooting.

150mm f-4 Variable Soft-Focus—By using this lens, you can get a soft-focus image without the halo effect that occurs with most diffusion attachments. In addition, the moderate focal length of this lens makes it ideal for portraiture.

The lens comes with three interchangeable diffusion discs to vary the soft-focus effect. Without any diffusion disc, the lens gives most diffusion due to built-in spherical aberration at f-4 and only slight diffusion at f-5.6. From f-8 to f-32, it yields a normal, sharp image. Therefore, you should always focus the lens when the image is sharpest and brightest. This happens at f-8. After focusing at f-8, select the aperture you want to use.

The 37mm fish-eye is designed to be used with a filter over its rear element at all times.

MAMIYA-SEKOR C LENSES FOR THE RB67 PRO-S							
Lens	Minimum Aperture	Diag. Angle of View	Minimum Focus Distance		Weight		Filter Size (mm)
			ft.	m	oz.	g	
37mm f-4.5 Fish-Eye	f-32	180°	0.02	0.006	48	1360	40.5
50mm f-4.5	f-32	82°	0.13	0.04	32	920	80
65mm f-4.5	f-32	69°	0.30	0.09	29	835	80
90mm f-3.8	f-32	52°	0.66	0.20	28	805	77
127mm f-1.9	f-32	38°	1.41	0.40	26	750	77
127mm f-3.8	f-32	38°	1.41	0.40	26	750	77
140mm f-4.5 Macro	f-32	35°	1.71	0.50	29	830	77
150mm f-4.0 Soft-Focus	f-32	33°	2.0	0.60	30	840	77
180mm f-4.5	f-45	28°	2.8	0.9	31	875	77
250mm f-4.5	f-45	20°	5.2	1.6	46	1310	77
360mm f-6.3	f-45	14°	11.5	3.5	43	1230	77
500mm f-8	f-32	10°	21.6	6.6	75	2140	105

The 150mm Variable Soft-Focus lens comes with three interchangeable discs. With these and the built-in spherical aberration of the lens, you can vary the soft-focus effect. Insert a disc by disassembling the lens and putting the disc over the rear element of the front lens half.

The diffusion discs have a large central hole surrounded by a number of smaller holes. The large hole in the disc determines the effective *maximum* lens aperture, and the number of smaller holes. Most of the light that strikes the film passes through the central aperture in the disc and is unaffected by the smaller holes.

To use the lens with one of the discs, unscrew the front part of the lens and attach the disc to the rear of the front lens section. Then reassemble the lens. Focus the lens while it is stopped down to *f*-8 and while you depress the depth-of-field-preview lever of the lens. Then set the lens to

its maximum aperture of *f*-4. This makes the diffusion disc act as the aperture. Use the marked aperture of the disc in exposure calculations.

The No. 1 disc has the largest marked aperture of *f*-5 and gives the least diffusion of the three discs. The No. 2 has an aperture of *f*-5.6; and the No. 3, which gives the maximum effect, is marked *f*-6.3.

To eliminate the soft-focus effect of the disc without removing it from the lens, use a lens aperture between *f*-8 and *f*-32. The lens aperture will be smaller than the central hole of the diffusion disc, eliminating the effect of the small holes.

The 500mm lens is not compatible with extension tubes because they would extend the lens past the holder. The extra stress created could damage the camera's bellows.

500mm *f*-8—This long-focal-length lens comes with a special lens holder that helps support it on the camera. After mounting the lens, attach the holder to the front of the lens and secure its other end to the tripod-mounting socket of the camera. The lens holder has its own tripod-mounting socket in the center of its bottom plate. The holder also has a sight at the front to help you aim the lens at the subject.

MOUNTING THE LENS

The simplest way to mount the lens is when both it and the camera body are cocked before mounting. To cock

For this photo, the No. 2 *f*-5 disc was used in the 150mm Variable Soft-Focus lens. The lens was set to *f*-4. This gave a soft-focus effect that worked well with brown toning and hand-coloring.

To cock the body, push the camera's cocking lever down until it stops. Let it spring back up.

the camera, push the cocking lever down about 75°. It will spring back up and lock when the camera is cocked completely. This cocks the body and lowers the mirror and auxiliary shutter in front of the film plane.

To cock the lens, turn the shutter cocking pins on the back of the lens to the red dots. This opens the shutter blades and cocks the shutter. The pins must be turned all the way to the red dots to cock the lens completely. When you remove your fingers from the pins, the pins spring back slightly to a set of green dots.

Cock the lens shutter by turning the pins until they are aligned with the red dots.

Before mounting the lens on the camera, turn the bayonet ring on the lens counterclockwise until its red dot aligns with the red triangular index at the top of the lens. Then match these indexes with the red dot above the camera's mounting flange. Twist the bayonet ring on the lens about 75° clockwise until it is snug. There is no audible click stop for the bayonet ring, but the three-lug bayonet mount holds the lens safely and securely.

Before mounting the lens, align the red dot of the mounting ring with the triangular index.

Insert the lens into the body with the indexes aligned with the body's mounting dot. Then turn the lens bayonet ring.

Other Methods—If you mount a lens on an uncocked camera, push the camera's cocking lever all the way down. This cocks both body and lens, making them ready for exposure. Do not have the dark slide out of the film back until camera and lens are cocked; otherwise, you will fog film.

Another case is mounting an uncocked lens on a cocked camera. Before you can cock the lens, you have to trip the shutter to release camera tension. This method takes longer than the other two because you have to circumvent the double-exposure-prevention mechanism without exposing film.

Use the small Multiple-Exposure Lever located on the right side of the film back's Film-Advance Lever. First, flip the multiple-exposure lever forward until it exposes a red dot. Second, pull out the dark slide slightly until a small cutout triangle is visible in the top center of the dark slide. This releases an interlock, but will stop light from exposing the film.

The Multiple-Exposure Lever is on the film back's winding lever. Push it forward to expose the red dot. Next, pull out the dark slide just enough to expose the cutout triangle.

Third, push the shutter button to trip the cocked camera. The mirror and auxiliary shutter will swing up. Push the dark slide in all the way and cover the red dot with the multiple-exposure lever. Fourth, push the cocking lever to cock the camera and lens together.

Removing a Lens—Cock both the body and lens by pushing the cocking lever down until it springs back up. If you try to push the lever but it won't move, the camera and lens are already

OTHER COCKING METHODS		
Mirror Condition	Shutter Condition	Operation
	Closed	
	Cocked or Uncocked	

cocked. Turn the bayonet ring of the lens counterclockwise until its red dot aligns with the red dot of the body and the red triangular index of the lens. Remove the lens.

The body and lens will always be cocked after they are separated. To prevent unnecessary wear on the leaf shutter, Mamiya recommends that you do not store a cocked lens for an extended time. To release the shutter tension, push the silver shutter-lock pin on the back of the lens while turning the cocking pins clockwise—in the direction *away* from the dots—as far as they will go. Do not turn them only partway because this will leave some tension in the shutter.

To release shutter tension, press the shutter-lock pin and turn the cocking pins away from the dots.

FILTERS

All Mamiya-Sekor C lenses for the RB67 Pro-S, except for the 37mm fish-eye and 500mm telephoto, accept 77mm screw-in filters and lens accessories. The 37mm fish-eye uses 40.5mm screw-in filters, and the 500mm telephoto accepts 105mm screw-in filters. Mamiya filters are made of high-quality optical glass for optimal image quality.

LENS ATTACHMENTS

These three accessories do not screw into the filter threads of the lens. Instead, they fit over the front of the lens, where they are secured with a set screw.

Gelatin Filter Holder—This holder accepts standard 75mm (3-inch) square gelatin filters. It holds them flat and securely against the front of the lens barrel.

Bellows Lens Hood—This is an adjustable bellows lens shade. The track of the hood is marked for Pro-S lenses from 90mm to 360mm.

A set of masks also comes with the hood. They go in a slot in the front and restrict the opening to the angle of view of the lenses you can use with it. You can use the hood with the gelatin filter holder attached to the lens.

Sun Shield—The shield is a metal sheet connected to a movable arm attached to the lens. With it you can

The sun shield can be revolved about the lens and angled in a variety of positions.

block direct light from striking the lens. This helps you make backlit photos without flare and ghost images.

INTERCHANGEABLE FILM BACKS

One of the major advantages of the RB67 Pro-S is that it is compatible with 13 different film backs that use roll, sheet and Polaroid film! This versatility is made possible by adapters that fit between the camera and back. In some cases, you have to use two adapters to attach certain backs to the camera.

Pro-S Revolving Adapter—The standard adapter is the Pro-S Revolving Adapter. With it you can use four Pro-S film backs and five other Mamiya film backs using the G-Lock system, described later.

MAMIYA FILTERS FOR THE RB67 PRO-S SYSTEM

Film	Filter Name	Color	Approx. Filter Factor	Sizes (mm)	Use
B&W	SY48 (Y2)	yellow	2X	40.5, 77, 105	Absorbs UV and some blue to increase tonal contrast between clouds and sky.
	YG	yellow-green	2X	77, 105	Absorbs blue and some red for masculine portraiture and lightening foliage.
	SO56 (O2)	orange	3X	77, 105	Absorbs more blue than SY48 and penetrates haze better for stronger tonal contrasts in landscapes.
	R (R60)	red	8X	40.5	Absorbs more blue and green than SO56 for more sky/cloud contrast. Darkens foliage.
Color	SL (Skylight)	pink	1X	77, 105	Absorbs UV and excess blue of open shade.
	LB-A (81C)	yellow	1.5X	40.5, 77	Absorbs excess blue on cloudy days.
	82C	blue	1.5X	77	Absorbs excess red of morning or evening sunlight.
Any	PL (polarizer)	gray	2X-4X	77	Eliminates reflections and increases tonal contrasts and color saturation.
	ND16	gray	16X	77	Reduces light reaching the film by 4 steps without changing contrast or color. Useful with Polaroid Type 107 ASA 3000 film. Gives it an effective speed of EI 200.
	UV	clear	1X	40.5, 77, 105	Absorbs UV to prevent excess blue in color photo or hazy effect in b&w film. Also protects the lens.

When red lines are visible on the focusing screen, the back is set for horizontal-format photos.

When no red lines are visible, use the blue lines to determine the left and right borders of the image.

To remove the Pro-S film back, move both Slide Locks to the left. The other Slide Lock is on the bottom of the revolving adapter.

When the film-advance lever of a Pro-S back is facing up, you'll see a horizontal-format rectangle on the top of the adapter in front of the lever. The focusing screen will show two red horizontal lines, indicating the top and bottom borders of the horizontal-format photo. When the red lines are visible, ignore the dashed blue vertical lines on the focusing screen.

Removing a Pro-S Film Back—Each Pro-S film back has its own dark slide, winder, counter, and double-exposure prevention device. This means that you can change wound or unwound backs in the middle of a roll without wasting film or losing count of the number of exposed frames. In addition, there are interlocks between the dark slide, film back, and camera body to prevent accidentally fogging film while changing backs.

Before removing a back, put the dark slide into it. The dark slide slips into a slot between two white lines on the right side. The dark slide is symmetrical, so you can't install it incorrectly. Then revolve the back so the film-advance lever is on top.

When the dark slide is completely inserted, it releases two Slide-Lock Release Levers that are on the adapter's right side. When these levers are released, you can move both the top and bottom Slide Locks to the left—in the opposite direction of their white arrows—to free the back from the adapter, which remains attached to the camera.

To adjust the back for vertical-format photos, turn the revolving adapter 90° clockwise.

For vertical-format photos, turn the back counterclockwise 90° until it clicks and stops. The mark on the top of the adapter is a vertical-format rectangle. The red lines of the focusing screen have disappeared. Now, the two remaining dashed vertical lines indicate the left and right borders of the image.

Turn the back counterclockwise 90° to get horizontal-format photos and the red lines again.

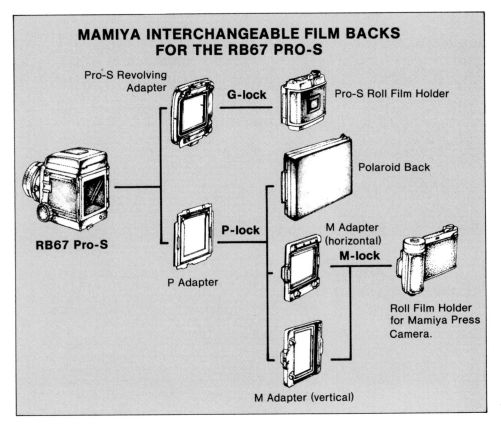

MAMIYA INTERCHANGEABLE FILM BACKS FOR THE RB67 PRO-S

Pro-S Revolving Adapter

G-lock

Pro-S Roll Film Holder

RB67 Pro-S

P-lock

Polaroid Back

P Adapter

M Adapter (horizontal)

M-lock

Roll Film Holder for Mamiya Press Camera.

M Adapter (vertical)

If you want to remove the dark slide from the detached back, press the small silver release lever.

When a Pro-S roll-film back is detached from the camera, a safety device engages the dark slide and prevents you from removing it. This prevents accidental exposure of film in the back. If you need to remove the dark slide from the detached back, press the small silver lever on the bottom of the back while pulling the dark slide out.

Attaching a Pro-S Film Back— Before attaching a Pro-S film back to the adapter, make sure the slide locks are still moved completely to the left. If they are on the right with nothing attached to the adapter, they will lock and not move to the left. If this is the case, depress both Slide-Lock Release Levers while moving the slide locks to the left.

If the back is not on the body and the Slide Lock is locked to the right, press the Slide-Lock Release Levers (arrows) while moving the Slide Lock to the left.

Then attach the film back with its film-advance lever facing up and with the dark slide inserted. Four pins on the adapter fit into four holes of the back. Slide both locks firmly to the right—in the direction of their white arrows—until they are snug. Because of an interlock, you can't remove the dark slide or push the shutter button until both slide locks are in place on the right side.

One of the advantages of the RB67 Pro-S system is the many different film backs you can use. This photo was made with the Pro-S 120 back in the horizontal position.

Pro-S 120 Film Holder—This is the standard film back for the RB67 Pro-S. It is pictured throughout this chapter. It is designed for 120 roll film only, yielding 10 6x7 cm exposures per roll.

Because 220 roll film does not have a continuous paper backing, you should not try to use it with this back. The exposure counter will automatically stop counting after the 10th exposure. Then the shutter button locks, and you'll have to roll up the rest of the film. In addition, the pressure plate is set for a thickness of film and paper backing, so if a 220 roll is loaded, it may not be held as flat as possible.

Pro-S 220 Film Holder—This film back is identical to the 120 back except that it is designed for 220 roll film and yields 20 6x7 cm exposures.

Do not use 120 film in this back because after the 10th exposure the film will still advance, although you'll only be "exposing" the paper leader of the roll. In addition, the pressure plate is closer to the film plane than in the 120 back, and the extra thickness of the 120 film and paper backing may cause unnecessary strain on the winding mechanism.

120/220 Roll Film Power Drive and Power Drive Control Pack—This is an automatic film winder that you can use with either 120 or 220 roll film. The special back uses an interchangeable pressure plate to adjust for the different thicknesses of 120 and 220

120/220 ROLL FILM POWER DRIVE & POWER DRIVE CONTROL PACK

Type: Automatic film winder built into Pro-S roll film holder that is adaptable for 120 or 220 film. Powered by power pack attached to RB67 Pro-S camera base.

Operation: Film wound from start mark to first frame. After exposure, film is automatically advanced when shutter cocking lever is depressed manually. After roll is exposed, film is wound up automatically. Stop winding by turning power switch off.

Film Advance Rate: Approximately 0.8 second per frame.

Shutter Speeds: Can be used with all lens speeds.

Power Source: Six AA batteries that fit into Power Drive Control Pack. Electrical connection between power pack and film holder.

Capacity: Approximately 60 rolls of 120 film with fresh manganese batteries or 150 rolls of 120 film with fresh alkaline batteries.

Other Features: Pro-S film holder has double-exposure prevention device with override, exposure counter, memo holder, manual film-advance lever, and dark slide. Power pack has tripod socket and cable release socket.

Dimensions/Weight: Roll Film Holder—Width 130mm (5.1"), height 120mm (4.7"), depth 42mm (1.7")/ 680g (25 oz.); Power Pack—Width 100mm (3.9"), height 40mm (1.6"), depth 95mm (3.7")/ 390g (14 oz.) without batteries.

film. The winder's motor is attached to the bottom of the special back and is connected to the power pack by an electrical cord or connector. The power pack uses six AA batteries and is attached to the tripod mounting socket of the camera body.

The back has the same type of exposure counter, film-advance lever, and double-exposure prevention device with override as regular 120 and 220 Pro-S backs. In fact, you can even use the back's film-advance lever to wind film manually.

When you use the winder, it advances the exposed frame after you depress the camera's cocking lever to cock the camera and lens for the next exposure. The winder takes about 0.8 seconds to advance each frame.

Pro-S 70mm Film Holder—This roll-film holder gives the maximum exposures per load of any of the Pro-S film backs. With a full cassette of 70mm film loaded in the back, you get 55 6x7 cm exposures. The film holder operates like the other Pro-S backs, except for loading.

You load two large cassettes into the back of the insert. One cassette holds the unexposed roll of film and the other cassette takes up exposed film. As with 120 film, you do not rewind the cassette when it is fully exposed. In fact, some photographers who shoot bulk-loaded 70mm film open a back with a partially exposed roll and remove only the exposed film for processing. After reattaching the end of the unexposed portion to the spool of the take-up cassette, begin shooting again.

The film is wound against its natural curl while in the back, so if a loaded roll is not used for some time, it can become curled where it contacts a roller in the back. This part of the film will never be held completely flat by the pressure plate, and an unfocused image will result. To avoid this problem, advance the film a couple of frames to bypass the curled section.

With the Mamiya 70mm back, you do not have to waste these frames. A suction bulb accessory is available that attaches to the bottom of the back. When you squeeze it, it stays compressed and removes air from inside the back. This suction holds the film flat against the pressure plate. Advance film only when the bulb is fully inflated. Then press the tip of the bulb to release the suction.

Old G-Lock Roll Film Holders—Three roll-film backs designed for older RB67 models also fit the RB67 Pro-S. One accepts 220 film for 20 6x7 cm frames, and another accepts 120 film for 10 6x7 cm exposures. The third back accepts 120 film for 10 4.5x6 cm images.

These roll-film holders do not have the *Pro-S* designation on the top slide-lock lever or in the insert, so you'll be able to tell them from the latest models. Essentially, the three holders look and operate the same way as Pro-S models. However, because they don't have the double-exposure prevention device, you must operate the camera and back as you would the old RB67.

Double Cut Film/Plate Holder Type A—This special film holder fits into the revolving adapter as described, except there are no interlocks between the holder and camera. It resembles and operates like a film holder used for view cameras. It has two dark slides and film chambers that hold *either* two pieces of 2-1/2x3-1/2 inch (6.5x9 cm) sheet film or two dry plates of the same size. The image created on the film is slightly smaller than the standard 6x7 cm format.

Removing the Pro-S Revolving Adapter—To use other film backs, including the Polaroid backs, you must first remove the revolving adapter from the camera. To do this, pull out the R-Lock lever located on the bottom of the camera body. The lever swings out and releases the adapter, which lifts off easily. Then you can attach the P Adapter, which is compatible with other backs.

To attach the Pro-S Revolving Adapter to the camera, align the white dot on the top of the adapter to the top center of the camera. While pressing the adapter on the body, push the R-Lock lever up and in. Make sure the

adapter fits tightly. If it is loose, light can leak into the film plane and fog film. Because of the many interlocks built into the Pro-S revolving adapter and Pro-S camera, you should not use the new adapter with the old RB67 body, nor use an old adapter with a Pro-S body.

This is the revolving adapter and back being reattached to the camera. Notice the levers and pins that are part of the many interlocks of the RB67 Pro-S.

Attaching the P Adapter—As shown on page 117, the P Adapter is necessary for attaching other film backs. It attaches to the RB67 Pro-S with the same R-Lock system used by the Pro-S revolving adapter. However, it does not have any interlocks. Align the white dot at the top of the adapter with the top of the camera. Tighten the assembly by pushing the R-Lock lever into the camera body.

The R-Lock lever is on the bottom of the camera. Pull it out to release the revolving adapter.

Mount the P Adapter with its engraved name on top and facing you.

With the P Adapter attached to the camera, you can use two types of Polaroid backs. You can leave the P Adapter attached to a Polaroid back all the time if necessary. This makes changing from a roll-film back to a Polaroid back faster.

In addition, two M Adapters fit onto the P Adapter. With these you can get horizontal- and vertical-format photos with two M-Lock roll-film backs and a focusing screen holder for sheet-film use. These M-Lock film backs are part of the Mamiya Universal Press Camera system, which is not described in this book.

Polaroid Film Backs—Both of these film backs incorporate parts made by Polaroid, so you load them as described in Chapter 4. The only difference is that they take different Polaroid film packs.

The Model 2 uses 100/600-series Polaroid film, and the M80 uses 80-series film. Both kinds of film are described in Chapter 4. The size of the image the RB67 Pro-S makes on Polaroid film is about 7cm (2-3/4 inch) square, which is the size of the square image you see on the camera's focusing screen.

Attach a Polaroid back to the P Adapter by inserting the large pegs of the back into the slots on the P Adapter's sides. Then slide the silver locking levers of the adapter up to lock the back. You can position the back so the dark slide is either on the left or right side.

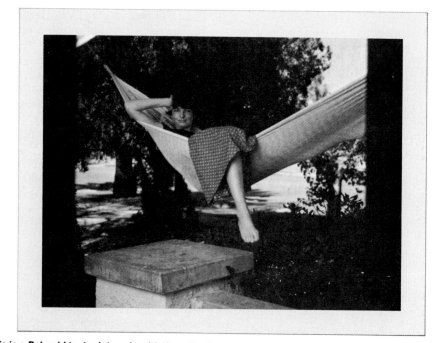

This is a Polaroid test print made with the color flash-fill examples shown on page 25. I made this exposure through the Mamiya 16X ND filter, which gave the Type 107 Polaroid film an effective speed of about EI 200. This was the same speed as the Kodak Ektachrome 200 Professional film used for the color photos. Therefore, I used the same exposure settings for the Polaroid test and the Ektachrome exposure.

Attach the Polaroid back to the P Adapter and slide up the locking levers of the adapter.

When using a Polaroid back, remember that there is no interlock between the camera and dark slide. You can trip the shutter whether the dark slide is in place or not. There is no double-exposure-prevention device.

LOADING 120 AND 220 FILM

You load the film inserts of the 120 and 220 Pro-S backs the same way. In fact, you can use the 120 or 220 inserts in the outer holder of either film back because the insert contains the pressure plate, exposure counter, and film-advance lever. You can load film when the back is either attached or detached from the camera.

To open the back, pull out the Back-Cover Latch on the bottom-right side of the film back while slightly pushing the back cover. Remove the insert.

To remove the empty spool from the left side of the insert, push the Spool-Release Pin that is next to the spool and lift the spool out. Then push the Spool-Release Pin on the right side and insert the empty spool.

Unwrap and remove the paper band on the film and insert the roll into the left side while depressing the spool-release pin. Orient the roll so the paper leader follows the white dashed line printed in the insert's film chamber. Pull the paper leader—with black side out— across the pressure plate and put the tapered end into the empty spool.

Wind the film-advance lever until the arrow printed on the paper leader aligns with the white triangular start mark next to the left spool-release pin. Put the loaded insert into the holder by aligning the top of the insert with

Open the back cover by pulling down the Back-Cover Latch.

Insert the unexposed roll into the left-hand chamber with the paper leader trailing to the left.

Use the film-advance lever to align the roll's start mark with that of the insert.

the white dot at the top of the holder. Close the back cover and push firmly on it while sliding the back-cover latch back in.

The exposure counter in the top of the loaded film back will show an **S** and a red mark. The red mark means incomplete film winding and, through an interlock, will lock the shutter button securely.

Wind the film-advance lever until it stops, about 4.5 75° strokes. When you release the lever, the exposure counter shows **1** without a red mark, indicating the first frame is in position and ready to be exposed. Before exposing film, remove the dark slide completely and store it on the left side of the camera.

CAMERA OPERATION

When you first begin using the RB67 Pro-S, operations may seem a bit strange and complicated. This is only because it does not operate like any other 35mm or medium-format SLR. After some practice shooting without film in the camera, you'll be better able to appreciate the control and flexibility the camera offers.

The only way to release the shutter without film in the camera is with the dark-slide lock disengaged and the multiple-exposure lever engaged. Withdraw the dark slide completely or partway to expose its small cutout triangle. Then flip the multiple-exposure lever forward to expose the red dot. Now all of the camera functions will work except for the exposure counter, which still shows an **S** and the red mark.

Exposure Controls—The camera does not come with a built-in meter, so you have to determine exposure with an accessory meter when you do not use one of the two metering viewfinders made for the camera.

After metering, set the *f*-stop using the aperture ring on the lens. Align the desired *f*-stop with the red dot on the lens barrel. The aperture ring has detents every half step.

Because all of the lenses have a built-in leaf shutter that is operated mechanically, the shutter-speed ring is on the lens. Each lens has the same range of shutter speeds, from 1/400 to 1 second, and T. Set the desired shutter speed opposite the same red index dot you used for the *f*-stop. Set the shutter speed only at the engraved numbers; in-between speeds can't be used.

White lines on a ring between the aperture and shutter-speed rings point to other combinations of *f*-stops and shutter speeds that you can use to get the same exposure value as the one you set.

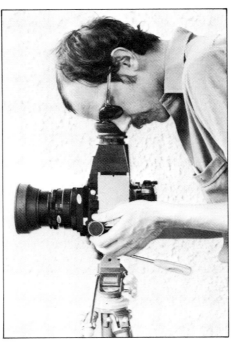

The camera has a large focusing knob on each side. Notice how the dark slide handily stores on the camera during shooting. The finder shown is the Magnifying Hood.

Viewing and Handling—Open the standard folding hood by lifting up on its back. Slide the small white button in the upper right-hand corner of the unfolded hood to the left to raise the 2.5X magnifier. Push down on its base to close it. Press the sides of the folding hood to fold it back down.

When the camera is cocked and the viewfinder is open, you see a right-side-up, laterally reversed image on the large 7cm (2-3/4 inch) square focusing screen. Because it does not

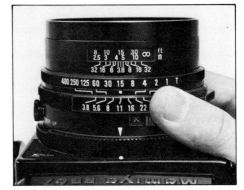

Set shutter speed and aperture across from the red index on the lens. Here, *f*-11 and 1/15 second are set. You also see other combinations of aperture and shutter speed that will give the same exposure.

have an instant-return mirror, the camera must be cocked for you to see the image on the screen. Lower the mirror and auxiliary shutter with the cocking lever.

Focus the camera by turning one of the large focusing knobs located on either side of the camera. The knobs control a rack-and-pinion bellows that moves the lens forward and backward. When the subject is in focus, move the Focusing-Knob Fixing Lever on

To avoid accidentally moving the focus setting, lock the focusing knobs by pushing the fixing lever forward.

the left-hand knob forward to securely lock the setting.

Most of the camera controls mentioned so far are on the camera's right side. Therefore, when hand-holding the camera, you'll naturally tend to support the camera in your left hand and operate the controls with your right. When you are ready to make an exposure, slide your left hand back to support the rear of the camera and use your right hand under the front of the camera so the index finger is on the shutter button.

When hand-holding the camera, use your left hand to adjust the focus knobs. Your right hand sets exposure and pushes the shutter button. Use the camera's adjustable strap to help steady the camera. The viewfinder shown is the standard Folding Focusing Hood.

Reading the Distance Scale— Because the lens does not have helicoid travel, you do not find subject distance from a scale on the lens. Instead, the RB67 Pro-S has a sliding distance chart on the right side of the bellows. After locking the focusing knobs, you can read both subject dis-

FOCUSING WIDE-ANGLE LENSES

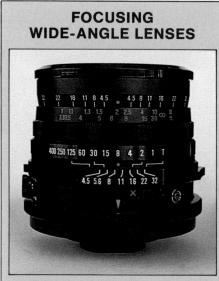

The 50mm and 65mm wide-angle lenses use floating lens elements to maximize flatness of field. You manually adjust the floating elements *after* focusing the image with the camera's focusing knobs. The floating ring is the green and red color-coded ring below the white depth-of-field scale. The 65mm lens is shown here.

After finding subject distance from the distance scale, turn the floating ring on the lens until that distance on its scale is aligned with the center red dot of the depth-of-field scale. Read depth of field from these scales.

tance and bellows extension from the chart.

The chart is color coded for most lenses from 50mm to 360mm. Select the curve on the chart that is the same color as the label of the lens you are using on the camera. Read the distance in feet or meters where the lens curve intersects the white distance scale. Black lines on the scale refer to distance in meters, and the red lines are for the distance in feet. When using the 150mm lens, you can approximate subject distance by using a distance value between the curves for the 140mm and 180mm lenses.

Read bellows extension (X) where the millimeter scale at the top of the sliding chart intersects the white distance scale. This value is helpful in close-up photography.

After determining approximate subject distance, you can manually set the depth of field scale on the lens. Turn the distance scale lever on the bottom right side of the lens until the subject distance indexes with the center line of the depth-of-field scale on the top of the lens. To read depth of field, read the subject distance that aligns with the index lines corresponding to the selected *f*-stop.

Because depth of field is shown by a manual setting, you should change it whenever you refocus or change aperture significantly. You can see depth

Depress the depth-of-field button to stop down the lens and visually judge depth of field.

of field on the focusing screen. After setting the *f*-stop, depress the depth-of-field button on the bottom right side of the lens. The diaphragm stops down to the preselected *f*-stop and remains stopped down as long as your finger remains on the button.

Exposing Film— Before you can expose film, you must release a series of interlocks designed to prevent wasted film and inadvertent multiple exposures. Cock the camera and lens simultaneously by pushing the cocking lever down completely. It has a 75° ratcheted stroke and springs back up once the body is cocked. After it is cocked, the lever locks in place and can't be moved.

Advance the film one frame by moving the film-advance lever one full stroke. Let it spring back all the way or else the shutter button will lock. This lever is also ratcheted, let-

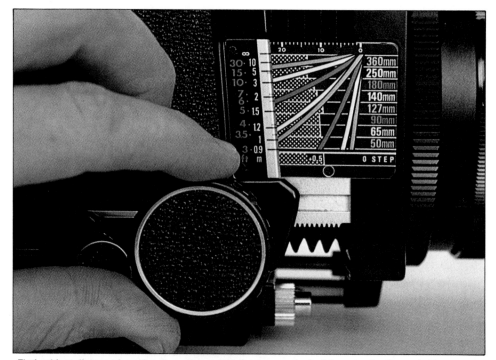

Find subject distance by using the color-coded distance scale. In this example, the scale shows that the 180mm lens is extended 23mm, giving a subject distance of 6 feet (1.8m). In addition, an exposure compensation of one half step is necessary for best exposure.

ting you wind film with a series of small strokes if desired. When the film is advanced and the lever released, the red mark disappears, the exposure counter advances, and the film-advance lever locks in place.

Remove the dark slide completely and store it on the camera's left side. Turn the knurled collar of the shutter button so its red dot aligns with the white dot on the camera body. The orange dot on the body marks the button's locked position. Depress the shutter button to make the exposure or use a threaded cable release attached to the shutter button.

After exposure, the red mark reappears in the exposure counter, indicating incomplete film winding. Move the film-advance lever again to advance both film and exposure counter and eliminate the red mark. Push the cocking lever to lower the mirror and auxiliary shutter and to cock the body and lens again. You can do these two operations in either order before depressing the shutter button. If only one lever is cocked, the shutter button remains locked.

After exposure a red mark appears next to the exposure counter, indicating incomplete film winding. Advance film and remove the mark by winding the film-advance lever.

Continue exposing film this way until the last exposure. Then the shutter button locks automatically and the film-advance lever moves freely. Move the lever until the roll of film is completely wound up, about three full strokes.

If you want to wind up a partially exposed roll without repeating the exposure operations, push the film-wind release lever on the rear of the Pro-S back to the left, in the direction of the arrow. This lets you use the film-advance lever to continuously wind film. When you open the film back to remove a wound-up roll, the exposure counter resets to S.

To advance a partially exposed roll of film, push the film-wind release lever to the left and wind the film-advance lever continuously. The release lever is below the arrow, and in this photo is covered by my left thumb.

Multiple-Exposure Operation— When you push the multiple-exposure lever forward before or after an exposure, it exposes a red dot. See page 115. This indicates that the film-advance lever is disengaged from the winding mechanism. The film-advance lever will lock. As long as the red dot is exposed, you can cock the camera and release the shutter any number of times.

A red mark appears in the exposure counter after the first exposure and remains visible until you reset the multiple-exposure lever and advance the film. This ends multiple-exposure operation.

Mirror-Up Exposures—Even though the camera mirror and auxiliary shutter are heavily damped, the RB67 Pro-S has a mirror-lockup mechanism to reduce mirror shock even more. Use it when the camera is on a tripod for long exposures, for close-up shooting, or for telephoto shots requiring minimal camera shake.

The Mirror-Up Knob is on the left side of each lens next to the bayonet ring. After focusing on the subject, pull out the knob and turn it clockwise so its red dot indexes with the orange dot labeled **MIRROR UP**. You can

Use the Mirror-Up Knob to lock up the mirror before exposure.

cock the shutter and advance film before or after moving the Mirror-Up Knob.

When you push the shutter button, the mirror and auxiliary shutter swing up against the focusing screen after the lens shutter closes and the aperture stops down. After waiting for vibrations to die down, trip the shutter either with a cable release screwed into the Mirror-Up Knob or by pulling the knob out and turning it counterclockwise to its original position. The knob does not spring back to the orange dot after exposure.

The easiest way to do the same thing is with the Dual Cable Release. The short cable screws into the mirror-up knob and the long cable screws into the shutter button. When you push the plunger partway, the shutter button is tripped first and the mirror and auxiliary shutter swing up. Wait a few seconds for vibrations to die down. Then push the plunger all the way to trip the lens shutter.

When you cock the camera and lens for the next exposure, the mirror and auxiliary shutter swing back down.

When you use the Dual Cable Release, the initial motion of the plunger, shown here, operates the camera's shutter button. Let vibrations die down, then push the plunger all the way to operate the lens shutter.

Rotate the film-advance lever and push the shutter button again to raise the mirror and auxiliary shutter before tripping the shutter again. Disengage the mechanism after the last mirror-up exposure by pulling the knob out and turning it counterclockwise until the red dots are aligned.

Long Exposures—To make an exposure longer than one second, set the shutter-speed ring to T. When you push the shutter button, it stays open even after you remove your finger from the button.

To close the shutter and end exposure, turn the shutter-speed ring to-

This photo was made after a summer rainstorm late one afternoon. Because the light was dim and I wanted good depth of field, a shutter speed of four seconds was necessary. This included compensation for the effect of long-exposure reciprocity failure and a warming filter on the lens. I used the Mirror-Up Knob and time-exposure setting of the lens and tripped the shutter with the Dual Cable Release. This helped preserve image sharpness by minimizing camera shake.

ward the 1 on the shutter-speed scale, or move the cocking lever of the camera down about 30°. The lever will not spring back up all the way until you move it through its complete 75° stroke.

Closing the shutter can cause some camera shake. To minimize this problem, put a lens cap over the lens or cover it with a black card to end exposure. Then close the shutter as described earlier.

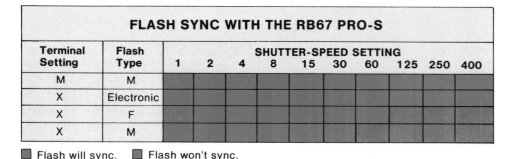

Terminal Setting	Flash Type	SHUTTER-SPEED SETTING									
		1	2	4	8	15	30	60	125	250	400
M	M										
X	Electronic										
X	F										
X	M										

FLASH SYNC WITH THE RB67 PRO-S

■ Flash will sync.　■ Flash won't sync.

USING FLASH

The flash terminal for the sync cord is at the top rear of the lens. The M-X lever is to the left of the flash terminal. Select either M- or X-sync by depressing the lever and sliding it to expose a white **M** or **X**. When you release the lever, it locks securely.

Because each of the lenses for the RB67 Pro-S has a built-in leaf shutter, you get electronic flash sync with each shutter speed when the lever is set to X. See the accompanying table to find the range of sync speeds for M- and F-type flashbulbs.

Set the M-X lever by pushing and sliding it. The lever locks when you release it.

INTERCHANGEABLE VIEWFINDERS

Besides the standard folding-hood viewfinder that comes with the camera, Mamiya makes six other viewfinders for the RB67 Pro-S. They are easy to attach and remove because there are no special couplings between viewfinder and camera. In fact, viewfinders made for older RB67 cameras will work with the Pro-S.

To remove a viewfinder, push the small latch under the camera nameplate while sliding the nameplate to the right, as viewed from the front. When the nameplate has moved as far as it will go, lift up on the viewfinder from the front.

Unlock a finder by pushing the latch and sliding the nameplate.

Attach a viewfinder by inserting the two prongs on its back into two slots on the camera while lowering the front of the viewfinder. Then slide the nameplate back to its locked position. The latch will lock automatically.

Put the back of the finder on the camera first then lower its front. Relock the finder with the sliding nameplate.

Folding Focusing Hood—This waist-level viewfinder effectively stops light from entering through the hinges of the opened sides. To increase contrast and enlarge the laterally reversed image, raise the magnifier by moving the white button to the left.

Then bring your eye to the lens. The magnifier is a -1.3 diopter lens. Five other lenses of +1 to -3 diopters are available to better fit your eyesight if necessary.

For many portrait, still-life or nature scenes, viewfinders that show a laterally reversed image are fine to use. Generally, these viewfinders are lighter and less expensive than prism finders.

Raise the magnifier of the folding hood by pushing this small white button.

Magnifying Hood—This viewfinder is a rigid version of the folding hood. Its 2.5X magnifier is surrounded by a rubber eyecup, so viewing is very comfortable and light tight. The magnifier has built-in diopter correction, as shown on page 11.

Dual Magnifying Hood—The only difference between this viewfinder and the previous one is the dual magnifier. You can select a viewfinder magnification of 3X or 5X with a large knob on the right.

Prism Finder—With this viewfinder, you see the image right-side-up and laterally correct. The eyepiece is at a 30° angle to the film plane, making it an eye-level viewfinder. Viewfinder magnification is 2.2X. Eight interchangeable eyepiece lenses in a diopter range from +3 to -4 are available to fit your eyesight.

Universal Sportsfinder—Use this sportsfinder to follow moving subjects with the camera or when you want to view more than the lens sees. The viewfinder also has an eyepiece that lets you see the central portion of the focusing screen magnified, allowing convenient focusing.

After installing the viewfinder, adjust the front frame to fit the field of view of the lens you are using by loosening the set screw on the viewfinder's left side. Slide the frame to index with the lens focal length engraved on the right rail. Insert a plastic field mask into the field frame. Two masks are available. One is for the 6x7 cm format. The other is for 4.5x6 cm images, which you can get only with a non-Pro-S back.

The Universal Sportsfinder is useful when you want to photograph moving subjects.

To view, look through the sight of the rear viewing frame so the red dot of the front frame is centered in the field mask's circle. The field mask has colored rectangles that indicate the approximate fields of view of the lenses you can use. The color of the markings matches that of the engraved lens focal lengths on the right rail.

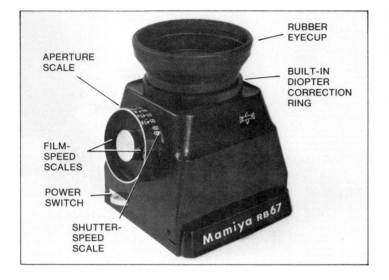

APERTURE SCALE

RUBBER EYECUP

BUILT-IN DIOPTER CORRECTION RING

FILM-SPEED SCALES

POWER SWITCH

SHUTTER-SPEED SCALE

Mamiya RB67

MAMIYA CdS FINDER SPECIFICATIONS

Type: Rigid hood viewfinder with built-in spot meter using a CdS photo cell. Meter operates manually by reading a 5.5mm diameter circle on the focusing screen. Adjust the meter's aperture and shutter-speed ring to determine exposure and transfer settings to camera lens. Viewfinder display shows match-needle indicator and location of metering cell. Built-in diopter correction in viewfinder's eyepiece.
Measurement Range: EV 3.8 to EV 18.8 at f-3.8 with ASA 100 film.
Film-Speed Scale: ASA 12 to 6400.
Working Range: Shutter speeds from 1/400 to 1 second.
Power Source: Two 1.5V silver batteries (Eveready S-76 or equivalent).
Dimensions: Width 110mm (4.3"), height 102mm (4.0"), depth 85mm (3.3").
Weight: 300g (11 oz.).

CdS Finder—This viewfinder is shaped like the Magnifying Hood, giving an upright, laterally reversed image. It has a manually operating CdS meter built into it. A small metering cell reads a 5.5mm diameter circle on the camera's focusing screen. The meter has a sensitivity range of EV 3.8 to EV 18.8 at f-3.8 with ASA 100 film.

The meter uses two 1.5V silver-oxide batteries, Eveready S-76 or equivalent. The batteries fit into a battery chamber on the meter's left side. *Do not* insert 1.3V mercury batteries. Even though they look the same, using them will make the meter unreliable.

After attaching the viewfinder to the camera, focus the lens to infinity and adjust the eyepiece of the viewfinder by moving it up and down until you get the sharpest possible focusing screen image.

Before setting film speed, set the meter for the maximum aperture of the lens. Pull the shutter-speed dial out slightly and turn it so the small orange f-number on the scale corresponding to the maximum aperture of the lens is aligned with a small index mark on the viewfinder. Be sure to reset this every time you use a lens with a different maximum aperture.

Set film speed by pulling the aperture dial out slightly and turning it so the film speed is aligned with an index mark. The film-speed scale is marked for ASA speeds from 12 to 6400 and DIN speeds from 12 to 39.

Turn the meter on by moving the gray power switch to ON. This moves the metering cell, which is connected to a plastic arm of the power switch, into the center of the focusing screen.

Set either metering finder for the maximum lens aperture by pulling on the shutter-speed dial while turning it. Align the f-number with the small index.

It reads a very small part of the image, letting you use it like a spot meter. Be sure the metering cell is moved all the way to the center of the screen. To meter other parts of the scene, move the camera until the area of interest is in the center of the screen.

CdS FINDER EXPOSURE DISPLAY

Adjust the aperture and shutter-speed scale of the meter until the match-needle indicator in the top left part of the screen is centered in the circle. Then turn the meter off to prevent unnecessary drain on the battery.

The aperture and shutter-speed scales of the viewfinder recommend several pairs of settings that you can use to get the same exposure value for the metered scene. Set the lens shutter speed and aperture based on these recommendations. Use the viewfinder's meter only on camera.

CdS Prism Viewfinder—This looks like the nonmetering Prism Viewfinder, but it has a CdS center-weighted meter that reads the whole viewfinder image. Like the CdS Finder, it uses two 1.5V silver batteries that fit into a chamber on the meter's left side. It's not reliable with 1.3V mercury batteries.

The meter has a sensitivity range of EV 3.8 to EV 17 at f-3.8 with ASA 100 film. After installing the batteries, check them by pushing the battery-check button on the finder's right side. If the batteries are good, a small light near the button will glow.

Attach the meter to the camera and set it for the maximum lens aperture and film speed as described for the CdS Finder. Turn the meter on using the power switch.

When you look through the eyepiece, you'll see a match-needle indicator above the focusing screen. The indicator is illuminated by a window in the front of the viewfinder. If this window is covered, you can't see the metering display.

Adjust the aperture and shutter-speed dials of the viewfinder until the

MAMIYA CdS PRISM FINDER SPECIFICATIONS

Type: Prism viewfinder with a center-weighted CdS meter. You operate the meter manually by adjusting the meter's aperture and shutter-speed ring to determine exposure. Transfer settings to camera lens. Viewfinder display shows match-needle indicator above the focusing screen. Interchangeable diopter correction lenses available for viewfinder's eyepiece. Battery-check button and light.
Measurement Range: EV 3.8 to 17 with ASA 100 film and *f*-3.8 lens.
Film-Speed Scale: ASA 12 to 6400.
Working Range: Shutter speeds from 1/400 to 1 second.
Power Source: Two 1.5V silver batteries (Eveready S-76 or equivalent).
Dimensions: Width 110mm (4.3"), height 102mm (4.0"), depth 95mm (3.9").
Weight: 1.1kg (2.4 lbs.).

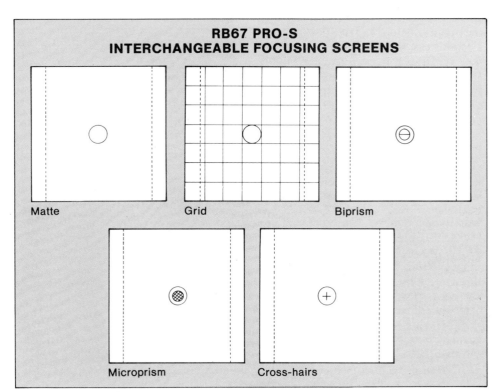

EXPOSURE INDICATOR'S ILLUMINATING WINDOW

FILM-SPEED SCALES

APERTURE SCALE

SHUTTER-

needle is centered in the indicator. Then turn the meter off to prevent unnecessary battery drain. Select an appropriate shutter speed and *f*-stop combination from the dials, and set the camera lens.

CdS PRISM FINDER EXPOSURE DISPLAY

INTERCHANGEABLE FOCUSING SCREENS

Five interchangeable focusing screens are part of the Pro-S system. To change screens, first remove the viewfinder. Then lift up on the sides of the focusing-screen frame. Install another frame and screen by lowering the frame into its slot. Press down lightly to make sure it is seated.

The frame is held loosely and may fall out if the camera is turned upside down with the viewfinder detached. Always use the camera with a viewfinder attached.

Besides the standard all-matte screen, there are four other plastic

The interchangeable focusing screen easily lifts out of the camera.

screens with a matte field and a Fresnel lens. They have focusing aids that make them suitable for various kinds of photography. Dashed blue vertical lines are inscribed on all screens.

CLOSE-UP PHOTOGRAPHY

Because of bellows focusing, you can do close-up photography without a special macro lens or extension tubes. However, these accessories are available for higher magnifications than you get with just the camera and lens. The system does not offer an adjustable accessory bellows.

Using Regular Lenses—The maximum extension of the camera bellows

RB67 PRO-S INTERCHANGEABLE FOCUSING SCREENS

Matte

Grid

Biprism

Microprism

Cross-hairs

APPROXIMATE MAXIMUM MAGNIFICATION WITH CAMERA BELLOWS FULLY EXTENDED

Lens	Lens-To-Subject Distance* inches	cm	Magnification	Exposure Compensation (Steps)
50mm f-4.5	1.9	4.9	0.88	1
65mm f-4.5	3.4	8.5	0.71	1
90mm f-3.8	7.9	20.0	0.51	1
127mm f-3.8	17	43.3	0.36	1
140mm f-4.5	23.9	60.7	0.30	1
180mm f-4.5	34	84.7	0.26	1
250mm f-4.5	64	160	0.18	1/2
360mm f-6.3	136	346	0.13	1

* Measured from front edge of lens barrel to subject.

is 46mm. You can find the maximum magnification of each lens with the extension formula in Chapter 2 or by referring to the accompanying table.

To find the exposure correction due to magnification, use the P value of the lens, the bellows extension, and the formulas of Chapter 2. If you use one of the metering viewfinders, you do not have to bother calculating exposure compensation as long as the light is within the meter's working range.

A third way is to use the sliding distance chart of the camera. After focusing on the subject, lock the focusing knob, and refer to the sliding distance chart. Note the pattern of the horizontal lens scale that intersects the white distance scale. If the pattern is hatched, set the camera for one more step of exposure. If the pattern is dotted, set the camera for one-half step more exposure by adjusting the aperture ring. If there is no pattern, no compensation is necessary. This is summarized in the bottom line of the sliding scale.

Mamiya recommends using an aperture of f-16 or smaller when you use the 50mm or 65mm wide-angle lenses for subjects closer than 3.3 feet (1m). In this case, set the floating ring of the lens to its minimum focusing distance. This helps produce best image quality.

Using Auto Extension Tubes—For higher magnifications with the RB67 Pro-S, use the Auto Extension Tubes. Two tubes, labeled No. 1 and No. 2, are available. They give 45mm and 82mm of extension respectively. You can use the tubes singly or stacked for 127mm of extra extension. Magnification ranges using combinations of

tubes and lenses are in the accompanying table.

Attaching a tube to the camera is the same as mounting a lens on the camera. The simplest way is to cock the extension tube before mounting it on the cocked camera. Cock the tube as you cock a lens. Install the tube and turn the bayonet ring to lock it. Mount the cocked lens, or another tube, onto the mounted extension tube in the same way. Detach the lens and tubes by turning the bayonet rings after cocking the camera body.

Mount the cocked extension tube to the cocked camera first.

Then mount the cocked lens onto the extension tube.

You can find the exposure correction one of three ways. The simplest is to use a metering viewfinder. You can also determine the P value of the lens and use it with the total extension of the lens and tubes in the formulas in Chapter 2.

Or, you can use the sliding distance chart with the accompanying table. After focusing on the subject, lock the focusing knob and note the bellows extension on the scale at the top of the chart. Refer to the table and find the lens and tube combination you are using. Find the exposure compensation in steps by referring to the entry in the last column. Read the value opposite the amount of bellows extension. Then adjust the camera and make the exposure.

Mamiya does not recommend using the 50mm wide-angle lens with extension tubes because image quality suffers at high magnification. The 65mm lens is suitable for use only with the No. 1 tube. When using any lens with the tubes, for best image quality work with the smallest aperture possible. Set the floating ring of the lens to its closest focus setting.

Image vignetting is a problem only when using both extension tubes with the 90mm through 360mm lenses, excluding the 127mm lens. If you shoot Polaroid film, the amount of vignetting will be greater, but this is because the image is larger. Vignetting in the 6x7 cm image area is the same as with conventional roll film.

Using the 140mm Macro Lens—This lens uses floating elements for best image quality in the magnification range of 0.3 to 1.2. The lens comes with a sliding distance chart that includes the 140mm lens. If your RB67 Pro-S doesn't already have this chart, replace it with this latest one.

To do this, extend the camera bellows fully. Then, with fingernail polish remover or lacquer thinner, dissolve the adhesive on the screws holding the chart. Unscrew the screws and remove the old chart. Attach the new chart with the screws.

When you use the lens without the tubes, first set the infinity mark of the lens floating ring to the red triangular index. Focus the camera. Then read bellows extension from the sliding distance chart and reset the floating ring to that value.

The floating ring has three other scales for use with combinations of the

USING EXTENSION TUBES WITH THE RB67 PRO-S

Lens	Extension Tube(s)	Lens-To-Subject Distance*		Magnification	Bellows Extension And Exposure Compensation (Steps)
		inches	cm		
65mm	No. 1	3.4— 9.6	8.7— 4.0	0.7—1.4	+1.5 / +1
90mm	No. 1	8.0— 4.4	20.4— 11.3	0.5—1.0	+1.5 / +1
	No. 2	4.8— 3.4	12.3— 8.7	0.9—1.4	+2 / +1.5
	No. 1 + No. 2	3.5— 2.8	8.8— 7.1	1.4—1.9	+2.5 / +2
127mm ƒ-3.8	No. 1	18.0— 9.6	44.1— 25.9	0.4—0.7	+1.5 / +1
	No. 2	11.0— 8.2	27.9— 20.8	0.7—1.0	+2 / +1.5
	No. 1 + No. 2	8.2— 6.9	20.9— 17.5	1.0—1.4	+2.5 / +2
180mm	No. 1	34.0—19.6	86.3— 49.9	0.3—0.5	+1.5 / +1
	No. 2	18.1—15.6	53.8— 39.6	0.5—0.7	+2 / +1.5
	No. 1 + No. 2	15.6—13.0	39.8— 33.0	0.7—1.0	+2.5 / +2
250mm	No. 1	64.3—36.1	163.0— 93.0	0.2—0.4	+1.5 / +1
	No. 2	39.4—28.8	100.0— 73.0	0.3—0.5	+1.5 / +1
	No. 1 + No. 2	28.9—23.8	74.0— 61.0	0.5—0.7	+2 / +1.5
360mm	No. 1	130.0—81.4	352.0—207.0	0.1—0.3	+1.5 / +1
	No. 2	87.5—65.1	222.0—165.0	0.2—0.4	+2 / +1.5
	No. 1 + No. 2	65.5—54.7	166.0—139.0	0.4—0.5	+2

* Measured from front of lens barrel to subject.

two extension tubes. When focusing with the No. 1 tube attached, align the triangular index mark with the center dot of the **No. 1** scale. Focus the camera, read the bellows extension, and reset the ring. Perform the same procedure with the No. 2 tube, but use the **No. 2** scale.

When using both tubes, set the center dot next to the **No. 1 + No. 2** symbol across from the index mark. You do not need to adjust the floating ring after focusing. For life-size shooting—a magnification of 1.0—use both extension tubes and extend the lens bellows 13mm.

ACCESSORY GRIPS

Three accessory grips are available for hand-holding the RB67 Pro-S. All relocate the shutter button to the handle of the grip. This lets you hold the camera and shoot with one hand while using your other hand to operate camera controls. Two of the grips are L-shaped and have the handle on the left side. The Pistol Grip has a handle under the camera. They are shown on page 90.

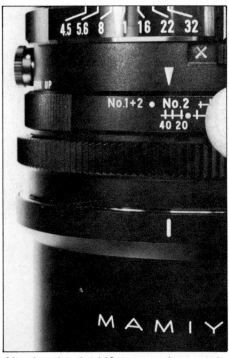

After focusing the 140mm macro lens, set the lens floating ring to the approximate bellows extension determined from the sliding distance chart. In this example, the No. 2 extension ring is being used so the No. 2 scale on the floating ring is set to about 35mm of extension.

Maximum magnification with the 140mm lens was used to make this close-up photo of a Cereus blossom. Exposure compensation was one step.

12

Hasselblad System

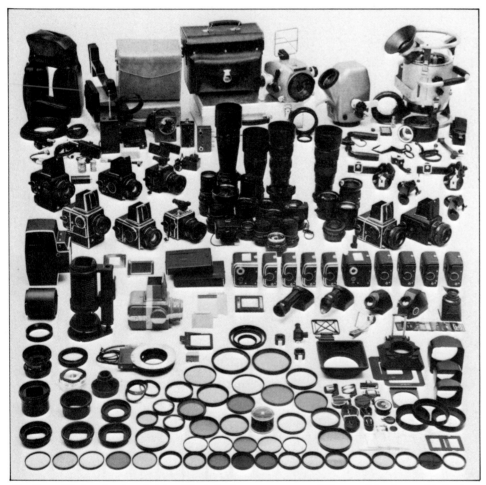

The Hasselblad system is extensive. It includes four cameras, over 20 lenses, interchangeable backs, viewfinders, and other accessories that make practically any kind of photography possible.

The first 6x6 cm medium-format SLR camera with interchangeable lenses, viewfinders, and film backs was the Hasselblad 1600F, introduced in 1948. It had a focal-plane shutter (F) with a top speed of 1/1600 second; hence, the name *1600F*. Since then the basic Hasselblad camera has changed, but its shape and design philosophy hasn't. The core of the Hasselblad system is still a cube-shaped camera body that accepts a wide range of interchangeable

accessories making practically any kind of photography possible. Many of the accessories available for older model Hasselblads fit today's cameras, and most of today's accessories fit older Hasselblad cameras.

Hasselblad's policy of making camera equipment durable and not obsolete has led to the development of a comprehensive system that includes over 300 items. There are four cameras with a basic format of 6x6 cm. Actual image size is about 56x56 mm.

The standard lens of the system is an 80mm Zeiss Planar.

In addition to the four cameras are two lines of interchangeable Zeiss lenses, filters and lens attachments, interchangeable viewfinders, and interchangeable film backs using four types of film and three image formats. An array of close-up accessories ranges from simple close-up lenses to adapters for photomicroscopy. Special-purpose accessories for scientific and underwater photography are also available.

This chapter discusses the latest models of the four Hasselblad cameras and the system accessories. A brief summary of developments since 1948 follows:

By 1957, the 1600F camera evolved into the 500C, which used Carl Zeiss lenses having a built-in Compur (C) leaf shutter for high-speed electronic flash sync up to a top speed of 1/500 second. The latest version of this camera is the **500C/M**. The *M* stands for a modification that occurred to the 500C in 1970, letting you interchange focusing screens yourself. Except for this change, the 500C works exactly like the 500C/M, discussed in this chapter.

A special non-reflex, wide-angle camera was introduced in 1954. It used a fixed-mount 38mm *f*-4.5 Biogon wide-angle lens, giving it the designation super-wide (SW). In 1959 it became the SWC. The SWC camera was modified in 1980 to accept Polaroid film backs in addition to other roll-film backs available from Hasselblad. It has evolved into today's **SWC/M**. Other than this improvement, the SWC/M is essentially the same as the 1959 SWC model.

In 1965 a motorized version of the Hasselblad 500C was introduced. Called the 500EL, it featured an

integral motor that automatically advanced film and cocked the camera. Exposures were made electronically in five different ways. In 1970 it too was modified to accept interchangeable focusing screens, changing the camera name to **500EL/M**. It accepts the same accessories as the 500C/M, in addition to special electronic triggering devices.

The first Hasseblad camera since 1957 to have a focal-plane shutter was introduced in 1977. Called the **2000FC**, it has a metal focal-plane shutter with a top speed of 1/2000 second. Shutterless Zeiss lenses with larger maximum apertures and closer focusing distances than the leaf-shutter lenses were designed for this camera. However, the 2000FC was designed to be used with leaf-shutter "C" lenses. The camera accepts other interchangeable accessories.

LENSES OF THE HASSELBLAD SYSTEM

Currently, Hasselblad offers two lines of interchangeable lenses. Hasselblad calls lenses with a built-in, Compur leaf shutter *C lenses;* those without built-in leaf shutters are called *F lenses*. These designations are *not* engraved on the lens barrel. Even so, there are enough differences between F and C lenses to eliminate any possibility of confusing them.

Interchangeable C lenses are compatible with the 500C/M, 500EL/M, and 2000FC cameras. All F lenses are interchangeable, but they are compatible only with the 2000FC camera.

All F and C lenses, except for the 140mm to 280mm zoom lens, are made in West Germany by the Carl Zeiss Co. Most are multicoated with Zeiss T* lens coating to minimize flare and ghosting. The zoom lens is made by the Jos. Schneider Co. of West Germany in both C and F versions.

C lenses have a shutter-speed range from 1 to 1/500 second, plus B. They have both M and X flash sync and a self-timer (V). A locking, cross-coupling exposure-value scale (EVS) and depth-of-field preview are built into each C lens.

F lenses have different exposure-value scales, depth-of-field preview, and locations of the focusing and aperture ring. Because F lenses do not have a built-in leaf shutter, they have larger maximum apertures and can focus closer than C lenses of the same focal length.

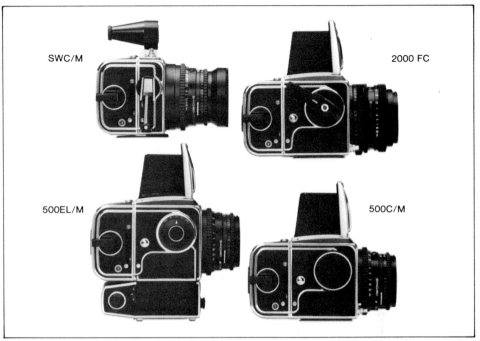

These are the four Hasselblad cameras discussed in this chapter.

HASSELBLAD C LENSES

C Lens	Minimum Aperture	Diag. Angle of View	Minimum Focus Distance ft.	m	Weight oz.	g	Filter Series
30mm f-3.5 F-Distagon	f-22	180°	1.0	0.3	48	1370	26
38mm f-4.5 Biogon	f-45	90°	1.0	0.3	20•	560•	63
40mm f-4 Distagon	f-32	88°	1.5	0.5	48	1375	104
50mm f-4 Distagon	f-22	75°	1.5	0.5	31	885	63
60mm f-3.5 Distagon	f-22	66°	2.0	0.6	23	645	63
80mm f-2.8 Planar	f-22	52°	3.0	0.9	17	465	50
100mm f-3.5 Planar	f-22	43°	3.0	0.9	22	610	50
105mm f-4.3 UV Sonnar	f-32	41°	6.0	1.8	24	670	50
120mm f-5.6 S-Planar	f-45	36°	3.0	0.9	23	640	50
135mm f-5.6 S-Planar	f-45	32°	1.8*	0.5	20	560	50
150mm f-4 Sonnar	f-32	30°	5.0	1.4	25	710	50
250mm f-5.6 Sonnar	f-45	18°	8.5	2.5	33	930	50
250mm f-5.6 Sonnar Superachromat	f-45	18°	9.0	2.8	27	760	50
350mm f-5.6 Tele-Tessar	f-45	13°	16.5	5.0	51	1450	86
500mm f-8 Tele-Tessar	f-64	9°	28	8.5	75	2130	86
140mm— 280mm f-5.6 Variogon Zoom	f-45	30°— 16°	8.2/ 3.5+	2.5/ 1.0	66	1870	93

* With bellows extension.
+ In macro mode.
• Lens is permanently attached to camera.

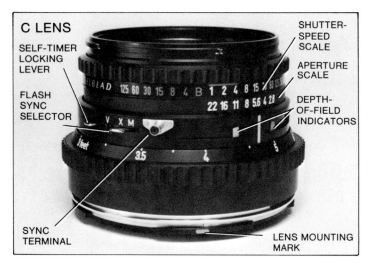

C LENS

SELF-TIMER LOCKING LEVER

FLASH SYNC SELECTOR

SYNC TERMINAL

SHUTTER-SPEED SCALE

APERTURE SCALE

DEPTH-OF-FIELD INDICATORS

LENS MOUNTING MARK

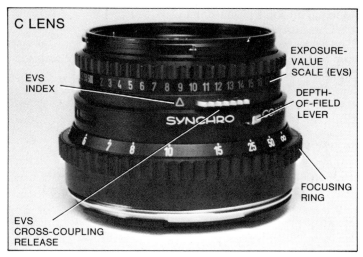

C LENS

EVS INDEX

EVS CROSS-COUPLING RELEASE

EXPOSURE-VALUE SCALE (EVS)

DEPTH-OF-FIELD LEVER

FOCUSING RING

The accompanying tables summarize features of C and F lenses. Special lenses are discussed here.

30mm f-3.5 F-Distagon C Fish-Eye—This ultrawide-angle lens has a diagonal field of view of 180° and gives typical fish-eye barrel distortion in a rectangular image. The lens gives good corner-to-corner image sharpness even at maximum aperture. Because the front element is large and curved, filters or a regular lens shade can't be used over the lens. Instead, the lens has a built-in hood and accepts a filter inside the lens barrel.

The lens comes with four Series 26 filters, which have 26mm diameters. These are yellow (Y50), orange (OR57), conversion (B11), and clear glass. For best image quality, a filter should be used in the lens at all times. To install one, you must take the lens apart. Turn the serrated grip behind the lens hood while holding the lens hood with your other hand. The filter screws onto the cone of the front half of the lens. Reassemble the lens.

38mm f-4.5 Biogon C—Because of this lens design, the rear element of the lens is very close to the film plane. Therefore, a special non-reflex camera body was designed for it. The lens is permanently attached to the SWC/M camera. It *cannot* be used with other Hasselblad bodies.

The lens has a diagonal angle of view of 90° on the 6x6 cm frame. It is optically corrected to give excellent corner-to-corner image sharpness with large apertures and small subject distances. In addition, the lens *does not* create rectilinear distortion, as most wide-angle lenses do.

When set to f-22, the lens has depth of field from infinity to 26 inches

HASSELBLAD F LENSES

F Lens	Minimum Aperture	Diag. Angle of View	Minimum Focus Distance ft.	m	Weight oz.	g	Filter Series
50mm f-2.8 Distagon	f-22	74°	1.0	0.3	43	1230	86
80mm f-2.8 Planar	f-22	51°	2.0	0.6	16	460	50
110mm f-2.0 Sonnar	f-16	39°	2.6	0.8	27	750	70
150mm f-2.8 Sonnar	f-22	30°	4.6	1.4	24	680	70
140mm—280mm f-5.6	f-32	30°—16°	8.2/3.5+	2.5/1.0+	66	1870	93
250mm f-4 Tele-Tessar	f-32	18°	8.5	2.5	30	820	70

+ In macro mode.

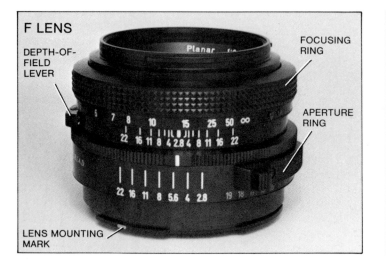

F LENS

DEPTH-OF-FIELD LEVER

FOCUSING RING

APERTURE RING

LENS MOUNTING MARK

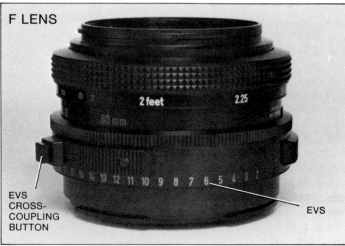

F LENS

EVS CROSS-COUPLING BUTTON

EVS

(65cm). Because of these features, the SWC/M can be used effectively in landscape and architectural photography and as a copy camera.

105mm *f*-4.3 UV Sonnar C—This moderate-telephoto lens has fluorite and quartz lens elements, which transmit UV radiation from 215nm to 400nm. Regular optical glass absorbs most UV radiation. The UV Sonnar is color corrected for visible wavelengths from 400nm to 700nm. This makes it useful in both scientific work involving UV radiation and general-purpose photography.

By using special interference filters with the lens, you can block visible radiation and record only UV wavelengths. No focus correction based on wavelength is necessary; visual focusing is accurate enough. When a haze or UV filter is used on the lens, UV radiation is blocked, and the lens can be used as any color-corrected lens without image degradation due to UV exposure of the film. This 105mm lens does not have Zeiss T* multicoating.

120mm *f*-5.6 S-Planar C—The *S* in the name of this lens denotes *special purpose*. It is optically corrected for best image quality at near subject distances, making it ideal for close-up photography when using extension tubes or bellows extension.

It gives best image quality in a magnification range from 0.1 to 0.5 at *f*-11. Maximum magnification without extra extension is about 0.17. The Proxar close-up lenses are not recommended for use with this lens. Hasselblad close-up accessories are discussed later in this chapter. General information is in Chapter 2.

You can also use the lens for far subjects; however, Hasselblad recommends you use smaller apertures than you normally would with a regular lens corrected for far distances. Apertures between *f*-11 and *f*-45 give best image quality in this case.

135mm *f*-5.6 S-Planar C—Like the 120mm S-Planar, this lens is also optically corrected for best image quality in the close-up range. However, the lens has no focus control. It is designed to be used with a bellows.

When fully retracted on the bellows, it acts as a regular 135mm lens focused at infinity. When fully extended on a bellows, it gives an image magnification of 1.0. Best image

WHAT ZEISS LENS NAMES MEAN

All lenses made by the Carl Zeiss Co. have a trade name that indicates something about the optical design of the lens. Here's what they mean:

Distagon: This wide-angle lens design is *retrofocus*, which means the rear lens node is in the air behind the rear element of the lens. Here's why: The distance between the rear lens node and the film plane is equal to lens focal length when the lens is focused at infinity. Because the distance between the lens mounting surface and the film plane in Hasselblad cameras is 74.9mm (3 inches), the rear node must be between the lens and film plane for lenses with focal lengths shorter than 74.9mm.

These lenses are designed to give best corner-to-corner sharpness for far subjects. When using them for near subjects, stop down the lens. The 40mm Distagon has a detent at the 3-foot setting of the focusing scale to remind you of this.

Biogon: The fixed-mount, 38mm wide-angle lens of the SWC/M camera is not retrofocus—called *true wide-angle*. The rear lens node is inside the lens. The mounting flange is only 34.5mm (1.3 inches) away from the film plane. This is why a reflex mirror cannot be used in the camera. Because of the lens design, however, the Biogon can be corrected for excellent image quality with *no* curvilinear distortion throughout the focusing range—in this case from 24 inches (65cm) to infinity with an *f*-22 aperture.

Planar: These lenses are designed to produce an image in a flat field. This promotes good corner sharpness in the image. They give best image quality when focused on far subjects.

S-Planar: These special-purpose (S) lenses are designed to give flat-field images when focused on near subjects. This makes them ideal for close-up work.

Sonnar: These are compact, moderate-focal-length telephoto lenses with most of their elements in the front section of the lens.

Tele-Tessar: These lenses have a positive lens element in the front of the lens and a negative lens element in the rear. A large air space separates the two. The rear lens node is in the air in front of the lens.

The 135mm S-Planar lens does not have a focusing ring. Use it with an extension bellows for image magnifications from 0 to 1.0.

quality occurs at lens apertures between *f*-11 and *f*-22.

250mm *f*-5.6 Sonnar Superachromat C—This telephoto lens is color corrected for optimal color reproduction across the visual range of wavelengths—the same as the regular 250mm *f*-5.6 Sonnar C lens. However, the Superachromat is also color corrected for infrared wavelengths from 700nm to 1000nm. This makes visual focusing accurate enough when using infrared-sensitive films. The lens is ideal for many scientific disciplines using both photography and infrared radiation, such as hydrology, plant pathology, and archaeology.

140mm-280mm *f*-5.6 Variogon—This is the only lens designed for

Hasselblad cameras that is not made by Zeiss. It is a Schneider lens available in *both* F and C lens models. Despite its name, the lens is *not* a varifocal zoom—the image stays in focus throughout the zoom range.

The lens focuses down to 8.2 feet (2.5m) at all focal lengths. It also has a macro-mode control that lets you focus as close as 3.5 feet (1m) when the lens is set to 140mm focal length.

Automatic Diaphragm Control Lenses—The 80mm and 100mm Planar and 150mm and 250mm Sonnar C lenses are available with a built-in, automatic-exposure, shutter-priority meter. A meter using a silicon photocell is attached to the top of the lens.

It does not meter through the lens. The meter measures the same angle of view as the lens, but due to its displacement from the optical axis, not the identical field. The metering pattern is essentially full-frame averaging for the 6x6 cm format. When using smaller formats made possible with other backs, you may get erroneous exposure settings because the meter will see more than the film is actually recording.

If you use a filter or close-up accessories, the meter will not automatically compensate for any resulting light loss. Instead, you should change the film-speed setting on the meter.

Film speed is set on the front of the meter. Set shutter speed with the shutter-speed ring of the C lens. The

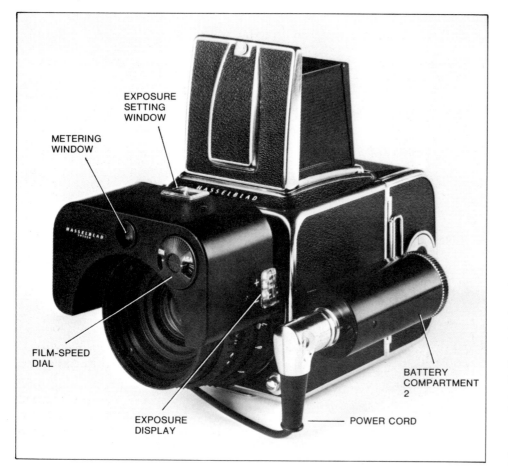

EXPOSURE SETTING WINDOW

METERING WINDOW

HASSELBLAD

FILM-SPEED DIAL

EXPOSURE DISPLAY

POWER CORD

BATTERY COMPARTMENT 2

HASSELBLAD AUTOMATIC DIAPHRAGM CONTROL SPECIFICATIONS

Type: Automatic-exposure meter that operates in a shutter-priority mode. Silicon meter is inside a housing on the top of an 80mm, 100mm, 150mm, or 250mm C lens. Metering pattern is full-frame averaging with the same approximate field of view as lens. Manually set film speed on meter and shutter speed on lens. The exposure display indicates over- or underexposure due to shutter speed selected.

Measurement Range: EV 3 to EV 18 with ASA film and *f*-2.8 lens.

Film-Speed Scale: ASA 25 to 1600 or DIN 15 to 33.

Power Source: Built in batteries of 500EL/M or Battery Compartment 2, which holds a DEAC 5/225 DKZ nicad battery available from Hasselblad. The battery compartment attaches to the accessory rail of the 500EL/M, 500C/M, or 2000FC cameras.

Other Features: Assembly kits are available to convert regular 80mm, 100mm, 150mm, or 250mm C lenses into Automatic Diaphragm Control lenses. Operates in temperatures from 122°F to −4° (50°C to −20°C).

setting is visible in a window at the top of the control unit.

When you point the camera at the scene, a motor built into the meter automatically rotates the aperture ring on the lens to the correct setting for an average scene. If the light level changes, the aperture will also change almost instantly.

The viewfinder image does not darken when the lens operates automatically. When you press the shutter button, the lens is stopped down just before the leaf shutter operates.

When the shutter speed you have selected cannot give good exposure with the film speed and aperture range of the lens, a red light on the left side of the meter glows one of two ways. When the top light marked + is lit, the lens cannot stop down enough and overexposure will result if you make the picture. Correct this by selecting a faster shutter speed.

If the bottom light marked − glows, the lens cannot open enough, giving underexposure when you push the shutter button. Correct this by select-

ing a slower shutter speed. To use the lens manually, turn off the meter's switch and set lens aperture yourself.

The meter has a sensitivity range from EV 3 to EV 18 at *f*-2.8 with ASA 100 film. The meter and motor operate on battery power supplied by either the batteries of the 500EL/M or the accessory Battery Compartment 2, which slides onto the accessory rail of the 500C/M and 2000FC. Continuous use of the unit on a 500EL/M drains a fully charged battery in about three hours.

Assembly kits containing the meter and motor are available from Hasselblad for converting regular 80mm, 100mm, 150mm, and 250mm C lenses into automatic metering lenses. A lens hood can be used only with the 250mm lens.

MOUNTING LENSES

Both C and F lenses mount the same way to the 500C/M, 500EL/M, and 2000FC cameras. As mentioned, F lenses work only with the 2000FC camera. Because the cameras use interlocks between the film back, body, and lens, both the camera body and lens *must* be cocked when you mount a lens. Otherwise you cannot mount the lens.

When the camera body is not cocked, the small indicator window on the camera's right side near the film-plane indicator shows red. When the body is cocked, it shows white.

To cock the 500C/M, SWC/M, or 2000FC body, wind the camera's cocking knob or crank one full turn clockwise until it stops. When the camera is cocked, the head of the cocking shaft—which is just inside the bottom of the lens mounting surface of the body—points to a red dot. When the camera is already cocked, the knob or crank won't turn. If a film back is attached to the camera, one

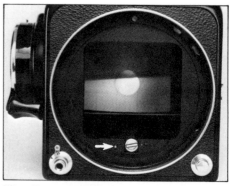

When the camera is cocked, the head of its cocking shaft points to the red dot (arrow).

frame will be advanced. To prevent this, remove the film back before winding. Reattach it after mounting the lens. This procedure also has interlocks, described later.

The 500EL/M camera will be cocked automatically after each exposure; however, the mirror should be *down* before you mount the lens. Put the camera's Exposure Selector Dial to A or O before mounting the lens. The reason will be made clear later when 500EL/M operation is discussed in more detail.

To cock the lens before mounting, turn the slotted head of its cocking shaft clockwise until the slot is aligned with a red dot. Use a thin coin to turn the shaft. Be sure it doesn't slip out of the slot and scratch the rear element.

Match the red alignment mark on the top of the lens mounting flange with the red dot on the top of the body mounting flange. Insert the lens and turn clockwise about 30° until the lens stops and you hear a click. This mates the head of the body's cocking shaft with the slot of the lens cocking shaft.

When mounting an F lens onto the 2000FC, be sure you don't press the cross-coupling button of the Exposure-Value Scale. This could damage the mechanism.

Because of the interlock system built into Hasselblad cameras, you can't remove a lens unless both it and the body are cocked. Winding the camera's knob or crank one full turn will cock both body and lens. Check the body's indicator window or winding crank to be sure the body is cocked. Another way to check with the 500C/M is to look through the viewfinder. When the mirror is down and you see the scene through the lens, the body is cocked.

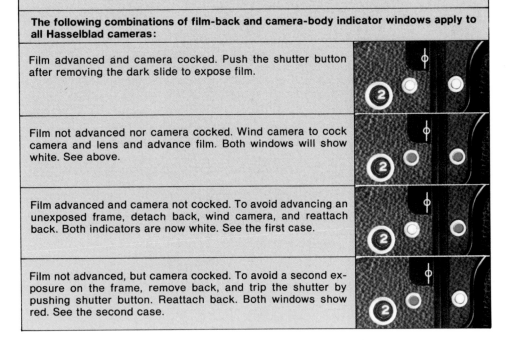

UNDERSTANDING INDICATOR COLORS

The following combinations of film-back and camera-body indicator windows apply to all Hasselblad cameras:

Film advanced and camera cocked. Push the shutter button after removing the dark slide to expose film.

Film not advanced nor camera cocked. Wind camera to cock camera and lens and advance film. Both windows will show white. See above.

Film advanced and camera not cocked. To avoid advancing an unexposed frame, detach back, wind camera, and reattach back. Both indicators are now white. See the first case.

Film not advanced, but camera cocked. To avoid a second exposure on the frame, remove back, and trip the shutter by pushing shutter button. Reattach back. Both windows show red. See the second case.

When using the 500EL/M, put the Exposure-Selector Dial to A or O before removing the lens. When using the 2000FC, make sure the camera is not in its pre-release condition with mirror up and focal-plane shutter open. If it is, depress the Mirror Program Selector button and wind the crank one full turn. Doing this cancels the pre-release.

To remove the lens, depress the silver lens-release button on the front of the body and turn the cocked lens about 30° counterclockwise. You can release shutter tension if you wish, although Hasselblad says it isn't necessary. Press the small pin inside the cylinder next to the slotted cocking shaft of the lens. This operates the lens and uncocks it. You'll have to

recock it before mounting it on a body.

Because the body is already cocked, you can quickly mount another cocked lens. In fact, Hasselblad *recommends* that you always store lenses and bodies in a cocked state because their tests indicate this does not adversely affect the life or reliability of the mechansims. This way your equipment is always ready to be assembled.

FILTERS AND LENS ACCESSORIES

Hasselblad offers many filters and lens accessories for general-purpose and special-effects photography. Some bayonet onto the lens, other screw in, and some are held by retaining rings. The series number of the filter or accessory is the diameter of the filter

Cock the lens by turning its cocking shaft with a thin coin.

To mount the lens on the camera, match the red mounting marks and turn the lens clockwise about 30°.

Remove the lens by pushing the lens-release button and turning the lens counterclockwise about 30°.

USING HASSELBLAD LIGHT-BALANCING FILTERS

A certain color temperature (K) has a decamired (DM) value based on this formula:

$$\text{DM value} = 100{,}000/K$$

For example, this gives 5500K a DM value of 18, and 3200K a DM value of 31. The higher the color temperature, or bluer the light, the lower the DM value.

In the decamired system, the difference (31 - 18 = 13) between these two values identifies a light-balancing filter that balances the two color temperatures. This number is used with Hasselblad light-balancing filters.

To balance 3200K color film with 5500K light, use a red 13 decamired filter. To balance 5500K film with 3200K light, use a blue 13 decamired filter. The four Hasselblad light-balancing filters in both red and blue can be combined in different ways to give different decamired filter values.

You can also use this formula to find the decamired filter value needed to balance two different color temperatures K and K*:

$$\text{DM filter value} = (100{,}000 \times (K-K^*))/(K \times K^*)$$

Decamired Filter Value	Approximate Wratten Equivalent	Purpose
CR 1.5	81A	To use Type B films with 3200K light. Slight warming effect.
CR 3	81B	Absorbs excess blue of open shade.
CR 6	81EF	Warming filter.
CR 12	85	To use Type A color film in 5500K light.
CR 13.5	85B	To use Type B color film in 5500K light.
CB 1.5	82A	To use Type A film with 3200K lights. Slight cooling effect.
CB 3	82B	To use flashcubes with 5500K film. To use Type B films with household lamps.
CB 6	82C & 82A	Cooling filter.
CB12	80B	To use 5500K film with 3400 light.
CB 13.5	80A	To use 5500K film with 3200K light.

HASSELBLAD FILTERS

Film	Filter	Color	Filter Factor	Series	Use
B&W	Y	yellow	1.5X	26, 50, 63, 70, 86, 93, 104	Absorbs UV and some blue to increase tonal contrast.
	YG	yellow-green	2X	50, 63, 86, 104	Absorbs more blue than Y filter and also lightens foliage.
	G	green	3X	50, 63, 70, 93	Absorbs red and blue for masculine portraiture or lightening foliage.
	O	orange	4X	26, 50, 63, 70, 86, 93, 104	Absorbs more blue than Y filter for better haze penetration.
	R	red	6X	50, 63, 70, 93	Absorbs more blue and green than O filter for more sky/cloud contrast.
Color	B 11	blue	2X	26	For 5500K film in 3400K light.
Any	HZ	none	1X	50, 63, 70, 86, 93, 104	Absorbs UV.
	GR-2	gray	4X	50	Reduces light through lens by two steps.
	GR-3	gray	8X	50, 63	Reduces light through lens by three steps.
	GR-6	gray	64X	50, 63	Reduces light through lens by six steps.

in mm. Filters of a certain series can be mounted to other filters from the same series. See the accompanying tables.

Filter Nomenclature—The mounting rings of Hasselblad filters for b&w photography are engraved with important information. For example, the red Series 50 filter is labeled **50 6X R -2.5**. This means it is a Series 50 filter with a filter factor of 6X, the color is red, and it absorbs 2.5 steps of light.

Light-balancing filters for color photography are available in two colors—red and blue. For each color there are four filters of different density. You can combine red filters, for example, to balance a relatively blue light source with a tungsten-balanced color film. See the accompanying table for recommendations.

The mounting rings of these filters are also engraved with important information. For example, one of the blue light-balancing filters is engraved **50 1.4X CB 3 -0.5**, meaning it is a Series 50 filter with a filter factor of 1.4X, the color is blue, its decamired shift value is 3, and it absorbs a half step of light.

The decamired shift value is directly related to the shift in color temperature created by the filter. Use decamired values when you combine filters of the same color. For example, a red filter with a decamired shift value of 13.5 acts like a Wratten 85B filter. Make an equivalent CR 13.5 filter by using a CR 12 filter with a CR 1.5 filter. See the accompanying table for equivalent decamired filter values and Wratten filter nomenclature.

Softar Accessories—These are plastic, soft-focus lens accessories composed of convex protrusions evenly distributed on the surface of the accessory. This makes the soft-focus effect independent of aperture. Three are available—I, II, and III. The higher the number, the softer the effect.

Multi-Prism Lenses—These lens accessories produce multiple images on film. Two types are available. One yields four duplicate images around the central image. The other gives five images surrounding the center one.

Professional Lens Shade—For maximum versatility from a single lens shade, consider this bellows-type model. It attaches to all lenses from 50mm to 250mm. The bellows can extend up to four inches (100mm) in

HASSELBLAD FILTER SERIES DESIGNATIONS

Series	Type of Mount
26	Screw-in
50	Bayonet
63	Held in place by a retaining ring. With an adapter retaining ring, these filters will also fit Series 50 lenses.
70	Bayonet
86	Screw-in
93	Screw-in
104	Bayonet

front of the lens. The bellows rail is marked for the correct setting with various lenses. Masks for the telephoto lenses come with the shade, and these fit into a slot in its front. A special gel filter holder is also available as an accessory. It holds standard 75mm (3-inch) square gel filters flat in a slot in the rear of the shade.

INTERCHANGEABLE FILM BACKS

Since 1948, the versatility offered by interchangeable film backs, or *magazines*, has been a key element in the success of the Hasselblad system. Nine backs are available for Hasselblad cameras. These backs use 120, 220, 70mm, Polaroid pack, and sheet films. See the accompanying table. Most backs have a dark slide, exposure counter, and interlocks that couple with the camera and lens. These make it difficult to waste film by exposing it accidentally or advancing it before exposure.

The film gate of each back made since 1948 has two small notches on the left side, as viewed from the camera. On film, these notches appear on the image, just outside the normal film format. This proves that the image was made with a Hasselblad camera.

120 & 220 Roll-Film Backs—The latest generation of roll-film backs has the letter A in the model names. This stands for *automatic*, meaning the exposure counter automatically stops at 1 when the first frame is in position in the film plane. This and other minor features make the A-model film backs easier to load and use than older backs. The name of each back indicates the number of exposures possible with the back. See the table below.

The A16 and A16S backs come with transparent focusing-screen masks that fit over the focusing screen. These indicate the field of view you are photographing. A black mask is also available for the A16S back, which gives superslides (S). Do not use the black mask when using a metering viewfinder.

70mm Backs—These special-purpose backs are useful when you want to expose plenty of film before having to reload. Controls and indicators are similar to those backs using 120 and 220 film. See Chapter 4 for a list of 70mm films available in cassettes or bulk rolls.

The Model 70 back accepts daylight-loading cassettes that hold up to 15 feet (4.6m) of film, yielding 70 6x6 cm exposures. Depending on the thickness of the 70mm film you use,

the Model 100/200 yields up to 200 exposures.

Sheet Film Adapter—This back is useful to expose special films available only in sheet sizes, or when you need only one or two exposures and not a whole roll of images. It accepts holders that hold one piece of 2-1/2x2-1/2 inch (63x63 mm) sheet film.

The most economical way to get this size is to cut a piece of 2-1/2x3-1/4 inch (63x83 mm) film. Hasselblad makes a special film cutter that does this quickly and easily.

Detaching a Film Back—Because of an interlock, you cannot remove a film back unless the stainless steel dark slide is in front of the film, blocking exposure. Insert the dark slide of a roll-film back into the slot on the left side of the back, as viewed from behind the camera. Install the slide so the flat side faces the film plane. You can put it in the other way, but the dark slide's handle will then fold back toward the film and make insert removal a bit slower.

When using roll film, it is good practice to advance film before removing the back. Wind the camera's crank or knob to do this. When an exposed frame is in the film plane, the indicator window on the back shows red; when an unexposed frame is in the film plane, the indicator shows white. See page 135.

This procedure is not absolutely necessary because you can detach the back if the window shows white or red, but it puts the back in a constantly ready state in case you have to quickly reattach it later.

The two small notches on the left side of this medium-format image indicate that the photo was made with a Hasselblad back, in this case the A12 back.

HASSELBLAD FILM BACKS

Film Back	Film Type	Image Format	Max. Exposures
A12	120	6x6 cm	12
A24	220	6x6 cm	24
A16	120	4.5x6 cm	16
A16S	120	4.5x4.5 cm	16
70	70mm	6x6 cm	70
100/200	70mm	6x6 cm	200
80	Polaroid Series 80	6x6 cm	8
100	Polaroid Series 100/600	6x6 cm	8
Sheet Film Adapter	2-1/2x3-1/4 sheet film trimmed to 2-1/2x2-1/2 inches	6x6 cm	1

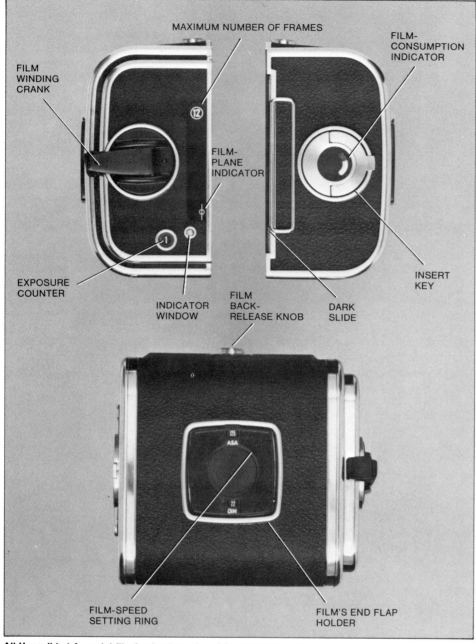

FILM WINDING CRANK

MAXIMUM NUMBER OF FRAMES

FILM-CONSUMPTION INDICATOR

FILM-PLANE INDICATOR

EXPOSURE COUNTER

INDICATOR WINDOW

FILM BACK-RELEASE KNOB

DARK SLIDE

INSERT KEY

FILM-SPEED SETTING RING

FILM'S END FLAP HOLDER

All Hasselblad A-model film backs that take 120 or 220 film have these features.

To remove a back, insert the dark slide, slide the film back-release knob to the right and swing the back off.

You can attach a back to the camera only after inserting the dark slide. Then engage the hinge pins and swing the back up.

To detach, slide the knob on the top of the back to the right. The back swings down and separates from its bottom hinge.

Attaching a Film Back—A roll-film back can be attached whether its indicator window or the camera's shows white or red. The dark slide must be installed for the back to couple to the camera.

Engage the hinge pins on the bottom of the body with the slots on the bottom of the back. Swing the back up while moving its release knob to the right. When the back couples with the body, release the knob then push it to the left to lock the back securely. An interlock prevents you from making an exposure if the dark slide is inserted in the back.

LOADING 120 OR 220 FILM

You can load 120 or 220 roll film while the back is either attached or detached from the camera. If the back is attached to the camera, the dark slide does not have to be inserted.

Because switching camera backs is so much faster than loading one, many Hasselblad users prefer to use backs loaded ahead of time while detached from the camera.

When working with more than one film back, be sure you do not mix inserts with backs. The three-digit serial number on the insert should be the same as the last three digits of the six-digit serial number of the film back. Each insert is carefully adjusted at the factory to give optimal film flatness with its matching back. Mismatching inserts and backs can create film-flatness problems, which may lead to unsharp images. In addition, light leaks may occur, and there may be inconsistent spacing between frames.

For optimal film flatness, use the insert with its matching back. The serial number of this insert, 259, matches the last three digits of the back's serial number 530259.

Removing the Insert—The silver insert key is on the left side of the roll-film back, behind the dark slide. Fold out its handle and turn it counterclockwise. The insert springs open a bit and the exposure counter returns to 0. Pull on the key to remove the insert. If the dark slide is installed backward, it can get in the way of the insert at this point. In this case, remove the dark slide and reinsert it properly.

Open the spool clips and put the empty spool in the top chamber. This is the one closed by the spool clip with the knurled knob. The unexposed roll of film goes in the other chamber, the one closed by the spool clip with the red triangle. Close both spool clips to secure the spools. Before drawing out the film leader, turn the insert key clockwise to release the film clamp.

The unexposed roll goes in the chamber *without* the knurled spool clip. Use the insert key to open and close the film clamp. This helps insure good film flatness.

Draw the paper leader across the film plane with the black side facing out. Slip the right side of the leader under the silver film clamp. Then turn the insert key counterclockwise to close the clamp. This important step also promotes good film flatness in the film plane. If you fail to do this, you may not get optimal image sharpness.

Insert the tapered end of the paper leader into the empty spool. Advance the paper leader by turning the knurled knob of the top spool clip clockwise. Stop turning the knob when the arrow printed on the paper leader aligns with the red triangle of the lower spool clip.

Put the insert into the film back. Lock it shut by turning the insert key clockwise until the handle will fold flush to the insert. The inside circle of

Turn the knurled knob on the spool clip until the start marks of the film leader and insert are aligned.

the insert key displays a film-consumption indicator. This spring-loaded device is a rough indicator of how much film you've shot. When an unexposed roll is in the back, the window is colored silver. As you expose and advance film, a red field progressively covers more of the silver area. When it is solid red, the roll is completely exposed or no film is in the insert. The indicator acts as a check against the back's exposure counter.

To advance the roll to frame 1, unfold the back's film-winding crank and turn it clockwise about 10 times until it stops automatically. A 1 will show in the exposure counter, indicating frame 1 is in position and the back is ready for use. Its indicator window will show white.

The back's film-winding crank is blocked while frame 1 is in position. After it is advanced, you can advance film continuously with the crank to roll up a partially or completely exposed roll. In this case, the camera's shutter button automatically locks.

On the rear of roll-film backs is a holder for the end flap of the film box or a memo. You should set the ASA/DIN dial on the holder. Turn the serrated ring inside the circle until the correct ASA and DIN speeds are visible through the windows.

DOING IT WRONG

Besides not using the film clamp properly and mismatching inserts and backs, there are other film-loading mistakes that lead to less-than-ideal image quality or wasted film.

If you put 220 film in a 120-type back, the film will not be as flat as possible in the film plane. The pressure plate of the 120 back is adjusted for the thickness of 120 film

and leader. 220 film does not have a continuous paper backing, so its thickness in the film plane is less than that of 120 film and leader.

In addition, the shutter button automatically locks after you make the last exposure on the roll, and the counter stops. You can wind up the roll with the back's winding crank, or you can go into a darkroom and spring open the insert to reset the back's exposure counter to 0. Close the back, then finish the roll by counting the remaining exposures.

Loading 120 film in the A24 back can put unnecessary drag on the winding mechanism and possibly cause the film to jam. This may happen because the thickness of 120 film and leader in the film plane is greater than that of 220 film.

Because the exposure counter will advance to frame 24 and a 120 roll only has room for 12 exposures, you may be fooled into thinking you are exposing more than 12 images, when actually you are "exposing" the paper leader.

MODEL 80 & 100 POLAROID BACKS

Two Polaroid backs using parts made by Polaroid and Hasselblad are available for Hasselblad cameras. These backs accept 80-series and 100/600-series Polaroid pack films described in Chapter 4. Both use a thin piece of optical glass in front of the film.

The glass is necessary to shift the plane of best focus, thus giving best image quality. However, the glass is in a vulnerable position. Without careful handling of the back, you can easily smudge, dirty, or crack it. Clean it as you would a lens element.

As mentioned earlier, SWC cameras cannot use Polaroid backs. In 1980, Hasselblad modified the SWC by raising the viewfinder, lowering the tripod seat, and installing a ratcheted camera crank. SWC/M cameras can use Polaroid backs. If you have an SWC, an authorized Hasselblad repair facility can modify it to an SWC/M with a kit available from Hasselblad.

Using the Backs—The Polaroid backs attach to the camera like a roll-film back. The silver release knob of the Polaroid back is on the left side, facing the front of the camera. Load the back as you would any Polaroid back, as described in Chapter 4.

The Polaroid backs also have an interlock so you can't press the shutter button unless the dark slide is removed. Wind the camera and remove the dark slide, which stores on the rear of the back. Adjust exposure controls and expose film. Process the film according to the manufacturer's directions.

A Warning About the Model 80 Back—The model 80 Polaroid back *is not* compatible with all Hasselblad cameras. Its glass plate protrudes out of the back. So if you were to attach the back to the 2000FC, the glass plate would *irreparably damage* the focal-plane shutter curtains. Replacing these extremely thin pieces of metal is a very expensive repair job. The model 100 back uses a recessed glass plate, so it is compatible with the 2000FC.

INTERCHANGEABLE VIEWFINDERS

Hasselblad makes other viewfinders in addition to the standard folding hood viewfinder. When you use a viewfinder, you see all of the focusing screen, which shows 96% of the photographed image. Each viewfinder is compatible with the 500C/M, 500EL/M, older models of these cameras, and the 2000FC. Most can also be used with the SWC/M when they are attached to a special focusing screen adapter. This is described later.

Viewfinders detach quickly and simply. First, remove the film back. Then slide the viewfinder back along the track until it is free of the camera. There are no buttons or latches to push; the viewfinder is held in place by spring clips.

Attaching one is simple too. With the back off the camera, slide the base of the viewfinder onto the track until the viewfinder is in place. Reattach the back.

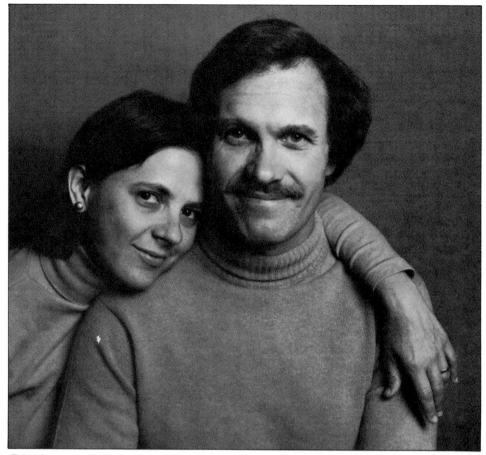

This b&w print was made from a Polaroid Type 665 negative exposed in the Model 100 back. The negative has very fine grain and medium contrast.

Folding Focusing Hood—This is the standard viewfinder that comes with the 500C/M, 500EL/M, and 2000FC cameras. It is very light and folds down neatly when not in use. To open it, slide its top button to the right. It springs open to show all of the focusing screen, which displays an upright, laterally reversed image.

To make critical focusing adjustments, pop up the 3X magnifier by sliding the button to the right again.

Bring your eye to the magnifier and focus the lens to get the sharpest image.

Diopter correction lenses for the magnifier are not available from Hasselblad. To correct the magnifier to your eyesight, you must either use it with your glasses on or have your optometrist glue the right correction lens over the magnifier.

Retract the magnifier by pushing it down. Close the hood by pushing in on its sides and folding the top back until it clicks shut.

Magnifying Hood—This is a rigid version of the hood with magnifier in place. It effectively blocks extraneous light from the focusing screen and makes focusing the laterally reversed image easier. It has a 2.5X magnifier eyepiece with a built-in diopter adjustment from −2.5 to +3.5. Because it has a soft-rubber eyecup over the eyepiece, you can press the magnifier against your face to steady the camera during exposure.

90° Prism Viewfinders—Two non-metering prism viewfinders are available. Both let you view an upright, laterally correct image through an

After removing the film back, take off the viewfinder by sliding it back.

Pop up the 3X magnifier of the open folding hood by pushing its button to the right.

HASSELBLAD METERING PRISM FINDER SPECIFICATIONS

Type: Prism viewfinder with center-weighted CdS meter. You operate the meter manually by measuring Exposure Value (EV) of the scene. Transfer value to the lens. Viewfinder display shows indicator needle on EV scale at bottom of focusing screen. Battery-check button. Exposure-compensation dial for one step of under- or overexposure.
Measurement Range: EV 3 to EV 18 with ASA 100 film and *f*-2.8 lens.
Film-Speed Scale: ASA 25 to 1600 or DIN 15 to 33.
Power Source: One 1.3V mercury battery (Eveready EPX-625 or equivalent).
Weight: 340g (12 oz.).

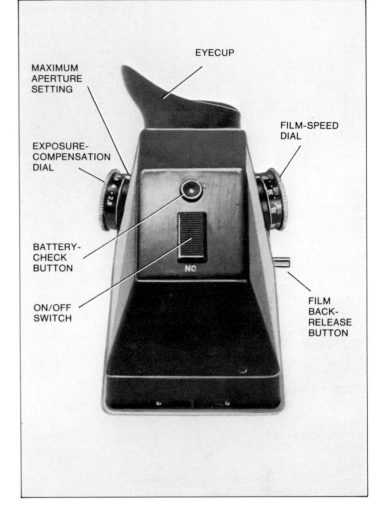

MAXIMUM APERTURE SETTING — EYECUP — FILM-SPEED DIAL — EXPOSURE-COMPENSATION DIAL — BATTERY-CHECK BUTTON — ON/OFF SWITCH — FILM BACK-RELEASE BUTTON

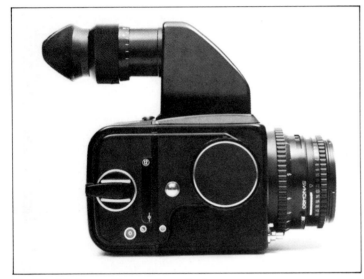

The HC-4 finder provides eye-level viewing.

eyepiece at a 90° angle to the film plane. Both can be used with all backs except the 70mm backs.

The HC-4 finder magnifies the focusing screen image 3 times and has an adjustable eyepiece correction lens from −5 to +5 diopters. It is the most convenient viewfinder to use when shooting vertical-format 4.5x6 cm photos, which is possible only with the A16 back.

The HC-3/70 finder has a longer eyepiece than that of the HC-4. This lets you use the HC-3/70 with the 70mm backs, which are longer than other roll-film backs. Of course, you can use this finder with the other backs, but there is no particular advantage in doing so. It magnifies the focusing screen image 4 times and has a built-in diopter correction from −5 to +5.

NC-2 45° Prism Viewfinder—This prism viewfinder gives a convenient viewing angle between that of the magnifying hood and 90° prism finders. It magnifies the focusing screen image 3 times. Eight correction lenses are available in diopter strengths from -4 to +3 in one-diopter increments.

Metering Prism Viewfinder—Pre-1981 versions of this viewfinder could not be used conveniently with a Polaroid back. You had to remove the finder before attaching the back. The 1981 version can be used without inconvenience because of a different housing design. All other features are essentially the same as the pre-1981 model.

The 1981 model has the same optical and physical features as the NC-2 finder. It uses the same diopter correction lenses. The major difference between the NC-2 and this finder is its built-in CdS meter for through-the-lens metering. This is a most convenient finder to use when you do close-up work or need to meter and shoot quickly. The meter is powered by a 1.3V mercury battery, such as the Eveready EPX625 or equivalent. It fits into a battery chamber below the eyepiece.

To test battery power, turn the meter on with the switch on the finder's top and press the battery-check button behind it for about a second. If the indicator needle moves erratically, replace the battery with a new one.

Before using the meter, set it for the speed of the film you are using. The Film-Speed Dial is on the left side of the finder, as viewed from the rear. Pull out the dial and turn it to set a film speed from ASA 25 to 1600 or DIN 15 to 33 across from the index. Also make sure the Exposure-Compensation Dial on the right side of the meter is set to its middle position. It has adjustments from -1 to +1 in half-step increments. Push the locking tab at the bottom and turn the dial to set it.

Then set the maximum aperture of the lens using the inner dial. The largest aperture you can set with the current model is *f*-2.8. If you are using the 110mm *f*-2 Planar F lens with the meter, you have to compensate for the

Because the metered area of this scene was darker than an 18% gray, I set the metering finder's Exposure-Compensation Dial to -1.

is described in more detail when 500C/M operation is discussed. Setting and using the EVS of F lenses is a bit different. It is described when 2000FC operation is discussed.

Meter Prism Finder VC 6—This metering viewfinder is to be available by mid-1981. It has many similarities to the other metering viewfinder: It can be used with a Polaroid back and it accepts the same diopter correction lenses; and its metering pattern is centerweighted with a readout in EV numbers.

It also has some improvements: The sensitivity range is greater—from EV 2 to EV 19 with an f-2.8 lens and ASA 100 film. Visible in the viewfinder is a red LED readout of the EV scale, a battery-check LED, and the film-speed and maximum aperture setting of the meter. This finder can be set for the f-2 F lens.

Set film speed with the dial on the meter's left side. You can set film speeds from ASA 12 to 3200 or DIN 12 to 36. The meter's battery-check and power buttons are on the front of the finder.

The meter turns off about 25 seconds after you turn it on. When metering, the finder displays the recommended EV number in red LEDs visible below the upright, laterally correct image.

Frame Viewfinder—This frame finder shows the field of view of the 150mm or 250mm Sonnar lenses and lets you view the subject directly, not through an optical system. It attaches to the front of the lens shade and is constructed to give minimal parallax error.

Your eye is aligned with the optical axis of the lens when you see only one

extra step of light coming through the lens. Set the meter for an f-2.8 lens and do *one* of these four corrections:

1) Set the Exposure-Compensation dial to +1.

2) Set the Film-Speed dial to *half* the actual film speed.

3) Meter with the lens set to f-2.8 and stopped down with the depth-of-field preview lever.

4) Meter normally, but set the lens Exposure-Value Scale for an EV setting one number *lower* than the meter indicates.

The meter has a center-weighted pattern that has 50% emphasis in a central 1-inch (25.4mm) diameter circle on the focusing screen. This makes the meter usable with formats smaller than 6x6 cm. However, you cannot get

accurate meter readings when you use the black focusing screen masks for the A16 or A16S backs. Use the backs' transparent masks.

To meter, turn the meter on and read the EV number indicated by the moving needle. It moves across an EV scale from 3 to 18. Transfer the EV reading to the Exposure-Value Scale (EVS) of the lens. Except for the special case of using the f-2 F lens, meter with the lens fully open.

As described in Chapter 5, an EV value is "shorthand" for a range of f-stop and shutter-speed values that will give the same exposure. After setting the EVS of the lens, you can select the f-stop and shutter-speed combination to create the image effect you want. Setting and using the EVS of C lenses

The Frame Finder is convenient for sports or aerial photography.

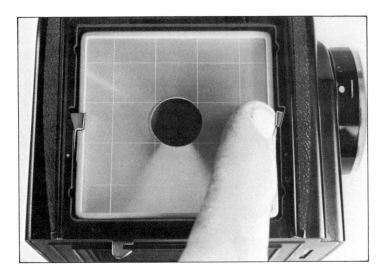

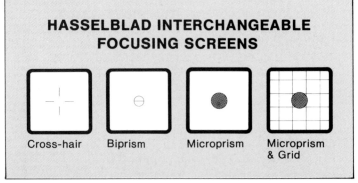

Cross-hair Biprism Microprism Microprism & Grid

Remove a focusing screen after removing the viewfinder. Push in the two tabs securing the screen and invert the camera so the screen falls into your hand. A fine-line version of the cross-hair screen is also available.

X in the frame. The inside square shows the field of view of the 250mm lens and the outside square shows that of the 150mm lens.

Sports Viewfinder—When your eye is against the rubber eyecup and you view through this finder's square frame, you see essentially the same field of view as the 80mm Planar lens in the 6x6 cm format or the 60mm Distagon lens in the superslide format.

You can insert masks into the frame that let you use lenses from 100mm to 500mm in the 6x6 cm format, from 80mm to 250mm in the 4.5x6 cm format, and 80mm and 150mm in the superslide format. The finder folds down when not in use.

INTERCHANGEABLE FOCUSING SCREENS

Except for SWC and SWC/M cameras, post-1970 Hasselblad cameras have user-interchangeable focusing screens. Five are available. The standard, ground-glass focusing screen of pre-1970 cameras can be changed, but only by an authorized

Hasselblad repair facility. There are three replacement screens for pre-1970 cameras.

To change a user-interchangeable screen, first remove the back, then remove the finder. Next, push in the two tabs on the left and right side of the focusing screen. Put the palm of your hand over the screen and turn the camera upside down. The screen should fall into your hand. If it doesn't, remove the lens. Then, with the mirror in the *down* position, tap the underside of the screen with your finger to loosen it.

With the camera right side up, place a screen base-side down on its four support pins. If you are going to use a viewfinder mask, position it on top of the screen. When you reattach a viewfinder by sliding it along the track, the two tabs spring out to secure the screen and mask.

INTERCHANGEABLE KNOB & CRANK

The 500C/M comes with a winding knob that operates quickly when you

are hand-holding the camera. After exposure, turn the knob clockwise while turning the camera in the opposite direction. This cocks the camera quickly and speeds up the time between exposures.

However, some photographers prefer to use a rapid-wind crank. Only the 500C/M camera accepts the interchangeable rapid winding crank and metering knob. The 500EL/M has no manual advance, and the rapid-wind cranks of the SWC/M and 2000FC are not removable.

Before detaching the knob from the 500C/M, cock the camera and lens. Push the small lever on the top of the knob toward you and turn the knob counterclockwise until the red circle of the knob aligns with the red triangle of the body. Remove the knob.

Attach the accessory crank or metering knob so the red circle aligns with the red triangle. Turn the accessory clockwise to lock it on. This operation should be done with the camera cocked.

Exposure Metering Knob—This meter uses a selenium metering cell,

HASSELBLAD EXPOSURE METERING KNOB SPECIFICATIONS

Type: Interchangeable winding knob for 500C/M with selenium meter. No battery needed. You operate the meter manually by measuring Exposure Value (EV) of the scene in either an incident or reflected mode. Transfer needle reading to the lens.
Measurement Range: EV 4 to EV 17 with ASA 100 film and *f*-2.8 lens.
Film-Speed Scale: ASA 6 to 1600 or DIN 9 to 33.
Other Features: Can also be used off the camera or attached to a special shoe that fits various lens hoods for use with other Hasselblad cameras.
Weight: 57g (2 oz.).

ZEROING MARK
FILM-SPEED SCALE
INDICATOR NEEDLE
EV SCALE
METERING WINDOW
OPALIZED PLASTIC INTEGRATOR

which requires no battery. Its sensitivity range is not very long—from EV 4 to EV 17 at *f*-2.8 with ASA 100 film. It is convenient as a backup meter in case your regular meter becomes unreliable or its battery dies.

Set film speed with the center dial of the knob. You can set ASA speeds from 6 to 1600 or DIN speeds from 9 to 33. You should periodically zero the meter. Do this by covering the metering window with your hand and turning the small calibration screw at the rear until the needle is zeroed.

You can use the meter in a reflected or incident mode. When using the reflected-light mode, point the clear metering window at the scene and read the EV number the meter indicates. A small mirror behind the needle helps you get the correct reading, which occurs when the needle covers its reflection. Transfer the EV number from the meter to the EVS of the lens. Select the shutter speed and *f*-stop combination you prefer and expose film.

In this mode with the camera cocked, the meter sees essentially the same field as the 80mm Planar lens in the 6x6 cm format. This makes it a full-frame averaging meter. With other lenses and formats, you won't necessarily be metering the same field you're viewing. This may lead to erroneous exposure settings. You can avoid this potential problem by using the meter's incident mode. Cover the clear metering window with the sliding piece of opalized plastic. Then meter the light striking the subject by placing the camera, with meter attached, at subject position.

For either mode, you can always remove the knob from the camera if

this simplifies metering. To use the knob attached to the 500EL/M or 2000FC, you should use an attachment that holds the knob to the front of the lens shades for the 80mm through 250mm lenses.

500C/M OPERATION

This all-mechanical camera is the basic workhorse of the Hasselblad system. Most of its operating features also apply to the other three cameras. As mentioned previously, all four cameras accept interchangeable backs and viewfinders. They all use C lenses. The size and shape of the 500C/M, 500EL/M and 2000FC camera bodies are nearly the same too, so camera handling is practically identical no matter which camera you use.

HANDLING & VIEWING

The 500C/M is designed to be used in what Hasselblad calls a "left-hand grip." Your left hand supports the

base of the camera, and your left index finger is on the shutter button, which is just to the right of the lens. Your right hand can then operate the winding knob, lens controls, and film back.

Open the standard folding hood finder by sliding its top button to the right. To use this waist-level viewfinder closer to your eye, pop up its magnifier by pushing the button again.

If you don't see an image on the focusing screen and the lens cap is not on the lens, the camera is not cocked. The non-instant-return mirror is up against the focusing screen and the lens shutter is closed. Lower the mirror and open the shutter by turning the camera's winding knob clockwise one full turn. This cocks the camera and lens and advances film one frame.

With your right hand, focus the C lens with its metal focusing ring, located at the back of the lens near the camera body. The location and hardness of the metal ring is uncomfortable for some photographers. To simplify focusing and make it faster,

HASSELBLAD 500C/M CAMERA SPECIFICATIONS

Type: 6x6 cm single-lens reflex with waist-level viewing and non-instant-return mirror.
Shutter: Compur leaf shutter built into each C lens, with shutter speeds from 1/500 to 1 second, including B. X-sync at all shutter speeds. M-sync also available.
Standard Lens and Viewfinder: 80mm *f*-2.8 Zeiss Planar C lens and waist-level viewfinder with built-in magnifier.
Film: 12 or 24 exposures with 120 (A12) or 220 (A24) film backs in the 6x6 cm format. Interchangeable backs for 4.5x6 cm (A16) and 4.5x4.5 cm superslide (A16S) formats. 70 or 100 to 200 exposures with two 70mm film backs. Interchangeable Polaroid and sheet-film backs.
Other Features: Interchangeable C lenses with Exposure-Value Scale, viewfinders, and focusing screens. Multiple-exposure capability, safety interlocks, camera pre-release, depth-of-field preview, self-timer, accessory grips, close-up, and underwater equipment.
Dimensions: Width 109mm (4.3"), height 104mm (4.1"), depth 170 (6.7").
Weight: 1.4kg (3.1 lbs.).

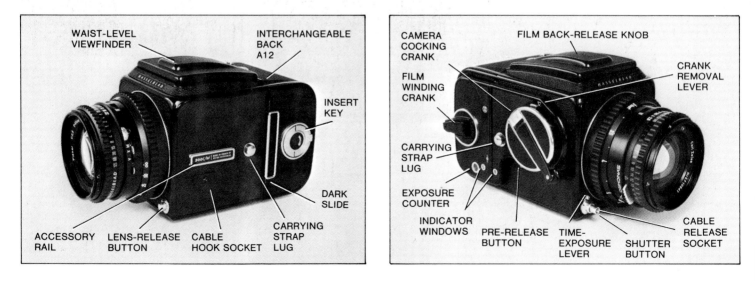

WAIST-LEVEL VIEWFINDER — INTERCHANGEABLE BACK A12 — INSERT KEY — DARK SLIDE — CARRYING STRAP LUG — CABLE HOOK SOCKET — LENS-RELEASE BUTTON — ACCESSORY RAIL

CAMERA COCKING CRANK — FILM WINDING CRANK — CARRYING STRAP LUG — EXPOSURE COUNTER — INDICATOR WINDOWS — PRE-RELEASE BUTTON — TIME-EXPOSURE LEVER — SHUTTER BUTTON — CABLE RELEASE SOCKET — CRANK REMOVAL LEVER — FILM BACK-RELEASE KNOB

This is the left-hand grip recommended by Hasselblad.

When you use the left-hand grip, your right hand is free to work the lens and camera controls.

Hasselblad offers two Quick-Focusing Handles. They press-fit over the lens focusing ring. You then focus by turning a handle instead of a ring. These focusing handles are for interchangeable C lenses only.

When you use the 500C/M with long-focal-length lenses or the bellows, the upper part of the focusing-screen image may be cut off, or *vignetted*. This happens because light is passing under the mirror instead of being reflected up. If the mirror were long enough to intercept these rays, it would collide with the rear of the standard 80mm lens. The image cutoff occurs only on the focusing screen, not on film. To see the small cutoff area, tilt the camera up slightly.

Previewing Depth of Field—A depth-of-field scale is in front of the lens focusing ring. As you change aperture, two thick red lines move along the distance scale of the lens, indicating approximate depth of field. Find depth of field by using the inner edges of the

The depth-of-field lever of C lenses is easily accessible to your left index finger.

red lines. Read the focused distance across from the white central index.

To visually check depth of field on the focusing screen, push the depth-of-field lever on the lower right side of the C lens. The lens stops down to the aperture indicated by the white central index. By turning the aperture ring, you can change the effect. When you turn the ring to the maximum lens aperture, the lever is released.

EXPOSURE CONTROLS

All exposure controls except for the shutter button are on the C lens. They are easy to operate with your right hand when you use the left-hand grip. All C lenses have the same controls in essentially the same place.

Exposure-Value Scale (EVS)—The unique feature of the C lens exposure controls is the cross-coupling Exposure-Value Scale (EVS). As mentioned in both Chapter 5 and earlier in this chapter, an exposure value represents a certain amount of exposure possible with different combinations of *f*-stops and shutter speeds.

The EVS of C lenses is engraved in red numerals ranging from 2 to 18. The scale corresponds to the EV scale of Hasselblad meters and many hand-held accessory meters, such as the Gossen Luna-Pro.

After you meter, read the EV number from the meter. Then depress the scale's cross-coupling release. It is a small, ridged metal release on the right side of the lens, near the depth-of-field lever. With the release depressed, turn the ring until its red triangle aligns with the correct EV number. A difference of one EV number is equivalent to one exposure step. The scale has half-step detents. When you let go of the release, the EVS locks.

Now the aperture ring and shutter-speed ring are cross-coupled. As you turn the outermost ring of the lens, you can select different combinations of *f*-stops and shutter speeds—all of which give the same exposure to the film, assuming that none of the shutter speeds will produce long-exposure reciprocity failure.

Previewing depth of field with C lenses is quick, easy, and helps get the picture you want.

On the Luna-Pro meter shown above, the EV reading is at the bottom of the scale ring. Transfer the reading to the EVS of the C lens, shown below. This displays seven pairs of exposure settings that give the same exposure.

You can now choose the settings that give good exposure and the image effect you want.

The shutter-speed dial of C lenses is engraved with white fractional speeds from 500 to 1. The green numbers on the scale indicate exposure time in seconds, from B (2 seconds) to 125. The slowest camera-controlled shutter speed is one second. You cannot turn the cross-coupled exposure rings past the B setting.

The green numbers are an exposure aid when you use EV 8 or smaller on the EVS. They indicate the aperture

When the EVS of the lens is set to 12, these exposure settings are cross-coupled on the C lens.

you should use for exposures longer than one second, which are made with the camera's time-exposure mode, described later. Long-exposure reciprocity failure should be considered when you use these long shutter speeds.

Bracketing—Because the aperture and shutter-speed scales are automatically cross-coupled when you let go of the EVS release, bracketing exposures with C lenses is not as convenient as it is with other lenses described in this book. Bracketing is quick and simple when the aperture and shutter-speed rings work independently.

To bracket exposures with a C lens, you have to change the setting of the EVS, thus selecting a different exposure. If you want to bracket a full step around EV 12, change the EVS to 11, select the aperture and shutter speed you want, and make the exposure. Then change the EVS to 13 and do the same thing.

If you prefer, you can ignore the EVS scale during bracketing. Depress the EVS release and rotate the aperture ring for one more and one less step of exposure, as indicated by the *f*-stop scale.

EXPOSING FILM

As you get used to working with a Hasselblad camera, you'll discover that the simplest way of using it is also the fastest. The simplest way avoids bringing the interlocks between body, back and lens into play. They exist in case you attempt to do something that would waste film and ruin exposures.

After cocking the camera, focusing, and setting exposure controls, you are ready to expose film. The indicator windows of both the camera and back should show white. Unlock the shutter button by removing the dark slide from the film back. Put it in your shirt pocket. You cannot store it on the camera.

When hand-holding the camera at waist-level, steady it by holding it against your body. If you use the camera with a viewfinder that has an eyepiece, steady the camera against your face. In either case, your right hand should be on the camera's right side, further steadying the camera.

When you push the shutter button with your left index finger, the leaf shutter closes and the automatic lens stops down to the preselected aperture. The reflex mirror swings up and the auxiliary shutter blinds in the rear

of the camera open. The leaf shutter opens and closes to expose film. When you release the shutter button, the auxiliary shutter closes. Both indicator windows show red.

Depress the shutter button for the total exposure duration. If you do not do this when making 1/4-, 1/2-, or 1-second exposures, underexposure results. Releasing the button too soon at these slow speeds closes the auxiliary shutter *before* the leaf shutter closes. A red line is above the white shutter-speed numbers 1 2 4 to remind you of this.

After exposure, the mirror stays up and the leaf shutter remains closed. Winding the camera's knob lowers the mirror, opens the leaf shutter, cocks the camera and lens, and advances film. Both indicator windows show white again.

Repeat this exposure procedure until the last frame of the roll is exposed. When this happens, the shutter button and winding knob lock and the film-consumption indicator is completely red. At this stage, many Hasselblad users change backs to continue shooting. Insert the dark slide, remove the back, wind the camera, and attach the ready-to-use back. Both indicator windows should show white for fastest camera operation.

To completely advance the exposed roll, unfold the back's winding crank and turn it about 5 complete revolutions. When you feel reduced resistance to turning, the roll is wound up. You can advance the roll completely any time after the first exposure.

Camera Pre-Release—The time delay between pushing the shutter button and exposure is about 1/125 second. This gives the lens, mirror, and auxili-

Pre-release the 500C/M by pushing up on the black button under the winding crank.

ary shutter time to stop down, raise and open.

To minimize this time delay, pre-release these mechanisms. Pre-releasing is also recommended to minimize camera vibrations just before exposure. This is valuable when you make exposures with the camera mounted on a tripod and when you photograph fast-breaking action. Most situations requiring a sportsfinder benefit from pre-releasing the camera.

The Pre-Release Button is under the winding knob. After winding the knob to cock the camera and lens, push up the Pre-Release Button. You'll hear the mirror and auxiliary shutter operate. In addition, the lens stops down and the leaf shutter closes. At this point, you *cannot* see an image on the focusing screen; nor can you cancel the pre-release. After waiting a few seconds for the vibrations to diminish, expose film by either pushing the shutter button or with a cable release screwed into it. You'll hear the quiet click of the leaf shutter opening and closing.

After exposure, cock the camera. To pre-release the camera for the next exposure, push the pre-release button again.

Long Exposures—The longest camera-controlled shutter speed is one second. For longer speeds, turn the cross-coupled exposure ring so the green B aligns with the white central index. If you wish, pre-release the camera after cocking it.

When you push the shutter button, the leaf shutter stays open for as long as the button remains depressed. Time the exposure and release the button to end exposure.

You can also make a time exposure by using the Time-Exposure Lever

Because slow color film, a small lens aperture, and the waning light of sunset were used to photograph this scene, a 1/8 second shutter speed was necessary. Pre-releasing the camera helped minimize vibrations during exposure.

To make an exposure longer than one second, set the camera's shutter-speed dial to B and set the time-exposure lever to T.

located on the camera's shutter button. After cocking the camera, move the lever from O to T. Pre-release the camera if you wish.

When you push the shutter button to expose film, the button stays depressed. In this way it is the same as using a locking cable release with the previous method.

Time the exposure and end it by pushing the lever back to O, for normal operation. You can't advance film with the camera's winding knob until the lever is back to O.

Multiple Exposures—Interlocks of the 500C/M prevent accidental multiple exposures. Therefore, you have to circumvent an interlock to make a multiple exposure.

After the first exposure, both indicator windows show red. Do not turn the camera's knob because this will advance film. Instead, reinsert the

dark slide and remove the back. Then cock the camera by winding its knob.

Reattach the back to the camera. The back's indicator window shows red, and the camera's is white. Remove the dark slide and expose the unadvanced frame again. Do this any number of times. The frame and exposure counter will not advance until you wind the camera's knob with the back attached to the camera.

Using Flash—All C lenses have a built-in Compur leaf shutter, giving flash sync at all shutter speeds. The flash terminal is on the left side of the lens.

When using electronic flash or flash bulbs at speeds of 1/30 second or slower, press the small locking catch near the Sync-Selector Lever and move the lever to X. When using M-type bulbs, move the lever to M for synchronization at all shutter speeds.

Flash sync at all shutter speeds is helpful when shooting back-lit scenes on sunny days. This flash-fill portrait was made with the SWC/M at a shutter speed of 1/500 second.

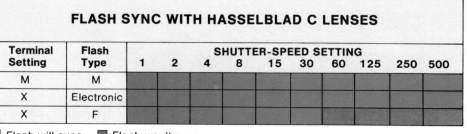

FLASH SYNC WITH HASSELBLAD C LENSES												
Terminal Setting	Flash Type	SHUTTER-SPEED SETTING										
		1	2	4	8	15	30	60	125	250	500	
M	M											
X	Electronic											
X	F											

■ Flash will sync.　■ Flash won't sync.

Self-Timer—An 8 to 10 second self-timer is built into each C lens. Use it for shutter speeds between 1/500 and 1 second, inclusive. Press the small locking catch near the sync-selector lever and move the lever to V. This stands for *vorlaufwerk*, which is German for *self-timer*.

Set the aperture and shutter speed on the lens and move the time-exposure lever next to the shutter button to T. Pre-release the camera at this stage if you wish.

When you press the shutter button, the timer begins and you hear a mechanical buzzing. In 8 to 10 seconds the camera exposes film. It also gives X-sync if you use a flash. After exposure, the shutter button springs back, the sync-selector lever automatically moves back to X, and the time-exposure lever moves back to O.

You must depress the shutter button throughout the timing. Otherwise, the shutter button springs back, mak-ing the auxiliary shutter close before the leaf shutter opens. If this happens, advance the film or make a "multiple exposure." You can use a locking cable release or the time-exposure lever to hold the button down.

SWC/M OPERATION

The SWC/M is unlike any other medium-format camera. It uses a permanently attached non-automatic 38mm *f*-4.5 Biogon C lens in a non-reflex camera body. The camera is versatile, however, because the body accepts interchangeable backs and viewfinders. Because of its unique features and versatility, this camera is used by many architectural, landscape, museum, industrial and scientific photographers.

The main advantages of the lens are optical. It gives a rectilinear image and exceptional image quality, even with near subjects. And, the price and weight of the SWC/M are not much more than that of the 40mm *f*-4 Distagon C lens! The 38mm Biogon uses Series 63 filters, which can fit on Series 50 lenses.

HANDLING & VIEWING

The SWC/M also uses a left-hand grip. However, because the camera's shutter button is on top of the camera, your left index finger works with your left thumb to turn the lens focusing ring. Your right hand winds film, adjusts exposure controls, and pushes the shutter button.

Hold the camera up to your face and look through the optical viewfinder attached to the top of the camera. It shows practically the same field of view being recorded on film. The top

When using the optical viewfinder of the SWC/M, a spirit level—visible through a prism reflector—indicates whether the film plane is vertical or not.

For self-timed exposures, press the locking catch and slide the sync-selector lever to V.

<div style="border:1px solid">

HASSELBLAD SWC/M CAMERA SPECIFICATIONS

Type: 6x6 cm non-reflex wide-angle camera with eyepiece or ground glass viewing.
Shutter: Compur leaf shutter built into lens, with shutter speeds from 1/500 to 1 second, including B. X-sync at all shutter speeds. M-sync also available.
Standard Lens and Viewfinder: Fixed-mount 38mm *f*-4.5 Zeiss Biogon C lens with Exposure-Value Scale. Eyepiece viewfinder that shows scene and built-in spirit level on camera top.
Film: 12 or 24 exposures with 120 (A12) or 220 (A24) film backs in the 6x6 cm format. Interchangeable backs for 4.5x6 cm (A16) and 4.5x4.5 cm superslide (A16S) formats. 70 and 100 to 200 exposures with two 70mm film backs. Interchangeable Polaroid and sheet-film backs.
Other Features: Lens corrected for curvilinear distortion, camera accepts interchangeable viewfinders when used with focusing screen adapter, multiple-exposure capability, safety interlocks, self-timer, accessory grips, and underwater equipment.
Dimensions: Width 108mm (4.3"), height 145mm (5.7"), depth 153mm (6.0").
Weight: 1.3kg (2.9 lbs.).

</div>

of the finder field is 6 inches (152mm) longer and 3 inches (76mm) wider on either side than the field of the lens.

When you look through the finder, you can also see a reflection of a spirit level on the camera top. The film plane is vertical when the bubble is centered in the circle. This is important to minimize image distortion such as converging verticals. Centering the spirit level is easiest when the camera is on a tripod, but with practice you can do it when hand-holding the camera.

The image visible through the optical viewfinder is always in focus. To focus the image made by the lens, adjust the focusing ring based on your estimate of subject distance. Or, first determine the aperture you wish to use. Set it on the lens as described for a C lens. Then put the infinity mark of the distance scale on the inside of the right-hand red depth-of-field indicator. When you do this at f-22, depth of field extends from 26 inches (65cm) to infinity.

Through-the-Lens Viewing—For critical work, such as copying or photogrammetry, you should view and focus the image made by the lens. Insert the dark slide and remove the back. Then attach the Focusing Screen Adapter to the camera. This is a plate that holds a ground glass screen and a Fresnel lens. Attach it as you would a back.

To see the image formed by the lens, you have to open the shutter. Wind the camera, set the shutter speed to B, and adjust the aperture ring to f-4.5 for the brightest possible image. Use an EV setting of 3. Move the time-exposure lever on the camera's shutter button from O to T. When you push the shutter button, the leaf shutter opens.

To view a scene through the 38mm Biogon lens, remove the back and install the focusing screen adapter. In this photo a waist-level viewfinder is attached to the adapter.

The 6x6 cm image on the ground glass is upside down and laterally reversed. To eliminate extraneous light from the focusing screen, attach the magnifying hood, the standard folding hood, or a prism viewfinder to the adapter.

The prism viewfinders correct only the lateral reversal; they don't turn the image right side up. To meter the scene with a metering viewfinder attached, set the meter for a maximum aperture of f-3.5—not f-4.5. Hasselblad has found that an f-3.5 meter setting gives best results.

Turn the focusing ring while viewing the scene. Because the lens is not automatic, turning the aperture ring stops down the lens. This way you can visualize depth of field. To turn the aperture ring you must depress the EVS release and move it.

When all settings are OK, move the time-selector lever back to O. This

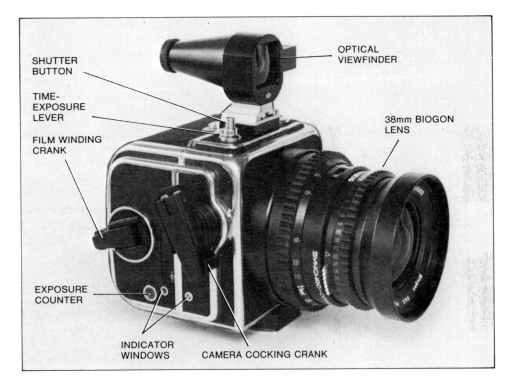
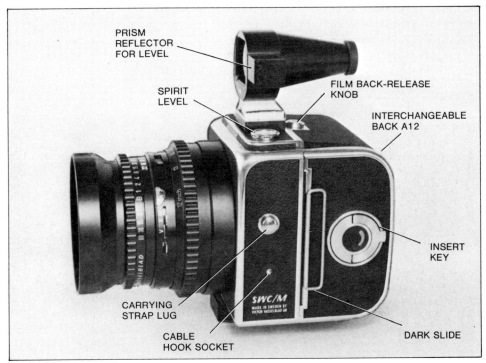

The SWC/M is an excellent camera for architectural and landscape photography. The built-in spirit level helps avoid converging vertical lines due to the film plane and subject plane not being parallel.

HASSELBLAD 500EL/M CAMERA SPECIFICATIONS

Type: 6x6 cm single-lens reflex with waist-level viewing and instant-return mirror.
Shutter: Compur leaf shutter built into each C lens, with shutter speeds from 1/500 to 1 second, including B. X-sync at all shutter speeds. M-sync also available.
Standard Lens and Viewfinder: 80mm *f*-2.8 Zeiss Planar C lens and waist-level viewfinder with built-in magnifier.
Film: 12 or 24 exposures with 120 (A12) or 220 (A24) film backs in the 6x6 cm format. Interchangeable backs for 4.5x6 cm (A16) and 4.5x4.5 cm superslide (A16S) formats. 70 and 100 to 200 exposures with two 70mm film backs. Interchangeable Polaroid and sheet-film backs.
Power Source: Rechargeable DEAC 5/500 DKZ nicad battery. Battery and recharger are standard equipment. Camera uses one or two batteries for 1000 or 2000 exposures per full charge.
Other Features: Interchangeable C lenses with Exposure-Value Scale, viewfinders, and focusing screens. Built-in automatic film and camera winder, exposure-selector dial for five different exposure modes, multiple-exposure capability, safety interlocks, camera pre-release, depth-of-field preview, self-timer. Accessory grips, close-up, battery recharging, shutter-release, and underwater equipment.
Dimensions: Width 100mm (3.9"), height 147mm (5.8"), depth 170mm (6.7").
Weight: 1.9kg (4.2 lbs.).

closes the shutter. Remove the viewfinder and adapter and reattach the back. Observe the indicator windows of the back and camera body to avoid wasting film.

EXPOSING FILM

The 38mm Biogon lens has all the controls of other C lenses except a depth-of-field lever.

After metering, set the EVS the same way as described for C lenses used with the 500C/M. Interlocks between the camera, lens, and back are the same. Remove the dark slide, level the camera, and push the shutter button. Hold the button in when using shutter speeds of 1/4, 1/2, and 1 second.

Because the winding crank of the SWC/M is ratcheted, you can rotate it one full turn or with a series of partial turns until it stops. Multiple-exposure, self-timer, and flash operation are the same as described for the 500C/M. So is long-exposure operation, except that the SWC/M does not have pre-release capability. It does not need it because it has no mirror or auxiliary shutter.

500EL/M OPERATION

When the National Aeronautics and Space Administration (NASA) needed motorized medium-format cameras to record space exploration, it chose Hasselblads. These were not ordinary production models, but the camera design *was* based on Hasselblad's only motorized camera—the 500EL, later modified to become the 500EL/M.

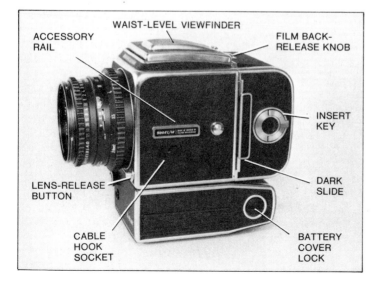

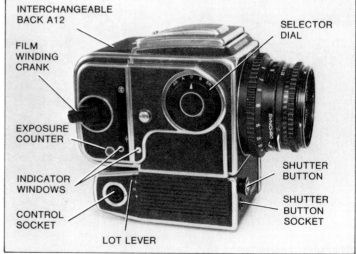

The 500EL/M looks like a 500C/M body permanently attached to a lower body section holding the battery pack and motor. Internally, however, the cameras are different because the transport mechanism of the 500EL/M is on the bottom of the camera. And, 500EL/M components are even more rugged and durable than those of the 500C/M, because of the extra mechanical stress motorized film winding creates.

When you push the shutter button or trigger the camera by remote control, an electric signal begins exposure, which operates mechanically like the 500C/M.

The camera uses battery power only to wind film and cock the camera and lens. After exposure, the motor automatically cocks the camera and lens and winds film, making the camera ready for another exposure. With fast shutter speeds, the maximum recycle rate is about one frame per second. Film winding is completely motorized—no manual override is possible with the 500EL/M.

The 500EL/M greatly extends the versatility of the Hasselblad system. In addition to being compatible with interchangeable C lenses, film backs, and viewfinders, the 500EL/M has an array of electronic triggering accessories to operate the camera from afar.

THE BATTERY

The camera comes with one DEAC 5/500 DKZ nicad battery and recharger. When fully charged, the battery has enough power for about 1000 exposures. There are two battery chambers in the lower body section. They are connected in parallel, so you can install two fully charged batteries to operate the camera for about 2000 exposures.

Because the 500EL/M has no manual override of its electronic functions, keeping the battery charged is very important. If the battery has no power, the camera will not work.

Installing the Battery—To open the battery chamber, turn the slotted battery-cover lock on the left side of the lower body section. Use a coin to rotate the lock 90° counterclockwise until the slot is vertical. Remove the battery cover. The two large holes you see are battery compartments. If you use just one battery, put it into either chamber. Insert one or two batteries narrow end first. This is the positive terminal, as evidenced by the + on its

base. Put the cover back on and close the lock.

If you install the battery backward, you can't put the cover on. This prevents using the camera or charging the battery. A 1.6A, 5x20 mm medium slow-blow fuse is housed in a small chamber between battery chamber and the motor. The fuse must be installed for the camera to operate. If you ever discover that it is blown, have the camera checked by an authorized Hasselblad repair facility.

The 500EL/M holds one or two Hasselblad nicad batteries and a 1.6A slow-blow fuse.

Recharging the Battery—There is no battery-check on the 500EL/M, so a good way to monitor battery charge is to listen to the film winder. When the recycle time becomes noticeably prolonged and the mechanism seems sluggish, battery power is nearly gone.

It is better to recharge the battery at this stage than to let it discharge completely in the camera. If it totally discharges in the middle of a cocking and winding cycle, camera operation stops and you may miss an important picture. You can recharge the battery with it inside or outside the camera. Hasselblad nicad batteries can be recharged about 1000 times.

Before plugging Recharger I into the camera, turn the Time-Exposure, Locking and Charging lever on the lower body section to L. From now on, I'll call this lever the *LOT* lever because these are the letters next to the lever. L stands for *locking*. It turns off the camera's electronic functions and prevents it from winding.

If the battery is not completely discharged, the LOT lever can be set to L or O for charging. If the camera stopped in mid-cycle because the battery discharged, you *must* put the lever to L. Otherwise, the electronic circuit is

open and no power will flow to the battery during recharging.

If the camera stops in mid-cycle, you must complete its cycle before recharging the battery. There are three ways to do this:

1) Install a fresh battery to complete the cycle. Recharge the dead battery in or outside the camera.

2) Remove the dead battery and let it sit for about 15 minutes. When you put it back in the camera, it may have enough power to complete the cycle.

Before charging the 500EL/M, set the LOT lever to L.

3) Remove the dead battery and insert a regular 1.5V zinc battery. With a piece of insulated wire, connect the negative terminal of the battery to the exposed fuse end. This will complete the cycle. Remove the 1.5V battery and recharge the camera battery.

Remove the plastic cover of the Control Socket. It is next to the LOT lever on the lower body's right side. Plug the socket of the recharger into it. Then plug the recharger into an AC outlet. If the battery is totally dead or nearly discharged, recharge it for 14 hours. If you recharge two dead batteries, give them 28 hours. You can time the charge with the Recharger I connected to a commercially-available timer.

A new battery that comes with the camera has a partial charge and should be recharged for about five hours to obtain full charge. Hasselblad also recommends that you recharge a battery one hour for every 72 exposures.

As a general rule, nicad batteries should not be overcharged. If you accidentally overcharge a battery by 100%—for example giving a 14-hour charge to a battery only 50% discharged—that battery has only 90% of its capacity. It will yield 900 exposures

This is a crew member of Apollo 12 during exploration of the Lunar surface in 1969. The camera attached to the astronaut's suit is a specially-designed Hasselblad 500EL with a 70mm back. Hasselblad cameras and Zeiss lenses have been used in all manned moon missions and are also being used by Space Shuttle astronauts. Photo courtesy of NASA.

flash are the same. See the earlier discussion of lens mounting. The 500EL/M will slightly vignette the focusing-screen image when you use long-focal-length lenses or a bellows.

EXPOSING FILM

Your right hand never has to cock the camera because the motor does this automatically after every exposure. Instead, your right hand gets a new task—selecting one of five different exposure-release modes on the Selector Dial on the camera's right side. Before using the dial, turn the camera on by moving the LOT lever to O, for normal camera operation.

Using the Selector Dial—The five exposure-release modes are combinations of normal 500C/M exposure operation, pre-releasing, and automatic film winding. Although using the selector dial may seem complicated at first, it becomes simple after a little practice. I suggest you practice without a film back attached to the camera.

instead of 1000. Excessive overcharging may result in battery leakage or swelling—dangerous to you and ruinous to the camera.

Hasselblad also makes the Recharger III. It has a built-in timer that can be set from 1 to 14 hours. In addition, it has a special socket that accepts a shutter release cord, so you can use the camera while batteries are recharging in the camera.

To recharge a battery outside the camera, put it in Battery Compartment 2. This can be connected to the

socket of either recharger. To recharge the battery when AC power is unavailable, use the Battery Case. It holds five standard 1.5V zinc batteries, which deliver enough power to recharge one battery in the camera.

Also available is an AC power supply that will operate the 500EL/M without batteries. It comes with a special battery cover that replaces the regular one. The socket of the AC unit fits into the special cover.

HANDLING & VIEWING

Hand-holding the 500EL/M is not much different than described for the 500C/M. Hasselblad recommends the left-hand grip. The major physical difference between the 500EL/M and the 500C/M is the lower body section. This makes the 500EL/M about one pound (454g) heavier and 1-3/4 inches (45mm) taller. To make handling easier, Hasselblad put two shutter-button sockets on the front of the camera for the removable shutter button. Put the shutter button in the socket that makes hand-holding easiest for you.

Because the 500EL/M accepts the same C lenses, backs, and viewfinders as the 500C/M, viewing, focusing, exposure setting, interlocks and using

The Selector Dial of the 500EL/M lets you choose one of five ways to expose film electronically. See the text for details.

To select a mode, turn the inner dial so the white triangle is aligned with the mode you want to use. Here's what the settings do:

O (Normal Operation): When you let go of the shutter button after exposure is complete, the auxiliary shutter closes, the camera is cocked and film is advanced. The mirror is down so you can view the scene.

S (Pre-Release): When you turn the dial to S, the camera is pre-released mechanically. The lens shutter closes, the lens stops down, the mirror swings up, and the auxiliary shutter opens. As with the 500C/M, this eliminates a 1/125 second delay

The AC power supply for the 500EL/M comes with its own battery-compartment cover, which replaces the one that comes with the camera.

between pushing the shutter button and exposure.

This is the only setting that doesn't lock the dial's triangle in place. After the pre-release, the triangle springs back to O. The S mode gives only one pre-release. Therefore, the camera operates in the O mode after film is exposed.

SR (Pre-Release Repeat): Turning the selector to SR locks it in place, so the camera is pre-released after *every* exposure and film advance. In effect, it saves you the bother of having to move the selector to S for a series of pre-released exposures.

A (Automatic): This is continuous, normal operation. As long as your finger is on the shutter button or the camera receives a triggering impulse— and if unexposed film is still in the back—the camera advances film and makes exposure continuously. The mirror swings down between exposures so you can see the scene through the finder.

The maximum frame rate is about one frame per second when you use the faster shutter speeds. Do not use this setting with shutter speeds slower than 1/15 second. If you do, you may not get full exposure because the film advances before the shutter closes.

AS (Automatic Pre-Release): The camera is pre-released when you select this mode. It stays pre-released during the exposure sequence, which is continuous as long as your finger is on the shutter button or the camera receives a triggering impulse. In this way it acts like the S setting. The mirror stays locked up throughout the sequence.

Using the Exposure Modes—As with the 500C/M, use the pre-release S and SR settings to minimize camera vibrations during exposure.

In addition, it minimizes the time delay between pushing the shutter button and exposure. Most camera noise and vibration will then occur *after* exposure. This is helpful for wildlife and people photographers who don't want to disturb their subjects before exposure. The O, S, and SR settings can be used for all shutter speeds and time-exposures.

Because neither of the automatic settings (A or AS) should be used with shutter speeds slower than 1/15 second, they are most useful for high-speed photo sequences. The A setting is most useful when you need to view

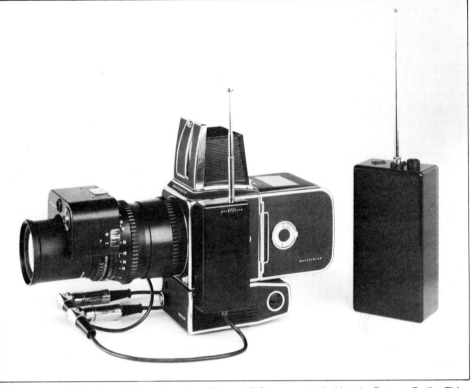

Here is the 500EL/M, a 70mm back, and a 250mm ADC lens controlled by the Remote Radio. This setup lets you automatically meter, expose, and advance up to 70 6x6 cm frames from as far away as 1000 feet (305m)!

the scene through the viewfinder between every exposure, such as when you follow action. Use the AS setting when the camera is in a fixed position that doesn't necessitate through-the-lens viewing or when you follow action through a frame or sportsfinder.

You can't remove or attach a lens when the camera is in any of the three pre-release modes. To cancel the pre-release in this case, put the selector dial to O and press the shutter button to operate the shutter, cock the camera and lens, and lower the mirror. If the film back was attached during this step, you'll have wasted one frame.

Alternate Shutter Release Methods—One of the great advantages of the built-in film winder of the 500EL/M is that you can operate the camera by remote control with cables, an intervalometer, or by radio. These accessories either plug into the camera's control socket or a shutter-button socket. Press the "shutter buttons" of these accessories for the exposure duration, especially when using long shutter speeds.

Many release cords are available. The three FK models plug into a shutter-button socket. Use one when another electronic device, such as an

Automatic Diaphragm Control C lens, is plugged into the camera's control socket. The FK cords are 1, 10, and 20 feet (0.3, 3.0 and 6.1m) long. No extensions are available.

The SK cord is five feet (1.5m) long and attaches to the camera's control socket. Its advantage is that SK extension cords 5, 16, and 100 feet (1.5, 4.9, and 30.5m) long can be used with it. To overcome internal resistance in the wire when using an extension of 100 feet (30.5m) or more, you must attach the Line Amplifier between camera and cord. This boosts the exposure signal.

For the most trouble-free remote signal, use the Remote Radio. The receiver plugs into the camera's control socket or SK extension cords and slides onto the camera's accessory rail.

When using the Line Amplifier, put it between the 500EL/M and the first connecting cord.

The battery-powered transmitter can be used up to 1000 feet (305m) away in good weather. It operates at a frequency of 27MHz, and has a replaceable crystal if you prefer to use a different frequency. It also has a release socket that accepts an SK release cord or the Intervalometer III.

The Intervalometer III triggers the camera automatically at a predetermined interval. You set the interval with two dials. The interval dial has settings from 2 to 12. The multiplier dial has three settings—1X for seconds, 10X for tens of seconds, or 60X for minutes. With such a range you can shoot 15 feet (4.6m) of 70mm film from 2.5 minutes to 14 hours. The unit plugs into the camera's control socket or SK extension cord and draws power from the camera.

Long Exposures—With either of the following long-exposure methods, the selector dial must be set to O, S, or SR. There are two ways to make an exposure longer than one second.

Set the lens shutter speed to B and pre-release the camera by setting the selector dial to S if you want to. When you press the shutter button, the lens shutter stays open for as long as your finger remains on the button. The same is true if you use a remote release.

Making a time-exposure is slightly different. With the shutter speed set to B and the camera pre-released or not, move the LOT lever to T. The shutter opens mechanically and stays open until you move the lever back to O. Prevent camera shake when moving the lever by covering the lens with a black card or lens cap before opening the shutter and before you close it. Moving the LOT lever from O to T

with the lens set to *any* shutter speed will mechanically trip the shutter.

Multiple Exposures—Because of the automatic film winder, you do not make multiple exposures with the 500EL/M the same way you do with the 500C/M. However, using the signals in the indicator windows is the same.

After the first exposure, continue depressing the shutter button. This prevents the film winder from advancing film. Turn the camera off by moving the LOT lever to L and remove your finger from the button. Insert the dark slide and remove the back. Its indicator window is red.

Move the LOT lever to O to cock the camera. Its indicator shows white. Reattach the back, remove the dark slide and expose film to make the second exposure on the frame. Repeat this as often as you like, but remember to keep your finger on the shutter button until you turn the camera off.

You can do the same thing by tripping the shutter with the LOT lever. Move it from O to T. Because this is a mechanical step, the film winder won't operate. After removing the back, cock the camera with the winder by moving the lever from T to O. Reattach the back and make the next exposure with the LOT lever again. Repeat as often as you wish.

Self-Timer—Set the C lens for a time exposure as described under 500C/M operation. The sync selector is set to V and the lens set to any shutter speed except B. The exposure selector dial can be set anywhere.

To start the time delay, move the LOT lever from O to T. You'll hear the mechanical buzzing for 8 to 10 seconds, then the shutter operates.

Advance film and cock the camera automatically by moving the LOT lever back to O.

If you set the shutter speed to B and use the self-timer, do not set the selector dial to A or AS. Moving the LOT lever to T starts the delay and keeps the shutter open until you move the lever back to O.

2000FC OPERATION

In 1977, the 2000FC was introduced. It's the first Hasselblad since 1956 to have a focal-plane shutter. The top speed of the electronically-regulated shutter is 1/2000 second. X-sync is at 1/90 second.

It is the only camera of the line that uses F lenses. These were designed for this camera and do not have built-in leaf shutters. Therefore, they are faster and can focus closer than C lenses. Another difference is that the 2000FC has three mirror programs to make viewing and shooting easier.

In spite of these changes, the 2000FC is only slightly heavier than the 500C/M and the body is practically identical. Because the 2000FC is compatible with C lenses, viewfinders, and all backs except for the Model 80 Polaroid, it has the same interlock system.

THE BATTERY

A 6V silver-oxide PX-28 battery, such as the Eveready No. 544 or equivalent, powers the shutter timing circuit of the 2000FC. A fresh battery has enough power for about 20,000 exposures.

There is no battery-check button on the camera, so monitoring the life of

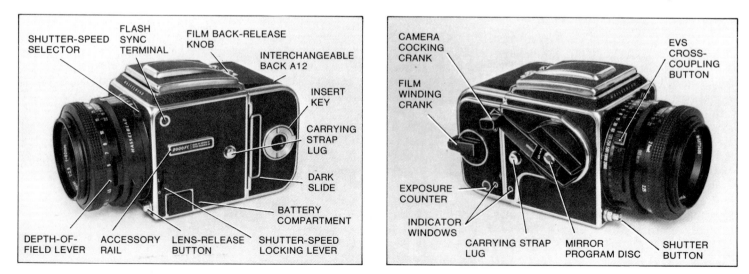

SHUTTER-SPEED SELECTOR
FLASH SYNC TERMINAL
FILM BACK-RELEASE KNOB
INTERCHANGEABLE BACK A12
INSERT KEY
CARRYING STRAP LUG
DARK SLIDE
BATTERY COMPARTMENT
DEPTH-OF-FIELD LEVER
ACCESSORY RAIL
LENS-RELEASE BUTTON
SHUTTER-SPEED LOCKING LEVER

CAMERA COCKING CRANK
FILM WINDING CRANK
EVS CROSS-COUPLING BUTTON
EXPOSURE COUNTER
INDICATOR WINDOWS
CARRYING STRAP LUG
MIRROR PROGRAM DISC
SHUTTER BUTTON

HASSELBLAD 2000FC CAMERA SPECIFICATIONS

Type: 6x6 cm single-lens reflex with waist-level viewing and instant-return mirror.
Shutter: Electronically controlled focal-plane shutter with shutter speeds from 1/2000 to 1 second, plus B. Half-step shutter speeds possible. X-sync at 1/90 second. M-sync also available.
Standard Lens and Viewfinder: 80mm *f*-2.8 Zeiss Planar F lens and waist-level viewfinder with built-in magnifier.
Film: 12 or 24 exposures with 120 (A12) or 220 (A24) film backs in the 6x6 cm format. Interchangeable backs for 4.5x6 cm (A16) and 4.5x4.5 cm superslide (A16S) formats. 70 or 100 to 200 exposures with two 70mm film backs. Interchangeable Polaroid and sheet-film backs.
Power Source: 6V PX28 silver-oxide battery (Eveready No. 544 or equivalent)
Other Features: Accepts interchangeable F and C lenses with Exposure-Value Scale. When C lens used, either lens or camera shutter can regulate exposure. Interchangeable viewfinders and focusing screens. Multiple-exposure capability, three mirror programs, safety interlocks, camera pre-release, depth-of-field preview, self-timer when using C lens, battery compartment for Shutter-Speed Multiplier 60X and other electronic accessories. Accessory grips and close-up equipment.
Dimensions: Width 110mm (4.3"), height 104mm (4.1"), depth 180 (7.1").
Weight: 1.5kg (3.3 lbs.).

the battery is not possible. Instead, it is good practice to replace the battery every year, whether it is dead or not.

Replacing a Dead Battery—If the battery is dead or missing, you can't make an exposure. When you push the shutter button, the reflex mirror locks up against the focusing screen and stays there. The focal-plane shutter won't open. If you were to put a fresh battery into the camera at this stage, the battery would lose all of its charge in about 15 minutes because the electronic circuit remains on.

Before removing the dead battery from the camera, you must release the mirror. You do this with a control on the camera's folding crank. Unfold the crank to find the silver Mirror Program Disc. It has a red button in its center. The numbers near the disc are for the three mirror programs, described later.

With a coin or fingernail, depress the silver disc and wind the crank

clockwise one revolution until it stops. You can release the disc as soon as you start turning the crank. This lowers the mirror and resets the camera. It does not advance film. The camera and lens are still cocked.

The battery compartment is on the lower left side, as viewed from the rear. Grip the cover with fingernails and pull it out. Remove the dead battery and install the new one. Insert the compartment back into the camera.

The battery compartment has electrical contacts leading to the shutter's timing circuit. A camera repairman can test the shutter through these contacts without dismantling the camera.

HANDLING & VIEWING

Hold the camera as you would the 500C/M—in a left-hand grip. If you look through the viewfinder but do not see an image on the focusing screen, wind the camera. What happens after this depends on the setting of the Mirror Program Disc, so I'll discuss the three programs now. As with the 500C/M, you won't be able to turn the crank if the camera is already cocked.

Mirror Programs—If the mirror drops down after winding, you have just cocked the camera and lens and advanced film. This non-instant-return mirror operation is like the 500C/M. With the 2000FC, this means the Mirror Program Disc is set to 1. When the mirror is up, you know the camera is not cocked.

When the Mirror Program Disc is set to 2 and an F lens is on the camera, the mirror will always drop down after exposure and the lens will be open to

its maximum aperture—whether the camera is cocked or not. This is the way most 35mm SLRs work.

The 0 setting locks up the mirror for the duration of the setting. This *is not* a pre-release mode. Use this feature before mounting a special-purpose lens that would interfere with mirror operation. Hasselblad doesn't make such a lens, but with the Lens Mount Adapter, you are able to mount other manufacturers' lenses to the camera.

You should also use this setting when you trigger the camera with an electronic shutter release that connects to the camera battery compartment. In this case, stop down the lens to the preselected aperture.

To select a program, insert a coin or fingernail into the slot of the mirror program disc. When the red button is depressed, you can turn the slot to align with one of the three numbers. To secure the setting, make sure the red button springs back when you release it. Change the mirror program when the camera is cocked.

Viewing—Focus an F lens by turning the knurled rubber focusing ring. The ring is near the front of the lens, making it a bit more convenient to use than the focusing ring of a C lens. Focusing handles are not available for F lenses. Nor can you use a focusing handle on a C lens when it is connected to the 2000FC. The camera's shutter-speed ring gets in the way.

The mirror of the 2000FC does not vignette the focusing-screen image when you use long-focal-length lenses or close-up equipment.

The depth-of-field scale is on the lens behind the focusing ring. It is similar to the scale on a lens for a

Release the locked-up mirror of the 2000FC by pushing the Mirror Program Disc and winding the camera's crank.

Change the mirror program of a cocked camera by pushing the red button in the center of the Mirror Program Disc. Turn the disc until its slot aligns with 1, 2, or 3.

Unlike a C lens, the depth-of-field lever of an F lens is on the left side.

35mm SLR. Check depth of field visually by pressing the depth-of-field lever on the left side of the lens. It locks when you move it down. Release the lock by pressing the lever in or by exposing film.

Changing Lenses—Generally, you mount and remove F and C lenses from the 2000FC as you do C lenses with the 500C/M and 500EL/M. However, there are two important things to remember when working with the 2000FC:

If the lens does not come off the camera—even though the camera is cocked—the camera is pre-released. Cancel the pre-release by depressing the silver mirror program disc and turning the camera crank one full turn. Then remove the lens.

When mounting an F lens onto the 2000FC, be sure you don't press the cross-coupling button of the Exposure-Value Scale (EVS). This could damage the mechanism.

Changing Backs—The 2000FC accepts all but one of the system's backs. They attach and detach from the camera in the same way described for the other cameras, but you should be more careful when changing backs on the 2000FC.

The auxiliary shutter blinds of the 500C/M, SWC/M, and 500EL/M act like swinging doors. If you push them, they'll swing in, undamaged. However, the metal shutter curtains of the 2000FC are made of very thin (0.014 inch, 0.36mm) titanium. You can see the closed shutter at the back of the camera body when you change film backs. The curtain is vulnerable when a back is not attached to the camera. **Do not** touch it or store the camera without a back attached. Change backs carefully to avoid damaging the curtain.

The only Hasselblad film back you can't use with the 2000FC is the Model 80 Polaroid back. Attaching it to the 2000FC will destroy the shutter curtains.

EXPOSING FILM

Because the 2000FC has a focal-plane shutter and is compatible with *both* F and C lenses, you can expose film three different ways. You can use the camera's focal-plane shutter with F and C lenses. Or, use the Compur leaf shutter of the C lens. Each case is discussed separately.

Cock the camera and lens by winding the crank one full turn. The indicator windows of the back and body should show white. Change the mirror program at this stage if you want.

Meter and adjust exposure-control settings. Remove the dark slide from the camera and expose film. After exposure, both indicator windows show red. When the roll is fully exposed, the shutter button locks. Wind up the roll with the back's winding crank.

F Lens and Focal-Plane Shutter—This is the simplest and most direct way of using the 2000FC. After metering, you have two ways of setting exposure controls because the shutter-speed and aperture rings normally work independently. They cross-couple only when you want them to.

Turn the aperture ring until the *f*-stop you choose aligns with the central white index on the lens. The aperture ring has half-step detents. Then with your left thumb, adjust the shutter-speed ring—which is on the camera's front face—until a shutter speed from 1 to 1/2000 second is opposite the selected aperture and aligned with a small white triangle.

A unique feature of the 2000FC is that in-between shutter speeds can be set. The ring has detents for half-step increments between engraved shutter speeds. See the accompanying illustration for these in-between speeds. You can't get settings between 1 and B or between B and C.

You can lock the setting with the Shutter-Speed Locking Lever next to

If the auxiliary shutter curtains of the 500C/M or 500EL/M are pushed in (left), they swing in undamaged. However, the extremely thin titanium shutter curtains of the 2000FC (right) should never be touched or bumped. Be very careful when changing film backs on the 2000FC and *never* store the camera without a back or cover over the shutter curtains.

SHUTTER SPEED SETTINGS ON THE 2000FC	
Engraved	**In-Between**
2000	
	1500
1000	
	750
500	
	375
250	
	180
125	
	90 (X-sync)
60	
	45
30	
	22
15	
	10
8	
	5
4	
	3
2	
	1.5
1	

Unlike a C lens, the EVS of an F lens cross-couples only when you press the lens cross-coupling button. Generally, this makes bracketing exposures easier.

the battery compartment. Move the lever from O to L.

You do not set exposure controls this way when you use one of the Hasselblad meters because their exposure readout is in EV numbers. After determining the scene's EV value, set the EVS of an F lens by turning the aperture ring until the correct EV number aligns with the white triangle. The scale goes from 2 to 19 in half-steps and is located in the same place as the EVS of a C lens.

Select a certain *f*-stop and shutter-speed combination by pushing the cross-coupling button on the aperture ring. When you rotate the ring, the aperture and shutter-speed rings cross-couple like those of a C lens. This lets you select equivalent exposures by turning the ring. As soon as you release the cross-coupling button, the rings work independently again. This makes exposure bracketing quicker and simpler than with a C lens.

When using flash with the camera's focal-plane shutter, plug the flash cord into the terminal on the camera's left side. The fastest X-sync shutter speed you can use is 1/90 second. It is marked with a red X on the camera's shutter-speed ring. If you select a faster speed, the flash won't fire during exposure. The shutter synchronizes with bulbs at speeds of 1/30 second or slower.

If the mirror program is set to 2, you'll be able to view through the lens even if the camera is uncocked. If this is the case, cock the camera, remove the dark slide, and push the shutter button. Keep your finger on the shutter button for the exposure duration as with the 500C/M and 500EL/M cameras because it is necessary when you use a C lens on the camera. The mirror drops down after exposure.

If the mirror program is set to 1, it stays up after exposure, signaling you that the camera is uncocked.

C Lens and Focal-Plane Shutter—There are good reasons to use C lenses with the focal-plane shutter of the 2000FC. You can use all of the camera's shutter speeds. You don't want to make your C lenses obsolete just because you use a 2000FC. In addition, lens selection is greater with the C line. See the lens table at the beginning of this chapter.

After mounting the C lens, set its shutter-speed dial to B. Then set its flash-sync selector to X. If it is set to M, the leaf shutter's built-in delay will not synchronize with the camera's focal-plane shutter. Underexposure will result. When using flash in this mode, plug the flash cord into the PC terminal on the *camera's* left side. Otherwise, the flash fires too early when triggered by the leaf shutter.

Set the desired shutter speed with the camera's shutter-speed ring. Adjust aperture with the aperture ring of the lens. When adjusting the ring, be sure you don't accidentally move the lens-shutter setting away from B. If you do, you'll get bad exposure.

When you push the shutter button, the leaf shutter closes, the aperture stops down, the leaf shutter opens, and the focal-plane shutter opens and closes to expose film. When you release the shutter button, the leaf shutter closes. For this reason, you should always keep your finger on the button for the exposure duration—just as you normally do for 1/2-, 1/4-, and 1-second exposures. Otherwise, the leaf shutter will close before the

camera's focal-plane shutter, underexposing the film.

After exposure, the mirror stays up whether the mirror program is set to 1 or 2. Wind the camera crank to lower it, open the leaf shutter, cock the focal-plane shutter, and advance film. This is like 500C/M operation.

C Lens and Leaf Shutter—When you need electronic flash sync at shutter speeds faster than 1/90 second, use the leaf shutter of a C lens. You also use this exposure mode when using the lens self-timer. This is described later.

Turn the camera's shutter-speed ring to the red C. Lock this setting with the camera's locking lever set to L. This makes the focal-plane shutter operate like the auxiliary shutter of the 500C/M and 500EL/M.

Set aperture and shutter speed on the C lens as described. Set the flash-sync selector to M or X, depending on the type of flash you're using. Plug the flash cord into the PC terminal *of the lens*. If you plug it into the camera's PC terminal on the body's left side, the flash fires before the leaf shutter opens and underexposure results.

When you push the shutter button, the mirror swings up, the leaf shutter closes, the aperture stops down, and the camera's focal-plane shutter opens completely. Then the leaf shutter opens and closes to expose film. When you release the shutter button, the focal-plane shutter closes. The mirror stays locked up whether the mirror program is set to 1 or 2.

Keep your finger on the shutter button for the exposure duration when making 1/4-, 1/2-, and 1-second expo-

SUMMARY OF 2000FC SHUTTER OPTIONS

Lens & Shutter	F Lens & Focal-Plane Shutter	C Lens & Focal-Plane Shutter	C Lens & Leaf Shutter
Shutter Settings	Camera controlled.	Leaf shutter at B. Leaf shutter sync-selector at X.	Camera shutter locks at C.
Shutter Speeds	B, 1 to 1/2000 second set on camera's shutter-speed ring.	B, 1 to 1/2000 second set on camera's shutter-speed ring.	B, 1 to 1/500 second set on lens shutter-speed ring.
Electronic Flash Sync	Connect flash to camera's PC terminal. Select shutter speed of 1/90 second or longer on camera's shutter-speed ring.	Connect flash to camera's PC terminal. Select shutter speed of 1/90 second or longer on camera's shutter-speed ring.	Connect flash to lens PC terminal. Select shutter speed from B, 1 to 1/500 second on lens shutter-speed ring.

sures. Otherwise, the focal-plane shutter will close before the leaf shutter closes, ending exposure early. Do not set the camera's shutter-speed ring to **B** instead of **C** when using the lens shutter. The **C** setting provides an earlier focal-plane shutter release than **B**, guaranteeing the shutter is fully open before the leaf shutter operates.

Pre-Release—The 2000FC has pre-release capability like the 500C/M and 500EL/M. To use it, slide the button under the winding crank to the rear. The mirror swings up and the lens stops down. If you use a C lens, the leaf shutter closes before the mirror swings up. The focal-plane shutter opens when you push the camera shutter button.

You can't change lenses with the camera pre-released. Cancel the pre-release by pushing the silver mirror program disc and turning the crank one revolution. This does not advance film or uncock the camera.

Self-Timer—Neither F lenses nor the 2000FC have a self-timer built in. If you want a self-timed exposure, you must use the self-timer of a C lens with leaf-shutter operation.

Adjust the camera as described for leaf-shutter operation with the 2000FC. Then adjust the exposure controls of the lens. Move the flash-sync selector on the lens to **V**. Start the timer by pushing the shutter button.

You *must* keep the shutter button depressed until the leaf shutter exposes film. Otherwise, it opens and closes before the focal-plane shutter opens. Obviously, holding the button down manually is impractical if you want to be in the picture. In this case, use a locking cable release to keep the button depressed.

After exposure, remove the cable release from the shutter button before winding the camera. If you don't, the camera operates as soon as you finish winding.

LONG EXPOSURES

Normally, the longest camera-controlled exposure you can make with the 2000FC is one second. It does not have a time-exposure lever to keep the shutter button depressed during longer exposures. Therefore, you hold the shutter button down manually or with a locking cable release when the shutter-speed ring is set to **B**.

When using a C lens this way, set its shutter speed to **B** and the camera's speed to **B**. This way the camera's focal-plane shutter regulates exposure time.

Shutter-Speed Multiplier 60X—This accessory gives camera-controlled long exposures up to 60 seconds. It multiplies all of the camera's shutter speeds by 60. To use it, remove the battery compartment from the camera. Put the battery in the Shutter-Speed Multiplier 60X, then install the multiplier in the camera instead of the battery compartment. The multiplier connects to terminals that lead to the shutter timing circuit.

Every camera shutter speed is now 60 times slower than the engraved setting. This makes the **1** setting equal to 60 seconds and the **2000** setting equal to 1/33 second. However, you really won't need to use the multiplier with engraved speeds faster than 1/60 second. This would only duplicate the speeds you can normally get with the camera. In addition, you should use the multiplier only when exposing film with the camera's focal-plane shutter. There is no particular advantage in using it with the leaf shutter of a C lens.

MULTIPLE EXPOSURES

There are two ways to make multiple exposures with the 2000FC. One is identical to the multiple-exposure method of the 500C/M. After exposure, insert the back's dark slide then remove the back. Wind the camera, reattach the back, and make the second exposure. Repeat as often as desired.

The simpler way avoids back removal. After the first exposure, both indicator windows show red. Depress the silver mirror program disc and turn the crank one revolution. You need to keep the disc depressed only at the start of the turn. This cocks the camera and lens without winding film. The back's indicator window still shows red, but the body's shows white. Expose film. Repeat if desired.

The Solar Telescope at Kitt Peak, Arizona, was photographed with the 2000FC and a C lens. The camera was pre-released before exposure.

CLOSE-UP EQUIPMENT

Close-up equipment is available for all Hasselblad cameras except the SWC/M. The accessories range from simple Proxar close-up lenses to bellows and microscope attachments.

As mentioned earlier, the 135mm and 120mm S-Planar lenses are designed for best image quality when used for close-up shooting. Other lenses can also be used with extension accessories and close-up lenses. You cannot reverse a C or F lens.

For simplified metering calculations during close-up shooting, use a metering prism finder. As long as the light level at the film plane is within the sensitivity range of the meter, it automatically compensates for light loss due to extension.

Hasselblad recommends various combinations of lenses and close-up accessories for different ranges of image magnifications. This information is summarized in this section. A description of the equipment follows. For additional information and formulas for close-up shooting, see Chapter 2.

PROXAR CLOSE-UP LENSES

Three close-up lenses, called *Proxar*, are available. They are made with a Series 50 mount only. Even though the S-Planar lenses also accept Series-50 accessories, they do not give best image quality with Proxar lenses.

Focal lengths of the close-up lenses are 0.5, 1.0, and 2.0m, giving them diopter ratings of +2, +1, and +0.5 respectively. Charts of this section show magnification ranges with Series-50 C and F lenses.

APPROXIMATE FOCUS TRAVEL OF SOME HASSELBLAD LENSES	
Lens	Focus Travel
80mm Planar C	9mm
80mm Planar F	16mm
100mm Planar C	15mm
110mm Planar F	21mm
120mm S-Planar C	23mm
150mm Sonnar C or F	21mm
250mm Sonnar C	32mm

HOW TO USE CLOSE-UP CHARTS

The charts on pages 159 to 162 summarize Hasselblad recommendations for close-up shooting. The heading of each illustration indicates which lens you use. Based on the desired image magnification, you can derive necessary total lens extension, the recommended close-up accessory, and exposure compensation in steps.

Bold black lines represent C lenses; dashed lines represent F lenses. The left side of the line represents the extension of the lens focused at infinity. The length of the line is the focus travel of the lens. The colored lines shown below are the code to the close-up accessory shown in the illustration.

Example: You want to use the 80mm f-2.8 C lens for an image magnification of 0.5. Find 0.5 on the Magnification Scale and follow the vertical line up to the Extension Scale. It indicates that 40mm of total extension is necessary. Follow the vertical line down to the solid black and green lines. They show that the 32mm extension tube with 8mm of lens focus travel gives 40mm extension and a magnification of 0.5. Follow the vertical line down to the Exposure Compensation Scale to find an exposure increase of about 1.0.

When using a Proxar (P) close-up lens, do not use the Exposure Compensation Scale.

| C Lens | ▬▬▬ | Proxar Close-Up Lens | ▬▬▬ | Bellows Extension | ▬▬▬ |
| F Lens | ▪▪▪▪ | Extension Tube | ▬▬▬ | | |

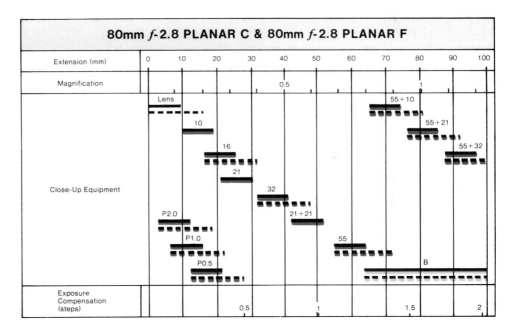

80mm f-2.8 PLANAR C & 80mm f-2.8 PLANAR F

Extension (mm)	0	10	20	30	40	50	60	70	80	90	100
Magnification					0.5				1		
Close-Up Equipment	Lens	10	16 / 21	32 / 21+21		55	55+10 / 55+21 / 55+32				
	P2.0 / P1.0 / P0.5					B					
Exposure Compensation (steps)			0.5		1		1.5		2		

AUTOMATIC EXTENSION TUBES

These tubes have a cocking shaft that retains automatic features of the lens. Before attaching tubes, cock them as you would a lens. Mount the cocked tube as you would a cocked lens onto a cocked camera. After mounting the tube, or tubes, attach the cocked lens.

The camera, tubes, and lens must be cocked before disassembly. Take the assembly apart by starting with the lens and work toward the camera. This prevents the cocking shaft from turning during disassembly, which could possibly jam the lens and tube together.

Five extension tubes with 10, 16, 21, 32 and 55mm lengths are avail-

Shown are the 16mm extension tube (top) and the 32mm extension tube (bottom). Notice that they have cocking shafts and mounting flanges like those of F and C lenses.

PUPILARY MAGNIFICATION OF SOME HASSELBLAD LENSES		
	Lens	P
C Lenses	38mm *f*-4.5 Biogon	1.06
	40mm *f*-4 Distagon	2.25
	50mm *f*-4 Distagon	1.80
	60mm *f*-3.5 Distagon	1.57
	80mm *f*-2.8 Planar	1.20
	100mm *f*-3.5 Planar	1.16
	105mm *f*-4.3 UV-Sonnar	0.86
	120mm *f*-5.6 S-Planar	1.06
	135mm *f*-5.6 S-Planar	1.18
	150mm *f*-4 Sonnar	0.75
	250mm *f*-5.6 Sonnar	0.57
	250mm *f*-5.6 Sonnar Superachromat	0.52
F Lenses	50mm *f*-2.8 Distagon	1.76
	80mm *f*-2.8 Planar	1.20
	110mm *f*-Planar	1.09
	150mm *f*-2.8 Sonnar	0.73

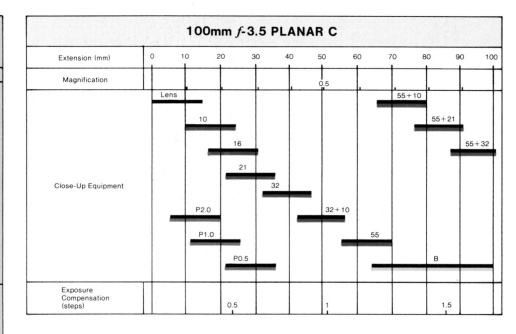

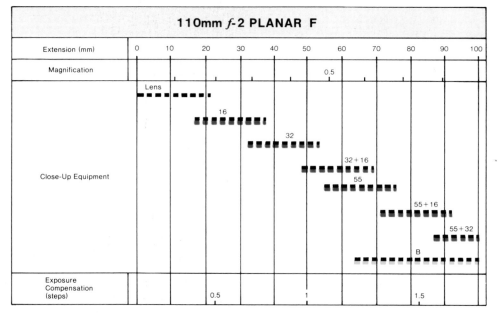

able. The 16mm and 32mm tubes are designed for use with F lenses, although they also work with C lenses.

Do not try to mount the 10mm or 21mm tubes between the 2000FC and the lens. The camera's shutter-speed ring gets in the way. You can, however, use the tubes in combination with any of the other three tubes mounted to the 2000FC. You cannot mount the 10mm and 16mm tubes to the rear of the 135mm S-Planar lens. Use them connected to a longer tube mounted to the lens.

EXTENSION BELLOWS
For adjustable extension from 2.5 to 8 inches (63.5 to 202mm), use an extension bellows. Two are available. The latest has a cocking shaft that preserves automatic features of the lens. The other bellows is an older, non-automatic model. In this discussion, I'll call these the *auto* and *non-auto bellows*.

Attaching the Bellows—Before attaching the auto bellows to the camera, cock the camera and the bellows. The rear standard of the auto bellows has a slotted cocking shaft like Hasselblad lenses.

First mount the bellows onto the camera as you would a lens. Then mount a cocked camera on the front standard of the cocked auto bellows. Do this as you would mount a lens on the camera. *Do not* mount lens first and camera second. When taking the assembly apart, take the lens off first and the camera off second.

Cock the camera before mounting the non-auto bellows onto it. The bellows' rear standard cannot be cocked. Mount it like a lens. The front standard of the non-auto bellows does have a cocking shaft. It is connected to a cable-release socket on the front standard's mounting ring. Align the head of the cocking shaft with the red dots by turning the cocking knob of the front standard clockwise until it stops. Then you can mount a cocked lens onto the front standard.

Adjusting the Auto Bellows—Adjusting this double-rail bellows is quick and simple. The large knurled knob under the front standard adjusts bellows extension. The rear standard is fixed. A cm scale on the top rail

reads extension from 6.5cm to 20.2cm in 0.5cm increments. Read bellows extension where the white index of the front standard crosses the scale. Use this value in extension formulas from Chapter 2 or with the tables of this section. In either case, use the lens with its focusing scale set to infinity for simplest operation.

Another scale on the bellows indicates the exposure compensation factor necessary when you use the 135mm S-Planar lens. Because this lens does not have a helicoid focusing screw, bellows extension is directly related to magnification and the exposure compensation factor.

When the bellows is fully compressed, the lens acts like any 135mm

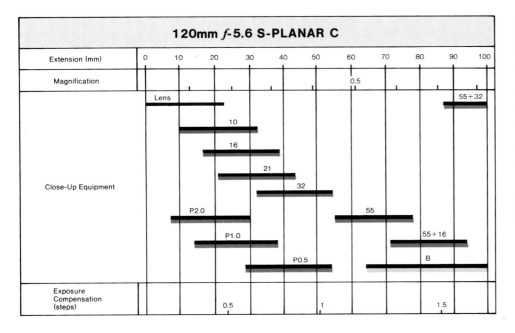

120mm f-5.6 S-PLANAR C

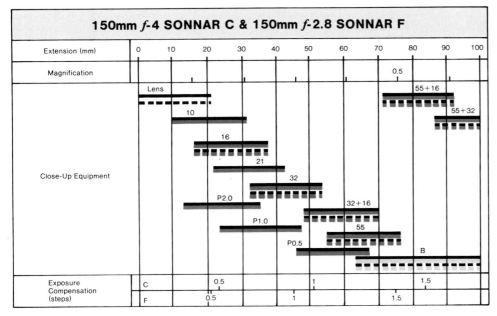

150mm f-4 SONNAR C & 150mm f-2.8 SONNAR F

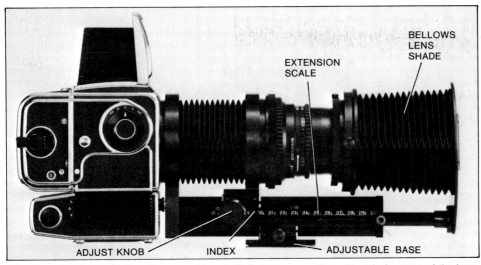

ADJUST KNOB INDEX ADJUSTABLE BASE

EXTENSION SCALE BELLOWS LENS SHADE

The Hasselblad Auto Bellows has a cocking shaft that preserves the automatic features of the lens used with it.

lens focused at infinity. When the bellows is fully extended, the lens gives a magnification of 1. The lens gives excellent image quality throughout the entire magnification range. If you want more magnification, use extension tubes between the bellows and lens.

After determining magnification, find the correct lens-to-subject distance. Formulas and charts in Chapter 2 tell you how. Make fine-focus adjustments by using the knob on the tripod seat of the lower rail. With it you can move the whole camera and bellows assembly back and forth without changing image magnification. Locking knobs for both adjusting knobs are on the bellows' left side.

Adjusting the Non-Auto Bellows— Basically, the non-auto bellows has the same adjustments as the auto bellows. However, this unit has a fixed front standard and a moving rear standard. The only scale on the non-auto bellows is reversed and shows extension from 6.5cm to 20.2cm in 0.5cm increments. Read extension with the index on the rear standard.

Shooting with the Auto Bellows— The same interlocks between lens, camera, and back are in effect when you use the auto bellows. After focusing, setting exposure controls, and removing the dark slide, you are ready to expose film. To minimize vibrations, pre-release the camera. Then push the shutter button to expose film.

The camera and lens operate like any camera and lens combination described so far. All of the different ways of exposing film, winding the camera, and using the lenses also apply to using the auto bellows.

Shooting with the Non-Auto Bellows—Pushing the shutter button of the camera attached to the non-auto bellows *does not* automatically operate the lens. Therefore, Hasselblad supplies a dual cable release to synchronize camera and lens operations.

Before attaching the two cables to the camera and lens, slowly push the plunger and look at the ends. A cable should come out of the red-ringed end first—but not completely—then out of the silvered end.

When the plunger is pushed in all the way, both cable ends should be fully extended. If this isn't the case, adjust the cables with the set screws at the end of each cable. This adjustment

250mm f-5.6 SONNAR C

Extension (mm)	0	10	20	30	40	50	60	70	80	90	100
Magnification				0.2				0.4			

Close-Up Equipment (bars across extension scale):
- Lens
- 10
- 16
- 21
- 32
- P2.0
- P1.0
- 55
- 55+16
- B

| Exposure Compensation (steps) | | | | 0.5 | | | 1 | | | |

MAGNIFICATION RANGES WITH HASSELBLAD LENSES AND EXTENSION BELLOWS*

Lens+	Magnification Range	Exposure Compensation (Steps)	Approx. Depth of Field at f-11 (mm)
80mm Planar C or F	0.79—2.53	1-1/2—3-1/3	3—0.5
100mm Planar C	0.64—2.02	1—2-2/3	4—0.7
110mm Planar F	0.57—1.84	1—2-2/3	5—0.8
120mm S-Planar C	0.53—1.68	1—2-2/3	6—0.8
135mm S-Planar C	0—1.0	0—2	∞—2.0
150mm Sonnar F or C	0.42—1.35	1-1/3—3	7—1.3

* Bellows extended from 63.5mm to 202mm.
+ Lens focus control set to infinity.

The Hasselblad Non-Auto Bellows has a cocking knob on the front standard. After exposure you must cock the lens shutter again by turning the knob clockwise one full turn. For the lens aperture to operate automatically, expose film with the dual cable release.

step is necessary to properly synchronize lens and camera operation. If the cables are not set properly, bad exposure results.

Screw the red-ringed cable into the socket on the bellows' front standard. Attach the silver cable to the camera's shutter button. If you are using the 500EL/M, you must use a special shutter button that accepts a screw-in cable release.

When you push the plunger to make the exposure, the cable that comes out of the red-ringed end operates the "automatic" features of the lens. The cable connected to the camera operates the camera soon after. When used this way, the non-auto bellows can be used with all combinations of camera, lenses, and exposure modes described so far.

Post-exposure operations are different, however. When you cock the camera and advance film, the lens remains uncocked. If you tried to expose film again, the camera would operate, but the lens wouldn't. So after each exposure with the non-auto bellows, remember to cock the lens with the knob on the front standard. Turn it clockwise one full turn until it stops.

The exception to this rule is when you use the focal-plane shutter of the 2000FC. A dual cable release is not necessary because the lens—whether F or C—can be stopped down manual-

The Hasselblad Ringlight is a handy flash to use for close-up shooting for even, shadowless light. It fits around most F and C lenses recommended for close-up work. Hasselblad does not make a power pack for the flash, but you can use any flash power pack rated from 300V to 360V.

ly with its depth-of-field preview lever. Make the exposure with the camera's shutter button or a single cable release. Recocking the lens is unnecessary because the shutter remains open throughout the exposure operation and is still cocked.

COPYING EQUIPMENT

Accessories are available to make copying with Hasselblad equipment easy. As mentioned, with an SWC/M camera you can make high-quality copies of subjects as close as 26 inches (65cm) at *f*-22. In this case, image magnification is about 0.17X, letting you copy a 33-inch (84cm) square document onto the 6x6 cm format.

Transparency Holders—Both extension bellows accept a special adjustable lens shade that attaches to the rail and lens. Each of these lens shades will accept a transparency holder on its front standard. With the holder, you can copy transparencies as large as the 6x6 cm format.

Adjust magnification with the bellows, then adjust subject distance with the lens shade. Use backlight to illuminate the transparency.

Linear Mirror Unit—To guarantee parallelism between the subject and film plane, use this accessory. The base of the larger mirror rests on the copy subject or hangs down in front of it. This puts the mirror parallel to the subject. The other mirror is attached to a lens mounting flange.

After setting up the camera on a tripod and focusing the lens, remove the lens and attach the mirror with lens flange. When using the unit with the SWC/M, attach it to the front of the 38mm lens.

When you view the subject through the camera, you can judge parallelism. If the film plane and subject are not parallel, you see a series of non-concentric circles. Adjust the camera until you see concentric circles. This camera setting gives a copy image without distortion.

Because of the optical design of the 38mm Biogon lens, you can use the SWC/M as a copy camera and get excellent image quality. This photo is of a page from the 1835 "Elephant Portfolio" *Birds of North America* by John James Audobon.

The Linear Mirror Unit is a handy device for copying flat documents. The large mirror goes on the subject, or parallel to it. The smaller mirror mounts to the camera body. When you view the large mirror through the camera you can tell if the film plane and subject plane are parallel, as shown below.

NON-PARALLEL PARALLEL

13

Bronica ETR System

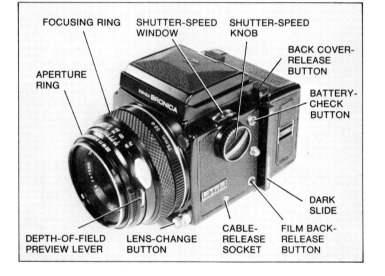

FOCUSING RING SHUTTER-SPEED WINDOW SHUTTER-SPEED KNOB BACK COVER-RELEASE BUTTON BATTERY-CHECK BUTTON APERTURE RING DEPTH-OF-FIELD PREVIEW LEVER LENS-CHANGE BUTTON CABLE-RELEASE SOCKET FILM BACK-RELEASE BUTTON DARK SLIDE

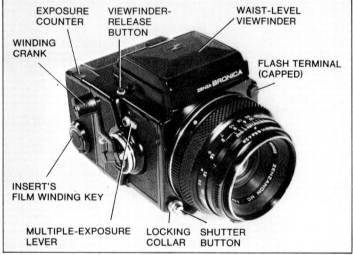

EXPOSURE COUNTER VIEWFINDER-RELEASE BUTTON WAIST-LEVEL VIEWFINDER WINDING CRANK FLASH TERMINAL (CAPPED) INSERT'S FILM WINDING KEY MULTIPLE-EXPOSURE LEVER LOCKING COLLAR SHUTTER BUTTON

Two medium-format single-lens reflex cameras made by Zenza Bronica are the ETR-S and the ETR-C. These nearly identical cameras are models of the Bronica ETR system, first introduced in 1975. The ETR-S camera is shown above.

Unless mentioned otherwise, the discussion in this chapter applies to both cameras. Differences between the two are pointed out as certain aspects of the system are covered. Basically, the ETR-S camera has more professional capabilities than the ETR-C because it accepts interchangeable film backs. The ETR-C doesn't.

The image format of the ETR cameras is 4.5x6 cm, with actual dimensions of 43x55 mm. With an image this size you get 15 or 30 exposures on 120 or 220 film respectively.

The standard lens for the ETR cameras is a Zenzanon-E 75mm, *f*-2.8 lens with a built-in leaf shutter. The ETR system is quite versatile and includes interchangeable leaf-shutter lenses, film backs, focusing screens, viewfinders, winders, and an assortment of equipment for close-up work.

It is a successful blend of medium-format capabilities in a relatively small package. As you'll see in the following discussion, the camera is easy to handle for both horizontal- and vertical-format shooting when used with one of the accessory winders.

BRONICA ETR-S CAMERA SPECIFICATIONS

Type: 4.5x6 cm single-lens reflex with waist-level viewing and non-instant-return mirror.
Shutter: Electronically controlled #0 Seiko leaf shutter in each lens with camera-controlled shutter speeds from 1/500 to 8 seconds, and T. X sync at all shutter speeds.
Standard Lens: Zenzanon-E 75mm *f*-2.8 lens.
Film: 15 or 30 exposures with 120 or 220 film, 90 exposures with 70mm film. Interchangeable backs available for each film size, and Polaroid film.
Power Source: 6V silver-oxide battery (Eveready No. 544 or equivalent).
Other Features: Interchangeable lenses, viewfinders, and focusing screens. Multiple-exposure lever, safety interlocks, battery check, accessory rapid winder and motor drive.
Dimensions: Width 101mm (4.0"), height 106mm (4.2"), depth 157mm (6.2").
Weight: 1.3kg (2.9 lbs.).

BRONICA ETR-C CAMERA SPECIFICATIONS

Type: 4.5x6 cm single-lens reflex with waist-level viewing and non-instant-return mirror.
Shutter: Electronically controlled #0 Seiko leaf shutter in each lens with camera-controlled shutter speeds from 1/500 to 8 seconds, and T. X sync at all shutter speeds.
Standard Lens: Zenzanon-E 75mm ƒ-2.8 lens.
Film: 15 or 30 exposures with 120 or 220 film loaded onto preloadable inserts. Camera does not accept interchangeable backs.
Power Source: 6V silver-oxide battery (Eveready No. 544 or equivalent).
Other Features: Interchangeable lenses, viewfinders, and focusing screens. Multiple-exposure lever, safety interlocks, battery check, accessory rapid winder and motor drive.
Dimensions: Width 101mm (4.0"), height 106mm (4.2"), depth 157mm (6.2").
Weight: 1.3kg (2.9 lbs.).

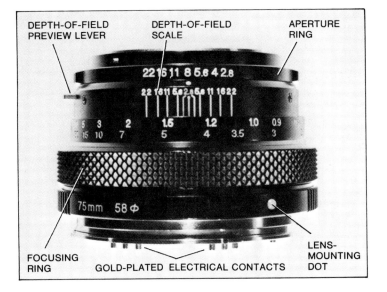

ETR LENSES

Lenses made by Bronica for ETR cameras are called *Zenzanon-E* lenses. Each is a multicoated, automatic-aperture lens with a built-in #0 Seiko leaf shutter. The shutter is electronically controlled by the camera body for speeds from 1/500 to 8 seconds, and T. The accompanying table shows the main features of the lenses. Special lenses are discussed here.

55mm ƒ-4.5 Super Angulon PCS— This wide-angle perspective-control lens is made by Jos. Schneider & Co. to Bronica specifications. It has gear-driven shift *and* tilt. The horizontal shift is 12mm to the right or left and the vertical shift is 12mm up and 10mm down. The lens tilts up to 10° vertically. If you use the camera for vertical-format shooting, the tilt becomes a swing.

With the shift feature, you can control converging verticals, which are inherent in architectural photography. With the tilt or swing control, you can place the zone of sharp focus in a plane not parallel with the film plane. Of course, you can use the shift and tilt for creative distortion too.

Like Zenzanon-E lenses, the PCS lens is multicoated, has an automatic aperture, and a built-in #0 Seiko leaf shutter. Floating lens elements help maintain good image quality throughout the focusing range.

Variogon Zooms— Two zooms made by Schneider are available for ETR cameras. They are the 70mm to 140mm ƒ-4.5 and the 125mm to 250mm ƒ-5.6 Variogon zooms. Bronica also calls these zooms *macro zooms* because of a control on the focusing ring that lets you focus as close as 16 inches (40cm) with the 70-140mm zoom and 30 inches (80cm) with the 125-250mm.

The zooms have multicoated optics, an automatic aperture, and a Seiko leaf shutter. Because the 125-250mm zoom is relatively large and heavy, it has a rotating tripod collar so you can balance the lens and camera on the tripod for either horizontal or vertical formats.

MOUNTING THE LENS

Each lens has a special Bronica four-lug bayonet mount. When you mount a lens, six gold-plated pins on the rear of the lens meet six gold-plated contacts inside the camera body. These transfer signals from the camera's shutter circuit to the lens. Mechanical linkages and springs in the lens actually cock and drive the leaf shutter.

The 55mm PCS lens is ideal for architectural photography.

Lens	Minimum Aperture	Diag. Angle of View	Minimum Focus Distance ft.	Minimum Focus Distance m	Weight oz.	Weight g	Filter Size (mm)
40mm ƒ-4	ƒ-22	82°	1.3	0.4	18	508	62
50mm ƒ-2.8	ƒ-22	70°	1.6	0.5	17	480	62
55mm ƒ-4.5 PCS	ƒ-32	65°	1.6	0.5	39	1105	95
75mm ƒ-2.8	ƒ-22	50°	2.0	0.6	15	417	58
105mm ƒ-3.5	ƒ-22	37°	2.9	0.9	20	568	62
150mm ƒ-4	ƒ-22	26°	4.9	1.5	22	626	62
200mm ƒ-4.5	ƒ-32	20°	6.6	2.0	25	719	62
250mm ƒ-5.6	ƒ-32	16°	11.5	3.5	29	820	93
500mm ƒ-8	ƒ-45	8°	28.0	8.5	64	1816	95
70—140mm ƒ-4.5 Variogon	ƒ-32	51°— 29°	1.3/ 0.8*	0.4/ 0.25*	53	1500	Series IX
125—250mm ƒ-5.6 Variogon	ƒ-32	32°— 16°	8.2/ 0.25*	2.5/ 0.8*	58	1650	93

BRONICA ETR LENSES

* "Macro" mode.

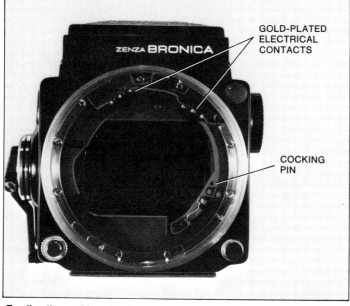

To align the cocking pin of the body's mounting flange with the green dot, turn the camera's winding crank 360° clockwise.

Align the lens cocking pins with their green dots manually by pushing one pin counterclockwise.

Because of an interlock between the camera body and lens, you can mount the lens only when it and the camera body are cocked. To cock the camera body, turn the winding crank 360° clockwise or use a series of ratcheted turns until it stops. This lowers the mirror in place in front of the film frame, advances film, and aligns the green dot of the body's cocking pin with a green dot next to the lens mounting flange.

To cock the lens, turn the two cocking pins on the bottom of the lens counterclockwise until they are aligned with two green dots. To mount the cocked lens, match the red dot on the outside of the lens with the red notch at the top of the camera body's mounting flange. Turn the lens 30° counterclockwise until it clicks. No aperture indexing is necessary.

As with mounting, you can't remove a lens unless both the camera and lens are cocked. This is because ETR cameras do not have an instant-return mirror or an auxiliary shutter. After exposure, the mirror remains up against the focusing screen. The lens shutter remains closed. If you could remove the lens at this time, you would fog film. The interlock mechanism is designed to prevent this.

Advance film and cock the shutter with a 360° turn of the winding crank. This lowers the mirror, which effectively blocks light from the film plane. Turn the collar of the lens-removal button 45° clockwise against noticeable spring tension and push the button in.

Then rotate the lens 30° clockwise to remove it. This two-hand operation takes some practice at first, but as you

get used to it, changing lenses becomes fast and easy.

You cannot mount or remove a lens incorrectly. If both the camera and lens are not cocked, the lens does not couple with the mounting flange when you try to mount it. If the camera is not wound before you try to remove the lens, you can't push in the lens-removal button.

2X TELECONVERTER

The 2X Teleconverter effectively doubles the focal length of the lens used with it. Fixed-focal-length lenses from 75mm to 500mm are recommended. Because the teleconverter increases the effective focal length of the lens, it requires an exposure compensation of two steps. All automatic features of the lens are preserved.

Mounting the Teleconverter—The teleconverter fits between camera and lens. Remove the cocked lens from the camera as described. Cock the teleconverter by revolving its cocking pins until they are aligned with the green dots.

Match the red dot on the lens with a red line on the mounting flange of the teleconverter and turn the lens counterclockwise with respect to the teleconverter. This is just like mounting a lens on the camera. Then mount the assembly onto the cocked camera as you would mount a lens.

FILTERS AND LENS ATTACHMENTS

Lenses of the ETR system accept screw-in filters and lens attachments.

Align the mounting dots and turn the lens 30° counterclockwise.

You turn and push the lens-removal button with one finger. Your other hand removes the lens.

Bronica makes 58mm and 62mm screw-in skylight (1B) filters only. Many other filters are made by accessory manufacturers. Most camera stores carry a wide selection.

Three plastic lens hoods are made for Zenzanon-E lenses: for the wide-angle lenses, the normal lens, and the telephotos. The Variogon zooms come with their own hoods.

Professional Lens Hood-E—This is an extremely versatile lens attachment that you can use for all Zenzanon-E lenses from 40mm to 250mm. It attaches with a tightening collar that slips over an adapter you screw into the lens. Standard adapters have 58mm or 62mm diameter threads. Screw-in adapters with 49mm, 52mm, and 55mm diameter threads are also available so you can use the hood with other brands of cameras and lenses. Masks for the 150mm and 250mm Bronica lenses come with the lens hood.

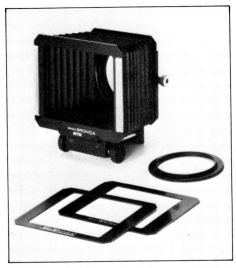

The Professional Lens Hood is a versatile lens accessory.

The hood is an adjustable bellows lens shade. The rail is marked with the focal lengths of the different Zenzanon-E lenses you can use with it. Align the front of the bellows with the focal length of the lens in use. In addition, you can insert 75mm (3-inch) square gel filters or special-effect masks into a slot in the front of the hood.

Focusing Handle—Attach this accessory over the lens focusing ring and tighten the set screw. The handle lets you focus quickly and accurately for fast-breaking action. It fits all lenses from 40mm to 500mm, except for the zooms and 55mm PCS lens.

THE BATTERY

The cameras use a 6V silver-oxide Eveready No. 544 battery or equivalent to power the electronic shutter-timing circuit and supply power for the accessory metering viewfinder.

According to Bronica, if you never use the metering viewfinder, the battery has enough power for about a year's use. If you use the metering viewfinder all of the time, the battery lasts between 6 and 12 months. The cameras do not use any battery power for 1/500-second exposures or time exposures.

A battery-check button is on the left side behind the shutter-speed dial. When you push it, a check light glows red if there is sufficient battery power. The check light is visible in the lower left-hand corner if you view the focusing screen without a prism viewfinder in place. When you use a prism viewfinder, the light appears in the lower right-hand corner.

Because no viewfinder is on the camera in this photo, the battery-check light is in the lower left-hand corner.

Dead Battery—When the battery is dead or installed incorrectly, the check light will not glow when you push the battery-check button. You can still change aperture, cock the shutter, and advance film because these are mechanical operations, but the shutter-timing circuit does not function. In this case, the shutter will give a 1/500 second exposure when you push the shutter button, no matter where you set the shutter-speed dial.

Changing the Battery—To remove a dead battery from the camera, push the button on the plastic cover labeled BATTERY at the camera bottom and slide it off.

Remove the dead battery and replace it with a fresh one. Make sure to observe battery polarity because if you put it in backward, the camera will still not function electronically.

The battery compartment of ETR cameras is on the bottom of the camera next to the tripod mounting screw.

Remote Battery Pack—In weather colder than about 32°F (0°C), the battery has reduced power and capacity. For maximum battery power in cold weather, use the Remote Battery Pack to keep the battery warm. The camera battery slips into a battery compartment of the remote pack. You put this into a warm coat pocket. The battery

Use the remote battery pack in weather colder than 32°F (0°C).

compartment has a long cord leading to a dummy battery that fits into the camera battery compartment.

INTERCHANGEABLE FILM BACKS

The major difference between the ETR cameras is that the ETR-S accepts four interchangeable film backs and the ETR-C doesn't. This makes the ETR-S more versatile and convenient for many kinds of photographic situations.

Available roll-film backs for the ETR-S are for 120, 220, or 70mm films, yielding 15, 30, or 90 exposures respectively. A back for Polaroid pack films is also available. See Chapter 4 for a list of films you can use with these backs.

The ETR-C uses preloadable film inserts for either 120 or 220 film. These inserts are also used in the 120 and 220 interchangeable film backs for the ETR-S.

Detaching an ETR-S Film Back— Because the ETR-S film backs have a dark slide and exposure counter, you can change them in the middle of a roll without wasting film. This is very handy if you want to shoot one scene with different kinds of film or use Polaroid film to check exposure and lighting.

Before you remove the film back, insert the dark slide into a slot on the left side of the back. Slide the dark slide in so a large dot on its handle is next to an identical dot on the film back. You can't put it in all the way if it is upside down.

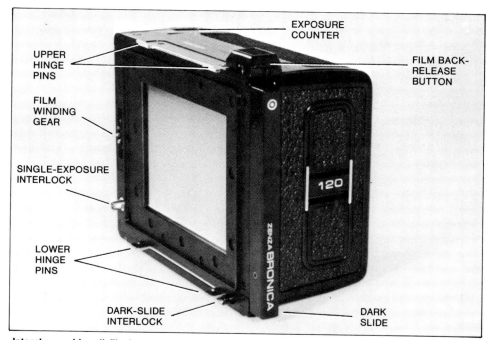

Interchangeable roll-film backs for the ETR-S have a number of controls and interlocks.

When you insert the dark slide with its white dot up, a small tab (arrow) on the dark slide cancels the interlock between the film-back release button and the back.

Next, push the small film back release button on the bottom left side of the ETR-S body and swing the film back up and off. The dark slide blocks exposure to the film when the back is removed.

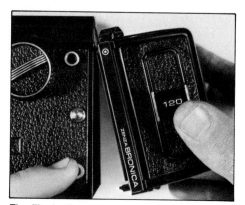

The film-back removal button is on the camera body next to the dark slide.

Even though there is an interlock between the dark slide and the back's removal button, you can still remove a back without a dark slide in place. Save this method for emergencies: While pushing the lens-release button, push the film back-release button and remove the back. If film is in the film plane, you'll fog the frame.

The camera body and film back couple in such a way that you can remove and attach the film back whether the camera is cocked or not, and whether an exposed or unexposed frame is in the film plane.

Attaching an ETR-S Film Back—To attach a film back to the ETR-S, slide the hinge pins on the top of the back into the slots on the camera body. Swing the back down until it clicks in place.

Remove the dark slide and put it in a pocket where it won't get bent. There is no place to store it on the camera body. You can attach the back to the camera without the dark slide in place, but of course this will fog film.

It is good practice to leave the dark slide in the film back whenever it is detached from the camera body. Another good practice is to remove the dark slide from the back as soon as you attach the back to the body. This prevents the back from falling off if the camera strap or your finger inadvertently depresses the film back-release button.

After attaching the film back and removing the dark slide, wind the crank. If the camera and lens are already cocked, the crank turns easily. It advances film only if an exposed frame is in the film gate.

If an unexposed frame is in place, film will not advance as you wind the crank. If the camera and lens are not cocked, turning the winding crank will cock them.

Film will advance only if the frame in the film gate is exposed, and the frame counter advances only when film does.

Therefore, if you always wind the crank after attaching a back, the camera and lens are always cocked and an unexposed frame is always in position. You *cannot* waste film or lose track of the number of exposed frames on the roll when changing from back to back.

LOADING 120 AND 220 FILM

Even though the ETR-S uses interchangeable film backs and the ETR-C doesn't, you load 120 and 220 film the same way with both cameras. A preloadable insert for 120 and 220 film is part of the 120 and 220 film backs you use with the ETR-S. The ETR-C accepts the same 120 or 220 inserts in its nondetachable back. Film inserts contain the exposure-counting mechanism.

The back cover-release button is on the top left side of the cameras. To open the back cover, first slide forward the small locking lever beneath the release button. While it is forward,

To open the back, slide the locking lever forward, then push the button to the right.

move the button to the right. The back cover opens from the top and swings down. Remove the insert. This operation does not depend on the position of the dark slide.

The unexposed roll of film goes into the top chamber of the insert. Remove the empty spool from this chamber by pushing the spool toward the hinged spool retainers. When the retainer opens, pull it all the way down with a fingernail. Open the bottom retainer, insert the empty spool, and close the retainer.

The unexposed roll goes into the top chamber of the insert. Make sure the hinged spool retainers close flush to the insert; otherwise, film can jam when you try to wind it.

When you unroll the paper leader and pull it across the pressure plate, the black side should face out. Insert the tapered end into the empty spool. Turn the insert's winding key counterclockwise until the arrow on the paper leader aligns with a small red triangle on the top left spool retainer.

Put the loaded insert back into the camera or film back so the unexposed roll is on top. Close the back cover. Wind the film to frame 1 with the camera's winding crank, about 5.5 revolutions. The crank automatically stops when a 1 shows in the exposure-counter window on the top right side of the back.

Use the insert's winding key to align the start marks of the spool and insert.

If you are loading 120 or 220 film backs ahead of time, you can put the first frame in position for exposure without attaching the back to the camera. Put the loaded insert into the detached film back. After closing the cover and making sure the dark slide is in place, use the insert's winding key to advance the counter to frame 1. The key automatically disengages when 1 shows in the exposure counter.

Loading Film Incorrectly—Because rolls of 120 and 220 film are constructed differently, as described in Chapter 4, you should not load 120 film into a 220 insert or vice-versa. The pressure plates and film counters are set differently.

The pressure plate of the 120 insert is slightly farther away from the film plane than the plate of the 220 insert. This compensates for the continuous paper backing in 120 rolls.

If you load 220 film in the 120 insert, the film will not be held as flat in the film plane as it should be. This contributes to a slightly unfocused image, although small apertures may compensate for this somewhat. The 120 insert's counter has numbers for every odd frame and dots for every even frame. It stops at 15, so even though you may be able to advance and expose film, you may lose track of the number of exposed frames.

If you load 120 film in the 220 insert, the additional thickness of the paper leader will cause unnecessary drag on the winding mechanism. The 220 insert's exposure counter has numbers for every even frame and dots for odd frames. It goes up to 30, so after you expose 15 frames on 120 film, the counter continues working and you can still advance and "expose" paper leader. It counts up to frame 22 and then stops because nothing is advancing in the insert. Normally, the camera's winding crank

and shutter will not function if film is not advancing in the insert.

Changing Inserts—With a preloaded film insert, you can load the camera very quickly. When one roll is completely exposed, simply open the back of the camera and replace the insert containing the exposed roll with an insert containing an unexposed roll. For this operation, both cameras work identically.

With both cameras, the insert's exposure counter goes back to S when the back of the camera or film back is opened. If you use the ETR-C, you can change film inserts containing partially exposed film by loading and unloading the insert in a darkroom or changing bag. In this case, however, the exposure counter would not indicate the actual number of exposures made. You could waste film or lose track of how much of the film has been exposed. If you need to change film in the middle of a roll, then you need the ETR-S and an extra back.

Using the Polaroid Back—This back contains parts made by Bronica and Polaroid. You load and use it like any medium-format Polaroid back, as described in Chapter 4. It accepts *either* 100/600-series or 80-series Polaroid film and yields a 4.5x6 cm image.

As with the other Bronica film backs, the Polaroid back has a dark slide. It is on the accessory's right side. You do not have to pull the dark slide all the way out of the back to expose film, although you can if you want to because the back has a light-tight felt trap. You can see a small engraved

You only have to pull out the Polaroid back's stainless steel dark slide enough to expose the engraved triangle. Here, the dark slide was lit to accentuate the triangle. In reality the dark slide is silver colored.

triangle on both sides of the dark slide when you pull the slide out far enough to completely expose film.

Because the dark slide is on the right side, there is no exposure interlock

The Polaroid back is useful for testing exposure and lighting before shooting conventional roll film. The color image shown above is reproduced from a Type 108 Polaroid print. The b&w photo at right was shot with b&w negative film with the same exposure settings and lighting.

Before using the Polaroid back to expose film, push down the multiple-exposure lever to expose the red dot.

between the camera body and back. To cock the camera, engage the multiple-exposure mechanism of the camera by flipping the small lever above the winding crank down to expose a red dot. It is also possible to operate the camera with the dark slide in front of the film frame. Of course, no exposure will reach the film and it will develop black. In addition, you can remove the back whether the dark slide is in front of the film or not.

CAMERA OPERATION

The ETR-S and ETR-C cameras expose film the same way. Control knobs and dials are in the same place, and except for interchangeable film backs, they accept the same accessories. After you load a camera with a roll of film, unfold the winding crank and wind it until it stops. The first frame is in position to expose film.

Exposure Controls—The camera does not have a built-in meter, so you need

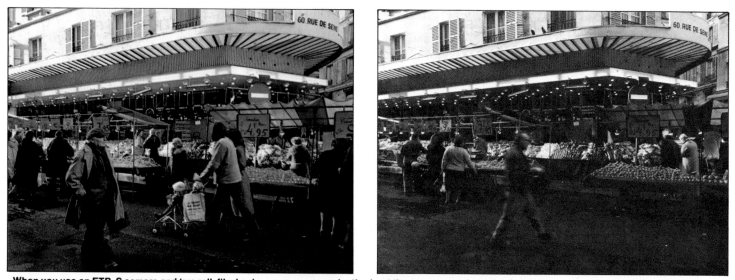

When you use an ETR-S camera and two roll-film backs, you can conveniently shoot the same scene in both b&w and color without the extra expense and weight of two camera bodies.

to use an accessory meter with any viewfinder other than the metering prism viewfinder described later. After metering, set the *f*-stop using the aperture ring on the lens. It has detents at every step.

Set shutter speed by turning the shutter-speed knob on the left side of the camera body. The chosen shutter speed is displayed through a window above the dial. You can also see the next faster and slower speeds on either side. Shutter speeds from 1/500 to 1/2 second are color coded in white, and speeds from 1 to 8 seconds are in red. In-between shutter speeds are not possible when you set shutter speed manually.

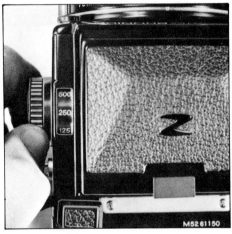

The shutter speed you set is the one in the middle of the window on the top of the camera.

Viewing and Handling—Bronica does not supply a viewfinder with the camera. You can choose among five interchangeable viewfinders described later.

Focus the lens with its large knurled ring. Preview depth of field by

Each lens of the system has a spring-loaded depth-of-field-preview lever in front of the rubber focusing ring.

depressing a lever on the left side of the lens near the aperture ring. The lever springs back as soon as you release it. It can't be locked.

The shutter button is on the front of the camera on the lower right side. The easiest way to hold the camera for both eye- and waist-level viewing is to cradle it in your left hand with your left index finger on the shutter button. This frees the right hand for focusing, winding the crank, and turning the shutter-speed dial.

This last operation is a bit awkward because the dial is on the left side of the camera. Shooting vertical-format photos can also be difficult. However, Bronica offers two accessory winders that solve both of these problems and make camera handling much faster and easier. They are described later.

Exposing Film—When you push the shutter button, the leaf shutter closes, the diaphragm stops down to the preselected aperture, and the mirror swings up. The shutter opens and closes for the chosen exposure time, then a red LED blinks on and off once in the blacked-out viewing area. This LED is the same light as the battery-check light. It signals you that the exposure is finished and winding is possible.

Because the shutter is very quiet, you can't always hear it operate, especially with slow shutter speeds. As soon as you see the LED glow, you can wind the crank 360° to move the mirror back down, cock the shutter, and advance film. *Do not* wind the camera before the LED indicates exposure is complete. If you do, the mirror drops down in place and effectively ends exposure. In addition, the next exposure will be automatically exposed at 1/500 second, no matter where you set the shutter-speed dial.

When the whole roll is exposed, tension in the winding crank lessens noticeably and the frame counter shows an orange line. After the last exposure, continue winding the crank for about three revolutions to completely wind up the film.

Multiple Exposures—To get multiple exposures, flip down the small silver lever above the winding crank to expose a red dot. Do this *after* the first exposure. This retracts the camera's winding gear from the film back and prevents the film from moving. It also keeps the exposure counter from advancing when you wind the crank.

When the multiple-exposure lever is flipped down, the camera's winding gear retracts. This prevents the film from advancing when you cock the camera.

To end multiple exposures, flip the lever back up after the last exposure. The next wind of the crank advances film and cocks the shutter.

Using the Camera Without Film—Normally, you cannot cock the camera or trip the shutter without film in the camera. The only way to operate the camera without film loaded is to use the multiple-exposure mechanism.

Flip the lever down to expose the red dot. Now you can cock the shutter and use the shutter button to trip it. All camera functions work as described, except for the frame counter. I recommend you familiarize yourself with camera operation this way before shooting film for the first time.

Long Exposures—The camera electronically controls long shutter speeds from 1 to 8 seconds. These speeds are marked in red on the shutter speed dial. If you want an exposure time longer than 8 seconds or if you want to save battery power during a long exposure, use the time-exposure lever on the underside of the lens next to the aperture ring.

For normal camera operation, the lever is screwed down and shows a

After loosening the set screw on the bottom of the lens, slide the lever to cover the A.

green A. To make a time exposure, loosen the small set screw until its head is above the lever. You *do not* need to remove the screw from the lens. Slide the lever so it covers the green A and exposes a red T.

The camera shutter speed dial can be set anywhere. If you are using the aperture-preferred metering viewfinder, turn off its meter before exposure to save battery power. The T setting will override the shutter speed the meter indicates in its exposure display. When you push the shutter button, the mirror swings up and the shutter stays open without using battery power.

To close the shutter, slide the lever so it covers the red T and again shows the green A. Even if the camera is on a tripod, this may shake the camera a bit. I recommend that you cover the lens with a lens cap or black card to end exposure, then slide the lever to close the shutter.

End the time exposure by sliding the lever so it covers the T.

When finished with the time exposure, screw down the set screw to avoid accidentally sliding the switch back to T. The cameras do not have a self-timer or a mirror-lockup device.

Using Flash—The ETR cameras have an X-sync terminal on the right side of the camera. Because Zenzanon-E lenses have a leaf shutter, you can get flash sync at all shutter speeds. F- and M-type bulbs will also synchronize with the lenses, but with a smaller range of shutter speeds. This is shown in the accompanying table.

Do not wind the camera before an exposure is completed because if you are using flash and you end a long exposure by winding the crank, the flash won't fire for the next exposure.

Shutter Release Safety Lock—The collar of the shutter button is a three-

Two Elinchrom 11 Mono Pro flashes and a portable flash were used to light this dancer. Because the lens shutter gave flash sync at 1/500 second, no exposure was recorded due to the bright modeling lights of the Elinchrom flashes.

Flash Type	FLASH SYNC WITH ETR LENSES									
	SHUTTER-SPEED SETTING									
	8s—1s	2	4	8	15	30	60	125	250	500
F										
M										
Electronic										

■ Flash will sync. ■ Flash won't sync.

way dial that controls the shutter-release.

When the red dot on the collar is at the bottom, you can use the shutter button, a cable release, or accessory winder to trip the shutter. If you revolve the collar 45° clockwise, you lock the shutter button only. The other two controls will still work.

Turning the collar another 45° clockwise to 9:00 locks all three shutter-release mechanisms.

INTERCHANGEABLE VIEWFINDERS

Five interchangeable viewfinders are available for ETR cameras. Attaching and removing a viewfinder

is fast and easy. To remove, push the small black button on the top right side of the camera body. Slide the viewfinder back about 1/4 inch (6mm) and lift it off.

To attach a viewfinder, insert the four tabs on the bottom of the viewfinder into the slots of the finder frame. Then slide it forward until it clicks in place.

Remove the viewfinder by pushing the release button and sliding the finder back. Attach a finder by inserting the back first, then sliding the finder forward.

Waist-Level Finder—To open this lightweight viewfinder, pull up on its sides. It springs open and shows all of the laterally-reversed image on the focusing screen, which is 90% of the image area. The waist-level finder effectively blocks light from all four sides, maximizing contrast in the focusing screen image.

You can also use the viewfinder up against your eye when you flip up the 1.25X magnifier. To do this, slide the small black button on the viewfinder in the direction of its arrow. The −1.5 diopter magnifier unscrews, so you can substitute another magnifier more suited to your eyesight if necessary. They are +1.5, +0.5, −0.5, −2.5, −3.5, and −4.5 diopters.

AE-II Finder E—This prism viewfinder shows the full focusing-screen image upright and laterally correct. With the AE-II, you can use the ETR cameras for manual or aperture-preferred automatic exposure.

The viewfinder meter uses two silicon blue photocells that give a full-frame-averaging meter pattern. It has a sensitivity range of EV 4 to EV 17 at ASA 100 with an f-2.8 lens.

Power for the AE-II viewfinder comes from the camera battery through gold-plated contacts above the focusing screen. These contacts are also used to send exposure signals between viewfinder and camera. No aperture indexing is necessary when you change lenses. The lens automatically tells the meter its maximum aperture through these contacts.

Before installing the AE-II on the camera, wipe all contacts with a soft, dry cloth. Dirty contacts could interfere with metering.

Set film speed with the dial on the left side of the viewfinder. Push the small silver locking button and turn the dial until the desired film speed

To set film speed, press the silver button and turn the film-speed dial. The exposure-compensation dial is also shown. Here, it is set to 1X.

from ASA 25 to ASA 3200 indexes with a small white line.

On the inside of the film-speed dial is an exposure-compensation dial. It can give one step of over- or underexposure in one-third-step increments. This is a handy control for metering nonaverage scenes, such as backlit or heavily shadowed scenes.

To use it, depress the small silver button on the scale and revolve the outside of the film-speed dial. For normal metering, set the dial to 1X. A setting of 2 gives one step more exposure, and 1/2 gives one step less exposure.

Turn the meter on with the mode-selector dial on the viewfinder's right side. To use it on automatic, depress the inside button of the dial and turn the dial from the red dot to A. Make sure the inside button returns flush with the dial. If it doesn't, the meter won't work reliably.

With this mode, you select aperture and the meter selects a shutter speed

BRONICA AE-II FINDER E SPECIFICATIONS

Type: Full-frame-averaging pentaprism viewfinder using two silicon blue photocells. Meter has automatic-exposure mode and manual mode. On **A** the meter is aperture preferred and chooses shutter speed steplessly. On **M** the meter indicates shutter speed for chosen aperture. You set shutter speed manually. LED display shows shutter speed, over- and underexposure when previewed. Exposure compensation knob allows compensation up to one step.

Measurement Range: EV 4 to EV 17 with ASA 100 film and f-2.8 lens.

Film Speed Scale: ASA 25 to ASA 3200.

Working Range: Stepless shutter speeds from 1/500 to 8 seconds.

Power Source: 6V silver-oxide battery of the camera.

Dimensions: Width 70mm (2.8"), height 44mm (1.8"), depth 111mm (4.4").

Weight: 426g (15 oz.).

INTERCHANGEABLE VIEWFINDERS

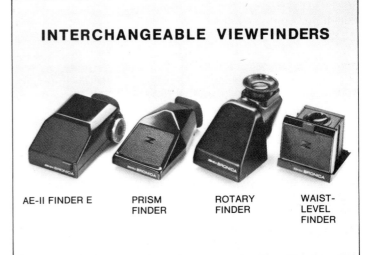

AE-II FINDER E PRISM FINDER ROTARY FINDER WAIST-LEVEL FINDER

For average scenes like this one, the AE-II finder sets the camera for good exposure when it operates automatically. For nonaverage scenes, you should either use the exposure-compensation dial or operate the meter manually, based on your interpretation of the scene's average luminance.

AE-II FINDER E
EXPOSURE DISPLAY

In this illustration, all of the LEDs are shown lit. Actually, only one LED lights when the meter operates.

With the mode-selector switch you choose either automatic (A) or manual (M) exposure operation. The in-between setting turns power off.

Preview the exposure display by pushing the shutter button or the button on the front of the AE-II Finder.

from 1/500 to 8 seconds steplessly. The camera's shutter speed dial is automatically disconnected. You can set the aperture between detents of the aperture ring if necessary.

To preview an approximation of the automatically-selected shutter speed, push in the camera shutter button halfway. You can also preview by pushing the button labeled AE-II on the front of the viewfinder.

The exposure display is an LED-illuminated series of shutter speeds below the focusing screen. If the selected shutter speed is between 1/500 and 1/60 second, a green LED illuminates the closest standard shutter speed. If the selected shutter speed is from 1/30 to 8 seconds, an orange LED illuminates the closest standard speed.

In the case of over- or underexposure, a triangle glows red. When the triangle points to the left, turn the aperture ring in that direction to select a larger aperture and prevent underexposure. If the triangle points to the right, turn the aperture ring to the right to close the aperture and avoid overexposure.

When you turn the mode-selector dial to M, the meter works manually. You adjust aperture, and the meter recommends an appropriate shutter speed for that scene. It does not set shutter speed for you. The exposure display shows a blinking shutter speed from 1/500 to 8 seconds in one-step increments. It does not indicate exposure settings finer than this one-step difference.

The best way to meter is to first set the shutter speed you want to use. Turn the aperture ring until the shutter speed you selected *begins* blinking in the viewfinder. Use those settings for the exposure. Because the meter is selecting shutter speed steplessly, this is a good way to get accurate meter readings. When in doubt, bracket with the aperture ring.

The meter is designed to work at the full aperture of the lens. You should not depress the depth-of-field lever during exposure when the meter is operating. If you do, the meter selects or recommends a shutter speed that will overexpose the film.

You can save battery power by turning the meter off—to the red dot or M—when not using it. The meter consumes more battery power when you use it in dark conditions than in bright conditions.

The viewfinder eyepiece is equipped with a -1.5 diopter magnifier. If necessary, you can substitute an accessory magnifier that fits your eyesight better. They are available in the same diopters as those for the waist-level viewfinder.

ETR INTERCHANGEABLE FOCUSING SCREENS

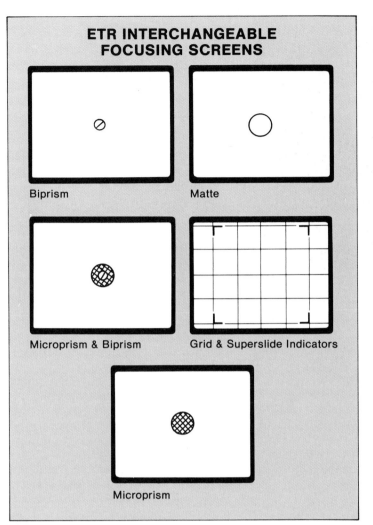

Biprism

Matte

Microprism & Biprism

Grid & Superslide Indicators

Microprism

For this nonaverage scene, I used the AE-II finder manually to determine an approximate shutter speed of 8 seconds with an aperture of *f*-11. Then I compensated for long-exposure reciprocity failure by bracketing with the lens aperture for a series of exposures. Because the light at the bottom of the tower is brighter than the light at the top, I gave more exposure to the top half of the tower. The back's dark slide became a moving mask over the bottom half of the picture.

Prism Finder—This viewfinder also gives a laterally correct, upright image like the AE-II Finder. It shows the same image area as the AE-II, but it does not have a meter. However, it is slightly smaller and weighs less. Correction lenses for the AE-II also fit this finder.

Prism Viewfinder Accessories—An Angle View Finder is available for the prism finder and the AE-II Finder. With it you can change the viewing angle from eye-level to a 90° angle, making it useful for close-up and copy work. It has a built-in correction lens you can adjust to fit your eyesight.

Also available is a viewfinder accessory called the Multi-Scope. It lets you look through the viewfinder at any angle because it rotates 360° around the viewfinder eyepiece. It has click stops every 90°. It also has a built-in diopter adjustment.

Rotary Finder—This pentaprism viewfinder has a special eyepiece that rotates 90° to the left or right from its vertical position. This makes it handy for low-angle and close-up shooting or for copy work. Like the other prism finders, it shows all of the focusing screen image and accepts accessory correction lenses.

Sports Finder—This lightweight, folding viewfinder is recommended for action photography, such as sports or news scenes. It has three wire frames and a plastic eyepiece showing the approximate field of view of the 50mm, 75mm, and 150mm lenses. A rectangular hole in the viewfinder base shows part of the focusing screen so you can check focus while using the finder.

FOCUSING SCREENS

Five interchangeable focusing screens are in the ETR system. To change screens, remove the viewfinder from the camera. Slide a small silver pin at the bottom of the screen to the left. Remove the screen by lifting on the metal tabs on the screen's frame. Do not remove the screen from the frame.

To install a screen, put the tab on the front of the frame into a slot in the camera and lower it in place. Slide the pin back to the right. Replace the viewfinder.

Besides the standard focusing screen already described, an all-matte screen and those with grid lines, a microprism and biprism are also available. All use a plastic Fresnel lens on the bottom of the screen for even distribution of light across the field.

After removing the viewfinder, slide the small retaining peg to the left. Then lift up the screen and frame with the metal tab (arrow).

I made this close-up photo with the 75mm lens and 28mm extension tube. The AE-II finder determined exposure automatically.

Extension tubes have two cocking pins, but only one green alignment dot.

USING BRONICA ETR CLOSE-UP LENSES WITH THE 75mm LENS

Close-Up Lens	Diopter	Magnification Range
No. 1	+2	0.15—0.35
No. 2	+4	0.30—0.52
No. 1 + No. 2	+6	0.46—0.66

CLOSE-UP LENSES

The two screw-in close-up lenses for ETR lenses have a 58mm diameter thread, so they fit only the 75mm lens. Of course, you could use a 62mm to 58mm step-down ring with the other Bronica lenses. However, if you use close-up lenses with the 40mm or 50mm lenses, the image may vignette.

The accompanying table shows the magnification range you can get with close-up lenses individually or combined on the 75mm lens. See Chapter 2 for more information about close-up lenses.

AUTOMATIC EXTENSION TUBES

Three automatic extension tubes of 14mm, 28mm, and 42mm extension are available for Bronica lenses. You can only use one tube at a time. They can't be stacked. See Chapter 2 for formulas to calculate magnification when using extension tubes.

Like lenses, the tubes have mechanical linkages and a set of gold-plated contacts on the mounting rings. These contacts relay signals from the camera body to the lens, allowing electronic shutter control and automatic-diaphragm metering when the AE-II finder is used.

Mounting a Tube—Remove the lens from the camera. Its shutter will be cocked, and you can ascertain this by making sure its cocking pins align with the green dots on the back side of the lens. The extension tube must also be cocked to mount on the lens. To do this, revolve its cocking pins until one pin is aligned with a green dot.

Match the red dot on the lens with a red line on the mounting flange of the tube and turn the lens 30° counterclockwise with respect to the tube. This operation is just like mounting a lens on the camera. Then mount the lens and tube assembly onto the camera as you would mount a lens.

Removing a Tube—The camera and lens must be cocked before you can remove the lens and tube assembly from the camera. Turn the collar of the lens-release button and push the button in while turning the assembly clockwise. This is like removing a lens from the camera.

The tube becomes uncocked when removed from the camera. To remove the lens from the tube, you must recock the tube. Realign its cocking pin with the green dot. Then push the tube's lens release button while revolving the lens clockwise. If the tube isn't cocked, you can't push the button and remove the lens.

MAGNIFICATION RANGE WITH ETR EXTENSION TUBES AND LENSES			
	EXTENSION TUBE		
Lens	14mm	28mm	42mm
40mm	0.35—0.50	0.70—0.85	1.05—1.20
50mm	0.28—0.42	0.56—0.70	0.84—0.98
75mm	0.18—0.36	0.36—0.54	0.54—0.72
105mm	0.13—0.27	0.27—0.40	0.40—0.53
150mm	0.09—0.22	0.19—0.31	0.28—0.41
200mm	0.07—0.16	0.14—0.23	0.21—0.30
250mm	0.06—0.14	0.11—0.20	0.17—0.25

Remove the extension tube from the lens by pushing the tube's release button and revolving the lens.

AUTO BELLOWS ATTACHMENT-E

For adjustable extension from 55mm to 155mm, use Auto Bellows Attachment-E. Like the auto extension tubes, it has a set of gold-plated contacts and mechanical linkages to preserve the electronic and automatic features of the lenses.

Attaching the Bellows—Cocking pins of the camera, lens and bellows must be aligned with their green dots to mount the units. To cock the bellows, revolve its cocking pins on the rear standard until the pins align with the green dots.

Now you can attach the cocked camera to the rear standard of the bellows. Line up the red dot of the standard with the red line at the top of the mounting flange and revolve the bellows counterclockwise 30°. This is just like mounting a lens.

Mount the lens onto the front standard in the same way. If during mounting you accidentally depress the camera's shutter button, the mirror will swing up halfway and stop. Continue turning the lens until it clicks in place. If you have film in the camera, cover the lens with a lens cap or remove the film back. Then push the auxiliary pin that is behind the lens-removal button on the front standard. This will make the mirror swing up all the way and trip the shutter.

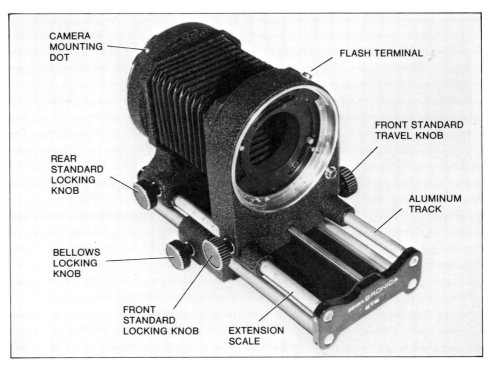

Pushing this pin releases a stuck mirror and operates the shutter in the lens.

To avoid wasting the unexposed frame in the film plane, flip the multiple-exposure lever to its horizontal position and wind the crank. The camera, lens, and bellows are now cocked and ready for exposure. Remember to flip the multiple-exposure lever back up after the first exposure of the frame.

Using the Bellows—The standards and the mounting base have both locking and travel knobs. The locking knobs on the right side must be loosened before you use the left-hand travel knobs. With these you advance the standards smoothly on the precision aluminum track. Because the mounting base also travels, you can balance the whole assembly on a tripod for steady, secure operation.

Find bellows extension (cm) from the scale by subtracting the smaller scale reading from the larger reading. In this example bellows extension is 8.0 - 1.0 = 7.0cm, or 70mm. Add this to 55mm to get total extension.

When the bellows is fully retracted, it has 55mm of extension. For the maximum extension of 155mm, you must extend the bellows 100mm. The scale is marked for this 100mm of extension.

The front edge of the standard indexes with 0 on a scale on the top right track. The rear edge of the front standard indexes with the amount of extension. The scale is marked in centimeters with divisions every 0.5cm.

Total extension is the *difference* between the two scale readings *plus* the 55mm of minimum extension. For example, if the front standard indexes at 8 and the rear standard indexes at 1, the adjustable extension is **8.0 - 1.0 = 7.0cm**, or 70mm.

Total extension, which is the value for X that you use in magnification formulas, is **70mm + 55mm = 125mm**. You can also measure this distance by measuring the distance between the mounting flanges of the camera and the front standard.

To use a flash with the bellows, you must plug the PC cord into the X-sync terminal on the front standard. The terminal on the camera or auxiliary winder will not operate if the bellows is attached. All other camera operations are normal.

The bellows can be used with other ETR accessories, such as extension tubes, interchangeable film backs, auxiliary winders, and the AE-II viewfinder for automatic exposure compensation. These accessories make close-up photography much easier. When using the winders, however, you must use the rear standard fully retracted so it indexes with 0 on the scale.

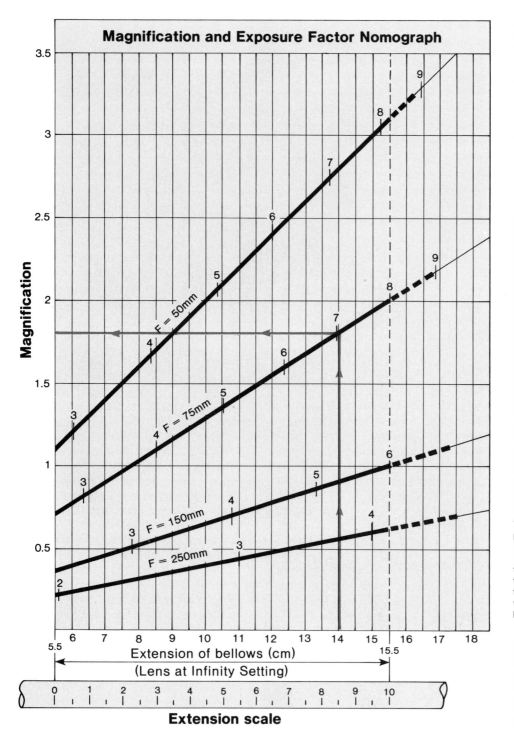

Magnification and Exposure Factor Nomograph

Magnification (vertical axis): 3.5, 3, 2.5, 2, 1.5, 1, 0.5

Curves labeled: F = 50mm, F = 75mm, F = 150mm, F = 250mm

Extension of bellows (cm) (Lens at Infinity Setting): 5.5, 6, 7, 8, 9, 10, 11, 12, 13, 14, 15, 15.5, 16, 17, 18

Extension scale: 0, 1, 2, 3, 4, 5, 6, 7, 8, 9, 10

Use this chart to quickly find magnification when using the lens at its infinity setting. The bottom scale is cm of *total* extension. Draw a vertical line up until it meets the bold black line corresponding to the lens you are using. Then draw a horizontal line to the left to intersect the magnificaton scale.

The numbers on the bold black line indicate the exposure correction factor at that magnification. The dashed part of the bold black line indicates the extra magnification created by using the lens focus travel. In this example, 14cm of extension with the 75mm lens set to infinity gives a magnification of 1.8 and an exposure correction factor of 7.

This yellow-tiger swallowtail butterfly was photographed at a magnification of 2 with the 75mm lens set to infinity and the bellows set for 155mm of total extension. Exposure compensation was three steps, so I entered a film speed three steps slower than actual film speed into the flash meter. Two Elinchrom 11 Mono Pro flashes were equidistant from the subject, giving even lighting.

Removing the Bellows—Remove the bellows and lens assembly from the camera as you would remove a lens. Wind the crank to cock the lens, bellows, and camera. Rotate the collar of the camera's lens-release lock and push it in. Then rotate the bellows and lens assembly 30° clockwise.

When you detach the camera from the bellows, its cocking pins release. Turn them so they realign with the green dots. Otherwise, you won't be able to remove the lens from the bellows.

To remove the lens from the bellows, push the lens-release button on the front standard while revolving the lens 30° clockwise. You can remove the lens from the bellows before detaching the bellows from the camera.

MAGNIFICATION RANGES WITH BRONICA ETR LENSES AND AUTO BELLOWS E

Lens*	Lens-To-Subject Distance+ inches	cm	Magnification Range •	Exposure Compensation (Steps)
40mm	1.0— 0.2	2.5— 0.6	1.38—3.88	1-1/2—3
50mm	1.9— 0.7	4.9— 1.9	1.1—3.1	1-1/2—3
75mm	5.6— 2.8	14.2— 7.1	0.7—2.0	1-1/2—3
150mm	21.7—11.3	55.1—28.7	0.4—1.0	1-1/3—2-2/3
250mm	57.4—28.6	145.9—72.6	0.2—0.6	1—2

* Lens set to infinity.
+ Measured from front lens surface to object.
• Bellows extension from 55mm to 155mm.

WINDERS

One reason you cannot usually handle medium-format cameras as quickly as 35mm SLRs is that manual winding cranks have a long stroke due to longer film travel. For example, the winding crank on the right side of the ETR cameras must move 360° before you can shoot the next frame. In addition, the cranks are usually less accessible than the winding lever on the top of a 35mm camera.

However, any problem this may create is solved by either of the accessory winders made for the cameras. One is manually operated and the other is a motorized film winder. Both have a shutter button on the grip. When you also use a pentaprism viewfinder, you can hold and handle the camera like a 35mm SLR.

SPEED GRIP

With this handy manual winder attached to the camera, your right hand holds the camera, winds film, and pushes the shutter button. As with a 35mm SLR, your left hand can focus, change shutter speed and support the camera during exposure.

Attaching the Grip—To attach the Speed Grip, first pull the pin that attaches the winding crank to the camera body. Pull it out as far as it goes—it's enlarged at the end so you can't remove it completely—and remove the winding crank. Push the pin back in all the way.

The Speed Grip is a handy accessory winder that makes camera handling much faster.

end of the grip's base springs up to lock it in place. Tighten the connection by sliding the locking lever on the bottom of the grip from O to C until it is snug.

Using the Grip—Now you can cock the camera and lens with two strokes of the ratcheted cocking lever on the Speed Grip handle. The first stroke moves the mirror, film and shutter

halfway. The shorter second stroke completes cocking and film winding.

When not winding the lever, your thumb rests in a contoured nook behind the hot shoe. Your right index finger will naturally be right in front of the grip's shutter button. Use the button to conveniently preview the AE-II metering viewfinder. The camera's shutter button can also be used to

To remove the camera's winding crank, pull out its retaining pin.

Slide the grip onto the camera by engaging the steel plate of the camera bottom in the grooves of the grip's base. Before sliding it in all the way, turn the winding linkage with the Speed Grip's cocking lever so the pin on the body's winder will slip into the groove of the linkage. Slide the grip on all the way. A small safety stop at the

When sliding the grip onto the camera, move the grip's winding linkage with the cocking lever so it will mate with the pin on the camera.

The locking lever on the bottom of the grip secures the assembly.

make an exposure when the grip is in place.

You can lock both shutter buttons with the Shutter Release Safety Lock. When you use a flash in the hot shoe of the Speed Grip, the flash terminal on the camera is inoperative, preventing the firing of two flashes by the camera.

MOTOR DRIVE E

This automatic film winder lets you shoot single or continuous frames with a maximum rate of one per second when you use a 1/500 second shutter speed. This is slower than motor drives available for 35mm systems because of the longer winding stroke necessitated by longer film travel.

Motor Drive E uses eight 1.5V AA batteries. To load batteries, first slide the main switch to **OFF**. Open the cover of the battery compartment by removing the cover screw. Insert the batteries into the chamber, making sure you observe battery polarity. Replace the cover.

Fresh batteries will wind 100 rolls of 120 film, or 1500 exposures. When the batteries have reduced power due to overuse or cold weather, the maximum firing rate is halved.

You can also use an external DC power source to run Motor Drive E. The source should supply a current of 4A at 12V DC. Its power cord plugs into an outlet in the back of the winder marked **EXT**. The plug and power supply are not available through Bronica, but your local electronics store probably has suitable units.

MOTOR DRIVE E SPECIFICATIONS

Type: Automatic film winder and shutter cocking unit for ETR cameras. Attaches to base and winding mechanism of camera.
Shooting Rate: Continuous operation up to one frame per second with the fastest camera shutter speed. Single exposures possible.
Shutter Speeds: Can be used with all camera speeds.
Operation: Activated by shutter button of winder or remote control switch. Film wound from start mark to first frame. After exposure, winder advances film and cocks shutter. Red LED on handle glows when winding and cocking completed. After roll is exposed, winder automatically winds up roll. Stop winding by turning power switch off.
Power Source: Eight AA alkaline, manganese, or nicad batteries fit into winder's base. Or, a 4A, 12V DC power source plugs into **EXT** outlet of winder.
Capacity: Approximately 100 rolls of 120 film with fresh alkaline batteries.
Other Features: Battery-check button and green LED light, remote-control outlet, hot shoe, handle for easy camera handling, tripod socket.
Dimensions: Width 165mm (6.5"), height 149mm (5.9"), depth 70mm (2.8").
Weight: 910g (32 oz.) without batteries.

For test operation 1, turn the winding linkage to align the red dots.

For test operation 3, depress the reset lever if the shutter release pin doesn't operate when you push the shutter button.

Test Operations—Before attaching the winder to the camera, perform the following operations to make sure the unit is working properly:

1) Turn the winding linkage counterclockwise with your fingers until the two red dots match. When they do, you'll hear and feel a distinct click.

2) With the main switch still set to **OFF**, press the small black Drive Button on the top of the grip. In this case, the button serves as the winder battery-check button. If the green LED glows, the batteries are good. If it doesn't, replace the batteries.

3) Slide the main switch to **ON**. Press the winder's shutter button. The red LED on the top of the handle should glow for an instant while the

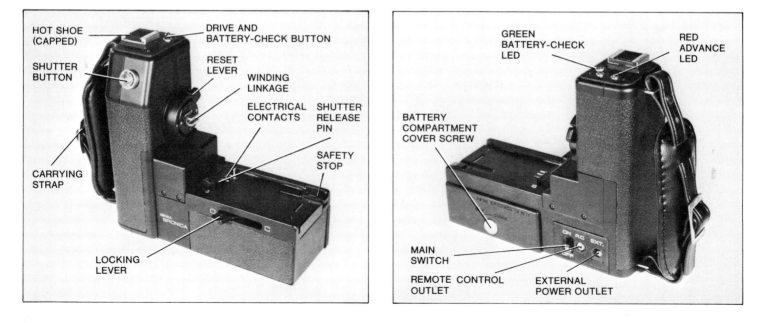

small release pin next to the winder's electrical contacts springs out then retracts. If the pin doesn't do this, depress the reset lever all the way down. Press the shutter button again.

4) Press the Drive Button to make the winder's linkage revolve. Release the button and turn the winder off. Reposition the winding linkage by turning it counterclockwise until the red dots match.

Before attaching the camera to the winder and loading film, make sure the camera has enough battery power. If it doesn't, replace its battery. Next, cock the camera and remove its manual winding crank as described.

Turn the camera's winding linkage counterclockwise until the pin is nearest the base of the camera. This aligns it with the winder's linkage so they'll couple when the camera is attached. Make sure there is no forward play in the camera's winding linkage.

Attaching Motor Drive E—Slide the camera onto the winder until you hear the safety stop spring up to hold the camera in place. Then slide the locking lever from O to C until it is snug.

When the camera is connected, three metal prongs on the winder relay signals from the camera to winder and back again. This is how the camera signals the winder that exposure is finished. Then the winder advances film, cocks the shutter and lowers the mirror in place. The small release pin next to the prong springs out when the winder's shutter button is pushed. It pushes a small plate in the camera that trips the shutter.

After connecting the camera to the winder, turn the main switch to ON. Make sure the lens time-exposure lever is set to A. Flip the multiple-exposure lever down to expose the red dot, and if you are using an ETR-S, remove the dark slide. Set the camera shutter speed dial for a one-second exposure and perform the following checking operations:

1) Depress the shutter release button. The red LED should glow for an instant before you hear the shutter close. If you hold your finger on the shutter button continuously, the shutter will open immediately after winding is completed. The LED *should not* remain glowing during this check.

2) Push the drive button. The camera should already be cocked by the first operation, so the winding linkage will not move. The red LED will go on. This indicates that the camera is ready for the next exposure.

3) Set the multiple-exposure lever back to its vertical position and depress the drive button again. The winding linkage revolves once to cock the camera. The red LED goes on to indicate the winder and camera are ready for exposure.

Using Motor Drive E—Load film as described. If you are using an ETR-S, you can either align the film's start mark with the insert's, or attach the back with the first frame already in position.

Put the camera multiple-exposure lever in the vertical position and turn the Motor Drive main switch to ON. Depress the drive button. It turns the winding linkage continuously until frame 1 is in position. Then the red LED turns on to indicate ready for exposure. It stays on until you make the first exposure or turn the main switch to OFF.

To make an exposure, push the Motor Drive shutter button. The red LED blinks once when the shutter opens. As soon as the shutter closes, the camera signals the motor and it automatically winds the film. If your finger remains on the button, camera and meter work continuously.

After you expose the last frame on the roll, pushing the shutter button does nothing but make the red LED blink once. Check the frame counter, and if the last frame has been exposed, push the drive button. This actuates continuous winding of the film. After three revolutions of the linkage, the roll will be wound up but the winder will not turn itself off. Turn the main switch to OFF to prevent excess battery consumption. Remove the film from the camera.

More Considerations—Here are some more operating instructions for the Motor Drive E.

When you install a camera on a winder, make sure the red dots on the winder's linkage are aligned. If they aren't, you must push the drive button after every exposure to finish the winding. To insure correct positioning before mounting the winder, turn its linkage clockwise past the red dot, then back clockwise until it stops.

When you install an uncocked camera on the winder, push the drive button to cock the camera and make the red LED glow continuously. If you

don't wind the camera this way, pushing the shutter button only trips the release pin.

If the dark slide of the ETR-S is in the back and you push the shutter button, you'll trip the release pin, make the red LED blink once, but get no exposure or film advance. Push down the reset lever, remove the dark slide and push the shutter button again to make an exposure and wind the film.

Pushing the camera shutter button or using a cable release will operate the camera and Motor Drive for single exposures only. If you depress the camera shutter button too long, the winder stops winding. Push the drive button again to wind the camera and make the red LED glow. Bronica recommends that you don't use the camera shutter button with Motor Drive E.

The Motor Drive E and the AE-II finder operating automatically are useful when you shoot action scenes.

14

Bronica SQ

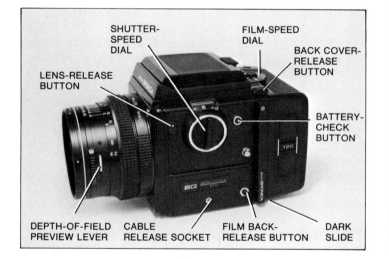

SHUTTER-SPEED DIAL
FILM-SPEED DIAL
BACK COVER-RELEASE BUTTON
LENS-RELEASE BUTTON
BATTERY-CHECK BUTTON
DEPTH-OF-FIELD PREVIEW LEVER
CABLE RELEASE SOCKET
FILM BACK-RELEASE BUTTON
DARK SLIDE

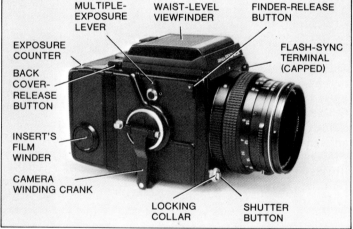

MULTIPLE-EXPOSURE LEVER
WAIST-LEVEL VIEWFINDER
FINDER-RELEASE BUTTON
EXPOSURE COUNTER
BACK COVER-RELEASE BUTTON
FLASH-SYNC TERMINAL (CAPPED)
INSERT'S FILM WINDER
CAMERA WINDING CRANK
LOCKING COLLAR
SHUTTER BUTTON

Another single-lens reflex medium-format camera made by Zenza Bronica is the SQ, introduced in early 1981. The basic format of the SQ (square) camera is 6x6 cm, with actual image dimensions of about 56x56 mm. With an image this size, you get 12 or 24 exposures on 120 or 220 film.

The standard lens for the SQ is a Zenzanon-S 80mm, f-2.8 lens with a built-in leaf-shutter. The growing SQ system includes interchangeable leaf-shutter lenses, film backs, focusing screens, viewfinders, and an assortment of automatic equipment for close-up photography.

The SQ is not the first 6x6 cm SLR made by Zenza Bronica. It replaces the Bronica EC-TL, which, like the SQ and the Bronica ETR system, also used an electronically regulated shutter and had many interchangeable accessories. However, the EC-TL had a focal-plane shutter and was larger and heavier than the SQ.

The design of the SQ is based on the successful Bronica ETR system, also described in this book. These two systems have many operating features in common, such as film loading, time-exposure operation, and use of extension tubes and bellows. Except for some minor differences due to their different sizes, SQ and ETR cameras look and handle similarly. However, the accessories of one system *are not* compatible with the other.

BRONICA SQ CAMERA SPECIFICATIONS

Type: 6x6 cm single-lens reflex with waist-level viewing and non-instant-return mirror.
Shutter: Electronically controlled #0 Seiko leaf shutter in each lens with camera-controlled shutter speeds from 1/500 to 8 seconds, including T. X sync at all shutter speeds.
Standard Lens: Zenzanon-S 80mm f-2.8 lens.
Film: 12 or 24 exposures with interchangeable 120 or 220 SQ film backs. Polaroid back accepting 80-series and 100/600-series Polaroid pack film also available.
Power Source: 6V silver-oxide battery (Eveready No. 544 or equivalent).
Other Features: Interchangeable lenses, viewfinders, and focusing screens. Multiple-exposure lever, safety interlocks, battery check.
Dimensions: Width 92mm (3.6"), height 109mm (4.3)', depth 179mm (7.0").
Weight: 1.5kg (3.3 lbs.).

LENSES OF THE SQ SYSTEM

Lenses made by Bronica for the SQ cameras are called *Zenzanon-S* lenses. Each is a multicoated, automatic-aperture lens with a built-in #0 Seiko leaf shutter. The shutter is electronically controlled by the camera body for speeds from 1/500 to 8 seconds, plus T. The accompanying table shows the main features of the system's lenses.

MOUNTING THE LENS

Each lens has a Bronica four-lug bayonet mount. When you mount a lens, six gold-plated pins on the rear of the lens meet six gold-plated contacts inside the camera body. These transfer signals between camera and lens. Mechanical linkages and springs in the lens actually cock and drive the leaf shutter.

Because of an interlock between the camera body and lens, you can mount the lens only when it and the camera body are cocked. To cock the camera body, turn the winding crank 360° clockwise or use a series of ratcheted turns until it stops. This lowers the mirror in place in front of the film frame, advances film, and aligns the green dot of the body's cocking pin with a green dot near the mounting flange.

To cock the lens, turn the cocking pins on the bottom of the lens counterclockwise to the green dots. The pins spring back between red bands and the green dots.

To mount the cocked lens, match the orange dot on the outside of the

BRONICA SQ LENSES							
Lens	Minimum Aperture	Diag. Angle of View	Minimum Focus Distance ft.	m	Weight oz.	g	Filter Size (mm)
40mm f-4	f-22	88°	1.3	0.4	22	620	82
50mm f-3.5	f-22	75°	1.6	0.5	20	560	67
80mm f-2.8	f-22	52°	2.6	0.8	17	470	67
105mm f-3.5	f-22	41°	2.8	0.9	19	550	67
150mm f-3.5	f-22	30°	4.9	1.5	21	590	67
200mm f-4.5	f-32	22°	6.5	2.0	24	685	67
250mm f-5.6	f-32	18°	9.8	3.0	29	815	67
500mm f-8	f-45	9°	28.0	8.5	65	1850	95

lens with the orange dot at the top of the camera body's mounting flange. Turn the lens about 30° counterclockwise until it clicks in place. No aperture indexing is necessary.

As with mounting, you can't remove a lens unless both the camera and lens are cocked. This is because SQ cameras do not have an instant-return mirror. After exposure, the mirror remains up against the focusing screen. The lens shutter remains closed. If you could remove the lens at this time, you would fog film. The interlock mechanism is designed to prevent this.

Advance film and cock the shutter with a 360° turn of the winding crank. This lowers the mirror and light baffle. Depress the Lens-Release Button while turning the lens about 30° clockwise. Remove the lens from the camera.

You cannot mount or remove a lens incorrectly. If both the camera and lens are not cocked, the lens does not couple with the mounting flange when you try to mount it. If the camera is not wound before you try to remove the lens, you can't depress the lens-release button.

TELECONVERTER S 2X

The Teleconverter S 2X effectively doubles the focal length of the lens used with it. It is recommended for use with all lenses from 40mm to 500mm. Because the S 2X increases the effective focal length of the lens, using it requires exposure compensation of two steps. All automatic features of the lens are preserved.

Mounting the Teleconverter—The teleconverter fits between camera and lens. Remove the cocked lens from the camera as described. Cock the teleconverter by revolving its cocking pins until they are aligned with the green dots.

Match the orange dot on the lens with an orange line on the mounting flange of the teleconverter and turn the lens counterclockwise with respect to the teleconverter. This is just like mounting a lens on the camera. Then mount the assembly onto the cocked camera as you would mount a lens.

FILTERS AND LENS ATTACHMENTS

Lenses of the SQ system accept screw-in filters and lens attachments. Bronica makes 67mm and 82mm

To cock an SQ lens before mounting, align the lens cocking pin between the red band and green dot near the mounting flange. Do this by moving the pin counterclockwise.

Mount the lens by aligning the mounting dots and turning the lens 30° counterclockwise.

You must cock the camera before removing the lens. Then depress the lens-release button and turn the lens clockwise about 30°.

screw-in skylight 1B filters only. Accessory manufacturers offer many other filters. Most camera stores carry a wide selection.

Professional Lens Hood-S—This is an extremely versatile lens attachment for use with all Zenzanon-S lenses from 50mm to 250mm. It attaches with a tightening collar that slips over an adapter you screw into the lens. The standard adapter has 67mm diameter threads. Screw-in adapters with 49mm, 52mm, and 55mm diameter threads are also available so you can use the hood with other brands of cameras and lenses.

The hood is an adjustable bellows lens shade. The rail is marked with focal lengths of the Zenzanon-S lenses you can use with it. Align the front of the bellows with the focal length of the lens in use. In addition, you can insert 75mm (3-inch) square gel filters or special-effect masks into a slot in the front of the hood.

Focusing Handle—Attach this accessory over the lens focusing ring and tighten the set screw. The handle lets you focus quickly and accurately for fast-breaking action. It fits all lenses from 50mm to 250mm.

THE BATTERY

The camera uses a 6V silver-oxide Eveready No. 544 battery or equivalent to power the electronic shutter-timing circuit and supply power for the accessory metering viewfinders. According to Bronica, if you never use a metering viewfinder, the battery has enough power for about a year's use. If you use a metering viewfinder all of the time, the battery lasts between 6 and 12 months. The camera does not use battery power for 1/500-second exposures or time exposures.

A battery-check button is on the camera's left side behind the shutter-

No viewfinder is on the camera in this photo. You can see the red battery-check light above the focusing screen.

speed dial. When you push it, a check light glows red if there is sufficient battery power. The check light is visible above the focusing screen.

Dead Battery—When the battery is dead or installed incorrectly, the check light will not glow when you push the battery-check button. You can still change aperture, cock the shutter, and advance film because these are mechanical operations, but the shutter-timing circuit does not function. In this case, the shutter will give a 1/500 second exposure when you push the shutter button, no matter where you set the shutter-speed dial.

Changing the Battery—To remove the dead battery from the camera, slide the plastic cover off the camera bottom after pushing the cover's button. Remove the dead battery and replace it with a fresh one.

Remote Battery Pack—In weather colder than about 32°F (0°C), the battery has reduced power and capacity. For maximum battery power in cold weather, use the Remote Battery Pack to keep the battery warm. The camera battery slips into a battery compartment of the remote pack. Put this into a warm coat pocket. The battery compartment has a long cord leading to a dummy battery that fits into the camera battery compartment.

INTERCHANGEABLE FILM BACKS

Interchangeable roll film backs for the SQ accept 120 or 220 roll film for 12 or 24 6x6 cm exposures, respectively. A back for Polaroid pack films is also available. See Chapter 4 for a list of emulsions you can use with these backs.

A unique feature of SQ roll-film backs is a built-in Film-Speed Dial that couples with a metering finder. After loading film, you set film speed with the dial at the top of the back. When you use one of the metering viewfinders, the dial automatically sets the finder for the correct film speed. This feature is very useful if you use more than one back and films having different speeds. It minimizes possible exposure errors due to improper meter setting.

Detaching an SQ Film Back—Because SQ film backs have a dark slide and exposure counter, you can change them in the middle of a roll without wasting film. This is handy if you want to shoot a scene with

different kinds of film or use Polaroid film to check exposure.

Before you remove the film back, insert the dark slide into a slot on the left side of the back. Insert the dark slide so a large dot on its handle is next to an identical dot on the film back. You can't put it in all the way if it is upside down.

Next, push the small film back-release button on the bottom left side of the SQ body and swing the film back up and off. The dark slide blocks exposure to the film when the back is removed.

The film back-release button is on the camera body next to the dark slide.

The camera body and film back couple in such a way that you can remove and attach the film back whether the camera is cocked or not, and whether an exposed or unexposed frame is in the film plane.

Attaching an SQ Film Back—To attach a film back to the SQ, slide the hinge pins on the top of the back into the slots on the camera body. Swing the back down until it clicks in place.

Remove the dark slide and put it in a pocket where it won't get bent. There is no place to store it on the camera body. You can attach the back to the camera without the dark slide in place, but of course this will fog film.

It is good practice to leave the dark slide in the film back whenever it is detached from the camera body.

After attaching the film back and removing the dark slide, wind the crank. If the camera and lens are already cocked, the crank turns easily.

If an unexposed frame is in place, film will not advance as you wind the crank. If the camera and lens are not cocked, turning the winding crank will cock them.

Film will advance only if the frame in the film gate is exposed, and the frame counter advances only when film does.

Therefore, if you always wind the crank after attaching a back, the camera and lens are always cocked and an unexposed frame is always in position. You *cannot* waste film or lose track of the number of exposed frames on the roll when changing backs.

LOADING 120 AND 220 FILM

A preloadable insert for 120 or 220 film is part of the 120 or 220 film backs you use with the Bronica SQ. These film inserts contain the exposure-counting mechanism.

The back cover-release buttons are on the top of the detachable back. To open the back cover, slide the two buttons toward each other. The back cover opens from the top and swings down. Remove the insert. This operation does not depend on the position of the dark slide.

To open the back, slide the two back cover-release buttons toward each other and swing the top of the back down.

The unexposed roll of film goes into the top chamber of the insert. Remove the empty spool from this chamber by pushing the spool toward the hinged spool retainers. When the retainer opens, pull it all the way down with a fingernail. Open the bottom retainer, insert the empty spool, and close the retainer.

When you unroll the paper leader and pull it across the pressure plate, the black side should face out. Insert the tapered end into the empty spool. Turn the insert's film winder counterclockwise until the arrow on the paper leader aligns with a small red triangle on the top left spool retainer.

Put the loaded insert back into the camera or film back so the unexposed roll is on top. Close the back cover. Advance the film to frame 1 with the

camera's winding crank. The crank automatically stops when a 1 shows in the exposure-counter window on the top right side of the back.

If you are loading 120 or 220 film backs ahead of time, you can put the first frame in position for exposure without attaching the back to the camera. Put the loaded insert into the detached film back. After closing the cover and making sure the dark slide is in place, use the insert's winding key to advance the counter to frame 1. The key automatically disengages when 1 shows in the exposure counter. These operations are the same as with the Bronica ETR. See page 168.

After closing the back, set the film-speed dial. It has detents for film speeds from ASA 25 to 3200 in one-third step increments. Set film speed by lifting the dial slightly while turning it. Set the speed across from the white index mark. The dial rotates in both directions.

After loading film, set the film-speed dial on the back. Lift the dial and turn it until the correct film speed is aligned with the white index.

Loading Film Incorrectly—Because rolls of 120 and 220 film are constructed differently, as described in Chapter 4, you should not load 120 film into a 220 insert or vice-versa. The pressure plates and film counters are set differently.

The pressure plate of the 120 insert is slightly farther away from the film plane than the plate of the 220 insert. This compensates for the continuous paper backing in 120 rolls.

If you load 220 film in the 120 insert, the film will not be held as flat in the film plane as it should be. This contributes to a slightly unfocused image, although small apertures may compensate for this somewhat.

If you load 120 film in the 220 insert, the thickness of the paper leader causes winding drag.

Using the Polaroid Back—This metal back contains parts made by Bronica and Polaroid. You load and use it like any medium-format Polaroid back, as described in Chapter 4. It accepts *either* 100/600-series or 80-series Polaroid film.

As with the other SQ film backs, the Polaroid back has a dark slide. It is on the accessory's right side. You do not have to pull the dark slide all the way out of the back to expose film, although you can if you want to because the back has a light-tight felt trap. You can see a small engraved triangle on both sides of the dark slide when you pull the slide out far enough to completely expose film.

Because the dark slide is on the right side, there is no exposure interlock between the camera body and back. To cock the camera, engage the multiple-exposure mechanism of the camera by flipping the small lever above the winding crank down to expose a red dot. It is also possible to operate the camera with the dark slide in front of the film frame. Of course, no exposure will reach the film and it will develop black. In addition, you can remove the back whether the dark slide is in front of the film or not.

CAMERA OPERATION

After you load the SQ, unfold the winding crank and wind it until it stops. The first frame is in position to expose film.

Exposure Controls—The camera does not have a built-in meter, so you should use an accessory meter with any viewfinder other than the metering viewfinders described later. After metering, set the *f*-stop with the aperture ring on the lens. It has detents every step.

Set shutter speed by turning the shutter-speed knob on the left side of the camera body. The chosen shutter speed is displayed through a window above the dial. You can also see the next faster and slower speeds on either side of it. Shutter speeds from 1/500 to 1/2 second are color coded in white, and speeds from 1 to 8 seconds are in orange. In-between shutter speeds are not possible when you set shutter speed manually.

Viewing and Handling—Bronica does not supply a viewfinder with the camera. You can choose among three interchangeable viewfinders described later.

Focus the lens with its large knurled ring. Preview depth of field by depressing a lever on the left side of the lens near the aperture ring. The lever springs back as soon as you release it. It can't be locked for stopped-down metering.

The camera shutter button is on the front of the camera on the lower right side. The easiest way to hold the camera for both eye- and waist-level viewing is to cradle it in your left hand with your left index finger on the shutter button. This frees the right hand for focusing, winding the crank, and turning the shutter-speed dial. This last operation is a bit awkward because the dial is on the left side.

Exposing Film—When you push the shutter button, the leaf shutter closes, the diaphragm stops down, and the mirror and light baffle swing up. The shutter opens and closes for the chosen exposure time, then a red LED blinks on and off once in the blacked-out viewing area. This LED is the same light as the battery-check light. It signals you that the exposure is finished and winding is possible.

Because the leaf shutter is very quiet, you can't always hear it operate, especially with slow shutter speeds. As soon as you see the LED glow, you can wind the crank 360° to move the mirror back down, cock the shutter, and advance film. *Do not* wind the camera before the LED indicates exposure is complete. If you do, the mirror drops down in place and effectively ends exposure. In addition, the next exposure will be exposed automatically at 1/500 second, no matter where you set the shutter-speed dial.

When the whole roll is exposed, tension in the winding crank lessens noticeably and the frame counter shows an orange line. After the last exposure, continue winding the crank for about four revolutions to completely wind up the film.

Multiple Exposures—For multiple exposures, flip down the small lever above the winding crank to expose a red dot. Do this *after* the first exposure. This retracts the camera's winding gear from the film back and prevents the film from moving. It also keeps the exposure counter from advancing when you wind the crank.

To end multiple exposures, flip the lever back up after the last exposure. The next wind of the crank advances film and cocks the shutter.

Using the Camera Without Film—Normally, you cannot cock the camera or trip the shutter without film in the camera. The only way to operate the camera without film loaded is to use the multiple-exposure mechanism.

Flip the lever down to expose the red dot. Now you can cock the shutter and use the shutter button to trip it. All camera functions work as described, except for the frame counter. I recommend you familiarize yourself with camera operation this way before shooting film for the first time.

Long Exposures—The camera electronically controls long shutter speeds from 1 to 8 seconds. These speeds are marked in red on the shutter-speed dial. If you want an exposure time longer than 8 seconds or if you want to save battery power during a long exposure, use the time-exposure lever on the underside of the lens next to the aperture ring. See page 171.

For normal camera operation, the lever is screwed down and shows an orange A. To make a time exposure, loosen the small set screw until its head is above the lever. You *do not* need to remove the screw from the lens. Slide the lever so it covers the orange A and exposes a red T.

The camera shutter-speed dial can be set anywhere. If you are using the aperture-preferred metering viewfinder, turn off its meter before exposure to save battery power. The T setting will override the shutter speed the meter indicates in its exposure display. When you push the shutter button, the mirror swings up and the shutter stays open without using battery power.

To close the shutter, slide the lever so it covers the red T and again shows the orange A. Even if the camera is on a tripod, this may shake the camera a bit. I recommend that you cover the lens with a lens cap or black card to end exposure, then slide the lever to close the shutter. When finished with the time exposure, screw down the set screw to avoid accidentally sliding the switch back to T. The camera does not have a self-timer or mirror-lockup device.

Shutter Release Safety Lock—The collar of the shutter button is a dial that locks the shutter. When the red dot on the collar is on the bottom, you can use the shutter button or a cable release to trip the shutter. If you revolve the collar 60° clockwise, you

lock the shutter button and cable release socket.

USING FLASH

The SQ camera has an X-sync terminal on the right side of the camera. Because Zenzanon-S lenses have a leaf shutter, they provide flash sync at all shutter speeds. F- and M-type bulbs will also synchronize with the lenses, but with a smaller range of shutter speeds. This is shown in the table on page 172.

Do not wind the camera before an exposure is completed. If you are using flash and end a long exposure by winding the crank, the flash won't fire for the next exposure.

INTECHANGEABLE VIEWFINDERS

Three interchangeable viewfinders are available for the SQ camera. Attaching and removing a viewfinder is fast and easy. To remove, depress the small black button on the right side of the camera body. Slide the viewfinder back about 1/4 inch (6mm) and lift it off.

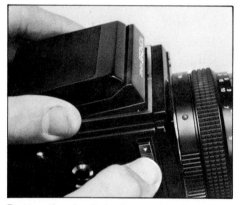

Remove the viewfinder by pushing the release button and sliding the finder back. Attach a finder by inserting the back first, then sliding the finder forward.

To attach a viewfinder, insert the four tabs on the bottom of the viewfinder into the slots of the finder frame. Then slide it forward until it clicks in place.

Waist-Level Finder—To open this lightweight viewfinder, pull up on its sides. It springs open and shows a laterally-reversed image on the focusing screen, which is 94% of the image area.

You can also use the viewfinder against your eye when you flip up the 1.25X magnifier. To do this, slide the small black button on the viewfinder in the direction of the arrow. The -1.5

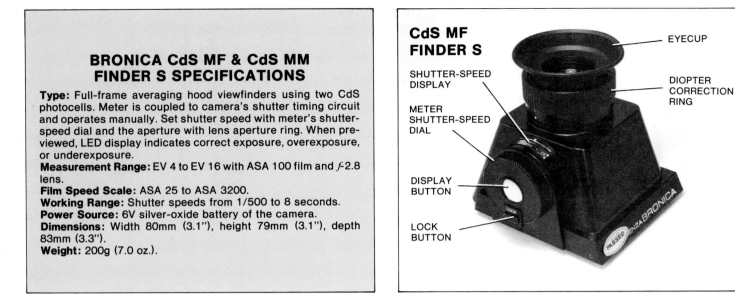

BRONICA CdS MF & CdS MM FINDER S SPECIFICATIONS

Type: Full-frame averaging hood viewfinders using two CdS photocells. Meter is coupled to camera's shutter timing circuit and operates manually. Set shutter speed with meter's shutter-speed dial and the aperture with lens aperture ring. When previewed, LED display indicates correct exposure, overexposure, or underexposure.
Measurement Range: EV 4 to EV 16 with ASA 100 film and f-2.8 lens.
Film Speed Scale: ASA 25 to ASA 3200.
Working Range: Shutter speeds from 1/500 to 8 seconds.
Power Source: 6V silver-oxide battery of the camera.
Dimensions: Width 80mm (3.1"), height 79mm (3.1"), depth 83mm (3.3").
Weight: 200g (7.0 oz.).

CdS MF FINDER S

- EYECUP
- SHUTTER-SPEED DISPLAY
- DIOPTER CORRECTION RING
- METER SHUTTER-SPEED DIAL
- DISPLAY BUTTON
- LOCK BUTTON

diopter eyepiece unscrews so you can substitute another magnifier more suited to your eyesight if necessary. They are available in diopters of +1.5, +0.5, -0.5, -2.5, -3.5, and -4.5.

CdS MF Finder S—This metering viewfinder operates manually and shows the full focusing-screen image upright and laterally reversed. The meter uses two CdS photocells for a full-frame averaging pattern. It has a sensitivity range of EV 4 to EV 16 at ASA 100 with an f-2.8 lens. It shows 94% of the 6x6 cm image. The eyepiece has built-in diopter correction from +2 to -3 diopters.

Power for the MF Finder S comes from the camera battery through gold-plated contacts above the focusing screen. These contacts are also used to send exposure signals from the viewfinder to the camera and vice-versa. No aperture indexing is necessary when you change lenses because the lens automatically tells the meter its aperture range through these contacts. In addition, contacts at the rear of the finder meet contacts of the roll-film back, which set the meter for the speed of the film in the back.

When the finder is attached to the camera, the shutter timing circuit is automatically disconnected. The shutter-speed dial of the camera can be set anywhere. The finder shutter-speed dial controls shutter speed.

Before previewing the LED exposure display, slide up the Lock Button on the finder shutter-speed dial. This releases the Display Button, which is in the center of the dial. When you push the button, you see an LED

indicator at the left side of the screen. The display stays lit for 30 seconds, then turns off to save power.

The MF Finder operates manually. If the LED in view is a green circle, exposure is correct. If the LED is a red +, the settings will give overexposure. A red - indicates underexposure. Adjust lens aperture or the finder's shutter-speed dial to light the green LED. When adjusting aperture or shutter speed, you must set the dials to detents for reliable metering. Detents on the aperture ring are in one-step increments; on the finder shutter-speed dial they are half-step increments.

The meter is designed to work at the full aperture of the lens. You should not depress the depth-of-field lever during exposure when the meter is operating. If you do, the meter recommends settings that will overexpose the film.

The red battery-check LED glows for the exposure duration when a metering finder is attached to the camera.

CdS MM Finder S—This eye-level prism viewfinder has essentially the same controls and operating features as the MF Finder S. Meter with it as you would with the MF Finder S. One difference, however, is the eyepiece. The eyepiece of the MM Finder can be moved from eye-level viewing—looking in the same direction as the lens points—to diagonal viewing at an angle of about 45° to the lens axis.

FOCUSING SCREENS

Five plastic interchangeable focusing screens are in the SQ system. To

change screens, remove the viewfinder from the camera. Then slide the screen locking levers at the right and left sides toward the back of the camera. Remove the screen with a pair of tweezers by lifting on the tab at the rear of the screen.

To install a screen, lower the front of the screen first and seat the screen's tab in the slot on the camera body. Slide the locking levers toward the front of the camera to secure the screen. Replace the viewfinder.

After sliding the screen locking levers back, lift out the screen with a pair of tweezers.

CLOSE-UP LENSES

The two screw-in close-up lenses for SQ lenses use a 67mm diameter thread. They fit Zenzanon-S lenses from 50mm to 250mm. They have focal lengths of 250mm and 500mm. See Chapter 2 for more information about close-up lenses.

AUTOMATIC EXTENSION TUBES

Two automatic extension tubes of 18mm and 36mm extension are available for Zenzanon-S lenses. You can

MAGNIFICATION RANGES WITH BRONICA SQ LENSES AND EXTENSION TUBES		
EXTENSION TUBE		
Lens	18mm	36mm
40mm	0.45—0.55	0.90—1.00
50mm	0.36—0.48	0.72—0.84
80mm	0.23—0.34	0.45—0.56
105mm	0.17—0.30	0.34—0.48
150mm	0.12—0.23	0.24—0.35
200mm	0.09—0.20	0.18—0.29
250mm	0.07—0.16	0.14—0.23
500mm	0.04—0.10	0.07—0.13

MAGNIFICATION RANGES WITH BRONICA SQ LENSES AND AUTO BELLOWS S		
Lens*	Magnification Range+	Exposure Compensation (Steps)
50mm	1.10—3.10	1-1/2—3
80mm	0.69—1.94	1-1/2—3
105mm	0.52—1.48	1-1/3—3
150mm	0.37—1.03	1-1/3—2-2/3
200mm	0.28—0.78	1—2

* Lens set to infinity.
+ Bellows extension from 55mm to 155mm.

use only one tube at a time. They can't be stacked. See Chapter 2 for formulas to calculate magnification when using extension tubes.

Like lenses, the tubes have mechanical linkages and a set of gold-plated contacts on the mounting rings. These contacts relay signals from the camera body to the lens, allowing electronic shutter control and through-the-lens metering when a metering finder is used.

Mounting a Tube—Remove the lens from the camera. Its shutter will be cocked. The extension tube must also be cocked to mount on the lens. To do this, revolve its cocking pins until one pin is aligned with a green dot.

Match the red dot on the lens with a red line on the mounting flange of the tube and turn the lens 30° coun-terclockwise with respect to the tube. This operation is just like mounting a lens on the camera. Then mount the lens and tube assembly onto the camera as you would mount a lens on the camera. See page 176.

Removing a Tube—The camera and lens must be cocked before you can remove the lens and tube assembly from the camera. Turn the collar of the lens-release button and push the button in while turning the assembly clockwise. This is like removing a lens from the camera.

The tube becomes uncocked when removed from the camera. To remove the lens from the tube, you must recock the tube. Realign its cocking pin with the dot. Then push the tube's lens-release button while revolving the lens clockwise. If the tube isn't

cocked, you can't push the button and remove the lens.

AUTO BELLOWS ATTACHMENT-S

For adjustable extension from 55mm to 155mm, use Auto Bellows Attachment-S. Like the auto extension tubes, it has a set of gold-plated contacts and mechanical linkages to preserve the electronic and automatic features of the lenses. It is like the bellows of the ETR system shown on pages 177 and 178.

Attaching the Bellows—Cocking pins of the camera, lens and bellows must be aligned with their green dots to mount the units. To cock the bellows, revolve its cocking pins on the rear standard until the pins align with the green dots. Now you can attach the cocked camera to the rear standard of the bellows. Line up the red dot of the standard with the red line at the top of the mounting flange and revolve the bellows counterclockwise 30°. This is just like mounting a lens.

Mount the lens onto the front stan-dard in the same way. If during

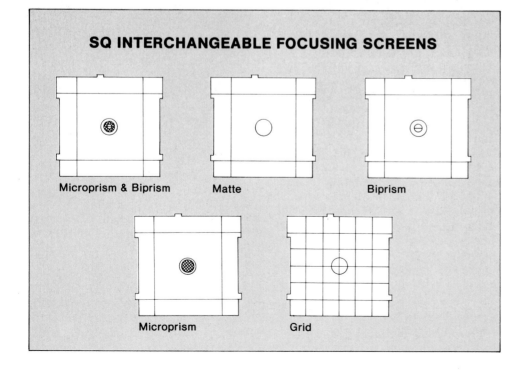

SQ INTERCHANGEABLE FOCUSING SCREENS

Microprism & Biprism

Matte

Biprism

Microprism

Grid

Turn the cocking pins on the rear standard to cock the bellows.

Pushing this pin releases a stuck mirror and operates the shutter in the lens.

Find bellows extension (cm) from the scale by subtracting the smaller scale reading from the larger reading. In this photo, bellows extension is 8.0 - 1.0 = 7.0cm, or 70mm. Add this to 55mm to get total extension of 125mm.

mounting you accidentally depress the camera's shutter button, the mirror will swing up halfway and stop. Continue turning the lens until it clicks in place. If you have film in the camera, cover the lens with a lens cap or remove the film back. Then push the auxiliary pin that is behind the lens-removal button on the front standard. This will make the mirror swing up all the way and trip the shutter.

To avoid wasting the unexposed frame in the film plane, flip the multiple-exposure lever to its horizontal position and wind the crank. The camera, lens, and bellows are now cocked and ready for exposure. Flip the multiple-exposure lever back up after the first exposure.

Using the Bellows—The standards and the mounting base have both locking and travel knobs. The locking knobs on the right side must be loosened before you use the travel knobs on the left. With these you advance the standards smoothly on the precision aluminum track. Because the mounting base also travels, you can balance the whole assembly on a tripod for steady, secure operation.

When the bellows is fully retracted, it has 55mm of extension. Maximum extension is 155mm. The scale is marked for 100mm of extension. When the rear standard and camera are retracted completely, the front edge of the standard indexes with 0 on a scale on the top right track. The rear edge of the front standard indexes with the amount of extension. The scale is marked in centimeters with divisions every 0.5cm.

Total extension is the *difference* between the two scale readings *plus* the 55mm of minimum extension. You can also measure this distance by measuring between the silver mounting flanges of the camera and the front standard.

To use a flash with the bellows, you must plug the PC cord into the X-sync terminal on the front standard. The terminal on the camera will not fire if the bellows is attached. Other camera operations are normal.

The bellows can be used with other SQ accessories, such as extension tubes, interchangeable film backs, and the metering viewfinders for automatic exposure compensation.

Removing the Bellows—Remove the bellows and lens assembly from the camera as you would remove a lens from the camera. When you detach the camera from the bellows, its cocking pins release. Turn them so they realign with the green dots. Otherwise, you won't be able to remove the lens from the bellows.

To remove the lens from the bellows, push the lens-release button on the front standard while revolving the lens 30° clockwise. You can also remove the lens from the bellows before detaching the bellows from the camera.

This grasshopper was photographed with a magnification of 2X on film. Setting up the bellows was easy after magnification was decided. Use the formula X = M x F to get total extension. Then subtract 55mm from X to find bellows extension. For more information, see Chapter 2.

Index

THANKS

Making this book would have been impractical, if not impossible, without the kind and generous assistance of the following people. They loaned me equipment, answered my many questions, and read the manuscript.

Bob Wells, Yashica, Inc.
Corrine DuBois and Bill Botkin, Rollei of America, Inc.
Roger Barnaby and Yoshio Arakawa, Pentax Corporation
Anthony Metz and Barbara Strauss, Bell & Howell/Mamiya Company
Ernst Wildi and Mike Malone, Victor Hasselblad Inc.
Larry Moyse, Bronica Division of Hindaphoto Inc.
Karl Heitz, Karl Heitz Inc.
Nancy Fishbein, Vivitar Corporation
Henry Horenstein, Polaroid Corporation
Jack Belcher, Larson Enterprises, Inc.

Front Cover Photos:
Landscape by Derek Fell
Studio still-life by Rick Gayle
Portrait by author

Back Cover Photo:
Ed White by James McDivitt
Photo courtesy of NASA

8.5005972632173